The Art of Antiquity

Piet de Jong
and the Athenian Agora

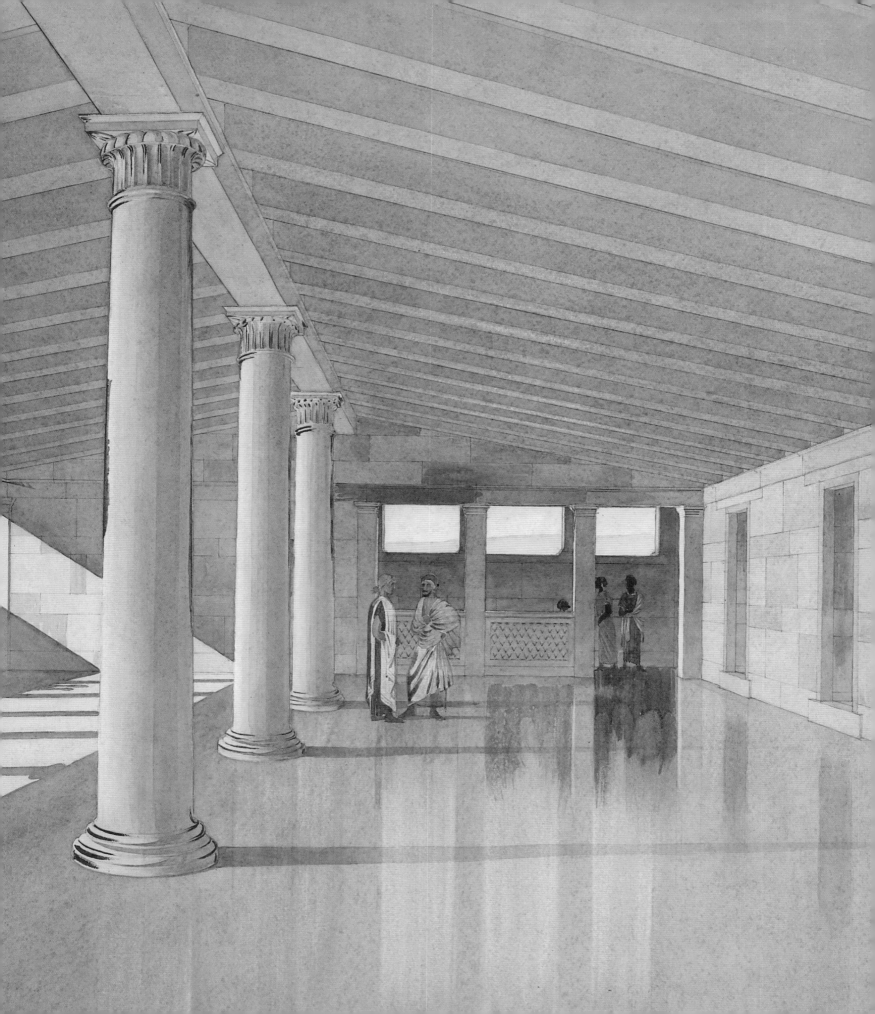

The Art of Antiquity

Piet de Jong and the Athenian Agora

John K. Papadopoulos

with contributions by

John McK. Camp II • Susanne Ebbinghaus • Walter Gauss

Anne Hooton • Jessica Langenbucher • Carol Lawton

Kathleen M. Lynch • Camilla MacKay • Carol C. Mattusch

Margaret Rothman • Susan I. Rotroff • James P. Sickinger

E. Marianne Stern • Barbara Tsakirgis

© The American School of Classical Studies at Athens, 2007

ISBN-13: 978-0-87661-960-5
ISBN-10: 0-87661-960-X

Book design and layout by Mary Jane Gavenda, Publications Management
Published in Greece by Potamos, Ypsilantou 31, 10675 Athens, Greece • www.potamos.com.gr

Frontispiece: The upper floor of the Stoa of Attalos before its reconstruction (detail)

Library of Congress Cataloging-in-Publication Data

Papadopoulos, John K., 1958–
 The art of antiquity: Piet de Jong and the Athenian Agora / John K. Papadopoulos; with contributions by John McK. Camp II . . . [et al.].
 p. cm.
 Includes bibliographical references and index.
 ISBN-13: 978-0-87661-960-5 (alk. paper)
 ISBN-10: 0-87661-960-X (alk. paper)
 1. De Jong, Piet, 1887–1967—Catalogs. 2. Archaeological illustration—Greece—Athens—Catalogs. 3. Agora (Athens, Greece) 4. Excavations (Archaeology)—Greece—Athens. I. Camp, John McK. II. De Jong, Piet, 1887–1967. III. Title.
N6797.D44A4 2007
759.2—dc22
 2006049905

Printed in Greece

CONTENTS

FIGURES AND TABLES

(Note: All Agora object photography by Craig Mauzy unless otherwise noted.)

ABBREVIATIONS

AA	*Archäologischer Anzeiger*		*GRBS*	*Greek, Roman, and Byzantine Studies*
AAA	*Athens Annals of Archaeology/ Ἀρχαιολογικὰ Ἀνάλεκτα ἐξ Ἀθηνῶν*		*Hesperia*	*Hesperia. The Journal of the American School of Classical Studies at Athens*
ABL	C. H. E. Haspels, *Attic Black-Figured Lekythoi*, Paris 1936		*ILN*	*Illustrated London News*
ABV	J. D. Beazley, *Attic Black-Figure Vase-Painters*, Oxford 1956		*JdI*	*Jahrbuch des Deutschen Archäologischen Instituts*
Add²	T. H. Carpenter, *Beazley Addenda: Additional References to ABV, ARV² and Paralipomena*, 2nd ed., Oxford 1989		*JGS*	*Journal of Glass Studies*
			JHS	*Journal of Hellenic Studies*
AE	*Ἀρχαιολογικὴ Ἐφημερὶς*		*LIMC*	*Lexicon iconographicum mythologiae classicae*, Zurich and Munich 1974–1997
AJA	*American Journal of Archaeology*			
AM	*Mitteilungen des Deutschen Archäologischen Instituts, Athenische Abteilung*		*MetMJ*	*Metropolitan Museum Journal*, New York
			MusHelv	*Museum Helveticum*
AMIran	*Archäologische Mitteilungen aus Iran*		*OJA*	*Oxford Journal of Archaeology*
AncW	*Ancient World*		*OpAth*	*Opuscula atheniensia*
AntCl	*L'Antiquité classique*		*Para*	J. D. Beazley, *Paralipomena: Additions to Attic Black-Figure Vase-Painters and to Attic Red-Figure Vase-Painters*, 2nd ed., Oxford 1971
ARV¹	J. D. Beazley, *Attic Red-Figure Vase-Painters*, Oxford 1942			
ARV²	J. D. Beazley, *Attic Red-Figure Vase-Painters*, 2nd ed., Oxford 1963		*PP*	*La parola del passato*
BABesch	*Bulletin antieke beschaving. Annual Papers on Classical Archaeology*		*QDAP*	*Quarterly of the Department of Antiquities*, Palestine
			RÉG	*Revue des études grecques*
BCH	*Bulletin de correspondance hellénique*		*SIMA*	*Studies in Mediterranean Archaeology*
BSA	*Annual of the British School at Athens*		*StMisc*	*Studi miscellanei. Seminario di archeologia e storia dell'arte greca e romana dell'Università di Roma*
BullMMA	*Bulletin of the Metropolitan Museum of Art*, New York			
ClAnt	*Classical Antiquity*		*YCS*	*Yale Classical Studies*

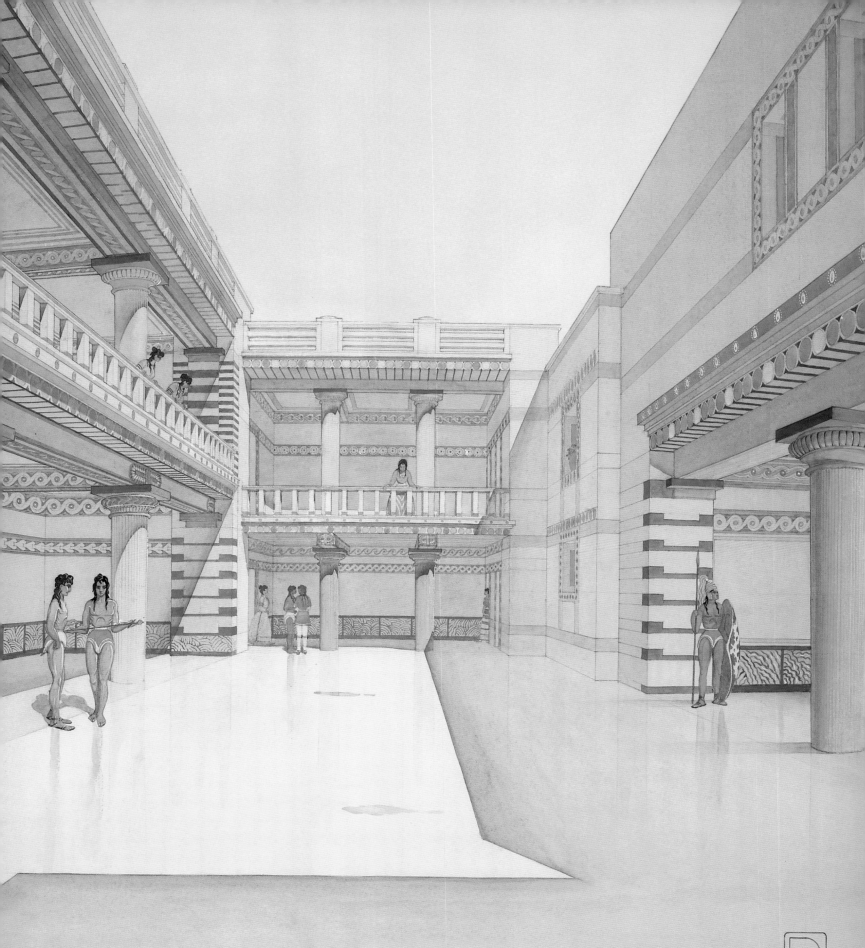

Detail of Fig. 2b

FOREWORD

THIS VOLUME BRINGS TOGETHER and illustrates in color a selection of the most important and representative watercolors by Piet de Jong, one of the great archaeological illustrators of the 20th century. The watercolors, together with a selection of ink drawings by the artist, derive primarily from the Archives of the excavations of the Athenian Agora, though several of his better-known watercolors, including those illustrating material from sites such as Knossos, Pylos, Mycenae, Ayia Irini, Prosymna, Ayioryitika, Corinth, and Eleusis, to mention only a few of the places where Piet de Jong worked in his long career, are also assembled. *The Art of Antiquity: Piet de Jong and the Athenian Agora* celebrates the 75th anniversary of the excavations in the Athenian Agora, the 50th anniversary of the reconstruction of the Stoa of Attalos, and the 125th anniversary of the American School of Classical Studies at Athens. It also celebrates the life and work of a singular artist and, in so doing, the work of all archaeological illustrators, the often anonymous people who have worked tirelessly to illustrate antiquity and to make the discipline of archaeology what it is.

The idea for this volume had its origins in the 1990s. Having agreed to take on the study and publication of all the Early Iron Age material from the Athenian Agora following the untimely death of Evelyn Lord Smithson, I wanted to establish how much of this material had been illustrated. The task was something of a pressing issue, since the difficulty of rendering in drawings the complex decoration of Athenian Protogeometric and Geometric pottery was one of the primary hurdles that had greatly slowed the progress of my predecessor. In scouring through the archived drawings in the Architects' Office in the Stoa of Attalos in search of illustrations of Early Iron Age pottery and other small finds, I soon came across several drawers of watercolors, together with some ink drawings, by Piet de Jong. Among this wealth of illustrative material there were many watercolors of the pottery for which I was responsible; these were not, however, the "scientific" drawings of pots showing elevation and profile that I was after at that time. Apparently, I was not the first to notice the dearth of more scientific drawings of the Early Iron Age material, for on several of the watercolors earlier scholars had written in light pencil their suggested amendments. Given the nature of the medium, however, together with the time that had lapsed since these annotations were made, it was clear that these amendments to the original watercolors were wishes that would never be fulfilled. Leafing through these watercolors was both captivating and eye-opening, and I soon found myself spending a great deal of time just looking at the watercolors and appreciating the art and technique of Piet de Jong. In addition to the many watercolors of Early Iron Age pottery, the drawers held veritable treasures from all periods of Athenian history, from the Neolithic era through post-Byzantine times. And over the next few years I found myself returning to these watercolors time and again.

Given the number and superb quality of Piet de Jong's watercolors, I was surprised not to find more of them published in color in one or other of the volumes in the Athenian Agora series. The vast majority of the watercolors that had been published had appeared in the journal *Hesperia* in preliminary reports or individual studies dealing with a particular object or groups of material; the watercolors were usually relegated to black-and-white prints and much reduced from their original size. It was sad to see the colorful originals bursting as they did with life reduced to small black-and-white reproductions

and scattered throughout various issues of a scholarly journal. It seemed that the era of publishing watercolors in hardbound archaeological monographs was well and truly over, an artifact of the past.

In trying to recapture the art of a bygone era, I enlisted the aid of several colleagues and friends working on various aspects of the material culture from the Agora Excavations. It was clear that the quantity and sheer scope of the discoveries from the Agora that had been illustrated by Piet de Jong was a task best approached by several specialists. Consequently, the watercolors of certain categories of material were given to those whose knowledge of it was greatest. Thus, John Camp wrote the entries of the watercolors on topography and architecture. Walter Gauss and Jessica Langenbucher worked respectively on the Neolithic through Middle Bronze Age pottery, and the finds of the Mycenaean era; Kathleen Lynch was responsible for the sizable sections on Athenian black-figure, red-figure, white-ground, and black-gloss pottery. Carol Mattusch wrote up the bronzes, including bronze sculpture; Carol Lawton the ivory and terracotta sculpture; and Barbara Tsagirkis the Roman mosaics. Susan Rotroff penned the entries on the Hellenistic pottery and, together with Margaret Rothman, the entries on the figurines. The sections on the Byzantine and post-Byzantine pottery and the wall frescoes from Saint Spyridon were written by Camilla MacKay. I took on the remainder of the material, including that of the period spanning the end of the Bronze Age through early Orientalizing, the Archaic and Classical odds and ends that nobody else claimed, and the entries on the Roman pottery, though in most of these chapters I enlisted assistance in the form of individual contributions from Susanne Ebbinghaus, Kathleen Lynch, James Sickinger, and Marianne Stern. One of the most important contributions to this volume is by Anne Hooton, the current Agora draftsperson responsible for illustrations—primarily ink drawings—of various types of material from the excavations. As an artist herself working on the same material as Piet de Jong, Anne viewed the watercolors from the point of view of style and technique. Moreover, she, like all of the contributors to this volume, has shared in the enthusiasm for the project from

the very beginning. I am grateful to all of my collaborators for keeping to the original brief for this book and doing so with such enthusiasm.

In preparing the introduction for this volume (Chapter 1), I wanted to do several things. First of all, I wanted to provide a biographical background on Piet de Jong and something of an overview of his work at other sites in Greece, thus better contextualizing his contribution to the Athenian Agora. To this end, various watercolors by Piet de Jong from sites such as Knossos, Mycenae, Pylos, Corinth, Prosymna, Eleusis, Ayia Irini, and Ayioryitika are also illustrated. More than this, I wanted to explore, however briefly, some of the more theoretical issues concerning archaeological illustration and the very notion of "antiquity depicted." Most of all, I wanted to avoid the often technical and sometimes mind-numbing descriptive ramblings of classical archaeology and Aegean prehistory. Following this introduction and Anne Hooton's chapter on Piet de Jong as artist, the format of the volume is essentially individual entries on individual pieces or groups of objects. As is explained more fully in the introduction, the various entries presented in this volume are not aimed to be definitive or exhaustive. The aim was always to tell a story. And to this end, we have essentially eschewed footnotes, though all the relevant bibliographical information on each entry is given in the catalogue information that forms the heading for each entry. Here the reader will find in summary form a brief heading, inventory and excavation identification numbers, notes on date, context, dimensions of the object(s) in question, as well as bibliographical information. (Note: all dimensions are in meters unless otherwise indicated.) The watercolors and inked drawings presented in this volume are not to scale, even though Piet de Jong always illustrated objects at 1:1 or to scale. The dimensions of the watercolor paper as opposed to the object itself are provided in tabular form in Chapter 18 for the illustrations in the Agora (Table 2) and in the figure captions for those illustrations from other collections. Given the enormous size of some of the watercolors and the diminutive size of others, not to mention the fact that many illustrate an object at the center of a much larger sheet of paper, it was necessary to crop, for

the sake of layout, several of the illustrations to the area immediately around the object itself. In the case of some of the watercolors, this has removed either the signature of the artist, the inventory number, or some other notation; the signatures of Piet de Jong and the various other labels that appear on the watercolors are more fully discussed in Chapter 18.

Although numerous people have contributed to this volume, only a select number of watercolors were able to make their way into the book. The watercolors and drawings by Piet de Jong presented in this volume represent the proverbial tip of an iceberg, and the "rejects," as we came to refer to them—the pieces not chosen for publication—would in themselves make a handsome volume. These illustrations, together with those more fortunate that have made their way into the following pages, are stored in the Architects' Office on the upper floor of the Stoa of Attalos.

In steering this publication through press there are many friends and colleagues who have helped in various ways. My first thanks must go to my collaborators who contributed their expertise to this volume. From the beginning of this project John Camp as Director of the Agora Excavations has been most supportive, and I cannot thank him enough for his many contributions to this volume. The Agora Archivists Jan Jordan and Sylvie Dumont have assisted in a variety of ways too numerous to mention here, being as they were constantly bombarded and interrupted with my many queries and often strange requests. To the Architect of the Agora Excavations, Richard Anderson, in whose office most of the Piet de Jong watercolors and drawings reside, I owe especial thanks, for every time I, or any one of my collaborators, entered his office we invariably disturbed his peace of mind.

There are some special debts of gratitude: Craig Mauzy, the Manager and Photographer of the Athenian Agora, has worked tirelessly on various aspects of this volume. Not least, the high-resolution digital images of Piet de Jong's watercolors used for this book were prepared by him. He has also assisted me in the early stages of getting this book off the ground. Throughout the course of the project, he has given freely of his time, wisdom, and energy. As a co-resident of the South

Workroom of the Stoa of Attalos, Susan Rotroff has acted as a tireless sounding board for my ideas, many of them poorly conceived, and I came to rely heavily on her guidance and sage advice. To Judith Binder I am most grateful for her many reminiscences of Piet de Jong; as a friend and contemporary of the artist, she helped me understand Piet as both an artist and as a person. My debt to Rachel Hood is enormous. Among other things, the biographical notes in my introduction are based on her published biography of Piet de Jong in her fabulous book, *Faces of Archaeology in Greece: Caricatures by Piet de Jong*, and I am grateful to her for a number of photographs of Piet de Jong published in this volume. More than this, she has been a source of all sorts of information and I have relied heavily on her knowledge of Piet de Jong and his work.

From the very inception of this project I received the assistance and full support of the various officers of the American School of Classical Studies, particularly Stephen Tracy as director of the School, Rhys Townsend as Chair of the Managing Committee, and Cathy Vanderpool as executive director; my thanks to them all. I would also like to express my gratitude to my friends and colleagues at the Benaki Museum for their support, good taste, and, not least, their good humor, particularly Angelos Delivorrias, Irini Geroulanou, Stavros Vlizos, Natasha Karagelou, and Myrto Kaouki.

For permission to illustrate watercolors from sites other than the Athenian Agora, I am grateful to a good many friends and colleagues, particularly Jack Davis, Brian Rose, and Carol Hershenson at the University of Cincinnati, Susan Walker and Christopher Brown at the Ashmolean Museum in Oxford, Guy Sanders, Charles Williams, and Nancy Bookidis at the Corinth Excavations, Natalia Vogeikoff-Brogan at the Archives of the American School of Classical Studies in Athens, Giorgos Rethymniotakis at the Herakleion Museum with regard to the Piet de Jong watercolors of Knossos in the museum commissioned by Nikolaos Platon, and Xeni Arapoyianni and Yioryia Hatzi at the Olympia Ephoreia with regard to the Piet de Jong watercolors of the Palace of Nestor at Pylos that were on display at the Chora Museum. I am also grateful to the Greek Ministry of Culture, particularly Alkestis Choremi and her staff at

the 1st Ephoreia of Prehistoric and Classical Antiquities. For photographs of Piet de Jong used in this volume other than those from the Athenian Agora, I am grateful to Rachel Hood, Robert McCabe, and the University of Cincinnati.

For seeing this volume to press I would like to thank Charles Watkinson and his staff at the Publications Office of the American School of Classical Studies in Princeton and Kostas Papadopoulos and his staff at Potamos Publishers in Athens. Both have contributed a great deal to this volume and the quality of the production of this book would not have been possible without the efforts of both men. In the Princeton Office I am particularly grateful to Mary Jane Gavenda, Jennifer Backer, Carol Stein, and Timothy Wardell. In Athens I am especially grateful to Christina Marabrea for overseeing the Greek translation and for tidying up a number of errors of fact and/or judgment.

Funding for this project has been generously provided by the Institute for Aegean Prehistory—and I am especially grateful to both Malcolm Wiener and Philip Betancourt for their assistance and advice—the Publications Office of the American School of Classical Studies at Athens, and the Agora Excavations of the American School of Classical Studies. For their assistance I am especially grateful to Cathy Vanderpool and Charles Watkinson.

More than anything else this volume celebrates the life and work of a great artist, as well as a person with a wonderful sense of humor. I only wish that he knew how much his illustrations are still used and how much they continue to delight not only specialists—those who have spent years poring over the material the watercolors illustrate—but also all those who have had the fortune, however fleeting, to engage with the work of Piet de Jong.

—*John K. Papadopoulos*

Chapter 1

The Art of Antiquity:
Piet de Jong and the Athenian Agora

John K. Papadopoulos

INTRODUCTION

THE ARCHIVES OF THE ATHENIAN AGORA EXCAVATIONS of the American School of Classical Studies at Athens contain a remarkable and unique series of watercolors and drawings—well over four hundred—by Piet de Jong, one of the best-known, most distinctive, and most influential archaeological illustrators of the 20th century. In an era before color photography was widely used and available for archaeological illustration, watercolors graced the frontispieces of many archaeological monographs, as they occasionally graced the walls of a museum, providing the reader and visitor with a colorfully cogent view of an object or ancient landscape that somehow surpassed the drabness and stark clarity of black-and-white photography. In addition to frontispieces, many final publications of an archaeological site included various watercolors, reproduced in color, of the finest and most important discoveries. Through the addition of watercolors, the archaeological monograph was transformed from a scientific account of data and interpretations into a virtual Thucydidean κτῆμα ἐς αἰεὶ—a legacy gift or possession for all time. There were many archaeological illustrators who made watercolors of archaeological sites and objects in the Mediterranean, but in Greece the greatest and most prolific was Piet de Jong. During his long career he was actively sought out by some of the leading archaeologists of the day, both Greek and foreign. And since his death in 1967 the very art of watercolor as a medium for archaeological illustration has all but disappeared. Piet de Jong not only lived in the era when the medium of watercolor for archaeological illustration was in demand, he very much defined and perpetuated the medium. His illustrations are works of art of ancient things that we have come to view as works of art themselves. Piet de Jong's art was the art of antiquity.

Much of our image of Aegean prehistory and Classical archaeology has been consciously or subconsciously defined by de Jong's illustrations and their style. Piet de Jong's work in Greece, particularly his contributions at Knossos and Pylos, are especially well known to Aegean prehistorians, but they are also known to nonspecialists who have visited these sites, even though they may never have heard of de Jong. In Minoan Crete, his contributions include the physical reconstruction in *beton armée*—as reinforced concrete was then known—and bright paint of the Palace of Minos at Knossos (Fig. 1) (Papadopoulos 1997). To visit the palace site at Knossos today is to experience firsthand not only the vision of Sir Arthur Evans but the handiwork and stylistic sensitivities of Piet de Jong. Despite the blatant physicality of the palace at Knossos, one of Piet de Jong's most enduring legacies was the reconstruction, on paper, of the Palace of Nestor at Pylos for Carl Blegen. Here Piet de Jong provided vividly colorful and visually distorted interior and exterior views of the building in the form of watercolors that were on display for a long time in the museum at Chora, not far from the palace site at Epano Englianos (Figs. 2a, b), together with a reconstructed floor plan of the Throne Room (Fig. 2c).

However significant Piet de Jong's contributions to Aegean Bronze Age archaeology, one of his longest and most fruitful collaborations was with the Agora Excavations of the American School of Classical Studies at Athens. During his long involvement with the Athenian Agora, which spanned more than three decades—particularly through his relationship with the first two directors, T. Leslie Shear and Homer Thompson—Piet de Jong illustrated some of the most important finds and monuments from the site. These range in date from the

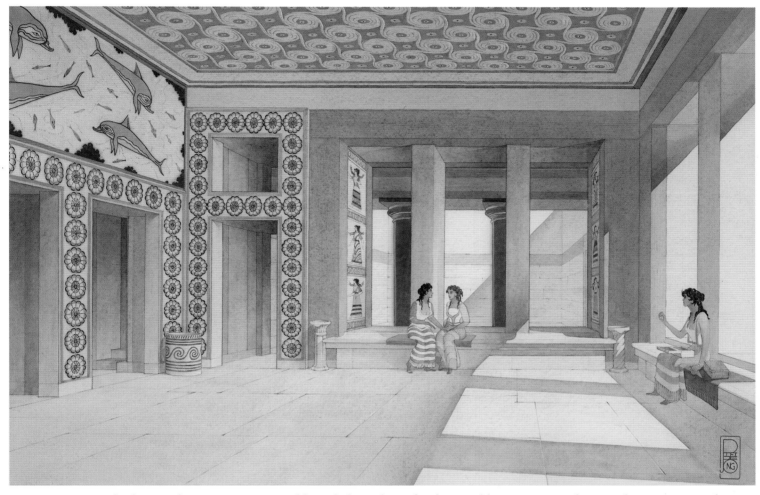

FIGURE 1. Watercolor by Piet de Jong commissioned by Nikolaos Platon for the Herakleion Museum showing the reconstructed interior of the Queen's Megaron of the Palace of Minos at Knossos. Herakleion Museum.
Horizontal orientation: 0.665 × 0.453 (as mounted), 0.901 × 0.722 (as framed). Type 7 signature in red ink at lower right corner

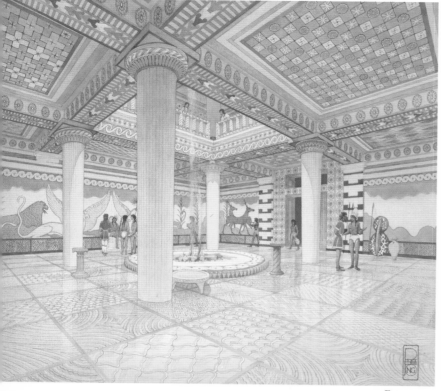

FIGURE 2A

FIGURE 2C

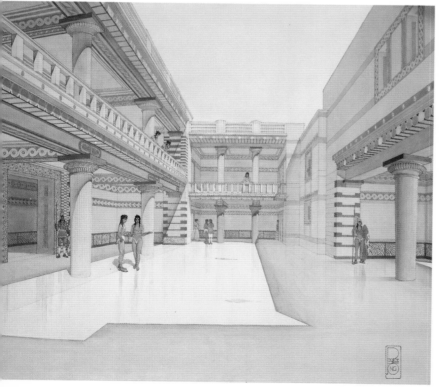

FIGURE 2B

FIGURE 2

A. Reconstruction of the interior of the Throne Room of the Palace of Nestor at Pylos by Piet de Jong.
Horizontal orientation: 0.730 × 0.618. Type 7 signature in red ink at lower right corner

B. Reconstruction of the courtyard in front of the Throne Room of the Palace of Nestor.
Horizontal orientation: 0.750 × 0.625. Type 7 signature in red ink at lower right corner

C. Floor plan of the Throne Room of the Palace of Nestor.
Vertical orientation: 1.375 × 1.200. Type 7 signature in red ink at lower right corner

Watercolors a and b originally hanging on the wall of the Archaeological Museum in Chora, now in the Ephoreia of Olympia; watercolor c still in the Chora Museum. Courtesy 7th Ephoreia of Prehistoric and Classical Antiquities of Olympia and the University of Cincinnati

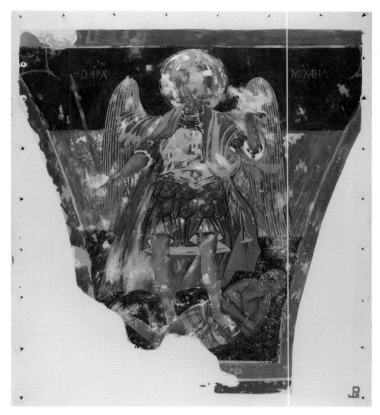

FIGURE 3. Watercolor by Piet de Jong of the fresco of Archangel Michael from the Church of the Prophet Elias and Saint Charalambos. Athenian Agora Painting no. 318

Neolithic period through the post-Byzantine era and include objects as varied as church frescoes (Fig. 3) and fragments of Athenian red-figured pottery (Fig. 4) to Mycenaean pots (Fig. 5), Roman lamps, and Classical architectural elements (Fig. 6). Many of these watercolors and drawings have been published, the majority in preliminary reports in *Hesperia*, most often as black-and-white reproductions that do not do justice to the colorful originals. A few have been published in color, but most of these are scattered in various issues of the *Illustrated London News* or similar popular journals of the day. Some of the watercolors have never been published. Until recently they were stored in the large gray filing cabinets of the Architects' Office in the Archives of the Agora Excavations on the upper floor of the Stoa of Attalos, where they languished in virtual oblivion, gathering dust. To peek into these drawers was to experience an explosion of color and light, to see familiar objects not in the sterile or manipulated light of the museum display, but as almost living entities bursting with life, eager to be seen. As Rachel Hood has remarked, Piet de Jong had the "skill and insight in bringing dead artifacts to life in a way that no photograph or mechanical means could do" (Hood 1998, p. 267).

The aim of this volume is to bring these illustrations out of their oblivion and to assemble in color a representative sample of the finest and most characteristic Piet de Jong watercolors, as well as some of his ink drawings, from the Athenian Agora. Since the majority of the objects illustrated by de Jong have been published, often in meticulous detail and sometimes in numerous publications, our aim here is not to provide a definitive catalogue raisonné but to tell a *story* about each piece or illustration (for storytelling in archaeology, see, among others, I. Morris 2000, pp. 309–312; Praetzellis and Praetzellis 1998). The broad variety of materials and chronological scope of the things illustrated by Piet de Jong demanded the skill and experience of different researchers familiar with the various categories of material. To this end, a number of colleagues and friends, all specialists working on material in the Athenian Agora, have penned entries on individual illustrations. This was done in part as a celebration of the 75th anniversary of the initiation of the Agora Excavations in 1931—together with the 50th anniversary of the reconstruction of the Stoa of Attalos and the 125th anniversary of the American School of Classical Studies at Athens—providing as it did the opportunity not only of reuniting the original artifact with its artful facsimile but also, through the illustrations of Piet de Jong, to enjoy the remarkable discoveries made in the Agora Excavations in the course of seventy-five years. Indeed, the illustrations presented in this volume give something of a panoramic sweep of Athenian archaeology, history, and culture, particularly of the part of the city that was the civic and commercial center in the Classical period. More than this, this volume was prepared as a labor of love and as homage to a unique illustrator and great artist, a person as colorful in life as many of his watercolors.

FIGURE 4

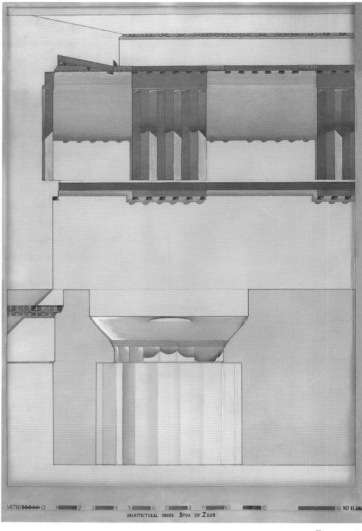

FIGURE 6

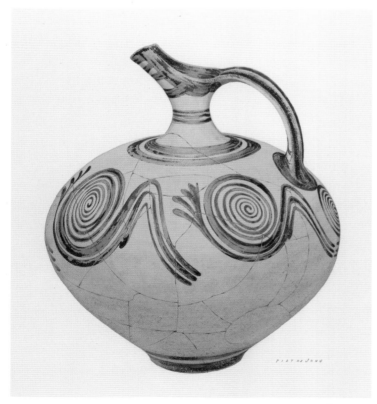

FIGURE 5

FIGURE 4. Watercolor by Piet de Jong of a fragment of an Athenian red-figured closed vessel (P 7241) by the Kleophrades Painter. Athenian Agora Painting no. 227

FIGURE 5. Watercolor by Piet de Jong of Mycenaean jar (P 23587). Athenian Agora Painting no. 351

FIGURE 6. Watercolor by Piet de Jong showing the Doric order of the late-5th-century B.C. Stoa of Zeus (PD no. 21)

PIET DE JONG AND GREECE

BEFORE DELVING INTO THE WATERCOLORS from the Athenian Agora that form the focus of this volume, it would be useful to provide a little background on some of the more salient aspects in the life of Piet de Jong (Fig. 7). A wonderful biography of the man is provided by Rachel Hood (1998, pp. 225–270), to which little can be added. Hood's richly illustrated appreciation tells the story of Piet de Jong's life and career in detail and with sensitivity. It begins with the migration of Piet de Jong's father, Jacques Leonardus de Jong, in 1885 from Gouda in the Netherlands, via Rotterdam, to Yorkshire in England, his marriage to Rosa Teale (née Ramsden) and the birth of Pieter Christiaan Leonardus (Piet) on August 8, 1887, his subsequent marriage on Valentine's Day, 1921, to Effie (Miss Euphemia Williamson Skinner; Fig. 8), and ends with the night of Piet's death on April 20, 1967. Hood's biography also conveys something of what Piet was like (Hood 1998, pp. 268–269):

> The outline biographical facts do not convey what Piet and Effie were really like. The cartoons that Piet made of himself and Effie [Figs. 9, 10] give nothing away and are devoid of anecdote. They show only that they were fond of kilims—that pattern and color were important to them; and that Piet was addressed deferentially, as was the custom, by the Greek dig workmen, as "Mr Engineer" [Ο ΚΥΡΙΟΣ ΜΗΧΑΝΙΚΟΣ]. Perhaps Winifred Lamb got to the kernel of the matter in a letter to her mother: (29.5.1924) "de Jong has more joy of life than almost anyone I know and it was he who, perhaps unconsciously, perhaps not, made the party so merry and prevented undue despondency when things were not going well, by his historic series of caricatures." Put another way by an American friend: "What an artist at savoring life . . . to walk down the street with Piet was a celebration."

Piet was a man of ingenious simplicity. In the days before air conditioning he would arrange a bucket containing a block of ice on his table and behind that a fan, the whole blowing delicious cool air over him as he worked through the Greek summer heat. He was a man of economy; he would arrive in Crete with apparently only a briefcase for luggage. This contained two cotton vests, one pair of cotton trousers and a few pencils. His movements were equally economic. His voice, only occasionally erupting into a chuckle, was pitched at a degree of quietness which demanded attention. He never lost his musical, Yorkshire accent. His clothes were those of a modest artist, perhaps a mustard colored or raw umber shirt, often a silk neckerchief, always the beret, always immaculate looking. "If I had known I looked like that," said Piet on seeing a photograph of himself, "I would have behaved quite differently." He was a master of color and may have found the freer nature of prehistoric pottery and fresco, where the subtlety of color change was so challenging, more to his taste than the perhaps more rigid classical works of art. He would stand back from his work to consider it as he went along, in the manner of an artist. His workshop in Norfolk was much admired by enthusiasts for its precision tools (which he made) "all beautifully graded in size and kept in perfect order."

Following his schooling, Piet de Jong trained as an architect at the Leeds Institute of Science, Art, and Literature, where he won various prizes. In 1912 he put in for a Royal Institute of British Architects (R.I.B.A.) Soane Medallion and received an Honorable Mention, which gave him £50 for traveling. This he spent in Italy, where he lived for several months drawing in Rome, later visiting Assisi, Perugia, Florence, Siena, Bologna, Venice, Murano, and Torcello. As Hood notes, "[T]he drawings made during Piet's stay in Italy in 1912 reveal a joy and intensity of emotion at the discovery of Renaissance architecture. His draughtsmanship is elevated to a plane worthy of the work of Brunelleschi and Bramante" (Hood 1998, p. 231).

Upon his return to England he worked for the Leeds firm of architects, Schofield and Berry, where he designed the First Church of Christ Scientist in Leeds, the only building in England for which Piet was largely responsible for the design, and a building variously described as "neo-Grec" and as "classical with a little Egyptian detail" (Hood 1998, p. 236). In 1916, Piet de Jong joined the army, where he served as a lance corporal and a member of the Army Cyclist Corps. Virtually nothing is known of his service during World War I, but by the summer of 1919 he was employed on the Reconstruction Programme for Eastern Macedonia. The program, which was initiated

FIGURE 7. Photograph of Piet de Jong (Hood 1998, frontispiece). Courtesy Rachel Hood

FIGURE 8. Piet and Effie de Jong in Athens, probably in the garden of Effie's apartment in Kydathenaion Street; photograph taken by Queenie Dewsnap soon after Piet and Effie's wedding in 1921. Courtesy Rachel Hood

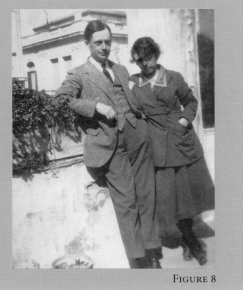

FIGURE 7

FIGURE 8

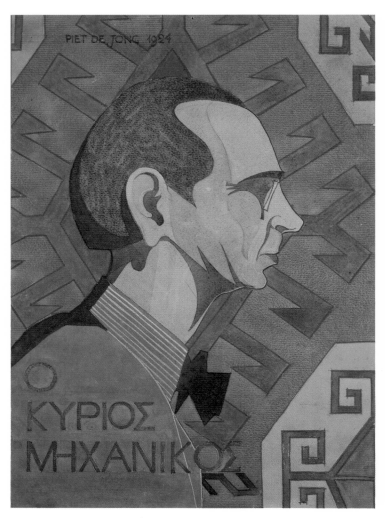

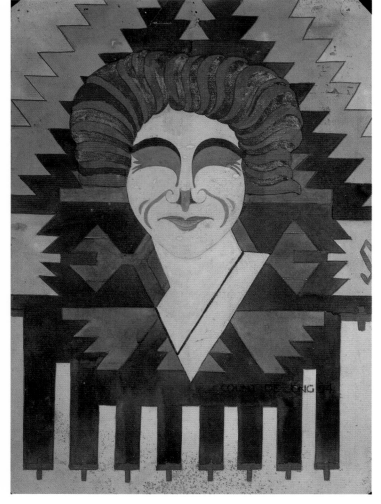

FIGURE 9. Caricature of Piet de Jong by Piet de Jong (Hood 1998, p. 224). Vertical orientation: 0.602 × 0.450 (as framed). Ashmolean Museum, Oxford

FIGURE 10. Caricature of Effie de Jong by Piet de Jong (Hood 1998, p. 242). Vertical orientation. Ashmolean Museum, Oxford

by the Greek government, saw British and French architects surveying and planning new towns and villages in northern Greece (Hood 1998, pp. 239–241). During this time Piet de Jong traveled extensively in northern Greece and Istanbul, and also visited Mount Athos. By 1920, Piet seems to have been commuting between Thessalonike and Athens and to have undertaken a number of short-term commissions (Hood 1998, pp. 243–244). In the same year, he was introduced to Alan Wace and made some of the illustrations of the first British season of work at Mycenae. In 1921—the year he married Effie—he was invited to join the digging and, among other things, completed the reconstructed view of Grave Circle A in 1922 (Fig. 11); indeed, his work at Mycenae in the early 1920s is fully recorded in the illustrations published in volume 82 of *Archaeologia* (Wace 1932) and in the *Annual of the British School at Athens*, especially volume 25 (Wace 1921–1923).

By 1922 Piet de Jong was established at the British School at Athens and began his long association with Sir Arthur Evans, resulting in his architectural reconstructions of the palace at Knossos in reinforced concrete and bright paint (Fig. 12). In 1923 he was officially appointed architect of the British

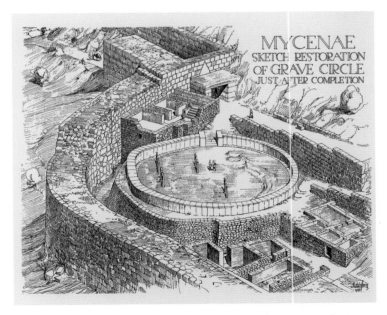

FIGURE 11. Reconstruction by Piet de Jong of Grave Circle A at Mycenae, prepared in 1922 and published in Wace 1921–1923, pl. XVIII

School, and spent much of the decade of the 1920s working at Mycenae, on Crete, and in Sparta. During the 1920s he also worked for Hetty Goldman, first at Halae and later at Eutresis, for Carl Blegen at Zygouries, and was also employed at Corinth, working for Bert Hodge Hill and, later, T. Leslie Shear; in 1929 he joined Humfry Payne at Perachora (Hood 1998, pp. 246–255). He also prepared several color plates for Carl Blegen's 1928 excavations at the Neolithic and Early Helladic settlement of Ayioryitika, the results of which were eventually published in 2002 (Petrakis 2002, no. 34, fig. 18; no. 88, fig. 25; nos. 290, 292, fig. 36; no. 420, fig. 37). Among the watercolors prepared by Piet de Jong of Neolithic pots from the site, Figure 13 is among the most characteristic. In 1930 Piet and Effie de Jong bought their home—Vinfreys—in the then remote village of Snetterton in Norfolk and, from that time on, Piet largely made forays to Greece to work on a part-time basis.

In the 1930s in addition to his work at the Athenian Agora, which took up much of his professional time, Piet de Jong completed all the Perachora drawings for Humfry Payne, as well as the plates for Carl Blegen's publication of Prosymna (Fig. 14) and the color plates of Charles Morgan's study of the Byzantine pottery at Corinth (Fig. 15); he also worked on the extensions of the British School Hostel and Library (Hood 1998, p. 259). His contribution to Corinth was to be more substantial, and included watercolors of some of the most famous objects from that site, a contribution that extended into the 1950s. Of the many watercolors by Piet de Jong in the archives of the Corinth Excavations, only a few are presented here (Figs. 16–18), in addition to the watercolor of the Byzantine plate (Fig. 15). The large Geometric krater (Fig. 16) from the North Cemetery was definitively published in *Corinth* XIII and considered to be of Corinthian manufacture, despite the fact that Paul Courbin thought the vessel to be Argive some years earlier, and an Argive provenance is now generally assumed (see Coldstream 1968, p. 140). Also from the North Cemetery at Corinth are two typical examples of Corinthian Archaic pottery, one a figured pyxis with protome handles (Fig. 17a), the other an amphora with heraldically positioned roosters (Fig. 17b).

FIGURE 12

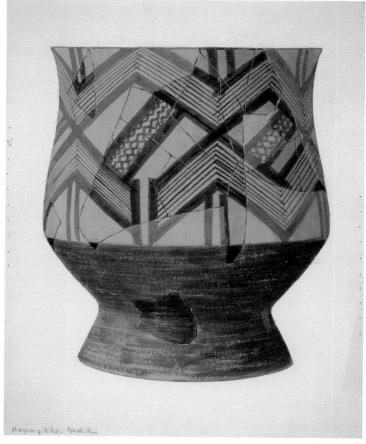

FIGURE 13

FIGURE 12. Watercolor by Piet de Jong commissioned by Nikolaos Platon for the Herakleion Museum showing the reconstructed North Entrance Passage of the Palace of Minos at Knossos. Herakleion Museum.
Vertical orientation: 1.015 × 0.613 (as mounted), 1.235 × 0.816 (as framed). Type 7 signature in red ink at lower right corner

FIGURE 13. Watercolor by Piet de Jong of a Neolithic pot from Carl Blegen's 1928 excavations at Ayioryitika.
Vertical orientation: 0.290 × 0.227. Collection of the Department of Classics, University of Cincinnati, Painting no. 182

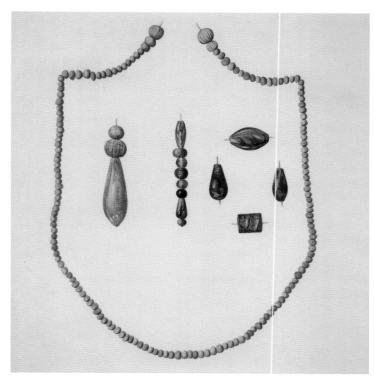

FIGURE 14. Watercolor by Piet de Jong of beads of amethyst, carnelian, and blue faience from Prosymna, Tomb III.
Vertical orientation: 0.283 × 0.230. Collection of the Department of Classics, University of Cincinnati, Painting no. 98

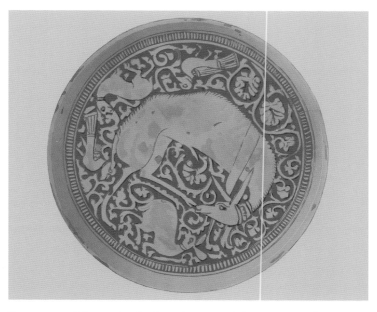

FIGURE 15. Watercolor by Piet de Jong of the interior of a sgraffito bowl from Corinth (C-29-03: *Corinth* XI, p. 331, no. 1666, frontispiece)

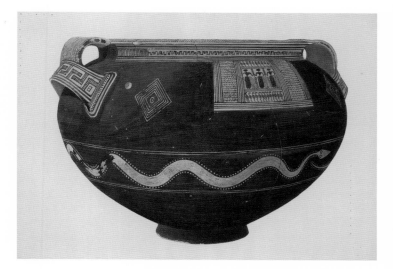

FIGURE 16. Watercolor by Piet de Jong of Argive Geometric snake krater from Corinth (T 2545: *Corinth* XIII, pp. 35–36, 45–46, no. 47-1, pl. 9; Coldstream 1968, p. 140).
Horizontal orientation: 0.469 × 0.338. Type 1 signature in red ink at lower right, identification number and "full size" at top left corner.
Courtesy Corinth Excavations

The latter two are among the finest and most characteristic examples of the type of pottery from Corinth—wealthy Corinth—that is found in quantity throughout the Mediterranean. But one of the most celebrated and idiosyncratic of all Corinthian pots is the delightful aryballos (Fig. 18), which dates to the Middle Corinthian period. The vessel was found in the excavations of 1954 on Temple Hill and comprehensively published the following year by Mary and Carl Roebuck (1955), including a black-and-white rendering of Piet de Jong's watercolor. The vessel depicts an aulos player and groups of naked young men in pairs, except for the front-most youth, who is leaping in midair. The inscription that winds its way sinuously around the figures was to be the one aspect of the pot that generated the most interest (see Amyx 1988, pp. 165, 556, 560–561, and Boegehold 1965, which review earlier contributions). The inscription, in the characteristic epichoric lettering of Archaic Corinth, names Polyterpos (from *polyterpēs*, which means "much pleasing," best taken as a proper noun) and Pyrwias, the leader of the chorus. The final part of the inscription has been variously interpreted either as "the olpa is his, his very own" or "here a dance for Dewo," Dewo being

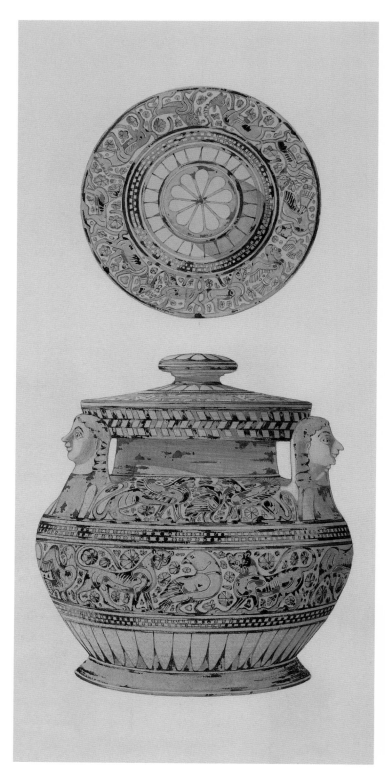

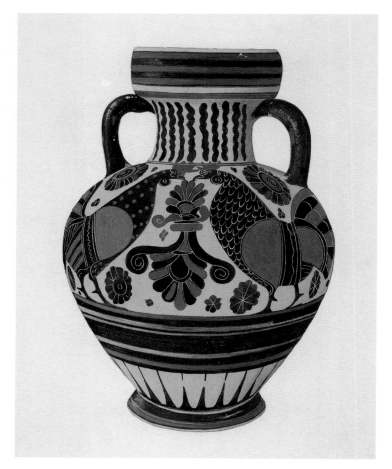

FIGURE 17B. Watercolor by Piet de Jong of Archaic (Middle Corinthian) amphora from Corinth, North Cemetery (T 3171: *Corinth* XIII, pp. 173–174, no. 141-5, frontispiece and pl. 85). Vertical orientation: 0.349 × 0.255. Type 1 signature down right side; identification and tomb numbers and "full size" at top left corner. Courtesy Corinth Excavations

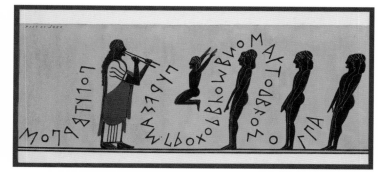

FIGURE 17A. Watercolor by Piet de Jong of Archaic (Middle Corinthian) lidded pyxis with protome handles from Corinth, North Cemetery (T 1513: *Corinth* XIII, pp. 183–184, no. 157-m, pls. D, 86, 87).
Vertical orientation: 0.510 × 0.350. Type 1 signature down right side; identification and tomb numbers and "full size" at top left corner. Courtesy Corinth Excavations

FIGURE 18. Watercolor by Piet de Jong of a Middle Corinthian "prize aryballos" from Corinth (C-54-1).
Horizontal orientation: 0.350 × 0.154 (as mounted). Type 2b signature at upper left. Courtesy Corinth Excavations

an early form of Deo, an ancient name for Demeter. A worthy dedication or votive offering to an Archaic sanctuary, the vessel is on display in the Corinth Museum, while Piet de Jong's watercolor (Fig. 18) hangs prominently beside the fireplace in the *saloni* (salon) of the Hill House at Corinth to the delight of the resident archaeologists and visitors.

In 1939 Piet returned to Norfolk after the outbreak of World War II and did not return to the Mediterranean until 1947. In 1941 he accepted a war job in London designing machine tools (Hood 1998, pp. 259–260). After the war, Piet was appointed by the London committee of the British School to manage the property at Knossos. Now at age sixty he was responsible for the upkeep of the palace, the Little Palace, the Caravanserai, Roman Villa, and the Kefala tombs, as well as for overseeing repairs to the Villa Ariadne and the Taverna. Piet also took it upon himself to cultivate the estate, and in this he had a good measure of success in the early years. But the enormity of the task was too great and in April 1952 Piet, on behalf of the British School, handed over the keys of the Villa Ariadne and the Evans estate to the then ephor of Crete, Nikolaos Platon (Papadopoulos 1997). During these postwar years at Knossos he prepared a series of large watercolors commissioned by Nikolaos Platon for the Herakleion Museum, showing parts of the palace—including the Queen's Megaron, the Hall of the Double Axes (Fig. 19a), the west side of the Palace of Minos with the Central Courtyard (Fig. 19b), the Dolphin fresco (Fig. 1), the North Entrance Passage (Fig. 12), and others—as well as a color plan and elevation of the Temple Tomb. Whether on paper or in the flesh, the Bronze Age palace at Knossos is intimately entwined with the artful craft of Piet de Jong, and it is as much a creation of the 20th century as it is of the Bronze Age. It has been said that Knossos today preserves some of the best examples of art deco architecture in Greece (Papadopoulos 1997).

Between 1947 and his death in 1967, Piet de Jong worked on a variety of projects in Greece and in 1957 joined the American excavations at Gordion in Turkey. In addition to his work at the Agora and the Palace of Nestor at Pylos, Piet illustrated the Late Minoan pottery from the cemetery at Katsamba for Stylianos Alexiou; drew seals for Doro Levi and for the German Archaeological Institute; worked for Spyridon Marinatos at the Minoan Villa at Vathypetro; helped Bert Hodge Hill with the study of the temples at Nemea and Tegea; worked with Oscar Broneer and others at Corinth, and with Jack Caskey at Lerna and later on Kea (Fig. 20); illustrated the celebrated Eleusis amphora for George Mylonas (Figs. 21a, b); and worked on a number of British School projects in Crete, such as the excavation of the Royal Road, the Gypsades cemetery, and copying more Minoan frescoes (Hood 1998, pp. 262–268). All this was achieved despite a severe lack of money and an increasingly arthritic right wrist (pp. 263–268). Piet de Jong's final working trip to Greece was in the spring of 1966, when he summoned the strength to travel and work only a few months following the death of Effie just after Christmas 1965 (p. 268).

Although Piet de Jong was underpaid, his skill as an illustrator was never undervalued. In a copy of a letter now in the Agora Archives, written to Edith Clay and dated March 25, 1952, Jack Caskey wrote, "Men of his abilities and experience are all too hard to find." As the person who commissioned the Pylos illustrations, Blegen noted, "Special mention should also be made of Piet de Jong, our artist, whose constructive imagination recreated and brought to vivid perception the lingering aura of the royal Mycenaean rulers who dwelt in this palace" (Blegen and Rawson 1966, p. x; Hood 1998, p. 267). Several photographs showing Piet de Jong at work at the Palace of Nestor are now in the Archives of the Department of Classics at the University of Cincinnati (Fig. 22).

A more nuanced appreciation of Piet de Jong's skill has been provided by Mabel Lang, who worked with Piet in making plausible reconstructions of the Pylos wall paintings (Hood 1998, p. 267):

> She says that her scholarly conscience had to be used to restrain some of his more "creative flights"; but that he had what amounted to a Mycenaean painter's instinct because like them he was influenced by his deep knowledge of their Cretan forerunners.

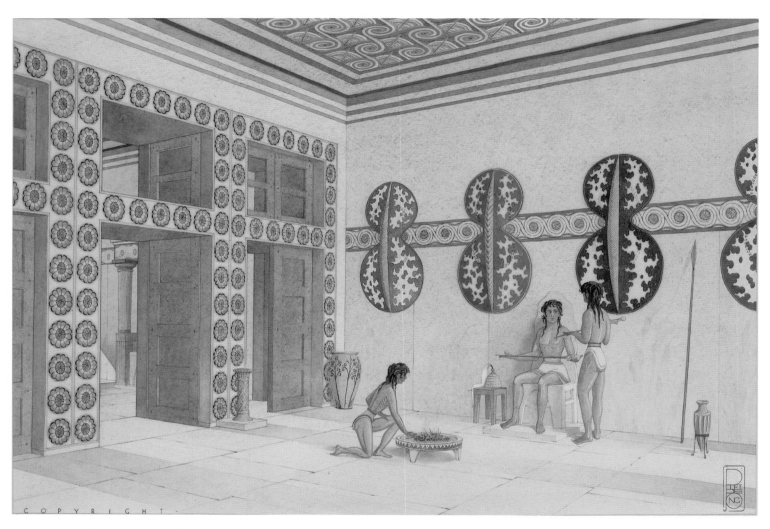

FIGURE 19A. The reconstructed interior of the Hall of the Double Axes at the Palace of Minos at Knossos. Watercolor by Piet de Jong commissioned by Nikolaos Platon for the Herakleion Museum.
Horizontal orientation: 0.653 × 0.450 (as mounted), 0.902 × 0.720 (as framed). Type 7 signature in red ink at lower right corner

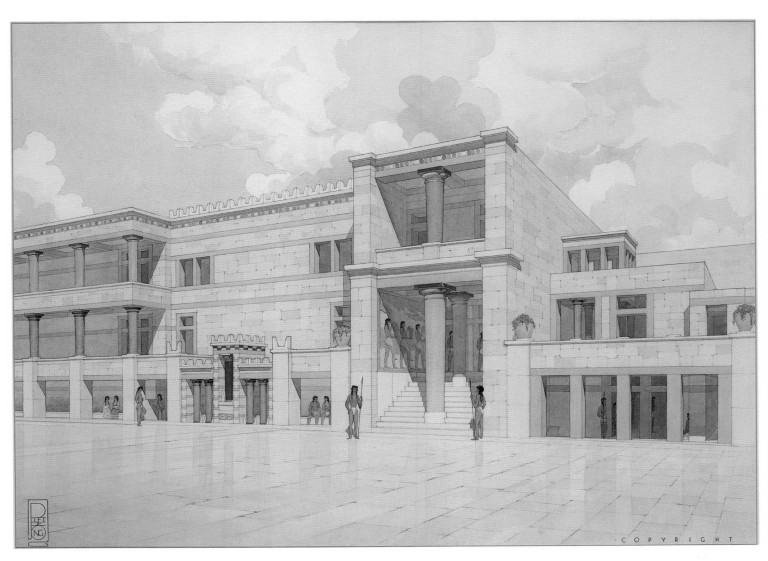

FIGURE 19B. The west side of the Palace of Minos and the Central Courtyard. Watercolor by Piet de Jong commissioned by Nikolaos Platon for the Herakleion Museum.
Horizontal orientation: 0.826 × 0.600 (as mounted), 1.039 × 0.855 (as framed). Type 7 signature in red ink at lower left corner

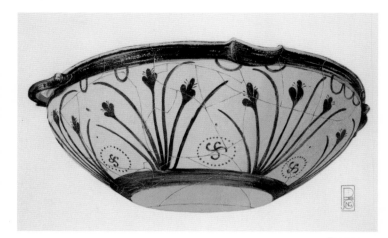

FIGURE 20. Watercolor of Mycenaean bowl with crocus-lily motif from Ayia Irini (P 186) by Piet de Jong.
Horizontal orientation: 0.349 × 0.249. Type 7 signature in red ink immediately to right of pot. Collection of the Department of Classics, University of Cincinnati, Painting no. 2

FIGURE 21. Watercolors of the Eleusis amphora by Piet de Jong for George Mylonas (after Mylonas 1957, color pls. A and B)
A. Detail of neck showing the blinding of Polyphemos
B. Detail of body showing gorgons and Athena

FIGURE 20

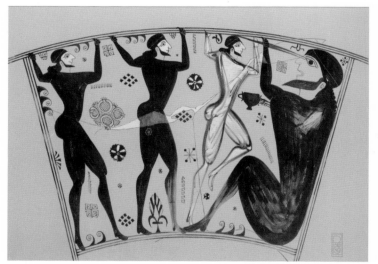

FIGURE 21A

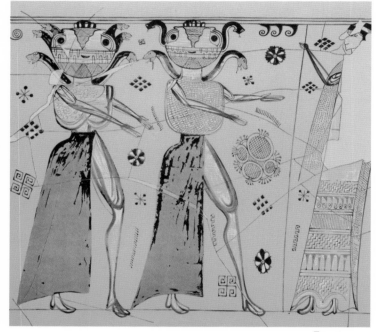

FIGURE 21B

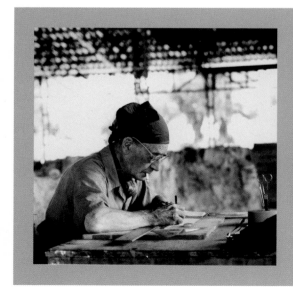
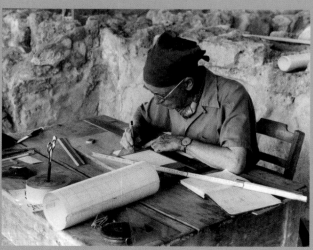

FIGURE 22. Photographs of Piet de Jong working on illustrations of the frescoes from the Palace of Nestor at Pylos. Collection of the Department of Classics, University of Cincinnati

In the preface to her volume on the Pylos frescoes, which is dedicated to Piet de Jong, Lang writes (1969, p. viii):

> I am also particularly grateful to the memory of Piet de Jong, a colleague with whom it was always a pleasure to work; he combined experience, "know how" and imagination with the patience, understanding and skill necessary to translate a student's figments into possible pictures; his death is an incalculable loss to the understanding of ancient art.

In a similar vein, the authors of the final volume on Pylos, published a few years after Carl Blegen's death, had this to say (Blegen et al. 1973, p. vii):

> Piet de Jong died April 20, 1967. His training as an architect, his admirable drawings, watercolors, and sketches, his thoughtful and always helpful advice, and his ingenuity in overcoming problems and difficulties, all these qualities made him a wonderful archaeologist, and a congenial companion. His death was a calamity for our expedition and will be long mourned. Our remembrance of Piet de Jong will live by his works.

Among all of his work, the watercolors of the frescoes and reconstructions of the Palace of Nestor at Pylos are some of the most memorable illustrations of the Aegean Bronze Age (Figs. 2a–c). They have graced not only the walls of the Chora Museum and the various volumes of the final publication of the site, but have been often illustrated in color in numerous synthetic overviews of the Mycenaean world and, as color slides or digital scans, provide a mainstay for teachers of Greek culture whenever the Classics are taught. Among the many watercolors of the frescoes of the Palace of Nestor, only a small selection is illustrated here; the originals are divided between the University of Cincinnati and the Archives of the American School of Classical Studies at Athens. Two of the most iconic of the Pylos frescoes are the lyre player and bird from the Throne Room of the palace (Fig. 23) and what has come to be known as "Battle Scene I: Duomachy and Mass Murder" from Hall 64 (Fig. 24), which was part of a larger battle scene. As with most of the frescoes, they are heavily restored, and whatever their accuracy, the iconography of the paintings is known today more through the watercolors of Piet de Jong than from the original Bronze Age fragments. In this way, Piet de Jong the artist has influenced our very concept of Mycenaean antiquity. Indeed, color photography of the fresco fragments was to prove both inflexible and inadequate as a means of representing the Pylos wall paintings. The manner in which Piet de Jong imparted his own sensitivities to the originals is perhaps best seen in the fragmentary fresco of the two life-size women (Fig. 25). The fragments were recovered from the northwest slope plaster dump at Pylos and clearly derive from a fresco of large proportions. Despite the fact that virtually nothing remains of the faces of the two female figures, Piet de Jong did not shy away from reconstructing their faces, complete with hairstyles accentuated with running spirals and tied up at the back, giving the appearance of a Minoan octopus, in a charming style that is as much a product of the 20th century as it is of the Late Helladic period. In another fresco, Piet de Jong's reconstruction of the fragmentary lion and griffin frieze (Fig. 26) from Hall 46 represents the final, published version of what the iconography may have looked like in its original state; in addition to this version, alternative and earlier draft versions are stored in the Archives of the American School of Classical Studies at Athens that give a different appearance, particularly of the head of the griffin. Whether complex pictorial representations or simple architectural ornamentation, such as the running spiral (Fig. 27)—one of several from the Palace of Nestor—Piet de Jong had the ability to make poorly preserved and often drab fragments come alive in a sensational manner.

The brilliance of Piet de Jong, however, was that his skill was not limited to a Minoan or Mycenaean idiom. He illustrated, with the same consummate skill, objects and monuments of the Archaic, Classical, Hellenistic, and Roman periods, as well as those of Byzantine and post-Byzantine times. Perhaps the person who summed up Piet de Jong's work best is Rachel Hood (1998, p. 265):

> There is a trompe l'oeil quality in his work, a pleasure in depicting the cracks and flaws in the pottery, the exact state of the glaze, whether it is burnished or worn, every detail is rendered with intense accuracy. The archaeologists asked for a restoration of the pictures and patterns on the pottery or a reconstruction of an architectural moulding. What they got were works of art.

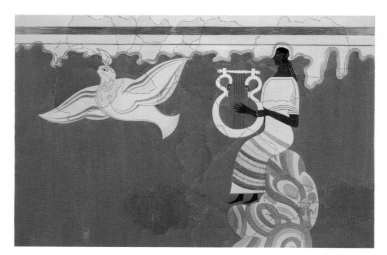

FIGURE 23

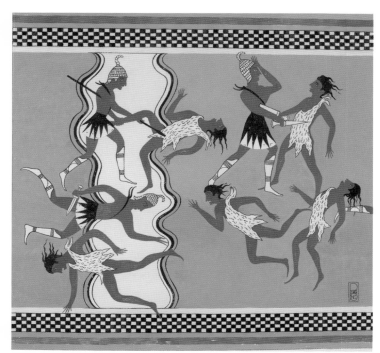

FIGURE 24

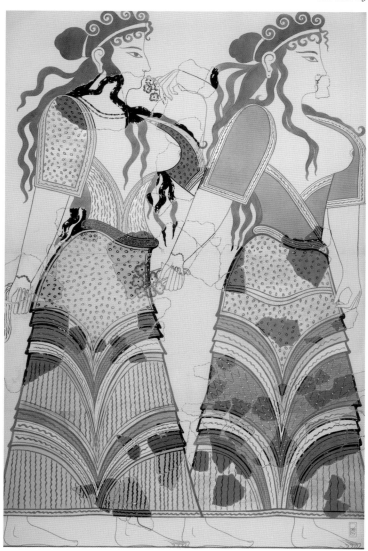

FIGURE 25

FIGURE 23. Watercolor by Piet de Jong of the lyre player and bird fresco from the Throne Room of the Palace of Nestor at Pylos (Lang 1969, pl. 126, 43 H 6).
Horizontal orientation: 1.028 × 0.690. Type 7 signature in white at lower left. Collection of the Department of Classics, University of Cincinnati, Painting no. 530

FIGURE 24. Watercolor by Piet de Jong of "Battle Scene I: Duomachy and Mass Murder" from Hall 64 of the Palace of Nestor at Pylos (Lang 1969, pl. M, 22 H 64).
Horizontal orientation: 0.820 × 0.730. Type 7 signature in red ink at lower right. Courtesy the American School of Classical Studies at Athens

FIGURE 25. Watercolor by Piet de Jong of the two life-size women from the northwest slope plaster dump at the Palace of Nestor at Pylos (Lang 1969, pl. O, 51 H nws).
Vertical orientation; watercolor composed of three sheets (measuring, from top to bottom: 0.998 × 0.695, 0.998 × 0.536, 0.998 × 0.697), with combined dimensions of 1.590 × 0.998. Type 7 signature in red ink at lower right. Collection of the Department of Classics, University of Cincinnati, Painting nos. 536a–c

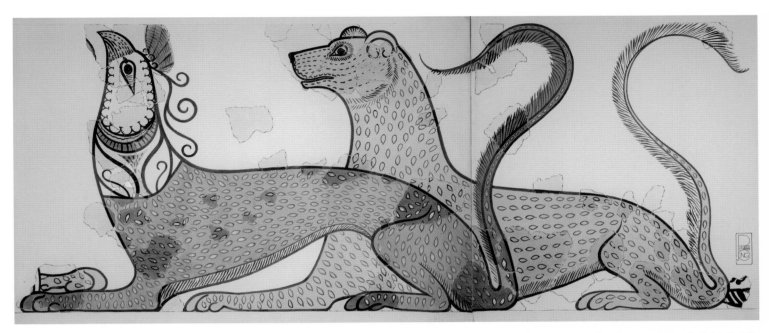

FIGURE 26. Watercolor by Piet de Jong of the lion and griffin frieze from Hall 46 of the Palace of Nestor at Pylos (Lang 1969, pl. P, 21 C 46). Horizontal orientation; watercolor composed of two sheets (measuring 0.997 × 0.695 and 0.695 × 0.650), with combined dimensions of 1.647 × 0.695. Collection of the Department of Classics, University of Cincinnati, Painting nos. 537a, b

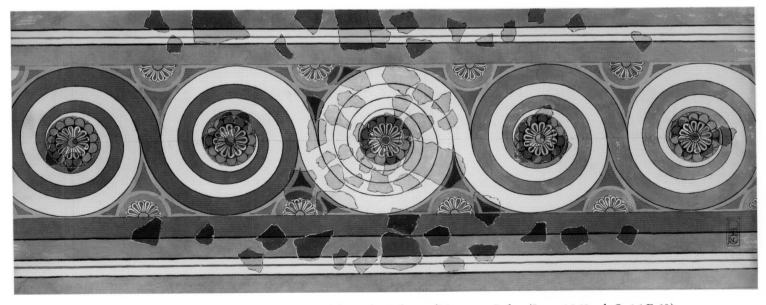

FIGURE 27. Watercolor by Piet de Jong of a running spiral from the Palace of Nestor at Pylos (Lang 1969, pl. Q, 16 F 60). Horizontal orientation: 1.078 × 0.715. Collection of the Department of Classics, University of Cincinnati, Painting no. 541

PIET DE JONG AND THE ATHENIAN AGORA

"IT IS DREADFUL THE WAY THE AMERICANS have snapped up de Jong!" So lamented Winifred Lamb in a letter to her mother, for in 1932 Piet de Jong began to work as a member of the American School team excavating the Athenian Agora (Hood 1998, p. 259). He continued to work at the Agora as a member of the team until World War II began, and then again in the 1950s and 1960s. Piet de Jong appears as a full-fledged team member in several photographs of the staff of the Athenian Agora housed in the Archives of the Agora Excavations—two in 1933, the other in 1934 (Lawall et al. 2001, pp. 165–166, figs. 1, 2; *Agora* XIV, pl. 112a), of which only the latter is here illustrated (Fig. 28). Piet de Jong's contribution to the Athenian Agora can be amply gauged by the work presented in this volume, which itself represents only a fraction of the work he completed at the site and in the old excavation house on Asteroskopeiou Street and later in the Stoa of Attalos.

In addition to the team photographs, Piet de Jong appears in a number of photographs now in the Archives of the Agora Excavations. Three in particular show him at work both on site and in the drafting room. Figure 29, which is dated April 13, 1935, shows Piet de Jong and the first director of the Agora Excavations, Theodore Leslie Shear, during the excavation and recording of a Geometric tomb, which was later published as grave XI (deposit G 12:24) by Rodney Young (1939, pp. 44–55). Several other photographs in the same series show Piet bent over the same burial, recording its dimensions. The second photograph illustrated here of Piet de Jong at work shows him in the drafting room at 25 Asteroskopeiou Street (Fig. 30). In this photograph, Piet is at his desk in March 1937, ancient pot in hand, drafting tools scattered all around the table. As the vessel is clearly hollow and the watercolor that Piet de Jong is preparing is large, this must be one of the Protoattic amphora necks that Piet was asked to illustrate with the decoration rolled out, as it were, in a continuous frieze. Mounted on the wall behind him are six of his signature caricatures of archaeologists of the day. From left to right they depict:

Humfry Payne (1902–1936; Hood 1998, pp. 134–137)
Georg Karo (1872–1963; Hood 1998, pp. 34–37)
Dilys Powell (1902–1995; Hood 1998, pp. 138–142)
Virginia Grace (1901–1994; Hood 1998, pp. 200–203)
Elizabeth (Libby) Dow (1906–1990; Hood 1998, pp. 204–206)
Elektra Megaw (1907–1993; Hood 1998, pp. 150–152)

Another photograph (Fig. 31) shows Piet, clearly aged, at work on a Mycenaean pot; this photo, in the Archives of the Agora Excavations, was taken by Robert McCabe in 1955 at Pylos (McCabe 2004, p. 48). Both photographs showing Piet at work on watercolors depict him without glasses; this is all the more noteworthy in the case of Figure 31, which shows Piet at the age of almost seventy and still capable of preparing meticulously detailed illustrations. The old excavation house at 25 Asteroskopeiou Street, which was torn down in the late 1950s, is illustrated in two views taken on February 15, 1957: the first (Fig. 32a) shows the middle courtyard from above; the stair to the left leads up to the drafting room, where Piet de Jong spent many months at work. The second view (Fig. 32b) shows the terrace, with the Hephaisteion clearly visible in the right background, and the cook, Abraham Vassileiades, seated at the table. This building served as the Agora Excavation base for a quarter century, between 1932 and 1957 (*Agora* XIV, pp. 225–226).

The six caricatures hanging on the wall in Figure 30 represent only a small portion of a collection of cartoons made by Piet de Jong during the 1920s and 1930s of some of the more prominent, and primarily English-speaking, archaeologists of the day. As Hood elaborates, the caricatures illuminate "aspects of their personalities and careers not usually revealed in their published writing. These were the archaeologists who, between them, excavated the legendary sites of Greece and the Near East—Knossos, Mycenae, Athens, Troy and Sparta. De Jong served them all as architect, draughtsman and friend" (1998, p. xvii).

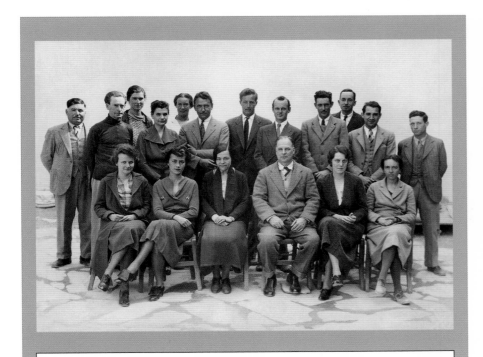

FIGURE 28. The staff of the Agora Excavations in 1934: (1) Gladys Baker; (2) Joan Vanderpool; (3) Lucy Talcott; (4) T. Leslie Shear; (5) Josephine Shear; (6) Dorothy Burr [Thompson]; (7) Sophokles Lekkas; (8) Piet de Jong; (9) Catherine Bunnell; (10) Alison Frantz; (11) Dorothy Traquair; (12) Rodney Young; (13) Eugene Vanderpool; (14) James Oliver; (15) Arthur Parsons; (16) Sterling Dow; (17) Charles Spector; (18) Homer Thompson (Lawall et al. 2001, p. 166, fig. 2)

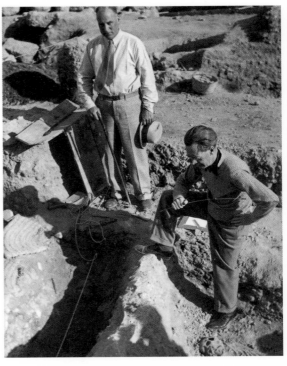

FIGURE 29. Theodore Leslie Shear (upper left) and Piet de Jong (center right) during the excavation of Geometric Tomb G 12:24 in the Athenian Agora, April 13, 1935 (the drawing of the tomb appears in Fig. 114)

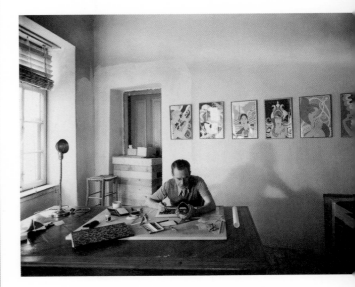

FIGURE 30. Piet de Jong drawing a vase in the drafting room of the old Agora excavation house at 25 Asteroskopeiou Street, March 1937

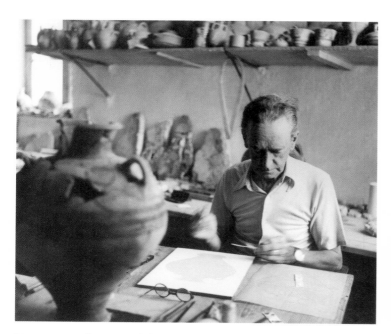

FIGURE 31. Photograph by Robert McCabe showing Piet de Jong drawing a Mycenaean pot at Pylos, 1955

FIGURE 32A

FIGURE 32

A. View from above of the middle courtyard of the old Agora excavation house at 25 Asteroskopeiou Street, February 15, 1957

B. View of the terrace of 25 Asteroskopeiou Street, with the cook, Abraham Vassileiades, seated at the table and the Hephaisteion in the right background, February 15, 1957

FIGURE 32B

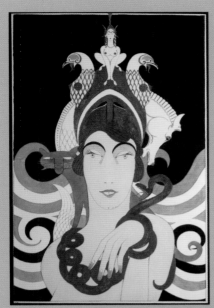

FIGURE 33A FIGURE 33B FIGURE 34

FIGURE 33A. Caricature of Virginia Randolph Grace (1901–1994) by Piet de Jong, undated, but probably from the mid-1930s. Vertical orientation: 0.502 × 0.326. Ashmolean Museum, Oxford

FIGURE 33B. Working sketch for caricature of Virginia Grace (pencil on tracing paper). American School of Classical Studies at Athens, Archives

FIGURE 34. Portrait of Virginia Grace by Eugene Vanderpool Jr., undated, but probably mid-1970s. Athenian Agora Archives

Among the many American School archaeologists Piet caricatured, only three are illustrated here. The caricatures are all in the Ashmolean Museum in Oxford. The first is the cartoon of "the amphora lady," Virginia Grace, together with a working sketch in the Archives of the American School of Classical Studies at Athens (Figs. 33a, b). In this caricature, made sometime in the mid-1930s, perhaps 1935, Piet de Jong portrays the face without any of the exaggerations or idiosyncrasies—except for the irregularity of the teeth—of some of the other faces. "He depicted, in fact, her calm, gracious, perhaps somewhat impenetrable exterior" (Hood 1998, pp. 202–203). The same calm and grace can be seen some four decades later in a photographic portrait of Virginia Grace by Eugene Vanderpool Jr. (Fig. 34). Despite all this, the cartoon—not least the naked frontal sphinx with breasts prominently exposed surmounting the Corinthian helmet—shocked Miss Grace who,

although very fond of Piet, was horrified by the "vulgarity" of the caricatures (Hood 1998, pp. 202–203). We do not know what Carl Blegen thought of his caricature (Fig. 35). The excavator of Korakou, Zygouries, Prosymna, Troy, and the Palace of Nestor at Pylos, among other sites, was rendered in profile, pipe in mouth. He holds and inspects a Mycenaean kylix from the Potter's Shop at Zygouries, which was illustrated for final publication by Piet de Jong (Blegen 1928, no. 48, pl. XVIII). The jug to the left of Blegen's head and the uppermost tankard were also published as watercolors by Piet (p. 130, fig. 129, pl. XIII [right]), while the pot to the right (together with the two terracotta figurines in the left foreground) was found at Prosymna (Blegen 1937, p. 129, fig. 516).

But arguably one of the most complex and wicked of all Piet's cartoons was that of the first director of the Agora Excavations, Theodore Leslie Shear (1880–1945) (Fig. 36; cf. Fig. 29).

From the cherry red spots of color on nose, cheeks, and chin, perhaps the result of a strong cocktail of which Shear was fond, to the symbolism of the stamps and the theater cum stadium, this was a symbolically rich memoir of an energetic archaeologist. In describing the cartoon, Hood (1998, p. 176) writes,

> The complication of this picture and the layers of meaning hidden in its imagery are a record of the sympathetic yet piercing relationship between Piet and Shear. Its elucidation would not have been possible without the most ready help of Shear's son [Professor T. Leslie Shear Jr.] who drew to my attention the vivid sparking jokes and wealth of information contained in this cartoon. Much of its significance would otherwise be lost.

In addition to the caricatures of Agora staff, the photographs of Piet at work at the site and excavation base, and, of course, the body of work he completed, the Agora Archives contain originals and copies of letters to and from Piet de Jong. The majority of these letters are between Piet and Homer Thompson or Piet and Lucy Talcott. Only two of the many letters are provided here as photographic facsimiles, both by Piet and both addressed to Lucy Talcott. Together they give some insight into Piet's relationship with his colleagues and friends and show something of the great humor—not to mention practical jokes—for which he was famous. The first letter (Fig. 37) was written while Piet was at work for Carl Blegen on the Pylos frescoes,

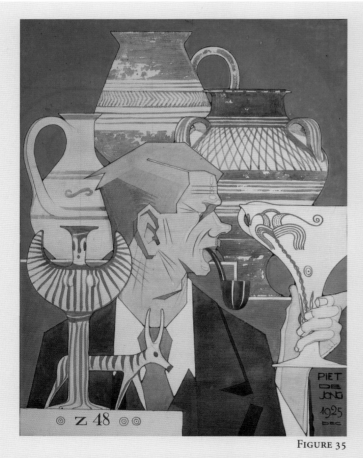

FIGURE 35

FIGURE 36

FIGURE 35. Caricature of Carl William Blegen (1887–1971) by Piet de Jong, dated December 1925.
Vertical orientation: 0.478 × 0.362. Ashmolean Museum, Oxford

FIGURE 36. Caricature of Theodore Leslie Shear (1880–1945) by Piet de Jong, labeled and dated ΠΑΛΑΙΑ ΚΟΡΙΝΘΟΣ 1930 vertically down the right-hand side and signed PIET DE JONG ΜΕΠΟΙΕΣΕΝ ("made me") down the left.
Vertical orientation: 0.510 × 0.350. Ashmolean Museum, Oxford

from the excavation base at Chora, Trifyllias. Laconically dated "Wednesday," the letter was probably written in 1962. The handwriting at the lower right is Lucy Talcott's and records what Piet owed the Agora Excavations for lunches. Of the people mentioned in the letter, "Alison" refers to Alison Frantz, "Libby" should be Elizabeth Dow, and "Judith and Eva" must refer, respectively, to Judith Binder (Perlzweig) and Eva Brann.

The second letter (Fig. 38) is earlier and was addressed to Talcott from the Taverna at Knossos. Although labeled by Piet as "Christmas day," the year itself is not recorded, though it should date sometime in the 1950s (probably mid- or late 1950s).

In another letter, dated Sunday, March 15, 1959, and written from Knossos, Piet writes candidly to Homer Thompson about the inadequate conditions in the new drafting office in the Stoa of Attalos, which had officially been opened only two years earlier. He writes,

I have been thinking about it, about where I can work on watercolours at the Agora. The drawing office won't do you know; too many people; everything the wrong height; quiet is essential, and there is none there. I hope you will be able to arrange something. And with a low table 75 cms. high, like the big one I had in the old place [i.e., Asteroskopeiou Street].

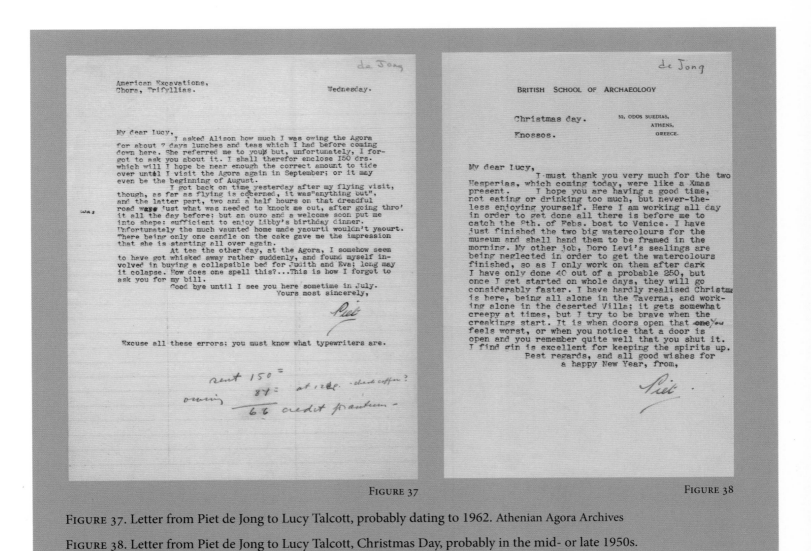

FIGURE 37

FIGURE 38

FIGURE 37. Letter from Piet de Jong to Lucy Talcott, probably dating to 1962. Athenian Agora Archives

FIGURE 38. Letter from Piet de Jong to Lucy Talcott, Christmas Day, probably in the mid- or late 1950s. Athenian Agora Archives

In addition to the letters, there were little mementos, such as the delightful tracing (Fig. 39)—for Lucy Talcott—of the interior of an Athenian red-figured cup attributed to the vase-painter Epiktetos, showing a hetaira, moving left, wearing a sakkos and holding a boot in each hand; on the floor is a low wash basin (*Agora* XXX, p. 339, no. 1554, pl. 146). This was all part and parcel of having Piet de Jong around.

The skill of Piet de Jong was called upon for all sorts of tasks. In addition to the many watercolors and measured drawings of objects, he was asked to reconstruct monuments, and sometimes even to illustrate a certain aspect of antiquity. There are numerous examples of his handiwork, such as the reconstruction of the Stoa of Attalos (Figs. 40a, b). This was one of several reconstructions of the building that were commissioned before the stoa was rebuilt; a watercolor of the same series by Piet de Jong was published as plate II in the first edition of *The Athenian Agora: A Guide to the Excavations*, which was prepared by Mabel Lang and C. W. J. Eliot and appeared in 1954. In the watercolor of the reconstructed ground floor (Fig. 40a), Piet de Jong had originally represented, in 1953, a squared-off annex at the north end of the stoa; in 1954 the

original was amended to show an arched annex. In the 1953 watercolor of the reconstructed upper floor (Fig. 40b), Piet de Jong reveled in depicting the flooring of the building as newly laid and highly reflective (as he did at Pylos, Fig. 2a).

Some of these reconstructions were grand in scale; others were more pedagogic. A classic example of the latter is Piet de Jong's ink drawing of the interior of a dining room in South Stoa I, designed to accommodate seven diners on couches (Fig. 41). The isometric reconstruction shows the walls cut away to expose the interior of the dining room, which is well lit, with shadows picking out the details of the couches and tables. Rather than crowding the composition, Piet showed only two diners reclining—the other five couches and tables are empty—in order to represent best the arrangement of the furniture in a room specially designed for the purpose with an off-center entrance. Like so many of his illustrations, this sketch has been used and reused countless times in both textbooks and classrooms.

In addition to the reconstructions of interior and exterior spaces, Piet was called upon to provide detailed and accurate large-scale illustrations that were to be used as virtual blueprints by the modern sculptors employed in the reconstruction of the Stoa of Attalos. One such illustration was Piet de Jong's massive Ionic capital (Fig. 42), which served as the model after which all of the Ionic capitals used in the building were made. Unlike the color reconstructions of other capitals (e.g., no. 10, Figs. 74a, b), the issue here was not color facsimile or reconstruction, but an accurate, to-scale rendering of an architectural element that was to be used by masons.

Piet de Jong's skill as architect and draftsman for the Agora Excavations was to be pushed to the limit, however, by what was to become a complex and somewhat pressing issue: the design and construction of a museum for the Athenian Agora. The numerous spectacular discoveries in the area of the Athenian Agora in the 1930s, which ranged in date from the Neolithic period through the post-Byzantine era, demanded a worthy venue for public display. Before the idea of restoring the Stoa of Attalos was first aired and finally decided upon, various plans were drawn up by a number of architects, including

FIGURE 39. Tracing of the interior of an Athenian red-figured cup by Epiktetos by Piet de Jong for Lucy Talcott. Athenian Agora Archives

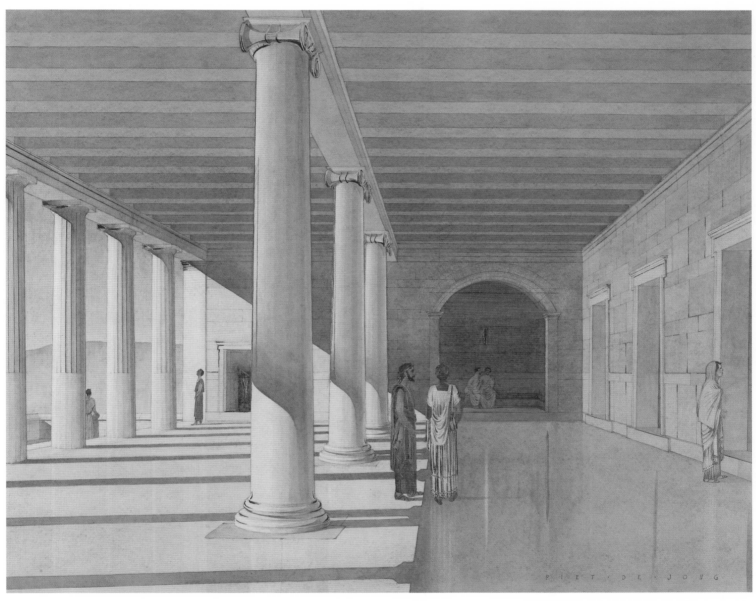

FIGURE 40A. Watercolor by Piet de Jong depicting the ground floor of the Stoa of Attalos before its reconstruction. Originally painted in 1953, with revisions in 1954. Athenian Agora PD no. 846

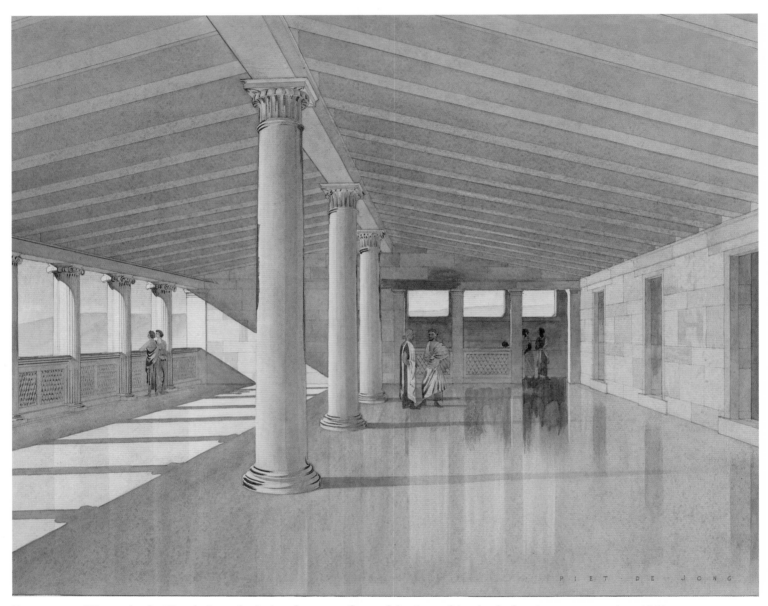

FIGURE 40B. Watercolor by Piet de Jong depicting the upper floor of the Stoa of Attalos before its reconstruction, 1953. Athenian Agora PD no. 847

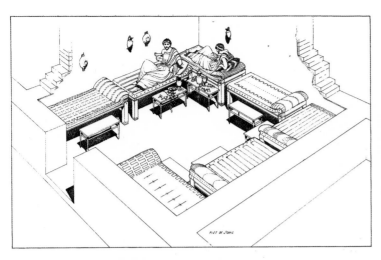

FIGURE 41. Furnished isometric reconstruction by Piet de Jong of a dining room in South Stoa I. Athenian Agora PD no. 791

FIGURE 42. Watercolor by Piet de Jong of one of the Ionic capitals of the Stoa of Attalos that was to be used as a virtual blueprint by the modern masons who were preparing the architectural members for the reconstruction of the building. Athenian Agora PD no. 1014

John Travlos, W. Stuart Thompson, and Phelps Barnum. In addition to preparing plans of his vision of the Agora Museum, Piet de Jong, in characteristic style, prepared a watercolor of what the exterior of his museum might look like, complete with the Athenian Acropolis in the background, sculpture, cars, and people all in the style of the 1930s (Fig. 43). As was the case with the subsequently reconstructed Stoa of Attalos, Piet de Jong's proposed building drew its critics—not least among them Homer Thompson—and no shortage of controversy. In the end, many of the earlier museum designs were bound for the scrap heap because they required either the clearance—or the covering over—of ancient structures.

Piet de Jong's contributions to the Athenian Agora are captured in the following laconic words by Lucy Shoe Meritt: "Piet de Jong recorded in ink and watercolor details of shape and ornament of both architecture and portable finds" (1984, p. 193). A delightful example of an object captured in both media—ink and watercolor—is the diminutive fragment of red-figure that must have amused Piet de Jong; having prepared an accurate watercolor of the fragment, Piet also produced an ink drawing of the main figure within a tondo (Figs. 44a, b). The fragment,

which derives from the body of an oinochoe that dates to ca. 400 B.C., preserves a comic mask placed on top of an inverted neck amphora (van Hoorn 1951, pp. 25, 87, no. 213, fig. 41; Webster 1953–1954, p. 196, fig. 1; *Agora* XXX, p. 244, no. 718 [P 13094], pl. 76). In the ink drawing, Piet de Jong has omitted the partially preserved hand of a child to the left and the decorated border below the amphora, thereby simplifying the image and heightening its comic effect.

Rachel Hood, recounting the reminiscences of several of Piet's contemporaries, not least those of Judith Binder, writes (1998, p. 266–267),

> As always he cheered people up. One day he made an exquisite drawing of an object with a classical inscription, which, when transliterated, was found to read "How's this, Lucy?" His working days at the Agora are still remembered for the practical jokes he played. He came to fetch a precious pot from an upper floor transporting it carefully to his drawing office on the ground floor. As he started down the stairs an almighty crash was heard and Piet was found to be treading sherds underfoot (for which purpose he had borrowed an old flower pot). The curses of the various New England ladies working on the dig had to be heard to be believed.

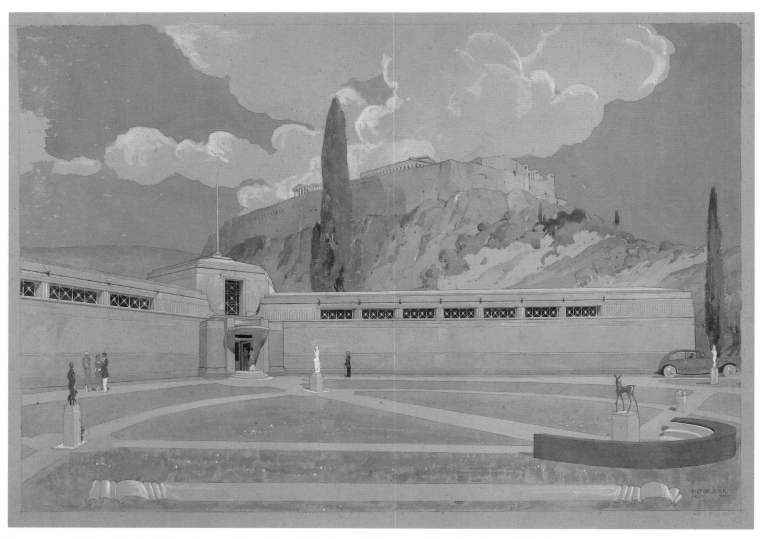

FIGURE 43. Watercolor by Piet de Jong of his vision of the Agora Museum. Athenian Agora Painting no. 327

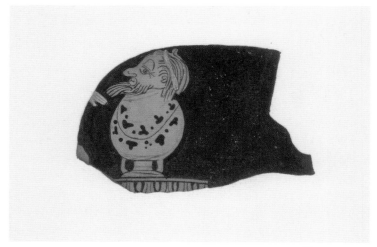

FIGURE 44A

FIGURE 44B

FIGURE 44A. Watercolor by Piet de Jong of a fragment of an Athenian red-figured oinochoe (P 13094). Athenian Agora Painting no. 230

FIGURE 44B. Red-figured oinochoe as a simplified ink drawing. Athenian Agora Painting no. 252

THE ART OF ANTIQUITY

THE UNDERLYING THEME OF THIS VOLUME, and the impetus for many of Piet's illustrations, was the very notion of "antiquity depicted." The latter was the title of the tenth Walter Neurath Memorial Lecture and the title of a fabulous small book by Stuart Piggott, published in 1978, which dealt with aspects of archaeological illustration. In the opening sentence of the book, Piggott writes, "In the first minute-book of the Society of Antiquaries of London, in 1717, William Stukeley, its first Secretary, wrote: 'Without drawing or designing the Study of Antiquities or any other Science is lame and imperfect'" (p. 7).

Not only is archaeology without illustration a lame and imperfect discipline, but the manner in which both earlier antiquaries and contemporary scholars view the past and put it on record is a complex process that shapes, determines, and defines how antiquity is conceived. As Ernst Gombrich elaborates, a pictorial representation "is not a faithful record of a visual experience but the faithful construction of a relational model. Neither the subjectivity of vision nor the sway of conventions need lead us to deny that such a model can be constructed to any required degree of accuracy. What is decisive here is clearly the word 'required.' The form of a representation cannot be divorced from its purpose and the requirements of the society in which the given visual language gains currency" (1960, p. 90).

All illustrators of antiquities, whether monuments in the ground or portable small finds, are products of their own time and their illustration the result of contemporary conventions. Moreover, as monuments and objects are studied and restudied, new interpretations of the same material not only reveal a more compelling picture of the past but offer a sharper awareness of the preconceptions that we bring to its reconstruction and (re)interpretation. In so many ways the things we study lead social lives and can be described through quasi-biographical narratives in much the same way that people are (see various papers in Appadurai 1986; Molyneaux 1997; Lyons and Papadopoulos 2002). Patterns of use and wear, when coupled with depositional history, have the potential to reveal ancient lifeways, cast light on a particular event or individual—or even several individuals—and tell many stories. The commemorative power of objects as a focus of memory is cogently captured by Marcel Proust (1983, pp. 47–48):

> The past is hidden somewhere outside the realm, beyond the reach of intellect, in some material object (in the sensation which that material object will give us) of which we have no inkling. And it depends on chance whether or not we come upon this object before we ourselves must die.

These biographies are brought to life by the discovery of objects, which subsequently—if they are lucky or are deemed worthy—reside in a museum display or—if less fortunate—in a storage facility removed from daylight. Occasionally an object dispatched to deep storage may be rescued from oblivion and put on a pedestal for all to see and enjoy. But most objects live out their visible, public, post-depositional life as an illustration, whether as a photograph, an ink drawing, a digital code, or a watercolor, sometimes in a variety of media. In this way, the modern biography of any archaeological artifact is very much in the hands of its illustrator. Just as the proverbial slave girl born on the wrong side of the tracks in Classical Athens did not experience Plato's world, so too an object illustrated by Piet de Jong does not enjoy the same status as one drawn or photographed by someone else. In so many ways, the fate of the object is irrevocably linked with its illustrator. But most illustrators did not work alone, in splendid isolation. The choice as to which object was to be illustrated, by whom and by what means, often fell to the archaeologist or person responsible for its ultimate publication, and in this way there is a three-way collaboration among object, illustrator, and scholar. The process by which an object is (re)discovered, studied, illustrated, and housed is every bit as individual and fascinating as the life of an individual and her/his rites of passage.

As Gombrich and others have stressed, there is no such thing as an objective illustration. Consequently, all archaeological illustrations have a dual or split personality as works of science *and* works of art. One might argue that a "good" drawing should strive to be both. Most professional archaeological illustrators, I suspect, aim at a restrained artistry—both in rendering the object and in their lettering (see Chapter 18)—a sense of style and balance. The balance lies in a fine line, a liminal area, between elegance before it becomes suspect and outmoded and diagrammatic austerity.

But certain illustrations have the ability to capture or captivate the viewer's attention more than others—some are more complex, more haunting, more memorable, more artful. The drawings and watercolors by Piet de Jong presented in this volume are themselves the products—the artifacts—of a bygone era of Greek archaeology. Nevertheless, their influence in shaping our image of Greek antiquity, particularly our image of Aegean Bronze Age antiquity, cannot be underestimated, and this is especially true of Piet de Jong's physical reconstructions in reinforced concrete, as was the case at Knossos. Although less blatant, his reconstructions on paper—whether the interior of the Palace of Nestor at Pylos, or the interior of an Athenian public dining room—continue to exert a powerful yet subtle influence on modern sensitivities, providing us as they do with a vista of an antiquity less "shabby," arguably more 1930s—more art deco or more art nouveau—than it otherwise may have been. More than this, Piet de Jong confronted and in a sense conquered the seen and represented world, and his illustrations virtually force the viewer to look beyond the object and to deal with the illustration directly, to treat the illustration as a world unto itself.

Unique and perhaps unrepeatable in style and particularly in technique (see Chapter 2), Piet de Jong's illustrations have much more than immense "period charm." The fact that so many were published, and many of them republished, clearly indicates that they served the "requirements"—as Ernst Gombrich or Stuart Piggott would say—of archaeologists of the 20th century. Whether they continue to serve the requirements of archaeologists of the 21st century remains to be seen.

CHAPTER 2

Le style c'est l'homme:
Piet de Jong as Artist

Anne Hooton

INTRODUCTION

PIET DE JONG WAS ONE OF THE GREAT archaeological illustrators of the 20th century. Although he worked in a variety of media, including ink, he is perhaps best known for his watercolors. De Jong was already a draftsperson of the highest order before he launched his career in archaeological illustration. His travels throughout Italy, coupled with his professional work as an architect both before and shortly after World War I (Hood 1998, pp. 225–270; see also Chapter 1), disciplined his eye for archaeological illustration, and it was this unique combination of skills as an artist and architect that made his work so distinctive.

Piet de Jong mastered the technique of watercolor and gouache in a career spanning more than five decades. His watercolors are works of art. Many were framed upon completion, but they were primarily intended to be viewed quite differently. They were commissioned by scholars of the day to represent colored facsimiles of artifacts intended for publication. It is important to bear in mind that de Jong illustrated artifacts in the days when artists were employed to represent artifacts in color. Although color photography had emerged, it was complicated, expensive, and technically inaccessible for many archaeologists, particularly in the field. It was not until much later, after World War II, that color photography slowly became more commercially accessible.

It is clear just by looking at de Jong's work that he invested an enormous amount of time in preparing each watercolor. Watercolor is a difficult and unforgiving medium that requires accurately executed preliminary sketches from measured drawings. Once the painting process began his working environment became *tout à fait*. No interruptions were possible. The sanctity of the space was essential for the concentration that de Jong required to execute these watercolors, as many of the original paintings, sculptures, architectural pieces, and artifacts he illustrated were masterpieces in their own right. He met this challenge both mentally and technically in the quiet calm of his studio.

What was expected of an archaeological illustrator especially in the early 20th century was quite different from what is expected today. An archaeological artifact drawing today has to meet fairly standardized conventions, with minor differences among countries and types of excavation; it is an accurately dimensioned record—and reconstruction—of an artifact recorded on drafting film, paper, or the computer. Legibility and accuracy are imperative. Although there are some variations in conventions, a section and an elevation are general requirements for either complete artifacts (Fig. 45) or fragments of an artifact. The section is commonly referred to as the profile, and the external face of the vessel is known as the elevation. A bisecting line divides these two fields. There is, however, no international convention as to the placement—right or left—of the bisecting line. A section is a slice through the maximum preserved face of the vessel, enabling a view of the thickness of its walls. A section is essential diagnostically for the scholar, illustrating the form of the rim, base, handle(s), and thickness of walls—information a camera cannot provide. The elevation on the other half of the bisecting line indicates all external painted or applied decorative features. On certain occasions a full elevation is required. This is particularly the case when the external decoration may cover the full elevation, where the decoration is very poorly preserved, or in the case of asymmetrical decoration that requires a full pictorial reconstruction (e.g., Fig. 46). At times it is necessary for a full program of views to be illustrated in one drawing. Composite

views such as a plan view—bird's-eye view—of the interior, rim, or underside of base can be presented on the same drawing (Fig. 47). Piet de Jong rarely painted sections; his illustrations were mainly complete elevations, traversing altogether an imaginary bisecting line.

Reconstruction of the artifact—if this is possible—on paper is an important aspect of drawing. If there is enough preserved of the rim or base with clear remains of a diameter, a reconstruction of a pot from a sherd can be attempted. The diameter is reconstructed, enabling a mirror image of the profile on the elevation face. Architectural fragments can also be reconstructed, requiring composite views in a program of drawing. Imaginative fields of unknown reconstruction, however, are rarely, if ever, permissible (Fig. 48). The possibility of reconstruction answers the question most often asked regarding artifact drawing: why draw when one can photograph? Both disciplines are a necessary part of archaeological documentation and research. Photography produces facsimiles of what is, or may be, visible to the naked eye; drawing is a composite of measured points and marks that permit the reconstruction of profiles and poorly preserved decoration not detectable by a camera.

Ironically, one of the distinctive differences between Piet de Jong's watercolors and modern archaeological illustrations is that he worked in many ways in a manner not unlike a digital camera. He was a camera of sorts, but with the robust and idiosyncratic hand of an artist. Before the age of Computer Assisted Drawing (CAD) systems and photographic digitizing, he prefigured the effortless visual scope in which artifacts could be rotated, manipulated, distorted, and edited. Piet de Jong created the impression of an animated view, real experience of the object, as though the viewer were standing next to it, capable of incorporating many views simultaneously. He rotated and distorted the artifact to achieve the desired view, distortion, and animation. In so doing, however, the paintings were no longer scientifically accurate, yet they appeared as such. The complexity of his intention and his success in executing these paintings are the things that made Piet de Jong a great artist. The inherent plasticity of computer line work and CAD animation cannot compare with the mastery of de Jong's hand.

When painting for his own pleasure de Jong often worked with an unimpeded hand. This is evident in his caricatures compiled by Rachel Hood (1998). He captured the archaeologists and philhellenes of the day and their research in an allegorical explosion of color with free, sweeping brush strokes, thin and uneven washes. Several of these caricatures of scholars connected with the Athenian Agora are presented in Chapter 1.

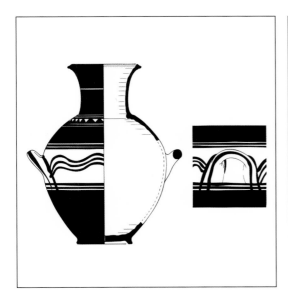

FIGURE 45. Early Iron Age amphora, P 6682 (PD no. 2774-17). Drawing Anne Hooton

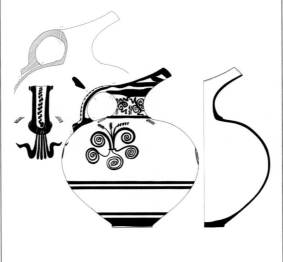

FIGURE 46. Mycenaean beaked jug, P 33177 (PD no. 2784-6). Drawing Anne Hooton

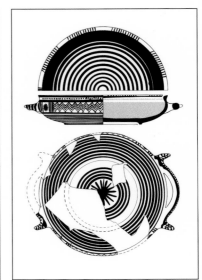

FIGURE 47. Late Geometric plate, P 28004 (PD no. 2774-62). Drawing Anne Hooton

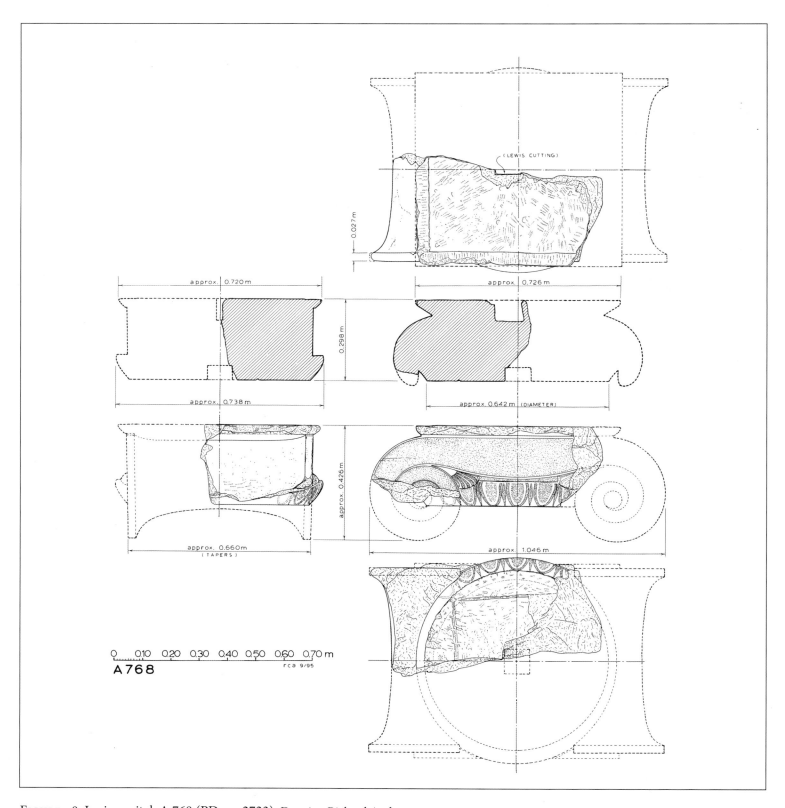

FIGURE 48. Ionic capital, A 768 (PD no. 2723). Drawing Richard Anderson

THE TECHNIQUE OF PIET DE JONG'S FINISHED WORKS

TRANSPARENT WATERCOLOR TECHNIQUE

The technique of watercolor is the building up of a painting on white paper, with transparent layers of color. Watercolor is ground pigment with various additives to form dry, densely packed blocks. The most commonly used watercolor is in the form of moist pans or tubes. The pigment is diluted by water, creating various densities of color. To enhance the luminosity and brilliancy of the transparent color, white coarse paper is used. The textured paper is technically known as "cold pressed" paper,

FIGURE 49. Watercolor paper (Movlin à papier d'arches) used by Piet de Jong and watercolor set thought to belong to him in the Archives of the Agora Excavations

whereas smooth paper is referred to as "hot pressed paper." Among the archive of de Jong's work in the Athenian Agora are several blocks of watercolor paper we believe belonged to him: pen tests in the line weight and color of his cartouches and other signatures found inside the cover are testament to his hand. These blocks are of the "cold pressed" type: Movlin à papier d'arches (Lorraine) and Reeves Series 305. With the paper is a box of watercolors, only minimally used, that are also believed to be the property of Piet de Jong (the mixed blue and white on the palette match the blue found on the inside cover of the paper) (Fig. 49).

The quality of the brush is integral to a successful watercolor painting. The result of the painting can be compromised by a poor-quality brush. At the top end of the market are the mink/marten brushes, followed by those made from red sable, ox, or acrylic. The first is composed of hair from the tail, each hair shaft cut at the root end, leaving its natural tip; the second is made from the ear of the animal. The generic watercolor brush has a distinctive inverted tear shape with a large lower body tapering to a fine tip. The heavy body is able to hold large volumes of paint while the tapering tip maintains a lively spring. Brushes vary in size and volume capacity. For very fine line work and detailing a different shape and series of brush is used. To create the exquisite line work of the Exekias Krater, for example (no. 82, Figs. 164a, b), de Jong used a very fine series of brush, most likely Series "00," which has only a few hairs.

OPAQUE WATERCOLOR TECHNIQUE

To create an opaque field of color, white is added to the watercolor, and this then becomes gouache paint. Gouache can be achieved either by mixing white pigment directly to the watercolor or by using artist-approved gouache paint from tubes. The nuances of gouache, such as wet-paint drying another hue—light paint dries darker whereas dark paint dries lighter—and painting an even field of color, require additional consideration when painting (see below). The density and opaqueness of gouache paint that characterizes the miltos red and brown surface on the painted antefix (Fig. 50) clearly contrasts the transparency of the yellow ochre background in the painting.

FIGURE 50. Tholos antefix, A 880 (Painting no. 217), detail

PAINTING TECHNIQUE

AS ALREADY NOTED, WATERCOLOR is an unforgiving medium; it is very difficult—at times impossible—to erase a mistake, so an accurate drawing in soft pencil is transferred by tracing onto the watercolor paper. It is evident from the photograph of Piet de Jong in his studio (Fig. 31) that he is in the preparatory stage of a watercolor. He drew the entire object on a separate piece of paper and then traced selected elements onto the watercolor paper. This photograph is a window into his studio, providing a wonderful snapshot of how de Jong worked. The object we can see de Jong working on is a Mycenaean pot from Pylos like many of the Mycenaean vases from the Athenian Agora presented in Chapter 5.

CARTOON AND PENCIL WORKING DRAWINGS

We can see traces of clearly identifiable pencil line in many of Piet de Jong's works. This is evident in the stately monotonal watercolor of an Ionic capital from the Stoa of Attalos (Fig. 51). Line work is evident on the edges, whereas most of the structural guidelines have disappeared under the density of the watercolor. After the base field of watercolor had dried, de Jong would then have drawn another cartoon in preparation for the next layer of watercolor, continuing this process for the following layers and shadows.

At times de Jong constructed directly onto the watercolor. For instance, we see the unmistakable compass points and pencil grid in the oculus of the volutes for the construction of the spiral scroll on the capital. The white highlights were painted directly onto the painting without preliminary pencil lines (Fig. 52). When de Jong worked to scale he drew planning grids directly onto the watercolor paper. This was the case with the frescoes from the Church of Saint Spyridon and probably also the Roman mosaic floor. In the example of the detail of Saint Diomedes of Bithynia, the faint lines of a pencil grid are perceptible. While working on the drawing in situ, de Jong probably placed a planning frame with a regular geometric grid in front of the fresco. The same grid was then transposed by scale reduction to the watercolor paper, each line of the grid with numbers referring back to the full-size grid (Fig. 53).

Another informative example of preliminary drawing are the two versions of the Sotadean kantharos, P 2322 (Figs. 54a, b), one of which is a working painting, the other a completed watercolor. In the working painting (Painting no. 9), de Jong reconstructs the handles in pencil; the lines direct one's eye to the position and orientation of the handles as if they were complete. In the other painting (PD no. 472), de Jong presents the corrected version for publication. Although de Jong painted the reconstructed handles, he clearly delineates between the preserved surface and the reconstructed surface. In yet another example (Fig. 55), the pencil cartoon is clearly evident in the magnificent fresco of Saint Triphon from the Church of Saint Spyridon. Whispers of pencil bleed under the painted area, thus indicating that de Jong constructed many drawings, probably in situ and to scale, to guide his steady brushwork.

WASHES AND COLOR UNDERLAYS

Laying down the first field of even color requires enormous skill and is possibly the most difficult aspect of watercolor painting. Piet de Jong controlled the paint with precise assurance, enabling a flat and even ground. Watercolor has a tendency over large areas to well in small deposits, creating a pitted, uneven texture. An accurate base drawing is required so that the paintbrush laden with watercolor can confidently sweep across the image area. If the brush is quickly reloaded with paint and drawn across the lower edge of the previous stroke then the paint will bleed evenly, leaving no perceptible edge and creating a seamless area of even wash. Such a technique is called wet on wet. Once this wash has dried it forms the foundation for the following layers of wash or gouache. The final layers accommodate the highlights painted in either dry brushwork or by the addition of finely articulated line work.

PENCIL MARKINGS

FIGURE 51

FIGURE 52

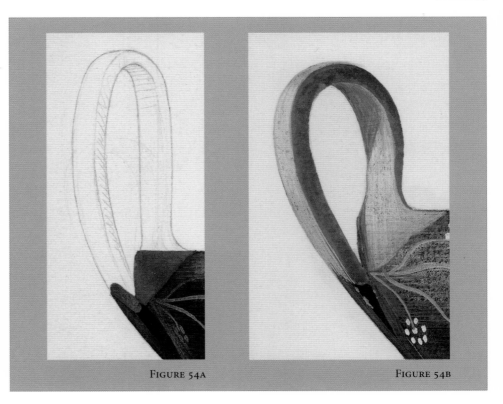

FIGURE 54A FIGURE 54B

FIGURE 53

FIGURE 51. Ionic capital, double column Type A (PD no. 1015), detail of pencil line work at corner of capital

FIGURE 52. Stoa of Attalos Ionic capital (PD no. 1014), detail of the volute (see Fig. 42)

FIGURE 53. Medallion of Saint Diomedes of Bithynia from the Church of Saint Spyridon (Painting no. 309), detail of edge indicating pencil planning grid

FIGURE 54A. Sotadean kantharos, P 2322 (Painting no. 9), detail of handle sketched in pencil

FIGURE 54B. Sotadean kantharos, P 2322 (PD no. 472), detail of painted handle (see no. 109, Fig. 194)

FIGURE 55. Medallion of Saint Triphon from the Church of Saint Spyridon (Painting no. 308), detail of pencil sketch at the edge of the painting

FIGURE 55

FIGURE 56. Black-figured amphora, P 13126 (Painting no. 302). The battle between Lapiths and Centaurs above a lotus chain

Each layer requires another cartoon drawn directly onto the surface or traced from the original pencil drawing onto the dried surface. The following layers may consist of fields of various densities of watercolor or opaque layers with more detailed information such as decoration, as is evident with the black-figured amphora of the Lapiths and Centaurs, P 13126 (Fig. 56). The illuminating effect of this painting relies on its convincing ceramic background, painted in a semi-transparent wash, which permits the warm glow of the ceramic to resonate under the dark silhouette of the pictorial band. It is—almost—as if we are looking at the original ceramic vessel. The seamless flattened view of the pictorial bands was resolved on another working drawing before being traced onto the watercolor. De Jong visually stitched together the pictorial elements while compensating for the correction of the curvature of the vessel to create the pictorial collar we can see.

The uniform mattness of the pictorial and decorative bands seems to absorb all light and then to convert that light into the radiating glow of the ceramic. The pictorial and decorative bands are painted in wash and the figures painted densely, creating an almost opaque brown still transparent enough to feel the warmth of the ceramic vessel. De Jong re-created the hand of the original vase-painter, an aspect that is most clearly evident when viewing the decorative bands (Fig. 56). It is as if the hands of the original artist and of the illustrator (de Jong) were one. The controlled flow of the brush, laden with color, paints a rhythm in the lotus chain, and this rhythm of semi-transparent and densely painted arches is captured in the original firing of the vessel. The fine line work of the anatomical forms and of the red miltos wash was rendered with opaque gouache.

The mastery of de Jong's rendering of the celebrated Exekias Krater, AP 1044 (no. 82, Figs. 164a, b), from the north slope of the Acropolis, leaves one breathless. It is as if de Jong allowed the original artist to inhabit him. It is often much more difficult to copy the work of another artist than it is to copy nature, since it is difficult to capture the individual nuance and delicate character of the original artist's eye and hand. De Jong executed the painting as though he were the original author. The background is painted in gouache, creating a flat base, as opposed to the radiance of the amphora with the Lapiths and Centaurs amphora (Fig. 56); the resulting dullness does not compete with the exquisite and delicate line work. The human figures, horses, and subsidiary decoration are painted in a dense watercolor, transparent enough to experience the base ceramic. The semi-opaque quality of the gouache creates a radiating white for the female flesh, whereas opaque gouache was used for defining the fine line work and for creating matt areas.

ADDITIONAL BRUSHWORK

Piet de Jong employed a variety of brush techniques. Although we do not have de Jong's brushes, we can ascertain their type by the flavor of his brushwork. The beguiling line work of the Exekias Krater (Fig. 57), so thoughtfully painted, a mere hair's-width from imperfection, was executed using the finest brushes, most probably a Series "00" brush. He literally drew with a paintbrush. De Jong also painted with fine lines to accentuate the form. His hand wove back and forth, guided by the curve of the form, to create a mesh of three-dimensional density. This is clearly visible around the area of the spout and shoulder of the Mycenaean jug P 15239 (Fig. 58).

Piet de Jong used a dry brush technique for painting the surface of a pot decorated with a burnished or semi-gloss glaze. To represent reflected daylight on the original glaze of the pot, he scraped the brush, full with partially dried gouache, across the surface; as the brushwork dried, it left a parched feathered impression, creating an indefinable edge similar to the way light fractures when it starts to disappear. Another example of the dry brush technique is demonstrated with the added blue paint on the floral frieze of the fresco from the Church of Saint Spyridon (Fig. 59). The heavy, dry brush strokes captured the parched paintwork of the later surface of the fresco in contrast with the earlier surface of the fresco, where he applied moist paint, creating a continuous flow.

The high-gloss nature of Greek black- and red-figure, black-gloss ware, and Hellenistic pottery required yet another technique. With either white or pale gray gouache, he painstakingly fused together individual lines in a rhythm of metallic incision to accentuate the shape. This is illustrated in the rim and lower body of the black-gloss phiale and the handle of a Hellenistic kantharos (Figs. 60a, b).

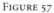

FIGURE 57

FIGURE 58

FIGURE 59

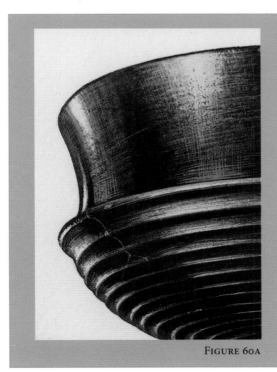

FIGURE 60A

FIGURE 60B

BRUSHWORK

FIGURE 57. Krater attributed to Exekias, AP 1044 (Painting no. 375), detail showing horses' manes and Poseidon (see no. 82, Fig. 164a)

FIGURE 58. Mycenaean beaked jug, P 15239 (Painting no. 61), detail of neck, spout, and handle (see no. 25, Fig. 92)

FIGURE 59. Decorative floral fresco from the Church of Saint Spyridon (Painting no. 307), detail of the dry brushwork in blue

FIGURE 60
A. Black-gloss phiale, P 9274 (Painting no. 42), detail (see no. 89, Fig. 171b)

B. Hellenistic kantharos, P 5811 (Painting no. 189), detail of the handle (see no. 113, Fig. 199)

DISTORTED AND ROTATED VIEWS

ONE OF THE MOST CHARACTERISTIC and idiosyncratic aspects of Piet de Jong's work was his ability to illustrate virtually any artifact from a distorted perspective. The rotated views and apparent distortion in Piet de Jong's paintings produced a distinctive effect in his work. This "signature" intended to harness visual tricks to create the illusion of an animated view. For instance, the "fish-eye" lens effect is apparent in many of his illustrations. One of the most informative examples of de Jong's distortion is his watercolor of the Mycenaean three-handled jar (Fig. 61). Here he has stretched

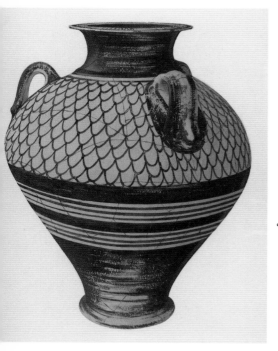

FIGURE 61. Mycenaean three-handled jar, P 15238 (Painting no. 63)

and enlarged the shoulder of a complete vessel, but the exaggerated, bloated girth of the shoulder of the vessel is not the only visual illusion at play. Not only has de Jong stretched the volume horizontally, he engineered this stretching vertically. Note that the base of the jar and its rim are not parallel. The viewer looks at the base as though he/she were standing far above, looking down upon it. At the same time, the shoulder seems to be just under the viewer's eye level, whereas the neck is at eye level. At the rim, however, the viewer is confronted with something of a bird's-eye view, as though he/she were slightly above, peering in. Such an overall effect could not be achieved photographically—unless the image was digitally manipulated—and it is an overall perspective that does not exist in nature.

There is little doubt that de Jong deliberately wanted his viewers to experience these collective distortions. He knew the paintings would be reinterpreted visually and corrected upon viewing; we animate the object by visually correcting it. At times this distortion is so subtle that one is almost not aware of it, as in the Mycenaean jar (no. 20, Fig. 85a); at other times, it is blatant as in the heavily distorted Mycenaean jar (Fig. 61).

COLOR PALETTE

THE COLORS PIET DE JONG USED are of the standard watercolor palette (see Table 1). Having analyzed the artifacts he was to copy, he then mixed the appropriate palette, structurally building up each layer as described above. He faithfully tried to capture the color of the artifact, whether metal, ceramic, bone, or stone. To secure the color, Piet de Jong painted color tests, most likely on scrap paper that he would have thrown away, but at times, when space permitted, he included the tests alongside the watercolor itself, as is evident on many of the Church of Saint Spyridon frescoes (Fig. 62).

Here it would be useful to understand a few facts about the character of color pigments and their relation to each other. There are three basic color relationships: primary, secondary, and tertiary. The primary colors are red, blue, and yellow and these cannot be produced by the mixing of other colors. When these are mixed in pairs they form secondary colors: red + blue = violet, blue + yellow = green, yellow + red = orange, and so on. It is important to note, however, that each primary color has a warm and cool value; for example, a warm red with more yellow is cadmium red, whereas a cool red with more blue is

FIGURE 62. Fresco from the Church of Saint Spyridon (Painting no. 324), detail of paint swatches on the corner of the sheet of watercolor paper

alizarin crimson. All colors have variations of warm and cool. The mixing of three or more pigments produces the tertiary colors, such as cadmium yellow + ultramarine blue + alizarin crimson = brown; lemon yellow + cerulean blue + cadmium red = gray. There are many variations of mixing that can produce a plethora of colors, especially the neutral grays and browns. These subtle colors, together with the proportion of each color when mixed, are a science at play, a symphony of possibilities requiring years of experience and much trial and error.

Although many do not consider black as a color *sensu stricto*, black nevertheless has its own warm or cool value, which is produced by mixing various colors: additional yellow, brown, or olive for a warmer value; additional blue for a cooler value. Although the black background of the fresco paintings is intended to be read as black, de Jong used a dense raw umber, which gave it warmth as though reflecting the soft golden light of the church (Fig. 63). Piet de Jong also used a warm black on the ceramics, possibly raw umber and black, whereas for the high black-gloss of Archaic, Classical, and Hellenistic pottery he used a cool black, probably a pure black painted over a warm sienna color with white highlights. Piet de Jong was a master at exploiting black.

There seems to be no standard "ceramic" color, as pottery varies according to the nature and conditions of fabric and firing. In order to render the color of pottery, Piet de Jong mostly used various densities of raw sienna, yellow ochre, and burnt sienna as a base ceramic color. De Jong painted variations of raw umber and burnt sienna for the glazes and paintwork. Applied or etched decoration was painted gray or white and raw sienna was used for "miltos red."

In his renderings of the frescoes from the Church of Saint Spyridon, Piet de Jong appears to have used a limited palette. Yellow ochre or raw sienna was used for the halos and textile details of the robes, raw sienna for the flesh—with diluted white highlights—burnt sienna for the robes, and raw umber for the background. The garments and decoration were highlighted with a diluted warm white-pink made from white added to burnt umber. The olive greens of the medallions were either mixed from pale yellow and black, or raw umber mixed with yellow and white. He also employed pale blue as another form of highlighting. This is evident in the dry brushwork of the fresco frieze from Saint Spyridon (see Fig. 59) and the highlights of the architectural painting of the sima restoration (no. 12, Fig. 77). Although these two paintings are of very different artifacts, the pale blue appears to have come from the same palette, a gouache most likely cerulean blue mixed with white.

Piet de Jong's basic color palette (Table 1) follows the standard watercolor palette compiled from Ralph Mayer and Steven Sheehan's *Artist's Handbook of Materials and Techniques* (1975).

Many of the color pigments are quite poisonous, including the cobalt violet, and caution must be practiced, especially when there is a tendency to shape the brush in the mouth. There are variations and additional colors such as olive green, Prussian or Winsor blue, and Carmine red. Although we do not have a full set of Piet de Jong's paints, it is clear that he used a standard, commercially available watercolor palette.

FIGURE 63. Medallion of Saint Triphon from the Church of Saint Spyridon (Painting no. 308), detail of background

TABLE 1. Piet de Jong's Palette

Reds	Cadmium red	(yellow red)
	Alizarin crimson	(blue red)
Blues	Ultramarine	(standard violet blue)
	Cobalt blue	(greenish blue)
	Cerulean blue	(greenish blue, pale sky blue)
Yellows	Cadmium pale	(lemon yellow)
	Cadmium yellow	(medium to deep orange yellow)
	Raw sienna	(orange yellow ochre)
Browns	Raw umber	(dark brown, greenish brown)
	Burnt umber	(dark brown greenish, yellowish violet)
	Burnt sienna	(reddish brown)
Greens	Viridian	(cool emerald)
	Green earth	(yellowish green)
	Phthalo green	(intense blue green)
Violets	Cobalt violet	(manganese based on arsenic)
	Mars violet	(bluish red)
Whites	Chinese white	(non-lead-based whites)
	Titanium oxide	
Blacks	Mars black	(oxide of iron)
	Lamp black	(pure carbon)
Gray	Paine's gray	(warm gray)

CODA

ARCHAEOLOGICAL DRAWING AND PHOTOGRAPHY are a valued discipline in the academic world. The realities of time constraints and the ever-improving plasticity of computer-generated drawing, however, are quickly bringing an end to the artistry that is possible and evident in this remarkable body of work. It is clear what we lose by steering so far from the world Piet de Jong inhabited. Let us hope that the characterless line of the computer and total reliance on photography—respected fields, of course, in their own right—do not supersede the art that was once valued so highly. Why does a drawing or a painting become more valuable over time? Perhaps the answer lies in its uniqueness, and we are reminded of what humanity is capable of creating at its best. Through the appreciation of the craft of artwork, we are permitted a window into the artist's odyssey. The further we remove ourselves from the handmade, the deeper our sense of loss.

CHAPTER 3

Topography and Architecture

John McK. Camp II

1. PLAN OF THE AGORA IN CA. 500 B.C. (PD NO. 2857, FIG. 64)

The first of a series of five period plans of the Agora, this draw-ing shows the area in the early years of its development as the civic center of Athens. Before the 6th century B.C., the center of town was further east and to the south of the Acropolis, while this area was used in the Bronze Age (2000–1100 B.C.) as a cemetery and in the Iron Age (1100–700 B.C.) for both burial and habitation. There is still some controversy over the exact date of the shift from private to public use of the land here and its laying out as the Agora. The earliest buildings, which are of uncertain function, are the two under the Old Bouleuterion, dating to the early 6th century B.C., close to the time of the lawgiver Solon. The plan shows the topography of the area of the Agora around 500 B.C. as it was conceived by the archae-ologists of the 1930s.

Among the more prominent structures are the Altar of the Twelve Gods and the Southeast Fountainhouse, here labeled "Enneakrounos." The Twelve Gods marked the center of the city, and the fountainhouse delivered water for the many peo-ple expected to congregate here. Of uncertain function are the structures labeled "Administrative Buildings" at the southwest. Other public monuments include the Agora boundary stone and the Old Bouleuterion (seat of the boule or senate). Early sanctuaries include the Aiakeion (incorrectly identified here as the "Heliaia") and the Temple of the Mother of the Gods; less securely identified are the archaic temples of Zeus and Apollo Patroos.

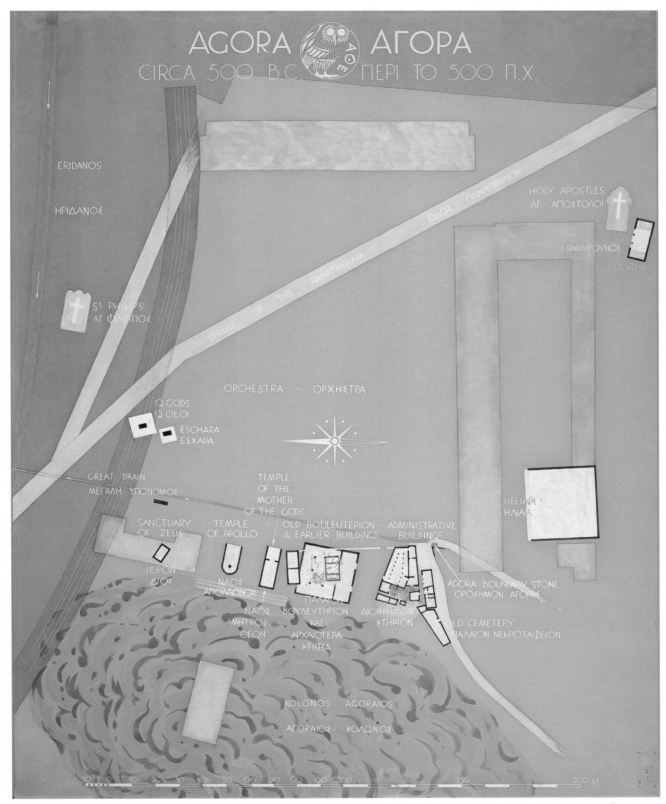

FIGURE 64

2. Plan of the Agora in ca. 400 B.C. (PD no. 2858, Fig. 65)

The plan of the late 5th century B.C. shows the Agora at the time of its greatest significance as the center of Athenian democracy, a time when Athens itself was contending with Sparta for the hegemony of the Greek world. In earlier days there were other civic centers in the city, and in later times Athens declined and power shifted elsewhere in the Mediterranean. These are the buildings frequented by Perikles, Sokrates, Sophokles, and the many others who made Classical Athens the foremost city of Greece in all fields of endeavor and the cultural icon the city has been ever since.

Almost all the major buildings needed to run the government clustered around the open square in the Classical period. The legislature in the form of the boule (senate of 500) was housed in the Bouleuterion and Tholos along the west side, commercial activities were administered at the south, in South Stoa I and the Mint, and the lawcourts began to develop at the northeast corner of the square. The military had headquarters at the southwest corner (Strategeion). Not shown and undiscovered at the time of the painting is a chief magistrate's office, the Royal Stoa, uncovered in 1970 at the northwest entrance to the Agora, and the Painted Stoa, a major social center and repository for memorials of Athenian military exploits, uncovered in 1981. Recent excavations and research have changed our interpretations of some monuments and have shown that several emendations to this drawing are necessary. The Eponymous Heroes and the Southwest Fountain should both be dated to the later 4th century B.C., and the Heliaia is now thought to be a sanctuary, the Aiakeion.

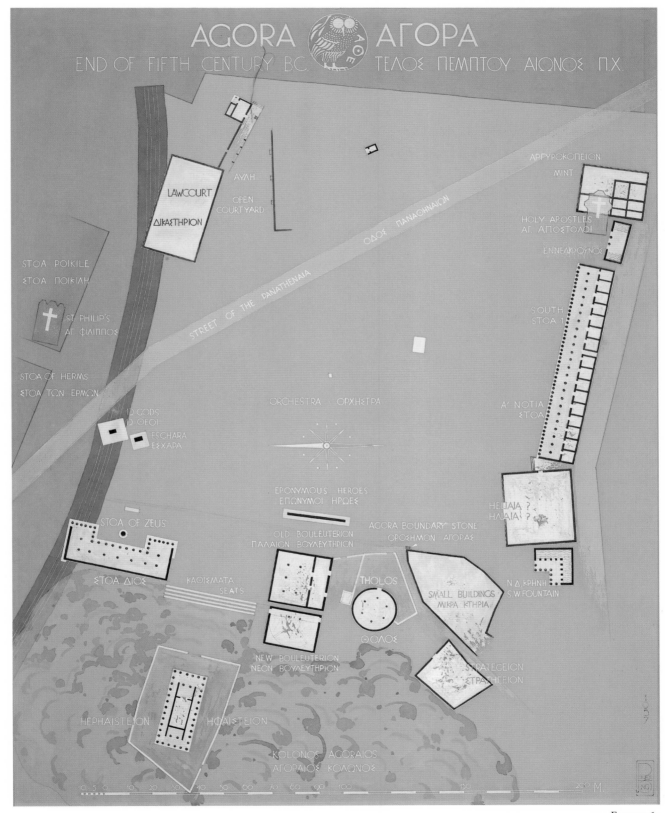

3. Plan of the Agora in the 2nd century b.c. (PD no. 2859, Fig. 66)

H. A. Thompson 1959, frontispiece.

This drawing shows the Agora after major changes and additions in the 2nd century b.c. during the Hellenistic period. After a grim period of war and Macedonian domination in the 3rd century b.c., Athens revived somewhat in the 2nd century, with the help of the Ptolemies of Egypt and the Attalids of Pergamon. Athens remained a cultural and educational center, but otherwise by then the city had lost most of its military, economic, and political prominence to new, large cities in the eastern Mediterranean, such as Ephesos, Miletos, Antioch, Alexandria, and Pergamon. A feature of all these grand cities were generously laid-out agoras, lined on all sides with magnificent colonnades or stoas. The old Athenian Agora was redesigned to emulate the new style. First to go up was the Middle Stoa (ca. 180–140 b.c.), which cut the old open square into two uneven parts. The smaller southern part was further elaborated with a second stoa (South Stoa II, ca. 150 b.c.) and a connecting building at the east (East Building, ca. 160 b.c.). Another handsome stoa was built along the east side of the square, more lavish than those at the south; it had marble colonnades and was two storeys high. Behind the colonnades were rows of shops, making it the ancient equivalent of a modern mall: forty-two shops on two levels under a single roof. The building was given to the Athenians by King Attalos of Pergamon (159–138 b.c.), who had studied in Athens under the philosopher Karneades. The west side, with its mix of venerable buildings, was harder to redesign. But even here the new Metroon (archive building) built in ca. 140 b.c. had a colonnaded porch that complemented the columnar façades of the older buildings to the north.

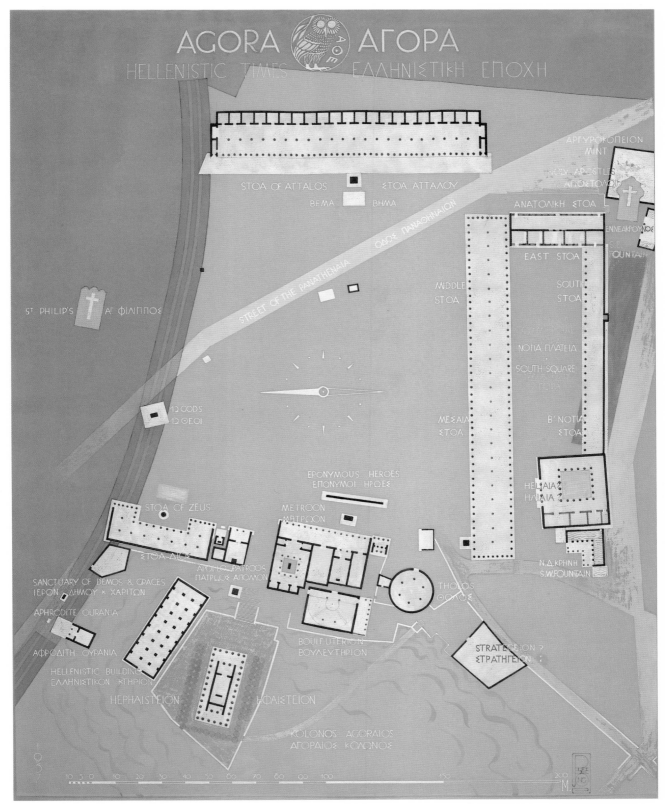

AGORA ΑΓΟΡΑ
HELLENISTIC TIMES ΕΛΛΗΝΙΣΤΙΚΗ ΕΠΟΧΗ

STOA OF ATTALOS ΣΤΟΑ ΑΤΤΑΛΟΥ

BEMA ΒΗΜΑ

ΑΡΓΥΡΟΚΟΠΕΙΟΝ MINT

ΑΓΙΟΙ ΑΠ-ΣΤΛΕΙ ΑΠΟΣΤΟΛΟΙ

ΑΝΑΤΟΛΙΚΗ ΣΤΟΑ

ΕΝΝΕΑΚΡΟΥΝΟΣ FOUNTAIN

EAST STOA

ΟΔΟΣ ΠΑΝΑΘΗΝΑΙΩΝ

STREET OF THE PANATHENAIA

St PHILIP'S ΑΓ ΦΙΛΙΠΠΟΣ

MIDDLE STOA

SOUTH STOA

ΝΟΤΙΑ ΠΛΑΤΕΙΑ

SOUTH SQUARE

12 GODS 12 ΘΕΟΙ

ΜΕΣΑΙΑ ΣΤΟΑ

Β΄ΝΟΤΙΑ ΣΤΟΑ

EPONYMOUS HEROES ΕΠΩΝΥΜΟΙ ΗΡΩΕΣ

HELIAIA ΗΛΙΑΙΑ

STOA OF ZEUS

METROON ΜΗΤΡΟΟΝ

ΣΤΟΑ ΔΙΟΣ

ΑΠΟΛΛΟ ΠΑΤΡΟΟΣ ΠΑΤΡΩΟΣ ΑΠΟΛΛΩΝ

Ν Δ ΚΡΗΝΗ S.W.FOUNTAIN

SANCTUARY OF DEMOS & GRACES ΙΕΡΟΝ ΔΗΜΟΥ κ ΧΑΡΙΤΩΝ

THOLOS ΘΟΛΟΣ

APHRODITE OURANIA

ΑΦΡΟΔΙΤΗ ΟΥΡΑΝΙΑ

BOULEUTERION ΒΟΥΛΕΥΤΗΡΙΟΝ

STRATEGEION ? ΣΤΡΑΤΗΓΕΙΟΝ :

HELLENISTIC BUILDING ΕΛΛΗΝΙΣΤΙΚΟΝ ΚΤΗΡΙΟΝ

HEPHAISTEION ΗΦΑΙΣΤΕΙΟΝ

KOLONOS AGORAIOS ΑΓΟΡΑΙΟΣ ΚΟΛΩΝΟΣ

10 5 0 10 20 30 40 50 60 70 80 90 100 150 200 M.

FIGURE 66

51

4. Plan of the Agora in the 2nd Century A.D. (PD no. 2860, Fig. 67)

The next plan in the series shows the Agora in the years around A.D. 150, the time of its most extensive development, before the first of several barbarian incursions in the following centuries. A number of changes took place in the centuries after the Hellenistic period. Most noticeable, the integrity of the public square was completely violated in the Roman period. The Odeion built by Agrippa and the Temple of Ares were both added in the late lst century A.D., effectively using up the remaining open space. This was possible because of the construction of a new agora some 100 meters to the east, paid for by Caesar and Augustus. Certainly commercial activities were transferred there, changing the character of the old agora as the center of town.

The new buildings of the Agora reflect the honored position of Athens in the Roman world. The city continued to enjoy the reputation as the cultural and educational center of the Mediterranean. It is not surprising, therefore, to find the addition of the Odeion (a cultural building originally), rebuilt at about this time to serve as a lecture hall, and the addition of a library, built by the philosopher Titus Flavius Pantainos around A.D. 100. The Temple of Ares is one of several examples of an old Classical temple brought in from elsewhere and reassembled in the Agora in the Roman period; it is possible that they were rededicated and used for the worship of the imperial family of Rome.

The period of the plan corresponds with the visit to Athens of Pausanias, the traveler who wrote the earliest surviving guidebook to Athens and Greece. The identification of many of the buildings depends on his account: the Stoa of Zeus, Apollo Patroos, Metroon, Bouleuterion, Tholos, Eponymous Heroes, Temple of Ares, numerous statues, the Odeion, the Enneakrounos fountain (probably misidentified), and the Hephaisteion. Not shown is the basilica, a typical Roman civic building, built in the time of Hadrian (A.D. 117–138) at the northeast corner of the square. It was only discovered in the 1970s and most of it still lies hidden under modern buildings.

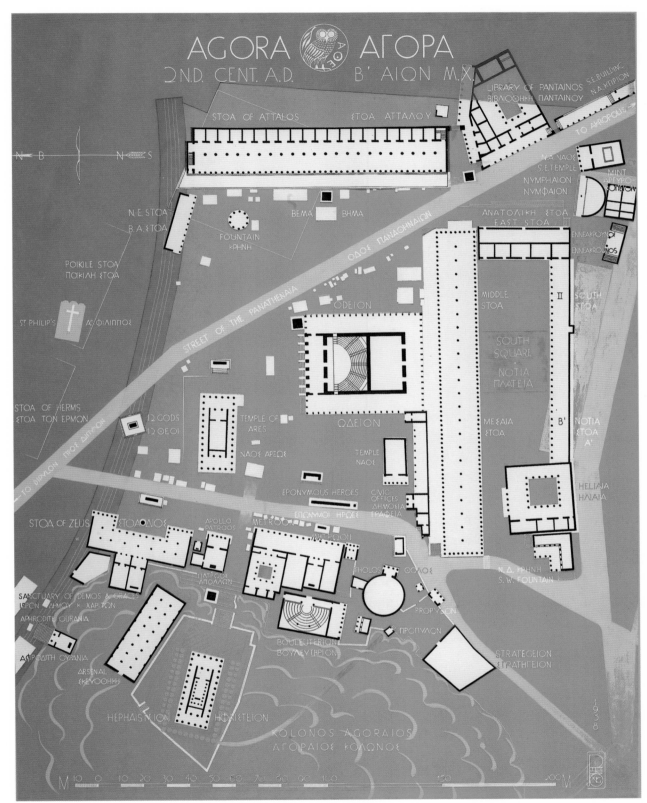

FIGURE 67

53

5. PLAN OF THE AGORA IN THE 5TH CENTURY A.D. (PD NO. 2861, FIG. 68)

The final drawing of this series shows the area of the Agora at the end of antiquity. In A.D. 267 Athens was devastated by some northern invaders, the Herulians, who attacked from the Black Sea; the city was totally destroyed before they were driven off. When the Athenians rebuilt their town it was on a much smaller scale, encompassing an area immediately around the Acropolis. The old Classical fortification wall, laid out by Themistokles centuries before, was largely abandoned and a new circuit was built, reusing dozens of pieces of the destroyed buildings. The new wall (shown in thick dark blue, at the top) ran down the east side of the Panathenaic Way, incorporating the ruins of the Stoa of Attalos and preserving it to its full height at the north end, and then ran eastward toward the Library of Hadrian. The old Agora, once the center of Athens in all respects, was now no longer even within the fortified limits of the city.

The city recovered gradually, thanks to the success of the philosophical schools, which still drew students from all over the Mediterranean. A revival of sorts in the area of the old Agora took place in the early years of the 5th century A.D., when the ruins of the old Odeion and the space to the south were used for a huge palace-like structure made up of numerous rooms, courtyards, and a small bath complex. The façade reused the huge marble giants and tritons that once adorned the entrance to the Odeion. Athens was a very pagan city and Christianity took a long while to take hold. The conversion of the Hephaisteion to a church of Saint George, with the addition of an apse to the east, now seems more likely to have occurred in the 6th or even 7th century A.D. rather than the 5th century.

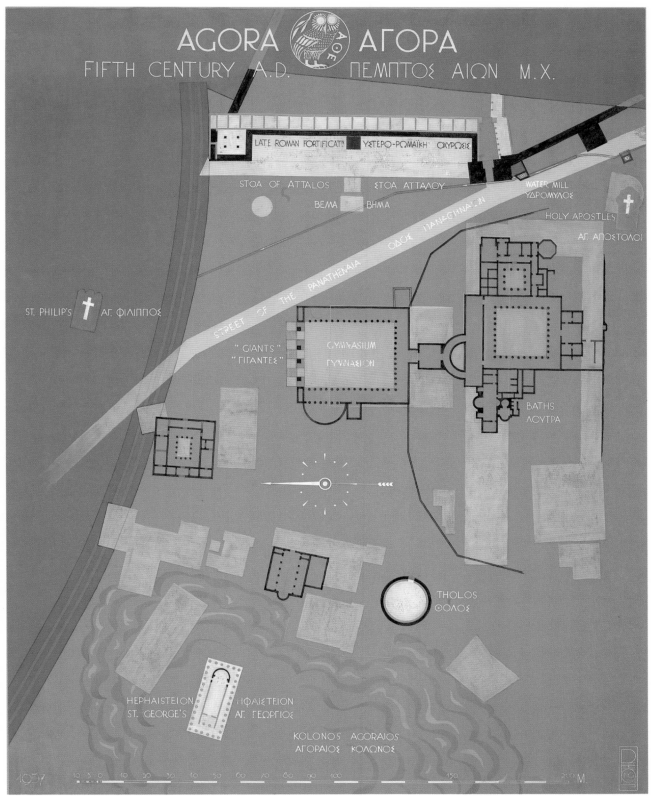

AGORA ΑΓΟΡΑ
FIFTH CENTURY A.D. ΠΕΜΠΤΟΣ ΑΙΩΝ Μ.Χ.

LATE ROMAN FORTIFICATⁿ ΥΣΤΕΡΟ-ΡΩΜΑΪΚΗ ΟΧΥΡΩΣΙΣ

STOA OF ATTALOS ΣΤΟΑ ΑΤΤΑΛΟΥ WATER MILL ΥΔΡΟΜΥΛΟΣ

BEMA ΒΗΜΑ

HOLY APOSTLES ΑΓ. ΑΠΟΣΤΟΛΟΙ

STREET OF THE PANATHENAIA ΟΔΟΣ ΠΑΝΑΘΗΝΑΙΩΝ

ST. PHILIP'S ΑΓ. ΦΙΛΙΠΠΟΣ

"GIANTS" "ΓΙΓΑΝΤΕΣ"

GYMNASIUM ΓΥΜΝΑΣΙΟΝ

BATHS ΛΟΥΤΡΑ

THOLOS ΘΟΛΟΣ

HEPHAISTEION ΗΦΑΙΣΤΕΙΟΝ
ST. GEORGE'S ΑΓ. ΓΕΩΡΓΙΟΣ

KOLONOS AGORAIOS ΑΓΟΡΑΙΟΣ ΚΟΛΩΝΟΣ

FIGURE 68

55

6. Plan of the north end of the Stoa of Attalos, with earlier remains (PD no. 2865, Fig. 69)

For general background on the area and the lawcourts, see *Agora*
 XXVII; *Agora* XXVIII; H. A. Thompson 1959.

This drawing, designed to hang in the basement of the Stoa of Attalos, was intended to show the complex stratigraphy of this part of the site, with its array of superimposed monuments representing several periods. The earliest remains (shown in green) are the prehistoric graves: chamber tombs of the Late Bronze Age (1400–1300 B.C.) and cist graves from the Early Iron Age (1100–900 B.C.). Next comes a succession of walls of the 5th and 4th centuries B.C. (blue). Found with them were two drain tiles set on their ends to form a container (by the red star near the center), which is identified as a ballot box. Within it were found seven bronze disks, inscribed with the words "public ballots," which were used by jurors when rendering a verdict. It seems likely, therefore, that we have here one of the popular lawcourts that served as a foundation of Athenian democracy. A larger, more substantial building with interior colonnades, also identified as a lawcourt, was built at the end of the 4th century B.C. (yellow and red) over the earlier Classical structures. It, in turn, was put out of use by the construction of the monumental Stoa of Attalos, a large shop-building, which was erected about 150 years later, in 159–138 B.C. (white and red). The foundations indicate that the building was originally planned to be somewhat shorter (by three shops: hatched walls) than the final version actually built. The Stoa of Attalos was rebuilt to serve as the site museum (1953–1956) and basements were created at foundation level, both for storage and for displaying these earlier levels.

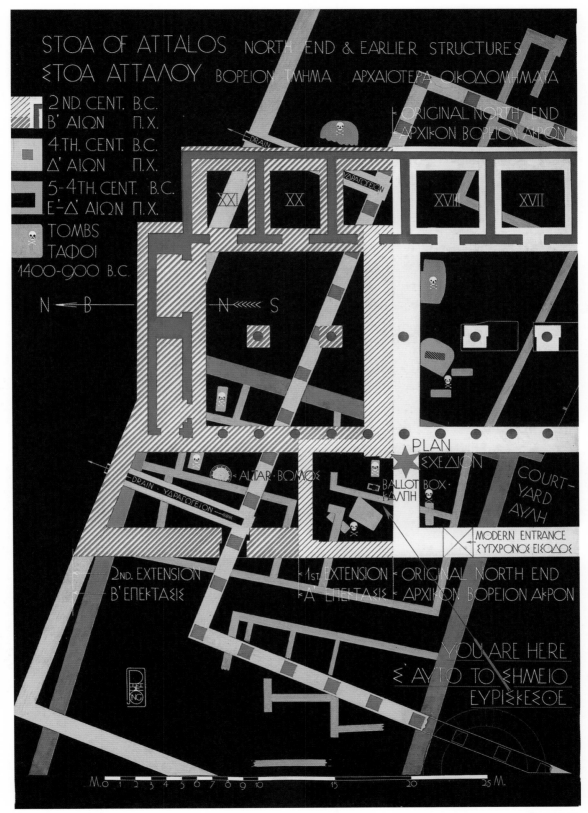

FIGURE 69

7. Eaves tiles and antefix from the Tholos roof (Fig. 70)

A 861 and A 880 (Painting no. 333)
Ca. 470 B.C.
A 861: Found near Tholos, February 15, 1938
A 880: Found north of Tholos, April 22, 1938
Eaves tile: 0.09 high
Antefix: Restored height: 0.306; width: 0.22
Thompson 1940, pp. 65–73 and frontispiece; *Agora* XIV, p. 43, pl. 35a.

Brightly painted roof tiles were a feature of Greek architecture for centuries, and generally the color on many examples, baked onto the clay, has survived remarkably well. The example here is from an unusual and important building, the Tholos (Fig. 71), which served as the dining hall and headquarters of the executive committee (*prytaneis*) of the Athenian boule. The building took the form of a large round drum and its steeply sloping roof, resembling a parasol, was one of the features remarked on most frequently in the ancient sources.

The watercolor is a composite and partial restoration of how the edge of the roof was treated. Large, flat, triangular pan tiles made up the overhanging eaves, their vertical faces painted with a double braid pattern in black and purple, divided by a row of small palmettes. The cover tiles over the joints were also triangular, ending at the edge of the roof in the usual fashion, with a large palmette antefix. Higher up, the tiles were diamond shaped, overlapping like fish scales, though how the very top was roofed remains a mystery. The light-on-dark style and details of the smaller palmettes of the antefix (with both curved and pointed leaves) suggest a date of around 470 B.C. for the roof, which accords with other evidence for the construction date of the building. Signs of burning and the findspots of many of the tiles indicate that this original roof was severely damaged by fire at the end of the 5th century B.C., though the building itself was repaired and continued to be used well into the Roman era.

FIGURE 70

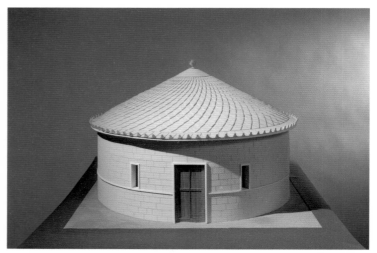

FIGURE 71

8. SIMA FROM THE HEPHAISTEION (FIG. 72)

A 1094 and others (PD no. 608)
5th century B.C.
Height: 0.229
Dinsmoor 1941, pp. 110–116; Travlos 1971, p. 270, fig. 344;
 Dinsmoor 1976.

The Hephaisteion is the handsome Doric temple that crowns the hill lying immediately west of the Agora. It is usually identified as a temple of both Hephaistos, god of the forge, and Athena, patroness of arts and crafts, though the old, popular name, the "Theseion," clings to both the building and the surrounding neighborhood like a limpet. Built about the same time as the great monuments of the Acropolis, the Hephaisteion is one of the richest and best-preserved Classical temples surviving from antiquity. Carrying a full complement of sculptural decoration, it was built almost entirely of fine white marble from nearby Mount Pentele. Much of the roof was also done in marble.

The drawing, in pen and ink, shows the sima or gutter that ran along the edge of the roof. It formed a barrier that trapped rainwater, directing it out the spouts cut in the form of lions' heads. The face of the sima was decorated with a simple, favored design of alternating palmettes and lotus plants. The basic form of simas, together with the use of floral decoration and the lion-head spouts, remained in use for centuries. As so often in Greek architecture, the form was fixed early on and only incremental changes took place thereafter. Greek art and architecture were evolutionary rather than revolutionary. It is interesting to compare the restrained Classical decoration of this piece with the sima of the Middle Stoa (no. 12); though essentially similar in form, the later piece reflects the more ornate decorative tastes of the Hellenistic period, some 300 years later.

FIGURE 72

9. Ceiling coffer from the Temple of Ares (Fig. 73)

A 387 and A 388 (Painting no. 329)
5th century B.C.
From the fill of the Valerian Wall (1939)
0.460 × 0.485
McAllister 1959, pl. 6a.

The Temple of Ares was a 5th-century marble temple, very similar in both plan and workmanship to the better-preserved Hephaisteion. It seems originally to have stood elsewhere in Attica, most probably at Pallene, to the northeast, where it may originally have been dedicated to Athena. In the early years of the Roman Empire it was dismantled, moved in pieces, and re-erected in the Agora, where Pausanias saw it around A.D. 150 and identified it as a temple to Ares, god of war.

The painting by Piet de Jong is a reconstruction of a ceiling coffer, showing the use of color as preserved in fugitive traces on the original fragments. Marble ceilings were rare, their use normally confined to temples. The bright colors were necessary to allow the decoration to be seen from below. The outer painted bead-and-reel served to disguise the actual joints between the slabs. The shading indicates that the central part was recessed, presumably to reduce the weight of the slabs, which would have to have been carried by the supporting beams. The transition from the horizontal to the vertical surface of the coffer was marked by a carved ovolo molding that was decorated with a painted bead-and-reel and an egg-and-dart. The starburst in the center was a common decorative motif in Greek art.

FIGURE 73

10. PAINTED IONIC CAPITAL (FIGS. 74A, B)

A 2972 (PD nos. 2159, 1629)
Middle to third quarter of the 5th century B.C.
Found July 1959 built into a tower of the Post-Herulian Fortification Wall, late 3rd century A.D. (R 15)
Height: 0.459; length: 1.235; width: 0.762
Meritt 1996, pp. 154–156, figs. 2, 20, pls. 40, 41; Camp 1986, p. 186, pl. XI; Travlos 1971, p. 111, fig. 152; *Agora* XIV, p. 166, pl. 84; Thompson 1960, pp. 354–356, pl. 77.

The capital, like so much of Greek architecture, was originally decorated with bright paints: mostly red and blue, but also yellow and black in this instance. This is a rare example of well-preserved original colors; usually only slight traces survive and they often fade when exposed to sunlight. The painted designs were used to decorate specific moldings. Here the small egg-and-dart at the top and the large one at the bottom are both painted on an ovolo profile, as expected. The alternating red spirals and concave-sided checkerboards across the middle, however, are unusual. Often the decorated areas are carved as well. The shading in the drawing shows that the spiral volutes and the long leaves of the palmettes springing from the volutes were carved. The fact that mostly painted ornament was used elsewhere instead of carving and the unusual freshness of the colors both suggest that the column was used in the interior of a building.

This column and pieces of several more like it had an interesting career. Set up originally in the 5th century B.C. at some unknown location, they were moved into the Agora of Athens in the Early Roman period. This is clear from the fact that all the pieces were inscribed with late masons' marks, used to guide the correct reassembly of the pieces in their new position. It seems as though the Athenian territory of Attica, severely depopulated at this time, proved a rich source of excellent Classical building material, available for reuse whenever it was felt a new temple was needed in downtown Athens. Following the destruction of the Agora in A.D. 267, the pieces found a new home, as part of the Late Roman fortification wall of the city, where they rested for almost 1,700 years, until their recovery in 1959.

FIGURE 74A

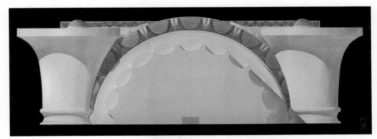

FIGURE 74B

11. Marble lintel block with a painted lioness
(Figs. 76a, b)

A 818 (Painting nos. 278 and 159)
Second half of the 5th century B.C.
Found March 10, 1938, built into the Post-Herulian Fortification
 Wall, late 3rd century A.D.
Pentelic marble.
Height: 0.468; width: ca. 0.38; thickness: ca. 0.27
Stevens 1954, pp. 169–184, pls. A (watercolor), 39–48.

This is a rare example of large-scale painting on marble surviving from the 5th century B.C. It shows the hindquarters of a female lion, striding to the right; behind her, to the left, are traces of what appears to be a large seated bird. Both lions and birds were popular subjects for Greek sculptors and vase-painters. The lioness is rendered in yellow, on a background of bright blue, surrounded by a border of red and green. The block seems to be a lintel, because there is a recessed coffer on the underside, intended to be visible and decorated with a lozenge/diamond pattern, with the sides of the recessed area painted with a gilded lotus and palmette on a blue background, as shown. The placement of the piece is a puzzle, and it has been suggested that it is part of a large throne, or the roof of a baldachino or naiskos over a statue. The most probable explanation, advanced by Stevens, is that it is the lintel of a window. The restored isometric drawing (Fig. 75) gives a better idea of the shape of the block.

Both the painting and the elaborate form of the block are largely without parallel in Athens or elsewhere. It must have come from a lavish and elegant building, presumably a temple, but as it was found reused in the late fortification wall there is no good way of determining its original location. Painted architecture was not uncommon in antiquity, but circumstances rarely permit examples to survive. Here de Jong's painting is less restoration or reconstruction—as with so many of his pottery and fresco watercolors—and more archival, for the colors inevitably have faded since the discovery of the piece, and this is our best record of its original appearance.

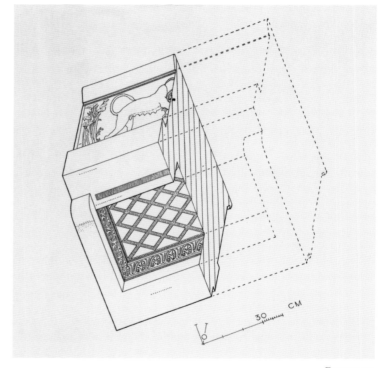

FIGURE 75

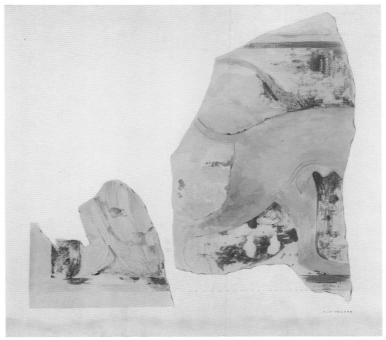

FIGURE 76A

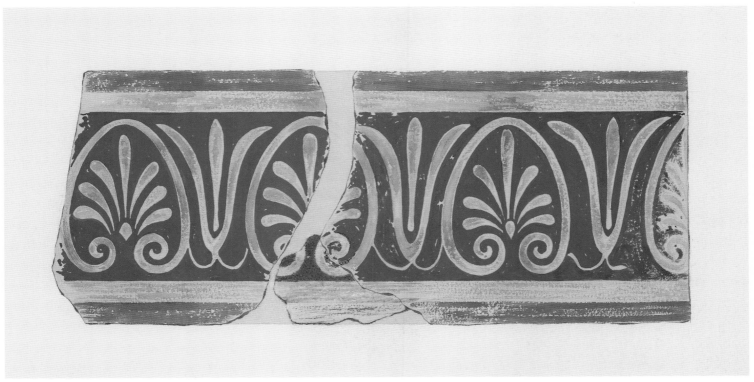

FIGURE 76B

12. Terracotta sima from the Middle Stoa (Fig. 77)

A 554, A 555, A 1442, A 1465, A 2308, A 3572, A 3497, A 3501,
 A 3616 (PD no. 1422)
2nd century b.c.
Sima: height: 0.21; length: ca. 0.68. Antefix: height: ca. 0.28–0.30
Agora XIV, p. 67, pl. 44a; Camp and Dinsmoor 1984, fig. 43;
 Travlos 1971, p. 239, fig. 306.

The piece shown here, a composite restoration based on several fragments, comes from the Middle Stoa, dating to ca. 180–140 b.c. It is part of the sima, the gutter at the edge of the roof designed to throw rainwater clear of the building. Earlier roofs had simple eaves and the water ran down the roof tiles and off the edge of the building all along its length (no. 7). A sima was made by turning up the lower edge of the eaves tile, thereby creating a barrier to catch the water, which was collected and directed to spouts set at regular intervals. The spouts, as here, usually take the form of lions' heads. The face of the sima between the spouts became a field for elaborate floral decoration, either painted, carved, or molded. Ornate, twisted tendrils, with kalykes and flowers springing from them, surmount the always popular meander pattern. These pieces were made in molds and then brightly painted. The palmette antefixes set atop the sima are a remnant from the older, simpler roofing system described earlier. Originally an antefix, it was the decorated end of a cover tile where it reached the edge of the roof. With the addition of simas, cover tiles no longer reached the edge and antefixes were superfluous. What happened, however, is a common occurrence in Greek architecture: an early functional element became embedded in the decorative scheme. The antefixes were now set at regular intervals (reflecting the position of cover tiles behind) along the top of the sima, serving only as part of the decoration of the roof. Such elaborate ornamentation is one of the artistic features of the Hellenistic world.

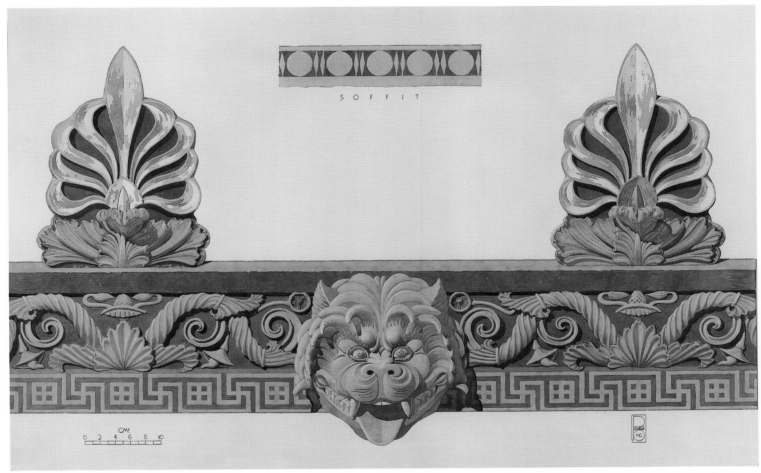

SOFFIT

FIGURE 77

CHAPTER 4

Neolithic through Middle Helladic Pottery

Walter Gauss

13. The earliest burial in the Athenian Agora
(Figs. 78a, b)

P 6072, P 6073 (Painting nos. 158, 250)
Late or Final Neolithic
Grave in Metroon drain cut (I 9:2) on the west side of the Agora
P 6072: height: 0.095; diameter: 0.102–0.112
P 6073: height: 0.090; diameter (estimated): 0.175
Shear 1935a, pp. 439–441; Shear 1935d, p. 648, figs. 2, 4; Shear
 1936a, pp. 20–21, figs. 17, 18; H. A. Thompson 1937, p. 1; Angel
 1945, pp. 291–292, no. 2, fig. 1, pl. 41:2; *Agora* XIII, pp. 92–93,
 nos. 384–385, pls. 27, 71; Schachermeyer 1976, p. 245;
 Immerwahr 1982; Alram-Stern 1996, pp. 115, 157–159.

In the spring of 1935, during his excavations on the west side of the area of the Athenian Agora, just to the east of the Hellenistic Metroon, Homer Thompson came across a burial at the bottom of a deep shaft. The date of this tomb was not immediately clear and was the object of much discussion and debate at the time. General consensus today would place the tomb in the Late Neolithic or Final Neolithic era, which was the date initially suggested by T. Leslie Shear. This is, consequently, the earliest grave to date found in the area of the Athenian Agora. The shaft, approximately 3 m deep and 0.70–0.90 m wide, ends in a rectangular chamber in which a thirty- to thirty-five-year-old male was buried on his side. It is of particular interest that this type of burial is otherwise unknown in Athens, as it is in Greece more generally; such shaft graves are better documented in the central Mediterranean.

Only two pots were recovered from this tomb—P 6072 and P 6073—both artfully rendered by Piet de Jong, the former found near the cranium of the deceased, the latter by the feet. One of the pots is a bowl on a conical foot made of coarse clay, with the exterior burnished; the other is a deep bowl with both the interior and exterior burnished. Both vessels are rather crudely made and neither reaches the quality of other Athenian Neolithic pots. It is worth adding that the deep bowl had seen service prior to its being deposited in the tomb, as the vessel had been repaired with three pairs of mending holes.

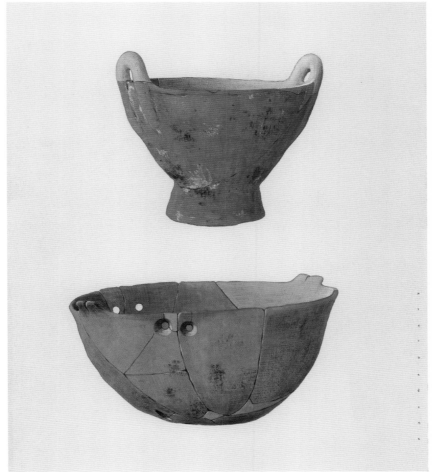

FIGURE 78A

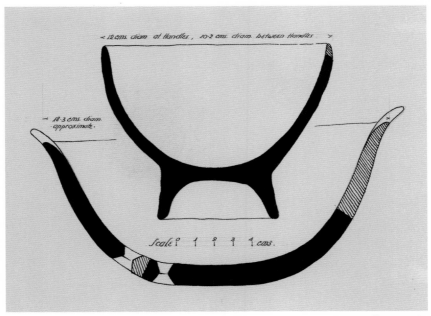

FIGURE 78B

14. Neolithic habitation and cult activity? (Figs. 79a–c)

P 14562, P 14871, P 10851 (Painting nos. 146, 157, 147)
Late Neolithic (4th millennium B.C.)
From three different wells on the northwest slopes of the Acropolis
 (U 24:2, U 26:5, T 26:3)
P 14562: height: 0.100; diameter (estimated): 0.220
P 14871: height: 0.196; diameter (belly): 0.214
P 10851: height: 0.150; diameter (belly): 0.156
P 14562: Shear 1940, p. 297, fig. 38; *Agora* XIII, p. 25, no. 19, pls. 3, 68.
P 14871: Shear 1940, p. 298, fig. 39; *Agora* XIII, p. 22, no. 1, pl. 1.
P 10851: Shear 1938a, p. 334, fig. 16; *Agora* XIII, p. 22, no. 3, pl. 1.

The area of the Acropolis and the Athenian Agora was largely given over to settlement in the Neolithic period, with many of the early inhabitants of Athens attracted to the plentiful water on the northwest slopes of the citadel. Although a Neolithic house was found on the south slope of the Acropolis and a Neolithic grave on the northeast slope, our best knowledge of the Neolithic period comes from the area of the Agora.

Along the north slope of the Acropolis, within the area excavated by the American School of Classical Studies, a number of deep shafts were found, between 3 and 7 m deep, initially interpreted as wells. The three illustrated vessels were recovered from these shafts. Handmade and highly burnished, with the surface characteristically variegated red, orange, and brown, the color and surface treatment are typical of the Neolithic period in Attica, Euboia, the Peloponnese, and the Cyclades. The shapes—a deep bowl and two hemispherical jars—are also typical of the period. Although very similar in appearance, the two jars are distinguished from one another in height and sur-face treatment. The entire surface of one of the jars (P 10851, Fig. 79c) is burnished; the other (P 14871, Fig. 79b) is pattern painted but with very little of the paint actually preserved. In typical fashion Piet de Jong transformed the poorly preserved remnants of paint into a bold representation of what the original decoration may have looked like.

As for the shafts, their function has tested the ingenuity of archaeologists. One interpretation sees these shafts as wells that were filled, after their period of use, with settlement material. Another, more intriguing interpretation prefers to see them in connection with a burial ritual involving only the partial or token burial of multiple human bodies. In the fill of the shafts not only human bone but complete and fragmentary pots, figurines, obsidian, and other stone tools were recovered. Both interpretations have their followers, but there is certainly room for further discussion and debate on the precise function of these early shafts on the north slopes of the Acropolis.

FIGURE 79A

FIGURE 79B

FIGURE 79C

15. Central Aegean networks (Figs. 80a–e)

P 10521, P 10522, P 10524, P 10527, P 10235 (Painting nos. 142, 149, 151, 153, 148)
Middle Helladic
From two different wells on the northwest slopes of the Acropolis (R 28:1, S 27:1)
P 10521: height: 0.12; diameter: 0.15
P 10522: height: 0.158; diameter: 0.205
P 10524: height: 0.277; diameter: 0.214
P 10527: height: 0.095; diameter: 0.250
P 10235: height: 0.260; diameter: 0.210
Agora XIII, pp. 74, 79–86, nos. 260, 301, 324, 328, 338, pls. 17, 20, 22, 23, 70.

The five pots illustrated here were found in one of two wells on the northwest slope of the Acropolis (P 10235 in well S 27:1, the remainder in well R 28:1) and can be taken as representative examples of Middle Bronze Age pottery. As this period is not as well known as other prehistoric periods, the Middle Helladic finds from this area are particularly important. With the help of these five pots it can be shown that Athens had direct or indirect contact with more distant parts of the Aegean. The solidly painted and burnished carinated cup P 10527 (Fig. 80d) and the matt-painted teapot P 10522 (Fig. 80b) are most likely imports from the Cyclades, whereas the belly-handled amphora P 10235 (Fig. 80e) was made, in all likelihood, in the southeastern Peloponnese, perhaps Lakonia.

Characteristic for the Middle Helladic pottery of the Greek mainland and of the island of Aigina are the two remaining vessels, P 10524 and P 10521 (Figs. 80c, 80a), which are pattern-painted with a dark brown to black matt paint. Located in the Saronic Gulf not far from Athens, Aigina was one of the production centers for so-called matt-painted pottery. A characteristic feature of Aiginetan pottery are potters' marks, and such a mark, incised in the wet clay, was found on the underside of P 10521, a bridge-spouted jar that was most likely made on the island. Moreover, this vessel, together with the teapot P 10522, shows the growing influence of Crete on the ceramic repertoire of the Aegean. In the matter of their form both vessels are shapes native to Crete and both became so popular that they were translated into matt-painted versions in a number of different production centers. This phenomenon was not a mere imitation of pottery shapes from one center to another, but the adoption of highly specialized drinking habits. An interesting, but speculative, idea is the possibility of the relocation of Cretan potters, who lived and produced their wares on Aigina and the Cyclades. To prove this more work will be necessary on the technique of manufacture and the origin of the clay.

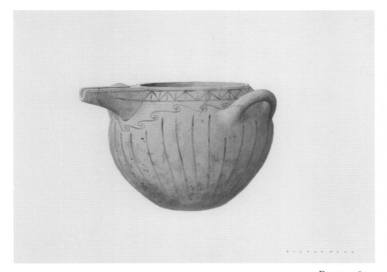

FIGURE 80A

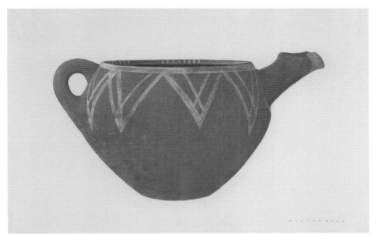

FIGURE 80B

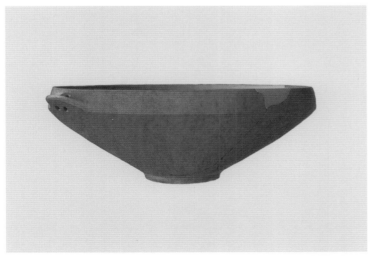

FIGURE 80D

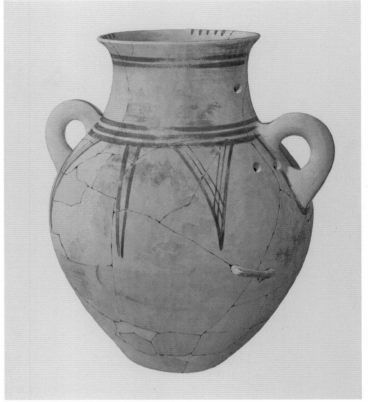

FIGURE 80C

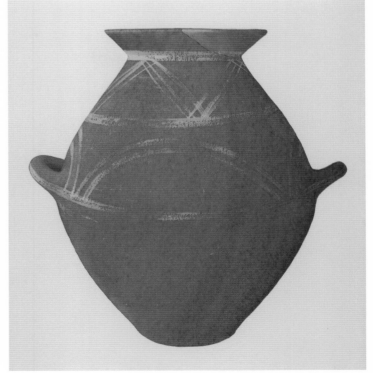

FIGURE 80E

CHAPTER 5

The Mycenaean Era in the Athenian Agora

Jessica Langenbucher

16. Minotaur leads Athenian captives (Figs. 81a–c)

J 5 (Painting nos. 235, 236, 237)
Ca. 1400–1375 B.C.
Disturbed grave J 8:4; May 10, 1933
Length (bezel): 0.019; width (bezel): 0.013; diameter (hoop): 0.016
Shear 1933a, p. 540, fig. 1, no. 4; Shear 1933c, p. 328; Shear 1935b,
 pp. 318–320, figs. 6–8; Webster 1958, p. 48, fig. 11; Thompson
 1962, p. 144; *Agora* XIII, p. 192, pl. 41; *Agora* XIV, p. 8, pl. 17c;
 Thompson 1976, p. 220; Camp 1986, p. 68.

In 1933 a Mycenaean grave was found containing the scant remains of three individuals, pottery fragments, one glass bead, and a gold signet ring. Rings such as these often represent cult scenes, and the religious significance of this object is suggested by a small column located to the left of the women in the scene. T. Leslie Shear published the ring in 1935 as part of the account of the 1933 campaign. His description conveys the excitement over the item thought to represent an early depiction of the myth of Theseus and the Minotaur, with the Minotaur leading the captive Athenian maidens to sacrifice. According to Shear,

> the ring is decorated with an interesting scene that evidently has religious or sacrificial importance. A group of three persons, two women and a man, is represented. On the right the man, who is apparently nude except for a loin-cloth, is striding to the right holding a long staff in his right hand [which may be] reasonably interpreted as a scepter. The man's left arm is concealed by his body, but he is evidently holding with his left hand one end of a double cord of which the other end is fastened to the waist of the foremost of the two women. . . . The position of their hands behind their backs gives the impression that they are bound. . . . The aspect of the head of the male figure suggests an animal type and I have proposed the interpretation of the figure as the bull-headed man, the minotaur, who is leading the captive Athenian women to the sacrifice.

In the well-known myth, Athenian captives are sent to Crete and to the Minotaur each year as part of a peace agreement with King Minos. One year the hero Theseus is chosen to be sent and he kills the Minotaur with the help of King Minos's daughter, Ariadne. Nowadays scholars are much more cautious when attributing a mythological or ritual significance to artifacts. In fact, the most recent publication of this artifact lists it as a "bull-headed man leading two female captives"; there is no mention of what mythological or religious significance the scene might hold. In order to convey the scene on the gem, Piet de Jong made three versions, each using different colors and media (watercolor and pencil).

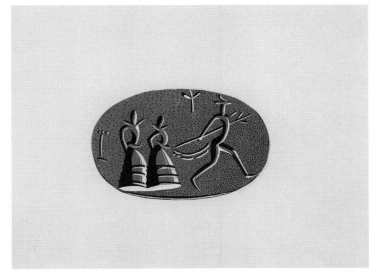

FIGURE 81A

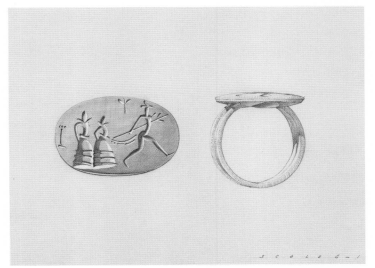

FIGURE 81B

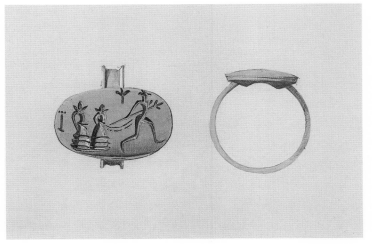

FIGURE 81C

17. Ritual object or prized possession? A bronze pouring vessel from a Mycenaean chamber tomb (Fig. 82)

B 966 (Painting no. 340)
Late Helladic IIIA–B
Found in a small chamber tomb, O 7:7; June 21, 1951
Height: 0.051; diameter: 0.10
Talcott 1951, p. 225; Thompson 1952a, pp. 106–107, pl. 26b; E. P. Blegen 1952, p. 122, pl. 9a; Townsend 1955, p. 214, no. 24; *Agora* XIII, p. 200, no. XIII-1, pl. 44.

Homer (*Odyssey* 4.615–617, trans. R. Lattimore) states:

> I will give you a fashioned mixing bowl. It is of silver
> all but the edges, and these are finished in gold. This is
> the work of Hephaistos.

In the ancient world vessels made of metal were valued commodities. In the passage cited above Menelaos gives Telemachos a magnificent guest-gift, a silver and gold vessel made by Hephaistos himself and originally given to Menelaos by the king of Sidon. Such vessels served as diplomatic gifts, prizes in athletic competitions, and ritual equipment found at sanctuaries and in burials.

Elsewhere in Homer (*Iliad* 23.217–221, trans. R. Lattimore) we read:

> Nightlong they piled the flames on the funeral pyre together
> and blew with a screaming blast, and nightlong swift-footed
> Achilleus
> from a golden mixing bowl, with a two-handled goblet in his
> hand,
> drew the wine and poured it on the ground and drenched the
> ground with it,
> and called upon the soul of unhappy Patroklos.

The golden mixing bowl and the goblet described in this passage are both part of an elaborate burial ritual of Achilles' companion, Patroklos. Relatively few metal vessels have been recovered in the excavations of the Athenian Agora. Of the three Late Bronze Age vessels that have been found, the one illustrated here is the best-preserved example of Mycenaean craftsmanship. This miniature vessel is an open, flat-bottomed cup with a shallow spout and two wishbone handles riveted on the inside. No other bronze vessel of its kind has been found at the Agora, but its shape has been inferred by several ceramic

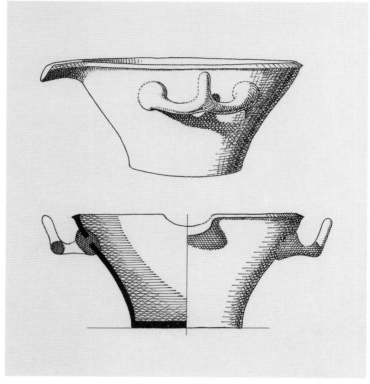

FIGURE 82

imitations. It is interesting to note that many of the clay vessels that are similar in shape are also very small. This leads to the question: what was such a small, costly vessel used for? Homer Thompson suggested that it served some sort of ritual purpose. An open vessel with a spout such as this was probably used for pouring liquids, and its small size and handsome craftsmanship make it rather impractical for domestic use. It could have been used for pouring libations in a burial ceremony similar to the one Homer describes above, or it may have been included among the grave goods because it was considered significant, perhaps having been used as a ritual object at one time.

18. THE FINAL RESTING PLACE OF A CANAANITE AMPHORA
(FIG. 83)

P 15358 (Painting no. 280)
Late 15th century B.C.
Chamber tomb, N 21–22:1; June 2, 1939
Height: 0.58; diameter: 0.325
Shear 1939b, p. 582, fig. 7; Shear 1940, p. 283, fig. 24; Grace 1956;
Thompson 1962, p. 146; *Agora* XIII, p. 164, no. I-8, pl. 31;
H. A. Thompson 1976, p. 223; Grace 1979, fig. 13.

During the Late Bronze Age the Mycenaeans enjoyed significant overseas commercial expansion to Egypt, Cyprus, the Levant, and the western Mediterranean. Mycenaean pottery has been found in abundance throughout the eastern Mediterranean and as far west as Sardinia and beyond. Exotic goods such as ivory, gold, tin, incense, and spices were exchanged for Mycenaean items such as wine, olive oil, textiles, and perfume. Trading posts and perhaps even colonies were set up to facilitate trade in distant places. Recent archaeological discoveries such as the Uluburun shipwreck off the coast of Turkey have revealed the cosmopolitan nature of the merchant vessels, which appear to have been filled with not only a wide variety of exotic goods from throughout the eastern Mediterranean, but an international crew as well. It is likely that the amphora illustrated here was brought to Athens on a similar merchant vessel.

This plain, pointed amphora was first identified as a Canaanite jar by Virginia Grace in 1956. Made of coarse reddish clay, it bears an incised mark on one of the handles that appears to have been made before firing and could be a potter's or merchant's inscription. The vessel was found leaning against a wall in the so-called Tomb of the Ivory Pyxides, along with a painted Mycenaean vessel and a copper ladle. It has been suggested that the ladle might have been used to pour wine from the two pottery vessels with which it was found for ceremonial libation. This type of jar is known to have been widely exported throughout the eastern Mediterranean, and it may have originally carried a local Canaanite product such as oil, myrrh, resin, or wine. It is not uncommon for imported items to be placed in Attic Mycenaean tombs as grave goods, and similar Canaanite or Syro-Palestinian amphoras were found in the tholos tomb at Menidi.

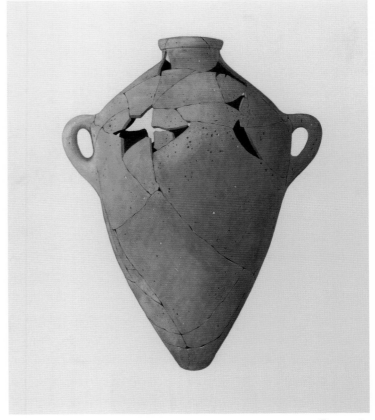

FIGURE 83

19. Treasures of the deep (Figs. 84a–c)

P 21246, P 23535 (Painting nos. 339, 347, 348)
Late Helladic IIB–IIIA1 (P 21246); Late Helladic IIIA2 (P 23535)
Chamber tomb at the north side of the Temple of Ares, May 9, 1951
 (P 21246); chamber tomb to the east of Stoa shop 19, July 9, 1953
 (P 23535)
P 21246: height: 0.27; diameter (body): 0.24
P 23535: height: 0.141; diameter (body): 0.135
P 21246: Talcott 1951; Thompson 1952a, p. 107, pl. 26a; Townsend
 1955, pp. 211–212, no. 17, fig. 7, pl. 73; Thompson 1962, p. 144;
 Agora XIII, p. 187, pls. 39, 67; Thompson 1976, p. 220.
P 23535: *Agora* XIII, pp. 227–228, pls. 53, 75.

Among the various decorative motifs depicted on Mycenaean pottery, perhaps the most charming is that of the octopus that derives from the Minoan Marine Style and was very popular in Late Minoan art. The differences between the Cretan versions of this motif and those of the mainland, however, are quite marked. The Minoan is characterized by wildly undulating tentacles often overlapping one another, white dots along the underside of the tentacles representing suckers, and a vivid landscape of sea life. Moreover, the octopus is often seen in a sideways or horizontal position rather than strictly upright. In comparison, the Mycenaean version appears much more formal. Of the two Mycenaean vessels illustrated here, the jug with the beaked spout (Fig. 84a) is more typical of the mainland variety. The octopus is in an upright, vertical position. It has eight rather plain tentacles that are all drawn in a similar manner and are clearly separated from one another, floating on a plain background save the lunate shapes that may represent seaweed. The hydria (Figs. 84b, c) falls somewhere between the mainland and the Cretan varieties. The octopus motif is depicted three times on the shoulder of this vessel; twice upright, and once sideways. Although its tentacles are less uniform than those on the other Mycenaean vessel, they do not overlap one another. Oddly, there are only four tentacles depicted for each creature. According to Immerwahr (*Agora* XIII), this is an abbreviated version often seen on kylikes. White dots cover both body and tentacles, which are suspended above a plain background.

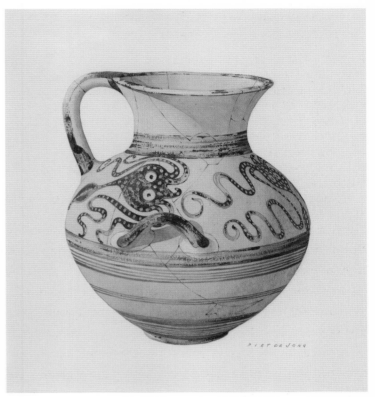

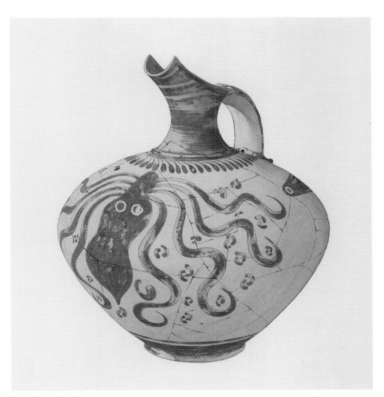

FIGURE 84A

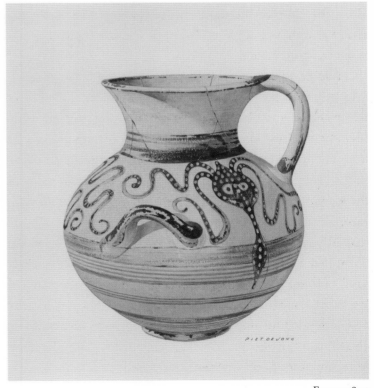

FIGURE 84C

20. Tales from the crypt: A Mycenaean chamber tomb and its grave goods (Figs. 85a, b)

P 15237, J 47, J 64, J 65, J 84 (Painting nos. 54, 196)
Late Helladic IIIA1 (P 15237); Late Helladic (J 47)
The "Tomb of the Ivory Pyxides" on a ledge at the east, May 26, 1939 (P 15237); from the same tomb on a ledge at the west, May 30, 1939 (J 47)
P 15237: height: 0.235; diameter: 0.175
J 47, J 64, J 65, J 84: length of largest piece: 0.049
Shear 1939b, p. 582, fig. 7, p. 585, fig. 16; Shear 1940, p. 280, fig. 17, p. 281, fig. 20, p. 290, fig. 32; Immerwahr 1966, p. 393, n. 53; *Agora* XIII, pp. 162–163, 169, nos. I-3, I-25–29, pls. 30, 33.

Mycenaean chamber tombs come in many shapes and sizes. Normally they consist of a single space that is roughly square with rounded corners, which is approached by a corridor called a dromos. Dug into the bedrock, most of these tombs were used for multiple burials in the form of family vaults. The first skeleton was often deposited on its back in the center of the tomb along with grave goods. Over time the tombs were reopened and the bones and accompanying grave goods were pushed aside to make room for new interments. As the chamber filled, earlier occupants were sometimes placed in niches along the sides of the tomb or the dromos. Eventually, the chamber went out of use, the dromos was filled in, and a new tomb was constructed.

Tomb I, also known as the "Tomb of the Ivory Pyxides" (Fig. 86), is by far the largest and the wealthiest of the Mycenaean chamber tombs discovered in the area of the later Athenian Agora. The tomb was entered by a very long dromos (at least 11 meters in length) running from north to south. The roof collapsed sometime during the Bronze Age, but many of the tomb offerings remained undisturbed so it was possible to ascertain their original positions. Apart from the ivory pyxis (no. 24), several of the artifacts recovered from the tomb are illustrated here, including gold ornaments that were likely sewn onto the burial shroud and a well-crafted three-handled jar. What is most interesting is that the tomb appears to have been intended for only one person, thought to be a woman, and though the valuable offerings remained in their place, the occupant of the tomb was never recovered.

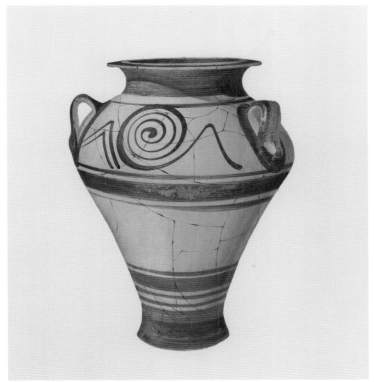

FIGURE 85A

FIGURE 85B

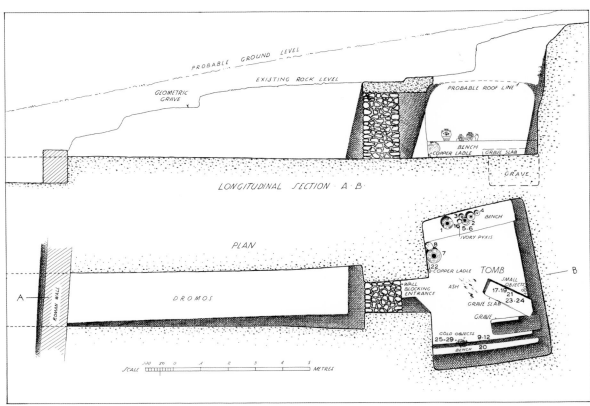

FIGURE 86

21. A WARRIOR'S TOMB UNDER THE TEMPLE OF ARES? (FIG. 87)

B 937, B 936, BI 665, ST 498 (Painting no. 336)
Late Helladic IIIA (B 937, B 936); Late Helladic II–III (BI 665); Late
 Helladic IIIB–C (ST 498)
Chamber tomb under the Temple of Ares
B 937: preserved length: 0.164; length of handle: 0.04; thickness of
 blade: 0.004
B 936: preserved length: 0.038; preserved width: 0.026; thickness:
 0.0115
BI 665: length 0.057; height to back: 0.036; height with central
 medallion: 0.041; thickness at top: 0.008
ST 498: length: 0.018; width: 0.0155; thickness: 0.007
Townsend 1955, p. 215, nos. 27, 28, 31, 34, fig. 8, pl. 76, p. 216,
 nos. 28, 31, p. 217, no. 34; *Agora* XIII, p. 189, nos. VII-27, VII-28,
 VII-31, VII-34, pl. 40.

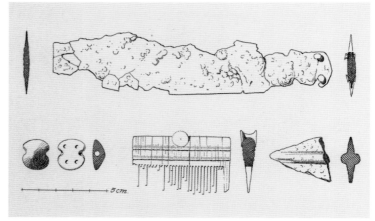

FIGURE 87

From the massive fortification walls at the citadels of Mycenae and Tiryns to grave goods in the form of weaponry and armor found throughout the Mycenaean world, it is clear that warfare played an important role in Mycenaean life. Grave stelae that at one time marked the position of the shaft graves at Mycenae show scenes of warriors with chariots, while Linear B tablets record inventories of armor and weaponry. In addition to the fortification walls, several of the citadels have secret cisterns that provided their residents with water during times of siege. A great deal of careful planning, including frequent modifications and upkeep of the fortifications, ensured the prosperity of many of the citadels, some for several hundred years.

Mycenaean soldiers were equipped with bronze swords, daggers, and shields of various shapes, including one designed in the shape of a figure-of-eight. These objects often appear as burial offerings in tombs. A collection of such objects found in a chamber tomb under the Temple of Ares included a miniature example of a figure-of-eight shield, a bronze razor, a bronze spear point, and an ivory comb (the last of which was associated with a nearby burial of a woman). These, along with a number of bronze and obsidian arrowheads, most likely contained in a bag or quiver, were placed in the tomb as grave offerings for the deceased, presumably a male, when he was laid to rest. Over time the container holding the arrowheads must have disintegrated, and as the body shifted during its decaying process it came to rest on the arrowheads. When the

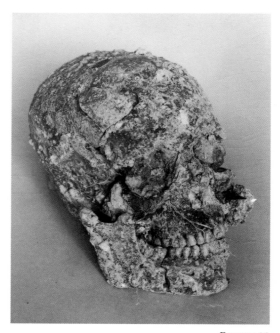

FIGURE 88

excavators uncovered the skeleton there were a total of nine arrowheads lodged in various places in and around his skull, including inside his mouth and nose (Fig. 88). At first glance it appeared that the deceased came to a grisly end, but a closer look revealed that it was unlikely that he died on the battlefield shot through with arrows.

22. RITUAL OBJECT OR PREHISTORIC DOLL? (FIG. 89)

T 1653 (Painting no. 224)
Late Helladic IIIA2–IIIB
Found in the upper part of the filling of a 6th-century well in
 section Σ, April 7, 1938
Height: 0.089; width: 0.039; diameter of base: 0.029
Shear 1939a, p. 212, fig. 11.

Clay figurines are found throughout the Mycenaean world in a variety of contexts. Excavated in tombs, sanctuaries, and even houses, some figurines are shaped like animals, but most are of female form with attributes such as prominent breasts. This particular example was found in a well that was abandoned in the 6th century B.C. The main types of female figurines are named after the shapes of the later Greek letters they resemble—phi (Φ), psi (Ψ), and tau (T). The one pictured here is of the "phi" variety, with arms close to the body. The lower part of the figurine is cylindrical, which allows it to stand unaided. Drapery is indicated by wavy vertical stripes of red paint from the neck to the foot of the figurine, as well as a horizontal stripe at the hip line. This figurine is similar to many others that have been found at the Agora as well as throughout the Mediterranean.

Scholars continue to debate what role these figurines played in Mycenaean society. Were they representations of religious figures, such as a particular goddess? Do they represent deceased relatives venerated in some sort of ancestor worship? Were they made by women as part of a female ritual, or were they simply toys for children to play with? Although we may never know how these figurines were used, we do know that they appear in a wide variety of contexts and were extremely popular. They must have played some sort of role in daily life, whether religious or secular. This is just one of the many unanswered questions about the Mycenaean way of life.

FIGURE 89

23. Floral swirls wound around revered vases (Figs. 90a, b)

P 21255, P 21250, P 21252 (Painting nos. 335, 334)
Late Helladic IIIA1 (P 21255, P 21250); Late Helladic IIB (P 21252)
Chamber tomb under the Temple of Ares, May 9, 1951
P 21255: height: 0.051; diameter: 0.121
P 21250: height: 0.058; diameter: 0.10
P 21252: height: 0.039; diameter: 0.091
Townsend 1955, pp. 206–208, nos. 5, 8, 4, figs. 5, 6, pl. 73;
 Agora XIII, p. 185, nos. VII-5, VII-8, VII-4; for discussion of
 the type, see Furumark 1941, p. 42.

While many Mycenaean vase forms follow earlier Helladic and Minoan traditions, one form remains conspicuous among them: the alabastron. According to Furumark, it takes its name from an Egyptian "baggy" vessel that is often made from alabaster. Although Egyptian alabastra come in both tall and squat varieties, all of the alabastron-type Mycenaean vessels are squat jars with a curved profile, and none is of the tall Egyptian variety. There is little doubt that the Mycenaean alabastron is related to the squat Egyptian type, but the form pictured here appears to have descended from the Late Middle Helladic piriform jar. It retains a flat bottom, horizontal handles, and a relatively high neck with a wide mouth, which are all features found on the piriform jar. But how do we reconcile these different aspects of the Mycenaean alabastra? Arne Furumark suggests that "it seems highly probable that the presence of similar native forms contributed to the popularity of the squat 'alabastron' and that the Mycenaean alabastron-shape represents a fusion between an ultimately Egyptian and a native shape." This fusion produced the elegantly shaped vessels pictured here. These three alabastra were found in the center of a chamber tomb among scattered skeletal remains and nine other vessels, which were placed in a straight row along a strip of earth. All are characteristically decorated, two with an ivy pattern in the main zone, and one with a wave pattern. What is particularly interesting about these three vessels as a group is that they all have decorated undersides, also illustrated by Piet de Jong, but in ink (Fig. 90a). Two of the vessels have a series of concentric rings and the third has a wheel motif painted on its underside. Both of these are considered standard motifs for the bottom of squat jars.

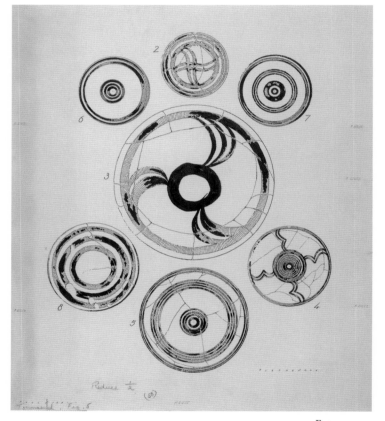

FIGURE 90A

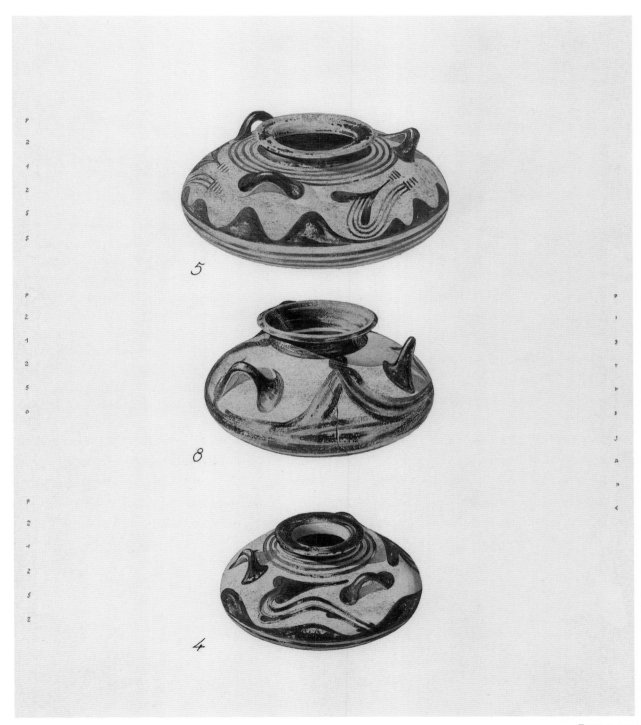

24. GRIFFINS ATTACK DEER ON AN IVORY PYXIS (FIGS. 91A–C)

BI 511 (Painting nos. 195, 204, 294)
Late 15th century B.C.
Found in the "Tomb of the Ivory Pyxides"
Maximum height (overall): 0.16; height of lid: 0.013; diameter of lid: 0.11
Lamerle 1939, p. 292, fig. 6, pl. LV; Shear 1939b, pp. 582–583, 585,
 figs. 12–14; Shear 1940, pp. 286–288, figs. 27–29; Thompson
 1962, p. 146, pl. XI; Vermeule 1964, pp. 219–220, 343, no. 17;
 Agora XIII, p. 166, no. I-16, pl. 32; *Agora* XIV, p. 7, pl. 18; Thompson 1976, p. 223, fig. 115; Camp 1986, p. 68; Camp 1990, p. 224,
 fig. 138.

The so-called Tomb of the Ivory Pyxides takes its name from two extraordinary ivory pyxides, the larger of which was found among several objects on the east bench of the largest and wealthiest chamber tomb at the Athenian Agora (see also no. 20). When the roof of the tomb collapsed in antiquity the vases surrounding the pyxis were broken; although also broken and split into many pieces, the pyxis was largely recovered complete. It is perhaps the finest example of its kind. Carved from a single piece of ivory and made watertight by lining the inside with tin, this vessel probably held oil or perfume. The ivory came from abroad, most likely from Syria or Egypt, and although the carved decoration is characteristically Aegean, some of the sculptural elements are Near Eastern in origin. Carved in fairly high relief, the scene depicts crested griffins (mythical creatures with the bodies of lions, and the heads and wings of eagles) attacking deer. On the lid, a griffin tears one deer with his beak and another with his hind claws. On the wall of the vessel, two similar griffins attack four deer. In

Hesperia for 1940, T. Leslie Shear captures the drama and violence of the attack:

> The griffins are approaching their prey from opposite sides. The one on the left of the scene is flying down with a great spread of wing and with his leonine hindquarters still high in the air. He has thrust the claws of his powerful forepaws into the flanks of a large stag which, thus hurled to the ground, has turned back its head toward its assailant in agonized gesture with mouth open and tongue lolling. The griffin on the right is swooping over the ground to the attack with his long lithe body extended, and with his hindlegs and tail stretched out behind. The wind produced by the rush of the great wings has blown over the small tree or shrub seen below the animal.

The pyxis is unparalleled in its portrayal of emotion and power. In the words of Emily Vermeule, "no other Mycenaean ivory matches this in its controlled organization of savagery and agony, the simple power of the bodies, the subtle use of landscape like the tree overblown in the rush of the griffin's leap."

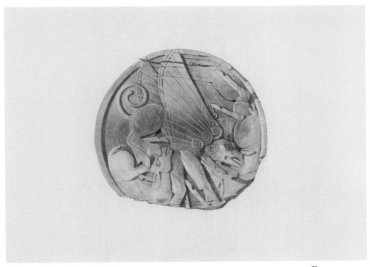

FIGURE 91A

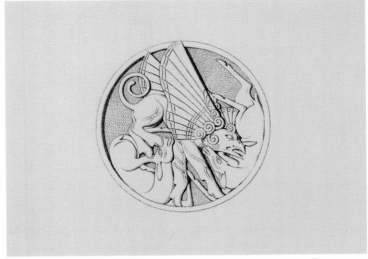

FIGURE 91B

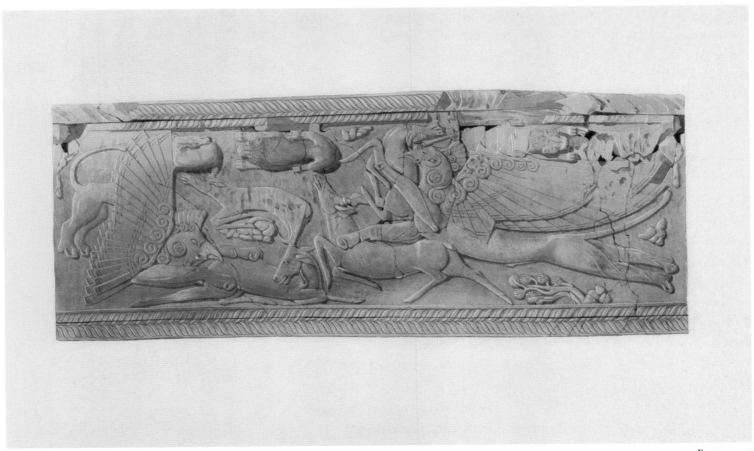

FIGURE 91C

25. A ceramic vessel in the shape of a copper vase (Fig. 92)

P 15239 (Painting no. 61)
Late Helladic IIIA1
Found in the "Tomb of the Ivory Pyxides," May 26, 1939
Height: 0.26; diameter: 0.17
Shear 1939a, p. 582, figs. 7, 10; Shear 1940, p. 281, fig. 21, p. 280, fig. 17; Immerwahr 1966, p. 393, no. 53; *Agora* XIII, p. 163, no. I-4, pls. 30, 67; Åström and Jones 1982; Jones 1986, p. 573; for discussion of type, see Furumark 1941, p. 20.

Ceramic vessels were often crafted to resemble metal vases. Unlike ceramics, vessels made of metal were valued commodities, and many Greek pottery shapes derive from metal prototypes. The bodies of the metal vases were made of one or more metal sheets riveted together, and the neck, rim, and base were then added to the body using a rib both to conceal the joint and to strengthen the vase. Ceramic versions of these metal vases are characterized by features such as clay rivets, a central spine on the handle(s), and neck and base rings. Usually undecorated, they sometimes have a highly lustrous gloss designed to mimic the shine of a metal vessel, and they are commonly found in a burial context.

The amphoroid beaked jug illustrated here is one of the finest examples of its kind. Several vessels of this form have been found in the Argolid and elsewhere in Attica, but this one is exceptional for its large scale and lustrous glaze. Its form resembles a Minoan copper vase found in the Tomb of the Tripod Hearth at Knossos. Shear wrote the following description when he published the vessel in 1940: "[I]t is covered with a lustrous red glaze but is otherwise undecorated. This fact, taken in connection with its shape and with the raised rim about the base of the neck, indicates that the shape is derived from a metal prototype." This point is generally agreed upon, but Furumark believed that the vessel form was originally ceramic and gained a metallic appearance over time. There has been much disagreement, however, over where this particular vessel was produced. Some scholars argue that it was made in the Argolid, while others favor a Cypriot origin.

FIGURE 92

26. A CHILD'S GRAVE (FIG. 93)

P 21307 (Painting no. 342)
Late Helladic IIB
Found in the "Lily Bowl Grave" (N 7:2)
Height: 0.10; diameter: 0.14
Talcott 1951, p. 225; Thompson 1952a, pl. 26c; *Agora* XIII, p. 206,
 no. XVI-4, pl. 47; *Agora* XIV, p. 4, pl. 16a.

In 1951, a small pit grave containing the burial of a child was found not far from the south bank of the Eridanos River. It is among the earliest Mycenaean burials at the Athenian Agora (Late Helladic IIB), and it is remarkable for its wealth of offerings in a single interment. Skeletal analysis revealed a child of about one and a half years at death. The body was surrounded by ten vases, a necklace with a gold pendant, an ivory comb and pin, and a collection of seashells. Among the vases was a splendid bowl decorated with lilies, which gave the burial its name—the "Lily Bowl Grave." Given the kinds of grave goods that accompanied the burial, it is likely that the child was female. The richness of the burial offerings also suggests that the child came from an aristocratic family. In *Agora* XIII, Sara Immerwahr noted that the wealth and spaciousness of the tomb were reminiscent of the shaft graves of Mycenae, particularly those found in the prehistoric cemetery below the Lion Gate.

The vase illustrated here was found at the head of the grave. It is a miniature three-handled jar, which is decorated with double axes and stylized plants that resemble reeds or grasses. Today nearly all traces of the decoration have vanished (Fig. 94). The double axe and reeds of Piet de Jong's reconstruction, made soon after excavation, are barely visible on the surface of the jar today. Both of these motifs are commonly found on vessels of this shape and have early Minoan parallels. Unfortunately, so little of the original decoration exists that it is difficult to know with certainty what the vase looked like in antiquity, but we have de Jong's reconstruction, which helps us visualize what the vessel might have looked like when it was laid to rest with the child.

FIGURE 93

FIGURE 94

27. THE CASE OF THE MISSING STIRRUP JARS (FIG. 95)

P 15070 (Painting no. 27)
Late Helladic IIIA2
Disturbed tomb with cist grave, N 21:5; May 13, 1939
Height: 0.11; diameter: 0.113
Shear 1939b, p. 587, fig. 17; Shear 1940, p. 291, fig. 33; *Agora* XIII,
 p. 170, no. II-1.

The stirrup jar is usually considered the most characteristic My-cenaean vessel shape. It is derived directly from Minoan prede-cessors. The Minoan form first appeared as a version of the tall amphoroid jar, but with several differences: the addition of han-dles, a spout, and a false mouth. Over time it developed a low ovoid shape, and by the Late Minoan period it became the most common vessel shape and its popularity continued with the My-cenaeans. By Late Helladic IIIB there were four types of stirrup jars in use: squat, conical, piriform, and rounded. The smaller ones are often found in tombs, and were commonly used for holding perfumed oil. The larger ones, usually associated with domestic contexts, were used for the storage of wine as well as oil. Since the form has a small spout, it was ideally suited as a container for precious liquids; it was easily plugged for transport and it allowed only a small flow of liquid when used. During the Late Helladic period, a time in which there was significant com-mercial expansion overseas, they were frequently used to trans-port wine, perfumed oil, and unguents. What is most interesting about the stirrup jars from the Agora is their paucity; since the commencement of the excavations only three complete vessels and four fragmentary examples have been found.

The one illustrated by Piet de Jong was found among sev-eral fragmentary vessels in a badly disturbed chamber tomb. It is of the globular type and is decorated with zones of broad and narrow bands on the body and hand-drawn concentric quarter circles around the top. In her attempt to come to grips

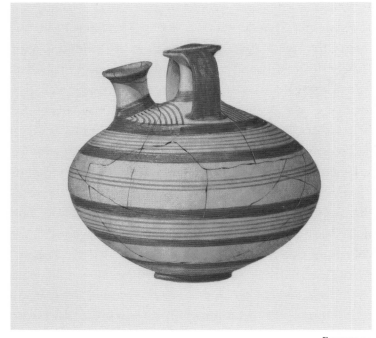

FIGURE 95

with the small number of stirrup jars in the area of the lat-er Athenian Agora, Sara Immerwahr argued that this was a matter of chronology. Most of the Agora tombs date to Late Helladic II–IIIA1, which is when the alabastron was the most popular vessel shape. The popularity of the stirrup vase rose dramatically during Late Helladic IIIA2, with the increase in commercial expansion. Consequently, we find many alabastra at the Agora but few stirrup jars.

The Athenian Agora from the End of the Bronze Age through the Protoattic Period

John K. Papadopoulos

28. Three Final Mycenaean pots from the northwest slope of the Acropolis (Figs. 96a–c)

P 17315, P 17316, P 17326 (Painting nos. 362, 363, 364)
Final Mycenaean
Well U 26:4
Height: P 17315: 0.405; P 17316: 0.378 (as restored); P 17326: 0.180
P 17315: Smithson 1982, p. 153, pl. 22b; the others unpublished;
 compare Smithson 1977; Rutter 1978.

The two hydriai and the oinochoe with trefoil mouth come from the latest well (U 26:4) on the northwest slopes of the Acropolis prior to the 6th century B.C., just east of the so-called Paved Court behind the Klepsydra, the remarkable spring that served Athens for centuries. This was a very large deposit that contained residual material dating back to the Neolithic period, though the latest pottery was consistently of the latest stages of the Mycenaean period. Although normally referred to as Submycenaean, this stylistic phase is largely defined on the basis of material from graves (such as tomb D 7:1; see no. 29), of which there are about 150 or so in or near Athens, that usually contain no more than a few pots. Nonfunerary deposits of the period, such as well U 26:4, are rare and often yield a range of pottery types that do not occur—or are not preserved—in tombs. As the lower chronological limit of this deposit approaches, if not overlaps, the earliest Protogeometric, a number of scholars have suggested that the application of the term Submycenaean to domestic deposits becomes redundant and some, such as Jeremy Rutter, have gone as far as to plea for its abandonment altogether. Whatever the final verdict, our picture of the last years of the Late Helladic IIIC period in Athens, as the late Evelyn Smithson cogently remarked, "may not be entirely fair, and to some extent it may be of our own creation, since we have tended to emphasize its poor and drab aspects and to assign what is good and experimental to a later 'Earliest Protogeometric' phase. It is hard to imagine that a totally bankrupt industry could have been the first to progress to the Protogeometric style."

As the person originally responsible for publishing these three pots, Smithson was not totally satisfied with Piet de Jong's watercolors of them, and she scribbled in light pencil a series of amendments directly onto the watercolor paper of all three illustrations, such as: "thicken lip," "trefoil too pronounced," "?," and so on.

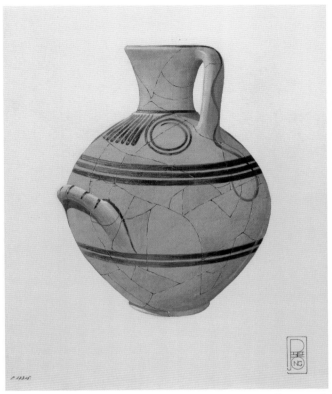

FIGURE 96A

FIGURE 96B

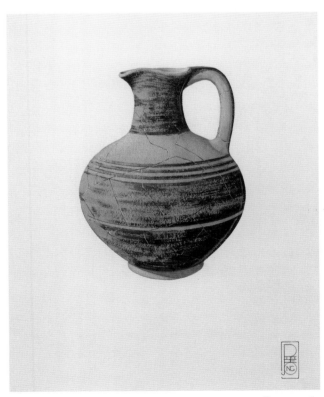

FIGURE 96C

29. A Submycenaean tomb (Figs. 97a, b)

P 7234, P 7235 (Painting nos. 21, 22)
Submycenaean
From a child inhumation pit grave on the Kolonos Agoraios,
 tomb D 7:1
Height: P 7234: 0.134; P 7235: 0.094
Shear 1937a, pp. 364, 366, fig. 28; Shear 1936b, p. 191, fig. 4;
 Kerameikos I, p. 132 ("ein spätmykenisches Grab"); Furumark
 1941, p. 606, form 38, no. 137, 5a; p. 635, form 80, no. 286, 3;
 Desborough 1952, pp. 46–47, 77; Mountjoy 1986, p. 306, form 38,
 no. 137, 5a.

These two pots were found in the same child inhumation pit tomb dug deep into bedrock immediately to the north of the later temple that has come to be known as the Hephaisteion (Fig. 98). Being well sealed, the tomb escaped the attention of later builders on the Kolonos Agoraios. Within the tomb the body of a young child was laid out in what was probably a fully extended supine position, oriented with the head to the east-southeast. The oinochoe was found placed on its side, mouth to the east, on the left side of the cranium of the deceased; the skyphos, more or less upright, was placed on the right side of the cranium and slightly behind it; there were no other offerings in the grave. Both pots are typical of the style generally referred to as Submycenaean, although some scholars prefer the term Final Mycenaean. The absolute chronology of Submycenaean has varied between 1075/50–1025 B.C., while some specialists argue for an initial date of ca. 1125/1100 B.C. and others 1060/40–1020/00 B.C. or slightly later. The light-colored and rather heavy fabric of the oinochoe is typical for this early period and contrasts with the redder fabric of Athenian pottery of later periods, such as that of the Early Geometric, Archaic, and Classical periods. The central shoulder of the oinochoe is decorated with an antithetic spiral pattern (Furumark motif 50), framed on either side by a tassel or necklace pattern (Furumark motif 72). The fabric of the skyphos, which is slightly different from that of the oinochoe, is also typical of Athenian pottery of this period. It is largely on the basis of tombs such as this that the Submycenaean style has been defined.

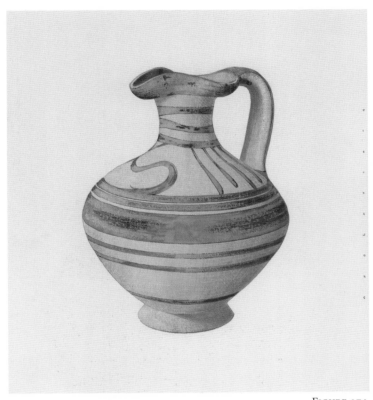

FIGURE 97A

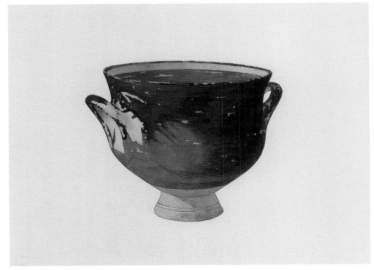

FIGURE 97B

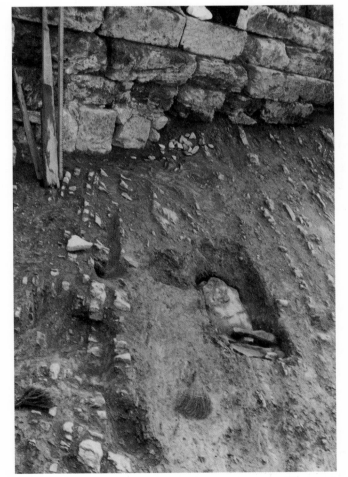

FIGURE 98

30. "WILD-STYLE" AMPHORA (FIG. 99)

P 7692 (Painting no. 365)
Final Mycenaean/Submycenaean
Cinerary urn and only pot in cremation tomb D 6:3
Preserved height (base to lower neck): 0.410
Unpublished.

Although very poorly preserved, this is one of the largest and most remarkable surviving vessels of the pre-Protogeometric period. The amphora has been variously dated by experts visiting the Athenian Agora anywhere between Late Helladic IIIC Middle through Submycenaean. Joining fragments preserve only about half the vessel, the profile complete from the base, except for the inner circle of the foot, through the lower neck. There are numerous nonjoining fragments, as well as many tiny flakes and chips, the original position of which cannot be established. It appears that the clay was probably poorly wedged at the time of manufacture so that it tended to splinter and flake in horizontal laminae. The distinctive decoration consisting of freehand circles and semicircles anticipates Vincent Desborough's "wild style," a term coined for a group of idiosyncratic large vessels of the earliest stages of the Protogeometric period. The fact that the vessel was the only pot in the tomb does not assist dating. The side of the amphora illustrated by Piet de Jong is very much a reconstruction. There are two and a half preserved sets of freehand circles, with space originally for five on the belly. The two sets at the side are decorated with what may be described as a "Mycenaean shield core," perhaps even a "proto-Dipylon shield." The central set is decorated with a quatrefoil core or "Maltese cross." The shoulder is decorated in zones framed by bands, including freehand sets of semicircles, each with a solid half-moon core, and an outer arc fringed with dots. The upper decorated band consists of a row of reserved dogtooth pattern, decorated with receding or diminishing chevrons or triangles, the latter not shown by de Jong: this is one of the very few vases in which the artist omitted a detail, albeit a minor one.

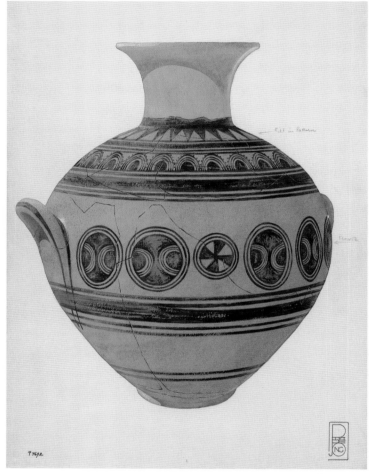

FIGURE 99

31. Palming it off onto a dead relative (Figs. 100a, b)

P 10582, P 7075 (Painting nos. 92, 67)
Submycenaean (P 10582), Developed Protogeometric (P 7075)
Pots deposited in tombs M 16–17:1 (P 10582) and C 11:2 (P 7075)
Height: P 10582: 0.155; P 7075: 0.158
P 10582: Papadopoulos, Vedder, and Schreiber 1998, p. 516, fig. 7.
P 7075: Papadopoulos 1998, p. 116, n. 41 (mentioned).

These two lekythoi are of similar size, shape, and decoration, down to details such as the fact that both have small airholes to the right of their respective handles. The primary difference between the two is that one has hand-drawn concentric semicircles, the other mechanically drawn semicircles made with a pivoted multiple brush. Piet de Jong has carefully rendered the hand-drawn as opposed to mechanically drawn semicircles on the curved surface of the two pots in a perspective that would be the envy of any draftsperson. Despite their similarity to one another, the two lekythoi are separated in time by a period of fifty to one hundred years, depending on how one dates Submycenaean in the conventional chronology, a fact that leads to all sorts of questions about the validity of this chronology. The earlier, Submycenaean lekythos (Fig. 100a) was found in a tomb on the north slope of the Areiopagos, an ancient burial ground that began in the Mycenaean period and continued with no break through various stages of the Geometric period, whereas the later lekythos (Fig. 100b) was found with five other pots in a Developed Protogeometric burial on the Kolonos Agoraios. This latter lekythos is of particular interest because of the damage caused to its rim, probably during the firing in the kiln, at which time the mouth was twisted on one side of the vessel and sprang out of shape. Had the rim and neck been found as a fragment, the piece might well qualify as a waster or production discard, but the damage is minor and the pot eventually made its way among the offerings of what was probably the burial of a child. Three of the other pots deposited in the same tomb were a sad lot of damaged seconds palmed off on a dead relative. This pot, among many others, serves to illustrate that potters were not averse to salvaging damaged vases and then selling them either to unsuspecting customers or to more demanding clients at a discount.

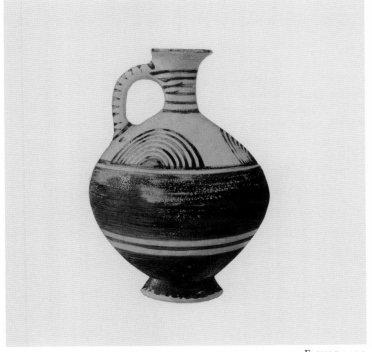

FIGURE 100A

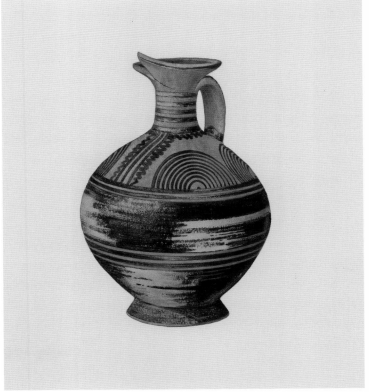

FIGURE 100B

32. TECHNICAL INNOVATIONS AT THE DAWN OF THE PROTOGEOMETRIC PERIOD (FIGS. 102A, B)

P 8041, P 3169 (Painting nos. 285, 55)
Late Protogeometric
Cinerary urns in tombs C 9:13 and E 12:1
Height: P 8041: 0.347; P 3169: 0.255
P 8041: Unpublished; mentioned in Desborough 1952, pp. 28–29, 95.
P 3169: Camp 1986, p. 29, fig. 13 (right); for the pivoted multiple
 brush, see Papadopoulos, Vedder, and Schreiber 1998.

These two closed vessels—the amphora (Fig. 102a) serving as the cinerary urn for its tomb, the oinochoe (Fig. 102b) as an offering—typify Athenian painted pottery of the Late Protogeometric period. The tombs from which they derive (tombs C 9:13 and E 12:1) were both on the Kolonos Agoraios; the former is a standard Athenian "trench-and-hole" cremation, the latter probably from a disturbed inhumation tomb. The Protogeometric period is often heralded as one of technical innovations, of which the most important has always been considered the use of a "multiple brush compass" to paint the characteristic concentric circles and semicircles, such as those on P 3169. Although it is now clear that the device was not a pair of compasses, the circles were drawn mechanically with what may be termed a pivoted multiple brush (Fig. 101). From the uppermost of the shoulder bands on P 3169 spring four sets of concentric semicircles, some of which alternate with crosshatched triangles. Each set of mechanically drawn concentric semicircles is made up of six arcs with a checkerboard core. The pivot point in each set is located on the horizontal band below, which would have served as a guidance line. Piet de Jong has not only carefully rendered the semicircles and checkerboard pattern in perspective, but he has indicated the pivot point for the fully visible set, which is covered over by the paint of the checkerboard. Another technical innovation that can be traced no earlier than the Protogeometric period is the use of potters' test pieces to gauge the correct firing of the pots and to ensure that the three-stage firing of painted pottery—oxidization, reduction, and reoxidization—was complete. The purpose of the three-stage firing and testing the progress of the kiln was to achieve a good black, which, in the best of cases, resulted in a good glossy surface or lustrous sheen, such as that rendered by de Jong for both vessels, especially P 8041.

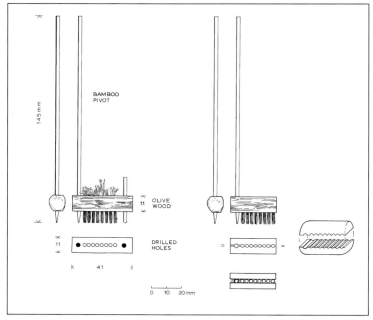

FIGURE 101

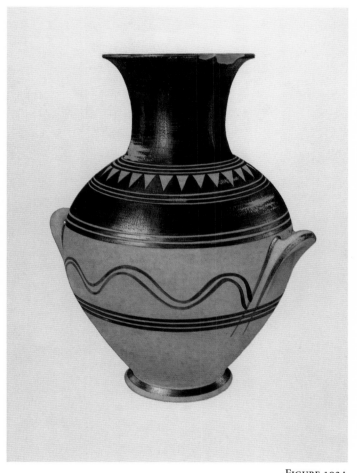

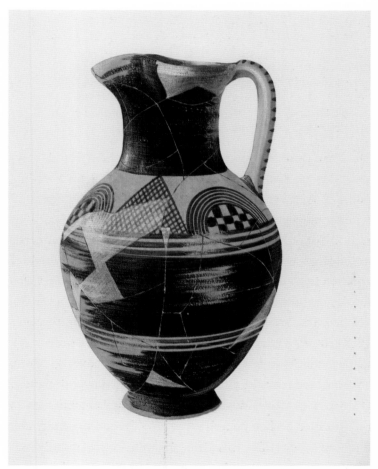

FIGURE 102A

FIGURE 102B

33. Semicircles and hatched triangles on small Early Iron Age closed vessels (Figs. 103a–c)

P 6686, P 6836, P 5863, P 5868 (Painting nos. 64, 68, 66)
Developed–Late Protogeometric
Offerings in child inhumation graves C 9:11, C 11:4, and F 9:1
Height: P 6686: 0.188; P 6836: 0.109; P 5863: 0.154; P 5868: 0.128
 (to lip), 0.162 (to top of handle)
P 6686: Shear 1936b, p. 193, fig. 7; Shear 1937a, p. 368, fig. 31;
 Desborough 1952, pp. 43, 223, pl. 114.
P 6836: Shear 1936b, p. 192, fig. 6; Shear 1937a, p. 367, fig. 30;
 Thompson 1976, p. 228; Camp 1990, p. 227; mentioned in
 Desborough 1948, p. 264; Desborough 1952, pp. 62, 66, 227;
 Smithson 1961, p. 170, under no. 53.
P 5863: Shear 1935a, p. 442, fig. 4; Shear 1936a, p. 24, fig. 22;
 mentioned in *Kerameikos* IV, p. 20, n. 18; Desborough 1952,
 pp. 72, 74, 85; Smithson 1961, pp. 161–162, under no. 26.
P 5868: Shear 1935a, p. 442, fig. 4; Shear 1936a, p. 24, fig. 22;
 Hafner 1952, p. 12, under pl. 46, no. 1.

The small closed vessels assembled together here include a hydria (P 6686, Fig. 103a), what is often referred to as a feeding bottle (P 6836, Fig. 103b), a lekythos (P 5863, Fig. 103c, left), and a trefoil oinochoe with high-swung handle (P 5868, Fig. 103c, right). Not only are these fairly standard vessels encountered as offerings among the Early Iron Age inhumation burials of children in the area of the Classical Athenian Agora, they also display the most characteristic decorative elements of the developed and later Protogeometric period (roughly the later 10th century B.C. according to the conventional chronology), namely mechanically drawn semicircles (P 6686, P 5863), crosshatched triangles (P 5868, P 6836), and dogtooth pattern (P 6836, Fig. 103b), as well as less common elements such as the so-called branch pattern separating the sets of semicircles on P 5863 (Fig. 103c, left). The perspective—masterfully manipulated—Piet de Jong has exploited to illustrate these pots also permits a clear view of the handle decoration, which is in some cases laddered (P 6686) and sometimes barred (P 5863, P 5868), while the lower handle attachment is often, though not always, ringed. Small pots such as these are sometimes found in adult graves as well, particularly the lekythos, which is among the most popular Athenian shapes of the Early Iron Age deposited in tombs. The lekythos, variously modified, endured as the funerary vase par excellence in Athens well into the Classical period (see Chapter 9).

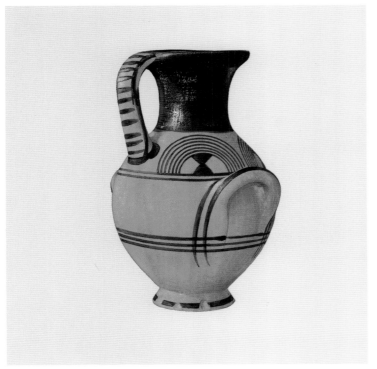

FIGURE 103A

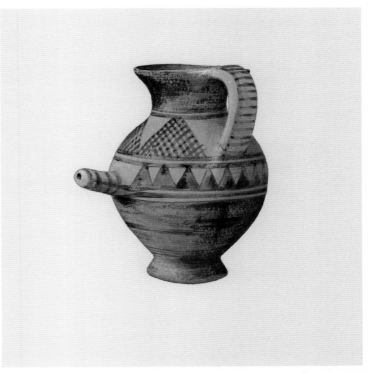

FIGURE 103B

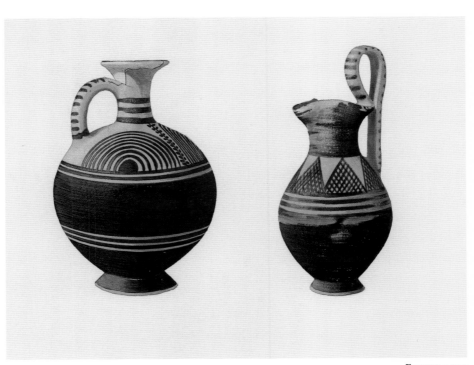

FIGURE 103C

34. A PARTING TOAST TO THE DEAD? (FIGS. 104A–D)

P 1045, P 9324, P 3171, P 7074 (Painting nos. 33, 32, 65, 62)
Various contexts ranging from Developed through Late Protogeo-
 metric/Early Geometric
Offerings in Early Iron Age tombs C 11:2 (P 7074), E 12:1 (P 3171),
 and M 17:2 (P 9324); debris in well H 16–17:1 (P 1045)
Height: P 1045: 0.157; P 9324: 0.113; P 3171: 0.129; P 7074: 0.109
P 9324: Shear 1937b, p. 179, fig. 2; *ILN* September 11, 1937, p. 432,
 fig. 17.
P 3171: Camp 1986, p. 29, fig. 13; the remainder unpublished
 though many are mentioned in Desborough 1952, pp. 82–86;
 C. W. Blegen 1952, p. 285.

The skyphos on a tall conical, or sometimes flaring, foot is the most common drinking vessel of the Protogeometric period. The examples assembled here are typical in terms of shape and decoration for the period ranging from Developed Protogeometric through Late Protogeometric/Early Geometric I. In terms of decoration, P 1045 (Fig. 104a) is a classic example of a "circles" skyphos, with mechanically drawn concentric circles flanking a crosshatched panel. Similar panels, alternating with checkerboard panels, are found on P 3171 and P 7074 (Figs. 104c, d), which are not only contemporary but so similar to one another in shape and decoration that it is plausible that they are by the same potter. The dark-ground system of decoration on P 9324 (Fig. 104b), with a zigzag framed by bands, is standard for the later stages of Protogeometric. With the exception of P 1045, these skyphoi were all deposited in tombs. Various interpretations have been put forward for the appearance of drinking and eating vessels in or near the grave, primarily in terms of pottery used in *nekrodeipna* or funerary feasts, but also for libations poured for the dead—a sort of "farewell toast," sometimes to appease the "thirst of the dead"—*la soive de la mort*—and, in certain contexts, associated with a continued cult for the dead. The fact that numerous such vessels are found discarded among domestic or industrial debris in abandoned wells in the area of the later Athenian Agora shows that they appeased the thirst of the living as much as they did for the dead.

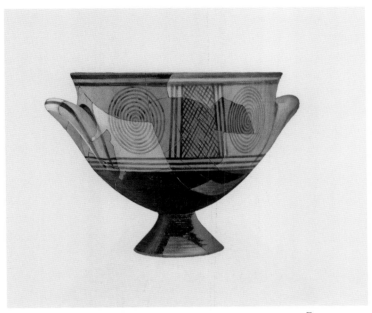

FIGURE 104A

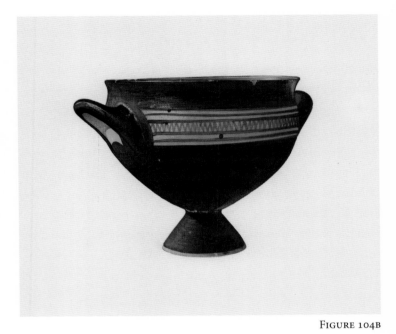

FIGURE 104B

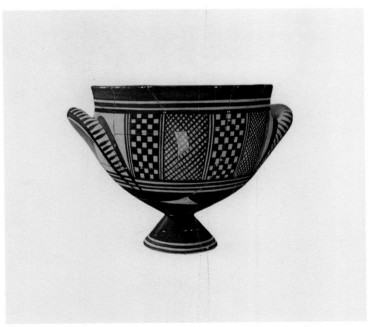

FIGURE 104C

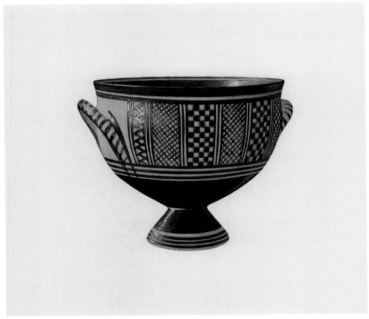

FIGURE 104D

35. Sometimes an Ash Urn, Sometimes a Well Pot (Fig. 105)

P 3747 (Painting no. 69)
Early Geometric II
From the fill of well H 15:1
Height: 0.325
Unpublished; briefly noted in C. W. Blegen 1952, p. 282; Marwitz
 1959, p. 95; Coldstream 1968, p. 16.

The complete or near complete state of preservation of many of the best-known Early Geometric neck-handled amphoras is the result of their having been used to contain the cremated remains of the deceased in tombs that were dug deep into bedrock. A common rule of thumb that has become enshrined in the literature on Early Iron Age burials largely on the basis of associated grave goods is that neck-handled amphoras were used for the cremated remains of males, whereas belly-handled amphoras were for females. A number of neck-handled amphoras were also found in tombs with iron swords, spearheads, and other weapons, thereby bolstering the interpretation of gender on the basis of associated grave goods. But the biological and social genders of the deceased were not always the same, and a number of more recent anthropological analyses of the actual human remains, particularly from cremation tombs, in Athens and elsewhere in the Greek world have torn apart many of the traditional, neatly constructed notions of sex and gender. These studies have established that certain types of tools, weapons, and jewelry are not gender specific and that there was a good deal of gender-bending in Greek Early Iron Age burials when the focus is only on objects deposited in graves. Many of the same types of pots used as ash urns in tombs were found discarded in Early Iron Age wells in the area of the later Athenian Agora, both in the dumped fill, deposited sometime after the well was abandoned, but especially in the period-of-use deposits. Pots such as P 3747 were specifically used to draw water from wells, and some of them were inadvertently dropped by their owners in the process of procuring water, much to the delight of archaeologists.

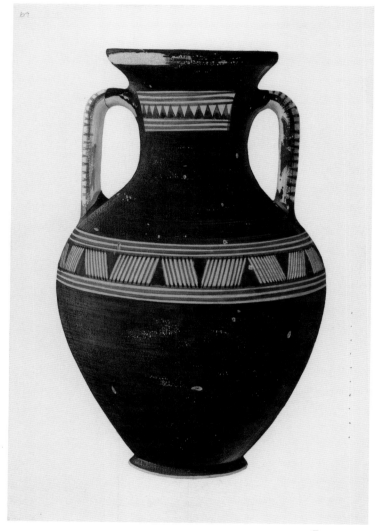

FIGURE 105

36. A BUCKET, BY ANY OTHER NAME (FIG. 106)

P 6163 (Painting no. 300)
Middle Geometric I
From the fill of well L 6:2 (lower deposit)
Height: 0.325
Shear 1936a, pp. 32–33, fig. 32; Papadopoulos 1998.

This vase brings into focus one aspect of pottery production that is rarely discussed: the potter's mistake. P 6163 is one of the most interesting, if not amusing, examples of the common accidents that can befall a potter. It was originally designed as a hydria but was later remodeled, prior to firing, into a krater. Published as a full-fledged and "handsome" krater in an early preliminary report, the vessel is unlike any Athenian krater in captivity and is best described as a bucket. The damage caused to the original closed vessel was probably at the juncture of the shoulder and neck, one part of any large amphora or hydria that was susceptible to damage during the drying phase. But rather than discard the vessel, the potter pared it down to the base of the shoulder, probably with a knife or some similar implement, resulting in a neatly chamfered rim of a type that is otherwise unknown among Athenian Early Iron Age kraters. The interior of the vessel, with prominent wheelmarks more usual on closed rather than open shapes, was then painted solid, except for a small reserved disk at the center of the floor, a feature common to many Athenian open shapes of the period. Sometime later, the bucket was dumped into the lower fill of well L 6:2, some fifty meters to the south of the Eridanos River, dating to Middle Geometric I (ca. 850–800 B.C.). The original type of vessel from which P 6163 is likely to have been cut can be illustrated by a closely related, though somewhat smaller hydria from the German excavations in the Athenian Kerameikos (Fig. 107). It is therefore only fitting that Agora P 6163 is illustrated here in the company of its alter ego—or id—Kerameikos inv. 783.

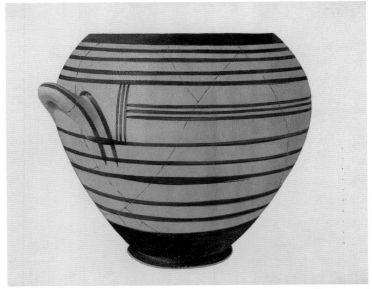

FIGURE 106

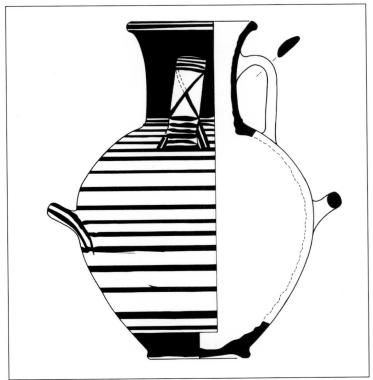

FIGURE 107

37. An imported Oriental glass amulet and the broken promise of chronological fixed points (Fig. 108)

G 53 (Painting no. 231)
Context Middle Geometric I (ca. 850–800 B.C.)
From the fill of well L 6:2 (at a depth of ca. 3.30 m)
Height: 0.019; width: 0.017
Shear 1936a, p. 33, fig. 33; Shear 1935a, p. 442, fig. 6; *ILN* October
 19, 1935, pp. 646–647, fig. 3; Young 1949, p. 427; Hävernick 1968,
 p. 649, no. 1; Papadopoulos 1998, p. 111.

One of the most remarkable imported objects of the Early Iron Age to have been discovered in the area of the Classical Agora is the small glass amulet consisting, on either side, of a female head in relief, facing forward. The hair is a heavy curled mass hanging to the neck, and around the neck there is a double-stranded necklace. Made of dark blue, slightly iridescent glass streaked with white, the neck was pierced with a small conical hole that served as a socket for the attachment of the amulet to its setting. The amulet, originally thought to provide an important chronological "fixed point," led Rodney Young to pen what was to become a classic statement, the force of which is as relevant today as when first made:

> The discovery of imported Egyptian or Oriental objects of the Geometric period in Greece is always a source of great rejoicing, and of hope that evidence is at least in hand from which external confirmation for the chronology of the so-called Greek "dark age" may be adduced. This rejoicing lasts until the experts have been consulted, and have disagreed; then it is time to look around, to pick up the pieces, to re-establish the bona fides of the find in question, and even, perhaps, to try to date it approximately from its Greek context.

Comparanda assembled by Young clearly pointed to a Phoenician origin, but included pieces dating to the 4th century B.C., while others were dated as Roman on the basis of style. In view

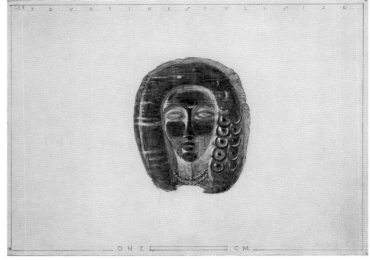

FIGURE 108

of the 4th-century Phoenician dating of a series of related amulets by Hävernick, Lucy Talcott, in a handwritten note in the Agora Archives, questioned the Geometric date of the piece and suggested that it may have been intrusive. Evelyn Smithson, however, remained skeptical, as there was no Classical material in the lower fill of this well. The evidence of context is, in this case, compelling and must take precedence over any date based on style; it indicates that the amulet is no later than Middle Geometric I.

38. A Geometric pyxis lid in the form of a skyphos
(Fig. 109)

P 14818 (Painting no. 82)
Middle Geometric II
Tomb N 21:6
Height: 0.171
Shear 1940, p. 291, fig. 34; Brann 1960, pp. 412–413, no. 3, pl. 91;
 Coldstream 1968, p. 22.

This pyxis lid derives from a disturbed inhumation tomb on the north slope of the Areiopagos. The tomb was originally published by Eva Brann as Late Geometric, but was reassigned by Nicolas Coldstream as the last in his list of significant Attic Middle Geometric II groups. Part of the tomb was placed over the redeposited bedrock filling of the dromos of the large Mycenaean chamber tomb N 21–22:1. In his preliminary report on the tomb, T. Leslie Shear noted that the location of this Geometric burial over the dromos of what is the largest, richest, and, at that time, earliest of the Mycenaean chamber tomb in the area of the later Athenian Agora was probably only a coincidence. The location, however, of tomb N 21:6, well away from other contemporary tombs on the Areiopagos, is now only one of several Early Iron Age tombs sited in direct relationship to Mycenaean graves. And it is clear that Early Iron Age tombs in the area of the Classical Athenian Agora were intentionally located in the same cemeteries as Mycenaean tombs, and sometimes in direct relationship to individual Bronze Age tombs.

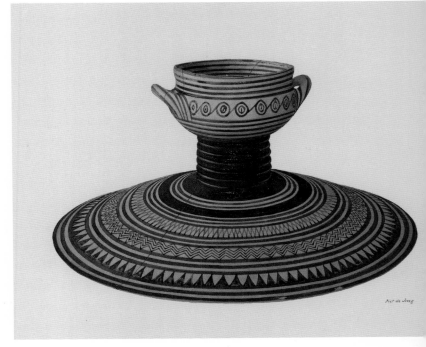

FIGURE 109

The distinctive pyxis lid from tomb N 21:6 has as its "handle" a skyphos of more or less life-size proportions. Geometric lids with "pot handles" are fairly common, though in the majority of cases the handle pot follows the shape of the main pot, such as a miniature bowl pyxis on a bowl pyxis, a flat pyxis on a flat pyxis, and so on. Eva Brann considered Geometric pyxides "dummies" and noted that they must have been made in the spirit in which we are intrigued by infinite mirror images. Life-size lid pots such as the skyphos on P 14818 had actual capacity and may have been used for an extra offering to the dead.

39. HORSE AND BIRD ON A GEOMETRIC KRATER (FIG. 110)

P 6422 (Painting no. 283)
Middle Geometric II
From well L 6:2 (upper deposit)
Restored height: 0.255
Davison 1961, fig. 145; Coldstream 1968, pp. 26–27.

The krater presented here is dated by its context to the later phase of the Middle Geometric period, conventionally 800–750 B.C. This was the time when living creatures—humans, animals, and birds—began to find themselves at home on Geometric pots. In earlier stages of the Protogeometric and Geometric periods such figures are usually cautiously tucked away in irregular spaces either below or beside a handle. By the beginning of Middle Geometric II, however, single animals had established themselves in square metopal panels flanking the main area of linear geometric design. As Coldstream once stated, as "the figures become more prominent, so their drawing gains in confidence." As for the horse on P 6422, there is a growing interest in anatomy, as Coldstream elaborates: these are "horses that have at last become creatures of flesh and blood. The frame of the body is more substantial; head and hooves are rendered with care that presages the Dipylon Master." Marsh birds, as Coldstream refers to them, such as the one under the handle of our krater, make their first appearance at this time in Middle Geometric II and, like the horses, are drawn with an economy of detail. Although it is hardly possible to recognize any particular species with confidence at this time, this has not dissuaded scholars from speculation. The characteristic hatching of the bird begins to take over from the silhouette variety, and by Late Geometric I it is preferred, thus allowing the birds, as Coldstream has cogently noted, "to be absorbed into the half-tone linear decoration without attracting too much attention to themselves." The horse and the bird, together with the human figure, define the experiment in representational drawing that was the hallmark of Greek Geometric art.

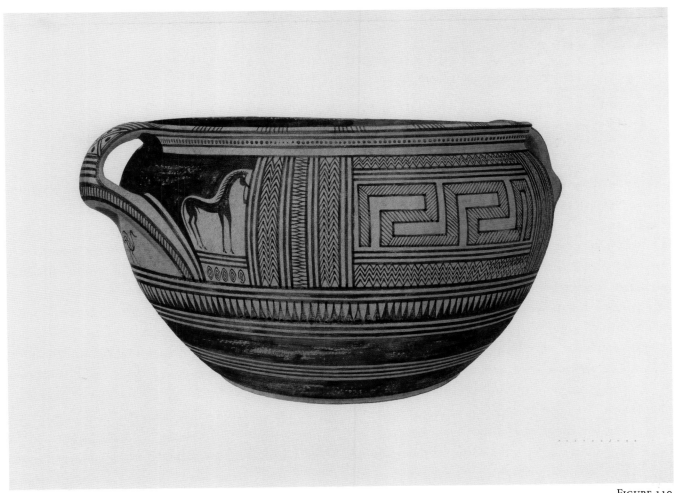

FIGURE 110

40. POURING WINE FOR THE LIVING AND THE DEAD
(FIGS. 111A–D)

P 552, P 15122, P 532, P 12104 (Painting nos. 45, 107, 288, 104)
Various contexts ranging from Middle Geometric I through Late
 Geometric
Offerings in Early Iron Age tombs I 18:3 (P 552), E 19:3 (P 15122),
 and pottery from well S 18:1 (P 12104) and votive deposit H 17:4
 (P 532)
Height: P 552: 0.317; P 15122: 0.215; P 532: 0.245 (as preserved);
 P 12104: 0.280
P 552: Smithson 1974, p. 362, no. I 18:3-1, pl. 78a.
P 15122: Shear 1940, p. 271, fig. 7; Brann 1960, p. 404, no. 1, pl. 89;
 Agora VIII, p. 60, no. 249, pl. 14; Coldstream 1968, p. 32, no. 37,
 pl. 7b, c.
P 532: Burr 1933, pp. 548, 557, 559, no. 37, figs. 7, 18; *Agora* VIII,
 p. 35, no. 40, pl. 4.
P 12104: Shear 1939a, p. 227, fig. 21; Brann 1961a, p. 119, no. L 10,
 pl. 14; *Agora* VIII, pp. 35–36, no. 43, pl. 4.

The oinochoe, which takes its name from the Greek word for wine, οἶνος, is the primary pouring vessel in the repertoire of pottery during any phase of the Early Iron Age. During the later stages of the Mycenaean period a distinctive trefoil mouth, which facilitated pouring, was developed (see Figs. 96c, 97a) and continued to be used throughout the Protogeometric and Geometric periods and beyond. The oinochoai assembled here date from Middle Geometric I (P 552, Fig. 111a) through various stages of Late Geometric (P 15122, P 532, P 12104). The common panel decorated with zigzags on the neck of the earlier P 552 is replaced, shortly after 750 B.C., by the panel containing a single grazing deer on P 15122 (Fig. 111b). The bold but elegant simplicity of rendering the animal, together with the distinctive filling ornaments and the manner of framing the scene with geometric patterns, is characteristic of the Dipylon Workshop, and the oinochoe is listed by a number of scholars as a classic example of the smaller work of this celebrated workshop. During the Late Geometric period the oinochoe became a vehicle of innovation in both shape and decoration, as both P 532 (Fig. 111c) and P 12104 (Fig. 111d) testify. Although the neck of P 532 is not preserved, it can be confidently reconstructed with a tall neck, as Piet de Jong anticipated. The numerous registers of geometric ornament separated by bands on P 532 contrasts with the sparser decoration of the so-called circles oinochoe, P 12104, but both jugs come out of the same potters' quarter in Athens. Oinochoai such as these are as common in graves (e.g., P 552, P 15122) as they are in wells (e.g., P 12104), and a few like P 532 derive from the small oval structure once thought to be a "Geometric House." The variety of their contexts points to the fact that they were used for different functions—funerary, domestic, cultic—and that these pouring vessels served the needs of the living as much as they did the dead.

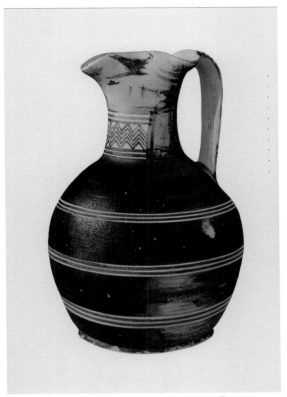

FIGURE 111A

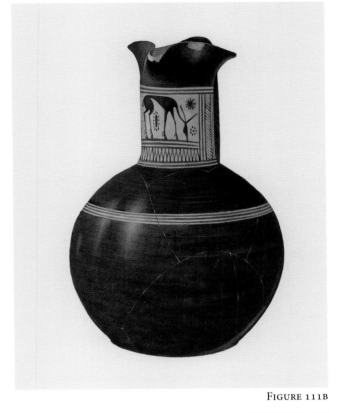

FIGURE 111B

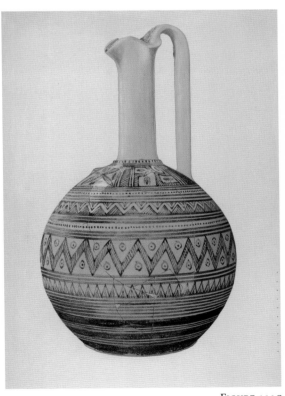

FIGURE 111C

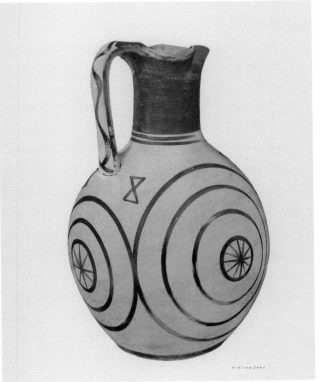

FIGURE 111D

41. "DIXIE CUPS" OF THE ANCIENT MEDITERRANEAN
(FIGS. 112A–D)

P 3748, P 5071, P 5073, P 4776 (Painting nos. 30, 3, 20, 87)
Various contexts ranging from Early/Middle Geometric through
 Late Geometric
Pottery from well (P 3748) and offerings in tombs G 12:17 (P 5071,
 P 5073) and G 12:8 (P 4776)
Height: P 3748: 0.099; P 5071: 0.050; P 5073: 0.070; P 4776: 0.077
P 3748: unpublished.
P 5071, P 5073: Shear 1936a, p. 31, fig. 30; R. S. Young 1939, p. 80,
 nos. XVII 1 and 2, fig. 54; *Agora* VIII, p. 61, nos. 262, 260, pl. 15;
 Coldstream 1968, pls. 9c, a; Travlos 1971, p. 14, fig. 15.
P 4776: R. S. Young 1939, p. 96, no. XX 3, fig. 67; for "Dixie cups,"
 see Saltz 1978.

The term "Dixie cup of the eastern Mediterranean" was coined by Daniella Saltz to refer to the distinctive pendent semicircle skyphos produced in Macedonia and in the *koine* comprising Euboia, Thessaly, and the Cyclades and found in many parts of the eastern and central Mediterranean in the Early Iron Age. The term can also be applied to a series of Athenian Geometric skyphoi, particularly those of the Late Geometric period, which, although not as ubiquitous as their pendent semicircle counterparts, are nevertheless found in varying quantities outside Athens. The shape and straightforward decoration of P 3748 (Fig. 112a) is typical of an earlier phase of the Geometric period. The three Late Geometric skyphoi derive from tombs, two of them from the same grave. Of these P 5071 (Fig. 112b) is a classic example of a chevron skyphos, P 5073 (Fig. 112c) a meander skyphos, and P 4776 (Fig. 112d) a rosette skyphos. Chevron and meander skyphoi in particular were also produced in a number of regional workshops throughout the Greek world and were often exported. Indeed, well-glazed Greek pots such as these were popular in the Mediterranean and usually stand out against the local products of various indigenous, non-Greek cultures. They may have been carried by Greek, Phoenician, and other merchants, and indeed a number of shipwrecks have furnished clear evidence that pottery cargo loads were quite varied, often carrying examples from different workshops in Greece.

FIGURE 112A

FIGURE 112B

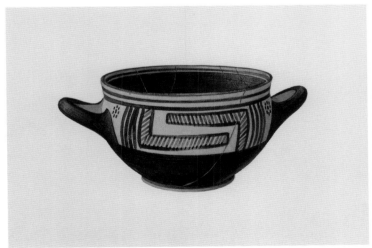

FIGURE 112C

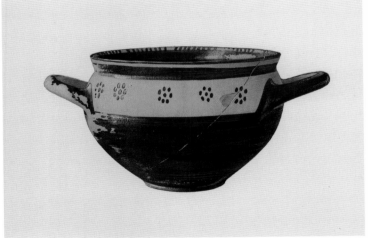

FIGURE 112D

42. KANTHAROI (FIGS. 113A–D)

P 4775, P 15124, P 5421, P 579 (Painting nos. 85, 73, 109, 57)
Late Geometric to Protoattic
Offerings in tombs G 12:8 (P 4775), E 19:3 (P 15124), and G 12:24
 (P 5421); Protoattic votive deposit H 17:4 (P 579)
Height (to rim): P 4775: 0.144; P 15124: 0.132; P 5421: 0.104; P 579:
 0.116
P 4775: R. S. Young 1939, p. 96, no. XX 4, fig. 67; *Agora* VIII, p. 52,
 no. 171, pl. 10.
P 15124: Shear 1940, p. 271, fig. 7; Brann 1960, p. 406, no. 6, pl. 89.
P 5421: R. S. Young 1939, pp. 47–49, no. XI 5, fig. 32; *Agora* VIII,
 p. 52, no. 173, pl. 10.
P 579: Burr 1933, pp. 589–592, no. 204, figs. 55, 56.

In addition to the skyphos, another popular drinking vessel in Geometric Athens was the kantharos. Although different types of kantharoi are known throughout the various phases of the Early Iron Age, the distinctive form with high-swung handles, such as the examples assembled here, first appears in the Athenian repertoire in the second quarter of the 8th century B.C. during the Middle Geometric II phase. Ancestors of the shape in Attica include Minyan goblets, and a number of Mycenaean open vessels with high-swung handles are reminiscent of the later shape. The earlier kantharoi with high-swung handles such as P 4775 and P 15124 (Figs. 113a, b) have a short, upright rim not strongly marked off from the body; they tend to be wider and rather full-shouldered in comparison to later examples. Sometime around 725 B.C. a number of kantharoi, such as P 5421 (Fig. 113c), lack the upright rim, but have instead a shape characterized by a drawn-in effect, which Eva Brann compared to a tulip flower. Contextually, Middle Geometric II and Late Geometric kantharoi are found in both graves and well deposits, whereas in the Protoattic period they do not occur much in household deposits but seem to have been used mostly as votives. A classic case is the 7th-century B.C. fragmentary kantharos (P 579, Fig. 113d) decorated in two zones over rays from the so-called Protoattic votive deposit published by Dorothy Burr in 1933. The side of the kantharos illustrated by Piet de Jong—the rim decorated with crosses and small filling triangles, the body with birds' heads and necks—shows only too clearly the breakdown of the Geometric tradition in the early Orientalizing period.

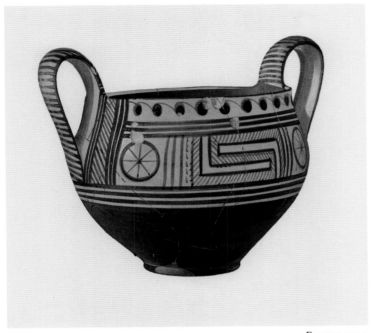

FIGURE 113A

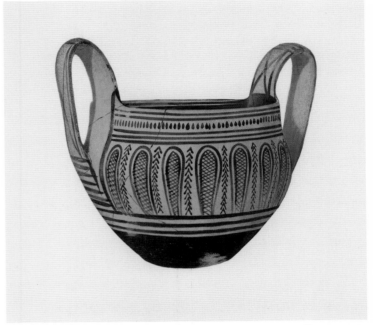

FIGURE 113B

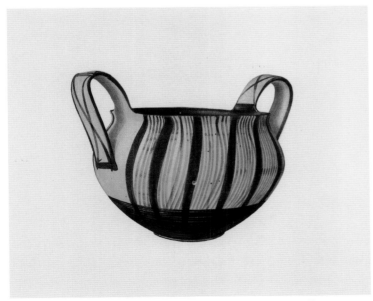

FIGURE 113C

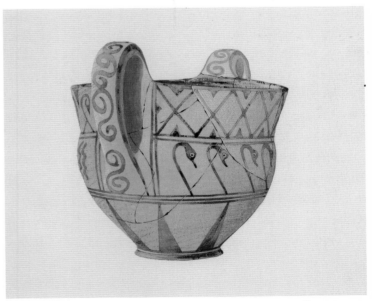

FIGURE 113D

43. Symbols of souls and scenes of the dead on Geometric amphoras (Figs. 115a, b)

P 5423, P 4990 (Painting nos. 270, 108)
Late Geometric
From tombs G 12:24 (F 12:2) and G 12:19
Height: P 5423: 0.373; P 4990: 0.327
P 5423: R. S. Young 1939, pp. 46–47, no. XI 1, fig. 32; *Agora* VIII,
 p. 31, no. 8, pl. 1; Lamberton and Rotroff 1985, p. 24, fig. 46.
P 4990: Shear 1936a, p. 28, fig. 26; R. S. Young 1939, pp. 55–57,
 no. XII 1, figs. 37, 38; *Agora* VIII, pp. 31, 69, no. 12 (336), pls. 1, 19.

The amphora P 5423 (Fig. 115a), dating to the third quarter of the 8th century B.C., was one of several pots placed near the feet of the deceased in tomb G 12:24 [F 12:2] (Fig. 114), an inhumation burial in the Geometric Grave Precinct near the later Tholos. The distinctive amphora with applied snakes on the rim, shoulder, and handles, P 4990 (Fig. 115b), was burned as part of what was thought to be a "sacrificial pyre" in the same cemetery; it dates to the last quarter of the century. On P 5423 a row of birds proceeds solemnly in single file in two registers around the pot. Often referred to in Greek Geometric art as a decorative—or sometimes filling—motif, the bird enjoys a long history on Greek painted pottery from the Bronze Age through the Early Iron Age and into later periods. In the Geometric period birds can appear in single panels or metopes (see no. 53, Fig. 129a), or in rows around a vessel. The long history of the bird as a symbol of the soul suggests that on grave gifts such as P 5423 it may have been more than merely decorative. Snake amphoras, such as P 4990, are of a class made especially for funerary use. This is a late form of the elongated amphora in which neck and body are almost the same height. All the figured scenes are funerary in character, arranged around the central prothesis (lying in state), and showing various phases of the ceremonies that were observed at a burial. The prothesis shows a checkered pall decorated with wreaths hanging over the dead; mourning women tearing their hair stand at either end of the bier, the one on the right on a stool, and one woman sits beside (under) it. In the neck panel on the other side three men carry, respectively, a wreath, a knife, and a pot, and there are rows of men and women in the register on the upper neck on both sides. Around the body zone are five

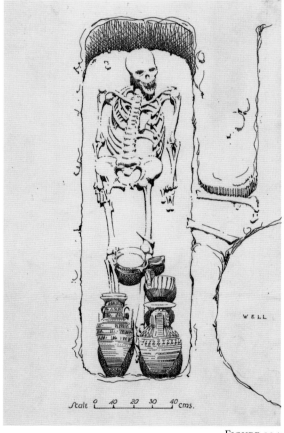

FIGURE 114

three-horse chariots. As none of the charioteers is armed, the scene represents a chariot race at the funeral games, such as those of Patroklos vividly related in Book 23 of the *Iliad*. The amphora belongs to the so-called Workshop of Athens 894, in which the Analatos Painter—and other potters of the early Orientalizing style—was also trained.

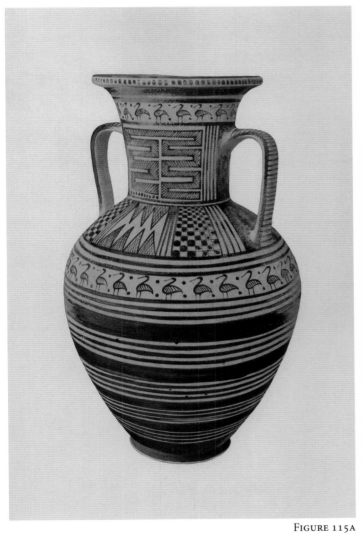

FIGURE 115A

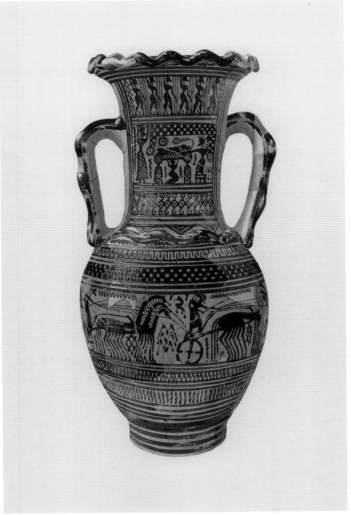

FIGURE 115B

44. Mysterious wheels (Figs. 116a, b)

P 7024, P 7280 (Painting nos. 293, 112)
Ca. 750 B.C.
From pit and well D 11:5
Preserved height: P 7024: 0.305; P 7280: 0.415
P 7024: R. S. Young 1939, pp. 180–181, no. C 134, fig. 130; *Agora*
 VIII, p. 60, no. 246, pls. 14, 42; Coldstream 1968, no. 7, p. 30.
P 7280: Shear 1936b, p. 193, fig. 8; R. S. Young 1939, pp. 181–182,
 226, no. C 136, figs. 131, 144; *Agora* VIII, p. 67, no. 320, pl. 18.

Both of these fragmentary amphoras were found in a remarkable well on top of the Kolonos Agoraios near its eastern edge, about 80 meters to the south of the east end of the so-called Hephaisteion. The deposit, mostly dating to the late 8th and first half of the 7th century B.C., was published soon after its discovery by Rodney Young in 1939. On the neck fragment of the large amphora P 7024 (Fig. 116a) attributed to the Dipylon Master we find, in different panels, bearded goats with their heads turned back, a fragmentary horse, and, in the uppermost panel, a compass-drawn toothed wheel with spokes and "double-axe" filling ornaments, flanked on either side by a snake outlined with dots. The iconographic prominence of the wheel is interesting as it is echoed on the neck of the fragmentary amphora P 7280 (Fig. 116b) where, instead of snakes, we find birds heraldically flanking a four-spoked wheel; a similar wheel, but reserved, is found at the center of the otherwise solidly painted body (not illustrated by Piet de Jong). The composition, which is almost a prototype of that on the later SOS amphoras, is further highlighted by what appears to be a small epsilon incised on the upper center of the circle on one side of the neck, illustrated by Piet de Jong in both the watercolor and an ink drawing (Fig. 117). These free-standing wheels closely resemble bronze counterparts, including some that were once attached to votive chariots or wagons, like many examples from the sanctuaries of Olympia and Delphi; related wagons, both life-size and as votive miniatures, are common in Bronze and Early Iron Age Italy. Alternatively, such small wheels in bronze may have served as pendants or other items of jewelry, either dedicated in sanctuaries or as offerings in graves. There are also a number of bronze wheels from various sanctuaries in the Greek world that are inscribed, sometimes with a dedication to a particular deity, sometimes with the name of the dedicant, that may have been offerings in themselves and not as part of a votive wagon group. The inscription on the wheel of P 7280, albeit a sole letter ("E"), is uncannily similar to the inscribed bronze votive wheels.

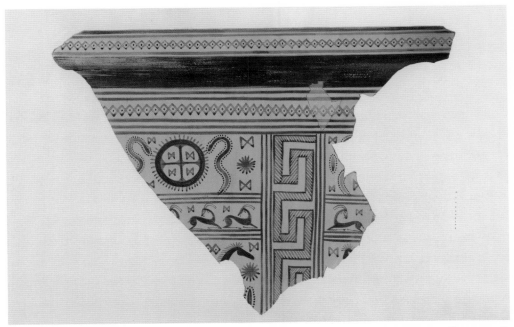

FIGURE 116A

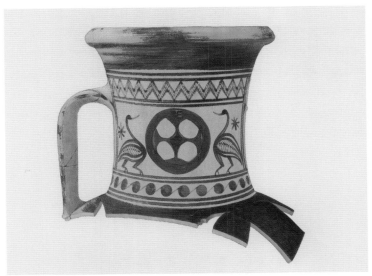

FIGURE 116B

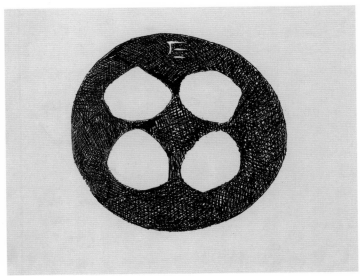

FIGURE 117

45. SIAMESE TWINS (AKTORIONE-MOLIONE) ON A TRICK VASE (FIGS. 118A, B)

P 4885 (Painting nos. 115, 297)
Late Geometric IIa
Tomb G 12:12
Height: 0.228
Payne 1935, pp. 149–150; Hampe 1936, pp. 87–88, fig. 31; R. S.
 Young 1939, pp. 68–71, figs. 43, 44; Fraser 1940; *Agora* VIII,
 pp. 35–36, 65–66, no. 44 (304), fig. 2, pls. 4, 17; *Agora* XIV, p. 15,
 pl. 24; Papadopoulos 1999.

Few Geometric pots have achieved the notoriety in modern scholarship of the oinochoe P 4885, with the enigmatic crossed tubes through its body and the well-known scene on its body often interpreted as Nestor fighting the so-called Aktorione-Molione "Siamese" twins. Virtually every major treatise on Geometric pottery has included a discussion, if not an illustration, of the pot, with particular focus on either the tubes or the iconography. Despite this attention, the function of the Agora oinochoe has continued to exercise scholars. The pot belongs to the Late Geometric IIa phase and can be dated around 720 B.C. or slightly earlier. Much of what has been written on the vase has concentrated on its iconography, beginning with Roland Hampe's 1936 interpretation, where the central, double figure was identified as the twin brothers Eurytos and Kteatos, collectively referred to in the Greek dual as the Aktorione, after their mortal father, Aktor, or, alternatively, Molione(s), after their mother. Scholarly reaction to this suggestion has ranged from positive to skeptical to negative. As for the tubes, a number of different interpretations have been put forward for their function, including the suggestion that they served to cool the contents of the vessel, making the pot a sort of primitive psykter. An alternative interpretation argued that the tubes were for a slow-trickling, long-term dispensing of the libations, whereas a totally different line of reasoning attempted to link the function of the tubes with the iconography of the vase by arguing that the tubes, defining the sign of the cross, were apotropaic, specifically averting the birth of Siamese twins. The obvious association of oinochoai and wine prompted my own suggestion that P 4885 is a trick vase. Imagine an oinochoe, a pouring vessel for wine, with *four* holes in its body that still pours! Impossible? Fill the oinochoe with wine and see what happens, noting especially the looks on the faces of those observing. Whether those who drank from the contents of the oinochoe saw the Aktorione or just "a battle"—or whether the wine made them see double—we may never know. What they did see was a pouring vessel full of holes dispensing wine for their enjoyment and that the same pot had a figured scene, appropriate for the place where a bard, or just a good old storyteller, sang a poem or told a tale.

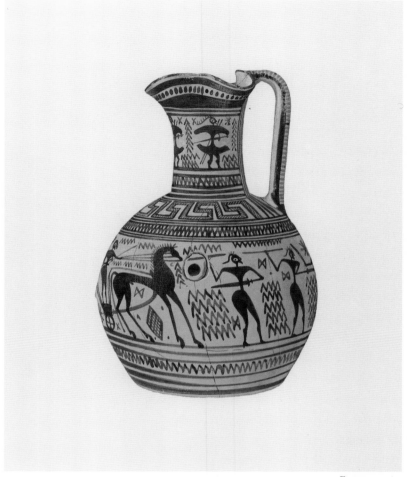

FIGURE 118A

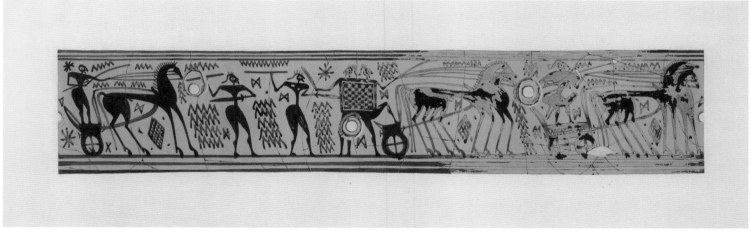

FIGURE 118B

46. Eating from or hanging on a wall? Portable art in the form of a plate (Figs. 119a, b)

P 7083 (Painting nos. 95, 98)
Late Geometric
Well D 12:3
Height: 0.036; diameter: 0.205
Shear 1937a, p. 369, fig. 32; Brann 1961a, p. 112, no. I 55, pl. 23; *Agora* VIII, p. 45, no. 114, pl. 42.

The majority of Piet de Jong illustrations show pots in a cleverly manipulated perspective, often skewed, that attempted both to represent the vessel as accurately as possible and to show as many details of its shape and decoration as possible. Occasionally, as with the Mycenaean alabastra (no. 23, Figs. 90a, b), he prepared more than one illustration in order to capture the decoration in its best light, but even in this case the pots themselves were tilted in the characteristic de Jong manner. The formal frontality, as it were, of the Geometric plate allowed him little room for maneuver and de Jong was compelled to illustrate two flat views of what was essentially the flattest of Geometric shapes. This he did magnificently, capturing both the rich chocolate-brown color of the painted decoration and its semilustrous glossy texture. The plate is among the most interesting of vessel forms of Athenian Geometric pottery. There is a rare predecessor in Middle Geometric, but it is only during the earlier stages of the Late Geometric period that it enters the repertoire of common shapes, emerging as a popular form that becomes rare again in the course of the 7th century B.C. Moreover, the plate is a shape particularly well represented in nonfunerary contexts in Athens; of the plates assembled by Eva Brann in *Agora* VIII, all were found discarded in wells or various domestic or industrial fills, and numerous fragmentary plates were encountered in the Geometric settlement at the site of Zagora on the island of Andros. Although plates are found in tombs, their notable presence in domestic contexts suggests that they were an indispensable element of the Late Geometric household or of the dowry of a Late Geometric girl. Whether used for dining or as a decorative hanging on a wall, as is common in traditional Modern Greek homes, or both, the decoration on the underside of plates—such as the quatrefoil and swastikas on this example—was meant to be seen.

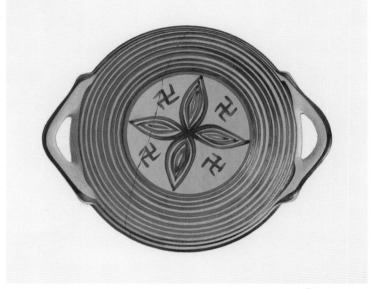

FIGURE 119A

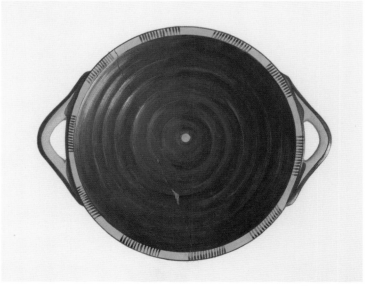

FIGURE 119B

47. Putting it in context or taking it with you? A Geometric tomb in the area of the Classical Athenian Agora (Figs. 120a–i)

P 4782, P 4783, P 4778, P 4780, P 4779, P 4784, P 4781
 (Painting nos. 72, 70, 74, 86, 53, 94, 93, 84, 47)
Late Geometric Ib
Tomb G 12:9, March 2, 1935
Height: P 4782: 0.155 (to rim), 0.185 (with handle); P 4783: 0.102
 (to rim), 0.122 (with handle); P 4778: 0.166 (with lid); P 4780:
 0.135 (with lid); P 4779: 0.130 (with lid); P 4784: 0.195 (with lid);
 P 9781: 0.112
R. S. Young 1939, pp. 87–93, nos. XVIII 1–7; Coldstream 1968, p.
 46, pls. 10j–l; *Agora* XIV, p. 14, pl. 23b.

Piet de Jong had a distinctive way of drawing tombs and skeletons, and one of the few photographs of him at work in the Agora shows him in the process of drawing a Geometric burial with the excavation director, T. Leslie Shear, looking on (Fig. 29). One such grave has already been illustrated (Fig. 114), but de Jong prepared ink drawings of many of these tombs for Rodney Young's 1939 publication *Late Geometric Graves and a Seventh-Century Well in the Agora*. Among many others, I illustrate here a photograph and drawing (Figs. 121a, b) of tomb G 12:9 (Young's grave XVIII). Although a fairly straightforward plan, de Jong's shading indicates not only depth but the relationship of the various tomb offerings to one another. The skull is rendered schematically, peering up from under a mass of pyxides, with something of a sinister smile on its face (cf. Fig. 114); the long bones are drawn with bold, confident lines that reveal the "big picture" rather than the detail. The decoration of individual pots is carefully rendered: there was to be no mistaking which pots belonged in which burial. The tomb yielded a total of seven pots—two tankards and five pyxides, four of which were equipped with their lids—together with a clay whorl, three bronze rings, and four iron fibulae not illustrated. The tankard developed out of the earlier one-handled cup, with the rim growing taller than the body and the handle high-swung above the rim. Early versions of the shape appear toward the end of the Middle Geometric period, but this new shape became very popular only in Late Geometric times. In comparison to other vessel forms, the shape of the pyxis defies generalization. The five examples from this tomb illustrate some of the varieties of pyxides current in the earlier part of the Late Geometric period, both in terms of shape and in the manner of decorating the body, lid, and underside. There is particular variety in the treatment of the lid handles, which range from simple cylindrical knobs (P 4779) (Fig. 120e) to elaborate affairs with three sculpted horses (P 4784) (Fig. 120f).

Nicolas Coldstream places this tomb among the earliest of his significant Late Geometric Ib groups, contemporary with the Hirschfeld krater and with the later vases from the Dipylon Workshop. Indeed, our knowledge of the chronological development of the Geometric style has largely depended on significant contexts, such as tombs, wells, or stratified deposits, that provide large nuclei of pots that show the range of shapes and the decorative idiom current at any given time. Grave deposits are particularly useful as they normally produce more complete vessels than other types of context. For the archaeologist, a grave such as this represents the basic unit, the indispensable context from which any statements about a culture can be formulated. At the same time a tomb is the resting place of an individual, and in the process of excavation not only is the context destroyed, but the resting place of the deceased violated; the best of their private offerings are usually put on public view in museums and their mortal remains are often relegated to the virtual oblivion of a dusty storage facility (and sometimes reburied or thrown away). In some cultures, the different values represented by archaeologists, anthropologists, and scientists, on the one hand, and indigenous populations, on the other, are at odds, sometimes with devastating consequences. In North America, for example, the NAGPRA (Native American Grave Protection and Repatriation Act) legislation has not only put a virtual end to the excavation of Native American burials, but has codified into law the rights of the dead. In Greece and in the Mediterranean ancient burial grounds continue to be considered prime targets for scientific investigation, yet most archaeologists would be loathe to disturb the remains of the more recent dead, particularly of individuals who have died in our lifetime. To excavate a cemetery is to destroy both the context and the privacy of the individual and, consequently, an archaeologist who has excavated a cemetery owes it to the culture being studied and to her/his own discipline to publish the results as comprehensively as possible.

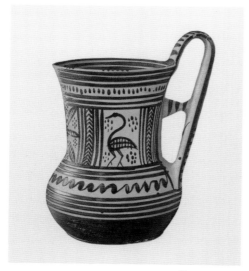

FIGURE 120A

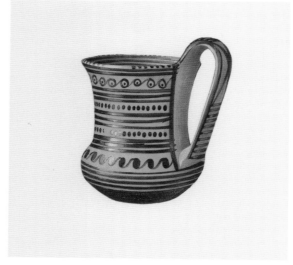

FIGURE 120B

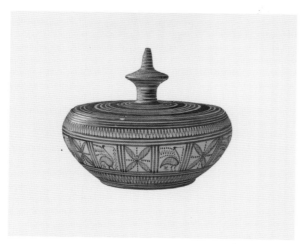

FIGURE 120C

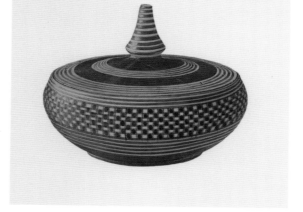

FIGURE 120D

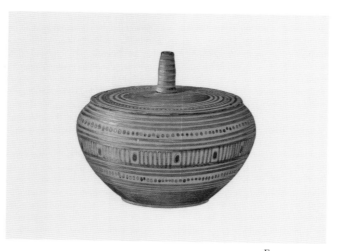

FIGURE 120E

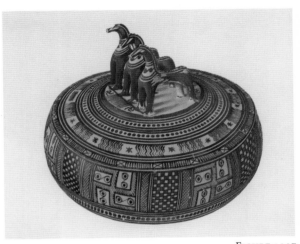

FIGURE 120F

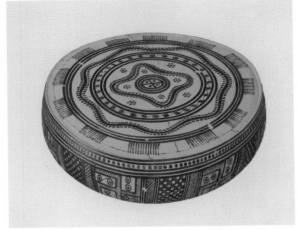

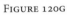

FIGURE 120G

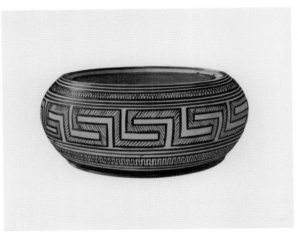

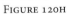

FIGURE 120H

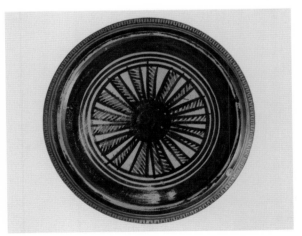

FIGURE 120I

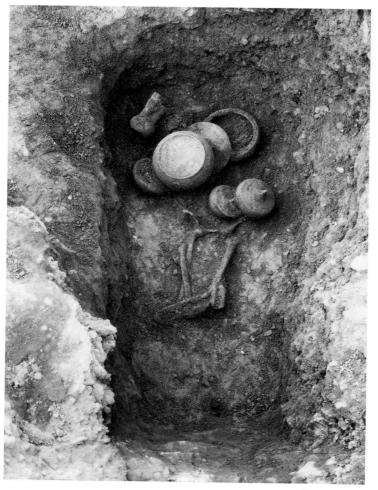

FIGURE 121A

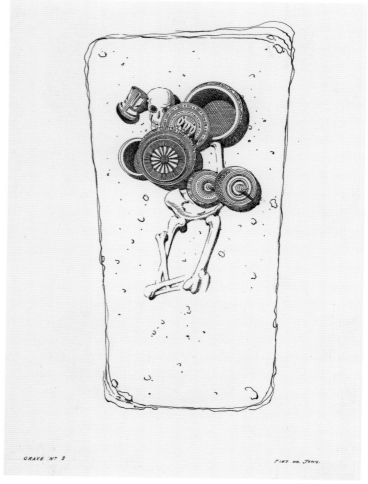

FIGURE 121B

48. I am Thario's poterion (Fig. 122)

P 4663 (Painting no. 41)
Mid-7th century B.C.
Deposit F–G 12:1 (sporadic finds in and near the Geometric grave precinct)
Height: 0.100; rim diameter (estimated): 0.185
R. S. Young 1939, pp. 124–126, no. B 55, figs. 89, 90; *Agora* XII, p. 7 (last example under ποτήριον); *Agora* XXI, p. 30, no. F 3, pl. 11; Lang 1974, fig. 5; Jeffery 1990, p. 76, no. 4, pl. 1.

A brief comparison of the photograph of the skyphos P 4663 (Fig. 123) and the watercolor by Piet de Jong (Fig. 122) shows the value of reconstructing a vessel on paper, as well as the genius of de Jong in rendering with clarity the shape, decoration, and inscribed letters on a fragmentary and poorly preserved pot. The focus of the watercolor is the inscription, one of the earliest from the area of the Classical Athenian Agora. It records private ownership. Θαρίο εἰμι ποτέριον: "I am Thario's poterion" or "of Tharios I am the cup." Names on vessels such as this, inscribed after firing, are most often in the possessive case, a fitting and sufficient way of marking one's belongings. As Mabel Lang has noted, few "declarations of ownership are so assertive as this, at least in this early period when writing required painstaking concentration." The early form of the *theta* in Thario's name shows the cross-in-circle, which continued in use until the middle of the 5th century B.C., at which time the dotted circle became standard. Ironically, the name of the cup—*poterion*, spelled ποτέριον instead of ποτήριον—is one of the few names for a Greek drinking vessel that is not commonly used by modern scholars. This is all the more surprising since among the names of vases actually inscribed on vases, poterion is the second most common after kylix (κύλιξ), itself a name inscribed on a variety of vessel forms ranging from Chiot chalices and Subgeometric skyphoi to Attic black-figure cups and other open two-handled vessels. It would appear that modern scholars' care in naming particular vessel forms was not shared by the ancient Greeks.

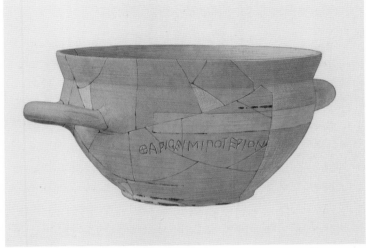

FIGURE 122

FIGURE 123

49. Volutes, floral devices, and amphoras on Protoattic wine jugs (Figs. 124a–c)

P 894, P 837, P 8996 (Painting nos. 75, 201, 24)
Protoattic
Votive deposit H 17:4 (P 894, P 837); well J 18:8 (P 8996)
Height: P 894: 0.265 (as restored); P 837: 0.283 (as restored); P 8996: 0.230
P 894, P 837: Burr 1933, pp. 592–595, nos. 211, 213, figs. 59, 60.
P 8996: Shear 1937b, p. 179, fig. 3; Young 1938, pp. 417, 425, no. D 17, fig. 5; *Agora* VIII, pp. 40–41, no. 85, pl. 5; Docter 1991; Papadopoulos and Paspalas 1999, p. 171, fig. 22.

The three jugs assembled here are sometimes referred to as neckless oinochoai, sometimes as olpai. The shape, with the characteristic trefoil mouth and either a single (P 8996, Fig. 124c) or double (P 894, P 837, Figs. 124a, b) vertical handle, is the least articulated of all shapes made for pouring. It was invented in Athens in the late 8th century and is characteristic of the 7th century B.C. A comparison with Geometric wine-pouring vessels shows how far the shape and decoration have developed in a relatively short period of time. The common elements of palmette and spurred volute on P 894 (Fig. 124a) are skillfully disposed into a panel on the surface of a pot of marked curvature; the numerous bands below echo a decorative idiom more common on contemporary Corinthian pottery. The fragmentary P 837 (Fig. 124b) is glazed all over except on one side of the handle and is decorated—in a distinctive light-on-dark style—with lines in added yellowish-white paint running around the neck and above and below the base of the handle. On either side of the handle a vertical line in added white between the horizontal lines defines a panel, which has, on one side of the vase, a rosette and, on the other, a swastika; the motifs themselves are Geometric in origin but the overall effect is new. The olpe with a representation of an amphora (P 8996, Fig. 124c) is one of the best-known and most illustrated 7th-century Athenian pots. The jug has been variously interpreted as a container for prize oil or wine; the amphora on it, which has the shape of the SOS storage jar, the predecessor of the Panathenaic amphora, is usually considered to be an indication of the contents. By pitting Athena versus Dionysos—the two most influential gods of the Athenians—various scholars have asked whether the contents of the amphora and jug are oil or wine or both.

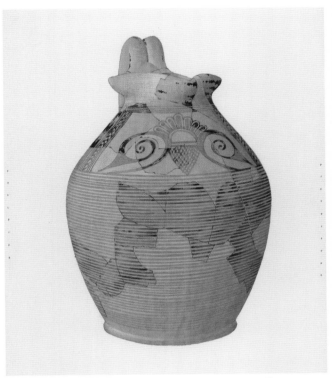

FIGURE 124A

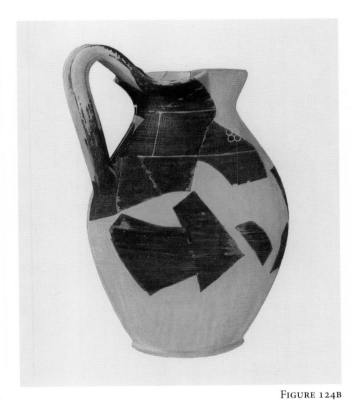

FIGURE 124B

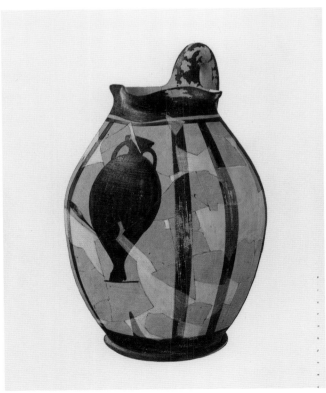

FIGURE 124C

50. ORIENTAL INFLUENCES: PRANCING HORSES, TREES-OF-LIFE, AND LABYRINTHS ON AN ATHENIAN POT (FIGS. 125A–C)

P 12178 (Painting nos. 58, 59, 271)
Early to Middle Protoattic
Well S 19:7, in the area of the later City Eleusinion
Height: 0.230 (to rim); 0.265 (to top of handle)
Shear 1939a, p. 227, figs. 22, 23; *Agora* VIII, pp. 86–87, no. 492,
 pl. 30; Thompson and Griswold 1963, back cover; Camp 1998,
 p. 16, fig. 21.

This olpe, iconographically one of the most interesting extant Early to Middle Protoattic vases, has defied straightforward attribution by specialists of early Orientalizing pottery. The figured decoration on the body shows, from left to right, three pairs of motifs: two labyrinth-like dotted meander patterns; a rosette tree with black-and-white petals, next to a tree-of-life in outline with black lotus or iris finials; and a pair of prancing horses with open mouths, bodies and legs painted solid, manes and tails in outline. In order to convey an accurate sense of the decoration and shape of the pot, Piet de Jong prepared three watercolors, including the roll-out of the figured scene. Individual elements of the figurative work find parallels and influences from foreign quarters. The long locks of the mane of the horses find close parallels in contemporary Cycladic pottery and may derive from the islands. The so-called tree-of-life occurs on related Protocorinthian and Cretan pots—two of the most profoundly orientalized Greek pottery styles—and, more significantly, on Phoenician ivories, especially from Assur. The labyrinth ornament is, as Eva Brann so nicely put it, a trompe l'oeil, consisting of one strand going up on the left and coming down on the right and overlapping in the center so as to form swastikas of sorts. The system is not quite a labyrinth, but a step meander. It resembles most closely the high meanders used in Athenian Geometric pottery, but with the meander upended. Such meander systems are popular in the Aegean islands, particularly Samos, and the dotted strands occur on both contemporary Corinthian and island pottery. The painter of this small pouring jug has abandoned altogether the formality of Greek Geometric design and embraced a new Orientalizing idiom, one full of exuberance and life.

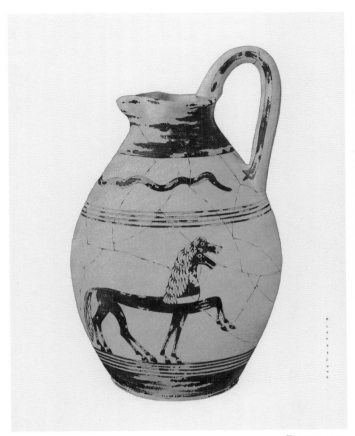

FIGURE 125A

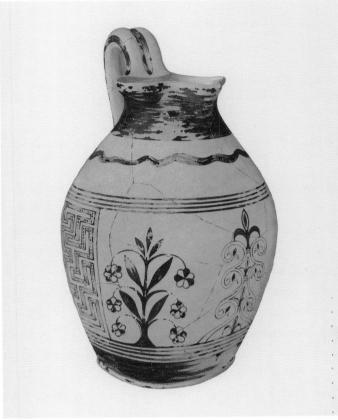

FIGURE 125B

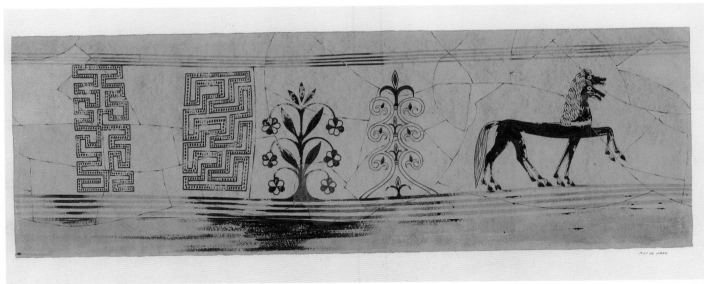

FIGURE 125C

51. The Ram Jug Painter and the Polyphemos Painter:
Athenians, islanders, or metics? (Fig. 126)

P 22550 (Painting no. 345)
Middle Protoattic
Well R 8:2, behind Stoa of Attalos shop VIII
Height: 0.255 (to rim); 0.295 (including handle)
Thompson 1952b, p. 147, fig. 5; Thompson 1953a, p. 48, pl. 18c;
 Karouzou 1952, p. 165; Brann 1961b, p. 348, no. G 5, pls. 69, 72;
 Agora VIII, p. 93, no. 544, pl. 33; cf. Morris 1984; Papadopoulos
 and Smithson 2002.

In a large panel on the front of this olpe is the protome head of
a lion in outline technique, facing right. The muzzle is dotted;
the mane and tongue are painted solid and covered with added
red. An incised line divides the tongue from the lower incisor.
Filling ornaments are varied and include tooth meander, hang-
ing spirals, zigzag lines, sets of diamonds, chevrons, S-shaped
lines, and a standing trefoil, and there are square ornaments
at the base corners. First attributed to the Ram Jug Painter by
Semni Karouzou, this olpe is one of the most characteristic
pieces by one of the two leading Middle Protoattic vase-paint-
ers. The other, the Polyphemos Painter, takes his name from
the celebrated Eleusis Amphora, published by George Mylo-
nas, who commissioned Piet de Jong to prepare a watercolor of
it (Figs. 21a, b). In discussing the Ram Jug Painter—so named
after a jug in Aigina—in *Agora* VIII, Eva Brann wrote,

> The Ram Jug Painter shows some signs of having learned
> abroad about such things as Cycladic outline protomes and the
> use of brown paint, but one likes to think of him as an Athe-
> nian, albeit a traveler. The Polyphemos Painter, on the other
> hand, was an Aeginetan, or at least he worked in Aegina.

Indeed, the Ram Jug was assumed to be Aiginetan when it first
appeared, and scholars such as Ernst Pfuhl, Humfry Payne,
John Beazley, and Thomas Dunbabin doubted whether it was
Attic, a point of view most recently argued by Sarah Morris.
But whether Athenians, foreigners, islanders, or metics (resi-
dent aliens), these are pot-painters whose work is sometimes
more amazing than appropriate. As Brann once put it, "Neither
painter has ever heard that pot-painting is a minor art."

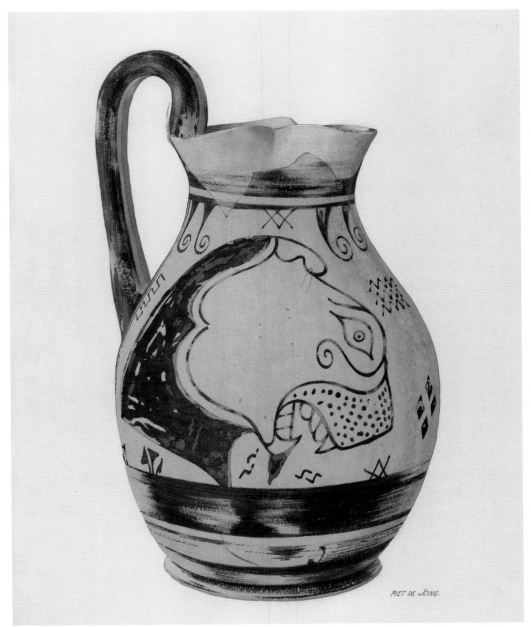

FIGURE 126

135

52. Amazing creatures by the Ram Jug Painter and by Piet de Jong (Figs. 127a–c)

P 4611, P 12612, P 1759 (Painting nos. 206, 25, 303)
Middle Protoattic
Accumulated road metal, deposit F–G 12:1 (P 4611); well P 7:2
 (P 12612); Protoattic votive deposit H 17:4 (P 1759)
Restored height: P 4611: 0.320; P 12612: 0.245; P 1759: 0.090 (pre-
 served height of fragment a with front of animal)
P 4611: R. S. Young 1939, pp. 106–109, no. B 1, fig. 74; *Agora* VIII,
 pp. 37, 93, no. 53 (543), pls. 4, 33, 44.
P 12612: Shear 1939a, p. 228, fig. 24; *Agora* VIII, p. 94, no. 552, pl. 34.
P 1759: Burr 1933, pp. 584–587, no. 194, figs. 48, 49; Cook 1934–
 1935, p. 198; *Agora* VIII, p. 96, no. 568, pl. 35.

The Ram Jug Painter acquired in his later years, as Eva Brann stated, "the ability to paint faces such as one might not mind seeing in life. They have, in fact, the beginnings of loveliness," and she pointed to P 4611 (Fig. 127a) as the prime example, adding, "the painter knows it and sometimes put a flower fillet on the forehead as a sign." The lean, standing sphinxes on P 4611, with their long, thoroughbred faces, light shirt fronts, and stiff pointed wings are considered one of the finest works by the Ram Jug Painter. Unlike the Polyphemos Painter, the Ram Jug Painter is restrained in his use of white, preferring the natural clay ground for his outline designs. By way of contrast, however, he matches outline designs with incised silhouettes for the sphinxes' wings, thus showing himself master of both techniques. Rather than reconstruct the design on the oinochoe on which it appeared, as was his habit, Piet de Jong was content to roll out the scene, letting the fragments speak for themselves: a tribute to a great painter by a great painter. The hemi-lion on the oinochoe P 12612 (Fig. 127b) is, in a manner of speaking, the complement of the lion protome head on P 22550 (no. 51, Fig. 126). Although unattributed, this oinochoe stands close to the work of the Ram Jug Painter, as a number of scholars have noted. The fragments of a lid, P 1759 (Fig. 127c), on the other hand, are either by, or close to, the work of the Kynosarges Painter, as John Cook was the first to point out. Unlike the fabulous mythical sphinxes on P 4611 and the rather amazing hemi-lion on P 1759, the creatures on the lid are very much the result of Piet de Jong's imagination. Eva Brann imagined the animal to be perhaps a boar, on the basis of the preserved fragments (Fig. 128), but de Jong preferred to see a stag and had no qualms in depicting it thus.

Figure 127a

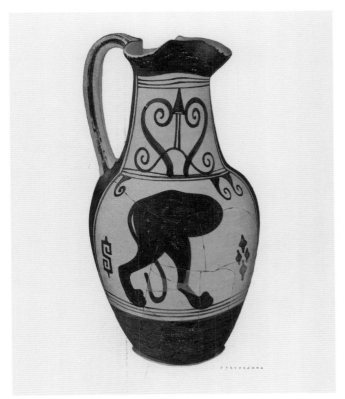

FIGURE 127B

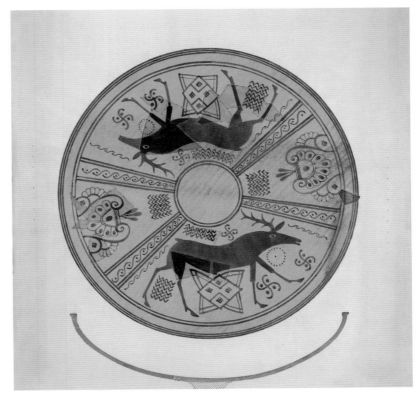

FIGURE 127C

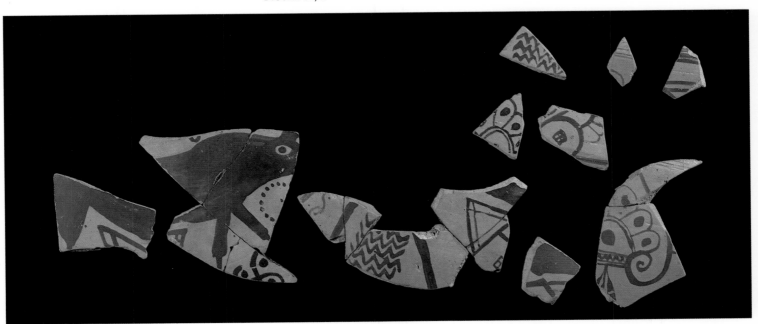

FIGURE 128

53. Protoattic birds of a different feather (Figs. 129a, b)

P 4950, P 4948 (Painting nos. 76, 291)
Middle Protoattic
Both pieces from the accumulated road metal, deposit F–G 12:1
Height: P 4950: 0.130 (as preserved); P 4948: 0.375 (as restored)
P 4950: R. S. Young 1939, pp. 133–134, no. B 69, fig. 96; Buschor
 1954, p. 11; Mylonas 1957, p. 111, fig. 39; *Agora* VIII, p. 95,
 no. 560, pl. 35; Lamberton and Rotroff 1985, p. 6, fig. 7.
P 4948: Shear 1936a, p. 35, fig. 35; R. S. Young 1939, pp. 128–131,
 no. B 64, figs. 92, 93; Kübler 1950, p. 43, no. 18; Benton 1961,
 no. 4, pl. V; *Agora* VIII, pp. 93–94, no. 549, pl. 34; also Cook
 1934–1935, pp. 170, n. 4, 191, n. 1, 216.

In the early Orientalizing period the schematic and often nameless birds of the Geometric period gave way to species that any natural historian would be happy to identify. Thus there is no doubt about the rooster on the neck of the amphora P 4950 (Fig. 129a), first attributed to the Polyphemos Painter by George Mylonas. The domestic chicken was known in Egypt by the middle of the 2nd millennium B.C., deriving from the red jungle fowl of Southeast Asia, which was fully domesticated there by about 2000 B.C. The earliest representations of the chicken—known as ὁ Περσικὸς ὄρνις or "Persian Bird"—in Greek art belong to the years of the late 8th century B.C., but it was only during the Archaic period that the chicken became common in Greece. By the 5th century B.C. there is a wide range of representations of fowl, particularly of fighting cocks, which were often love gifts. In the early 5th century B.C., in the famous episode recounted in Aelian's *Varia Historia* (2.28), Themistokles held up fighting cocks as an example to his countrymen, proclaiming, "These endure pain not for their country or for the gods of their fathers but simply for the sake of avoiding defeat!" At the time when P 4950 was painted, roosters and chickens were exotic and special, and thus this portrait of a rooster, complete with menacing spurs, is all the more splendid.

Although the birds with ragged rears drawn in silhouette (with large reserved rings for eyes and legs formed by downward converging lines, on the stamnos, or egg-shaped krater,

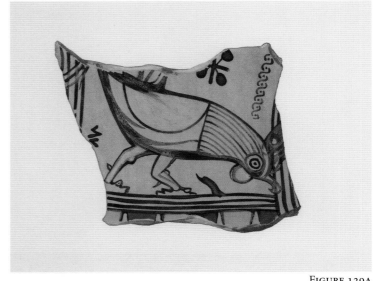

FIGURE 129A

P 4948 [Fig. 129b]) lack the specificity of the chicken, it is highly likely that the two heraldically facing creatures are geese rather than the ducks that Brann preferred to see. Among the domestic birds, neither ducks nor swans were common in antiquity, though numerous references in ancient literature to goose breeding—and fattening—make it clear that the goose was a familiar sight in the ancient Greek world. As a contemporary, more or less, of our stamnos, the great bard Homer himself mentions, in the *Odyssey* (19.535–543), that Odysseus's wife Penelope kept twenty geese.

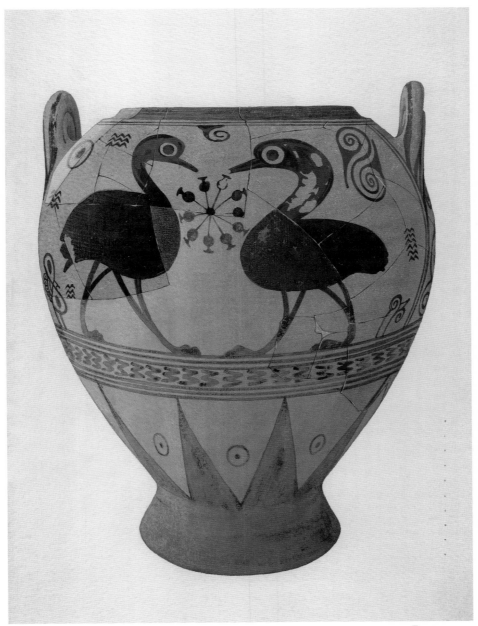

FIGURE 129B

54. Architectural monumentality on Protoattic pots by the Pair Painter (Figs. 130a, b)

P 22299, P 22551 (Painting nos. 344, 346)
Middle to Late Protoattic
Well O 12:1 east of the Odeion (P 22299); well R 8:2 behind the
 Stoa of Attalos (P 22551)
Height: P 22299: 0.500; P 22551: 0.283 (as preserved)
Thompson 1952b, pp. 147–148, figs. 4, 6; Thompson 1953a, pp. 39,
 48, pls. 18b, d; Brann 1961b, pp. 324–325, 347–348, nos. F 4, G 4,
 pls. 68, 69; *Agora* VIII, pp. 96–97, nos. 572, 573, pls. 2, 36, 42;
 Camp 1998, p. 16, fig. 22 (P 22551).

The two amphoras illustrated here are by the same hand, a painter thus far known only from his works found in the area of the later Agora, dubbed the Pair Painter because of his preference for facing protomes. Both amphoras are similarly shaped, with a kalyx of rays at the bottom, a zone of strong-linked spiral or related ornament at the widest point of the body, and an alternating black-and-white tongue pattern on the shoulder. Both the protome of the charging bull on the neck of P 22299 (Fig. 130a) and the facing-horse protomes on the body of P 22551 (Fig. 130b) have details picked out with incision. Cycladic influence, in the use of protomes and in the powerful spirals, is unmistakable. The decoration is the same for both sides of both vessels, and many of the subsidiary or filling motifs on the neck of P 22299 are found on the body of P 22551. Horse-head protomes as part of quadrigas, similar to P 22551, together with bulls and other powerful animals, were common on Archaic pediments and other votive or architectural reliefs from the Athenian Acropolis (Fig. 131), the animals often curtailed in order to fit them into the restricted picture frame of the pediment or relief. In a similar vein, the monumental bull protome on the neck of P 22299 bears an uncanny resemblance to the relief fresco of the charging bull on the North Propylon at Knossos (Fig. 12), another site that Piet de Jong was intimately involved with. This is not to say that one copied the other—the chronological disparities between Protoattic amphoras and Bronze Age and Archaic relief frescoes and sculpture are insurmountable—but only that the figures on the Pair Painter's amphoras are not that far removed in time from

FIGURE 130A

the Archaic architectural relief sculptures of the Acropolis, and both media emerged from the same cultural context that saw a need for large-scale monumental sculpture of a sort that had not been seen in Greek lands since the Bronze Age palaces of Minoan Crete and the Mycenaean mainland were destroyed.

FIGURE 130B

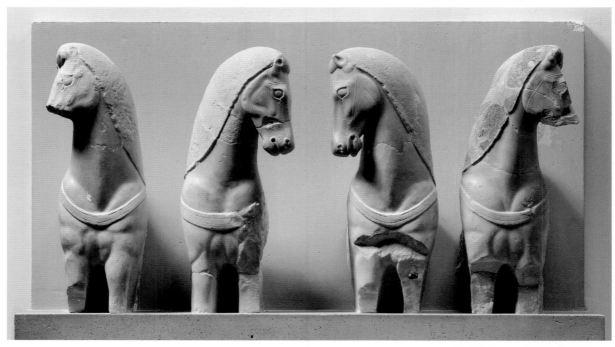

FIGURE 131

55. Musicians, row dancers, and other Protoattic human figures (Figs. 132a–c)

P 10154, P 10229, P 26411 (Painting nos. 71, 105, 367)
Early (P 10154, P 10229) Protoattic, Early to Middle (P 26411)
 Protoattic
Well T 19:3 (P 10154, P 10229); well R 17:5 (P 26411)
Preserved height: P 10154: 0.280; P 10229: 0.125; P 26411: 0.150
P 10154: Shear 1938a, p. 341, fig. 23; *Agora* VIII, p. 74, no. 384,
 pls. 22, 42.
P 10229: *Agora* VIII, p. 78, no. 416, pl. 25.
P 26411: Brann 1961b, pp. 375–376, no. S 3, pl. 87; *Agora* VIII,
 p. 78, no. 417, pls. 24, 25; Thompson and Griswold 1963, fig. 43.

The three fragmentary amphoras assembled here are all examples of snake amphoras, such as P 4990 (Fig. 115b), which developed during the Late Geometric period and continued into the Protoattic period, with applied snakes on their rims, shoulders, and handles. Where the scene on the neck of the Geometric amphora of this type was funerary, the iconography of the Protoattic amphora necks is taken from contemporary ritual and life. On the neck of P 10154 (Fig. 132a) there are seven human figures. At the left two women are led by a man (a new fragment, not incorporated in Piet de Jong's illustration, gives the sex of the middle figure), all holding branches. In the center a lyre player faces the other half of the dance over a floral ornament. On the right side are three figures, also holding branches, the first and last women, the middle figure not preserved. A related row dance is found on the neck of P 10229 (Fig. 132b), though it lacks the musician and consists solely of women, ten in all, with reserved faces, hair as if in nets, and white on their outline skirts. Some of them stand on tiptoe and, like the figures on P 10154, they also hold branches, while the zigzag motif between the women is sometimes interpreted as representing water. Such row dances were performed at various celebrations and rituals, including rites of passage, such as initiations and marriages, and continue today as an enduring aspect of Greek tradition. In contrast to the exuberant figures on P 10154 and P 10229, those on P 26411 (Fig. 132c) are more somber, their mood reflected in their long gowns: they move forward slowly, in procession. The branches they hold are smaller than those on the other amphoras and, like them, they defy straightforward identification. Burr Thompson and Griswold identified the scene on P 26411 as votaries carrying myrtle branches. Although we cannot be sure of the species, the fragrant myrtle would be appropriate, as it was used at weddings because of its association with Aphrodite and for the crown of initiates into the Eleusinian Mysteries.

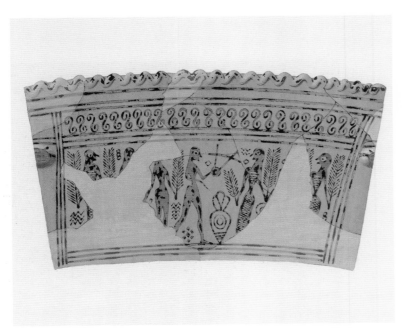

FIGURE 132A

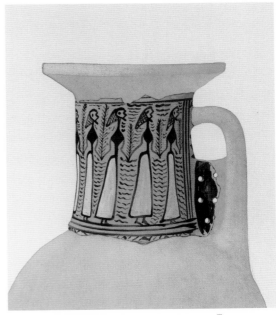

FIGURE 132B

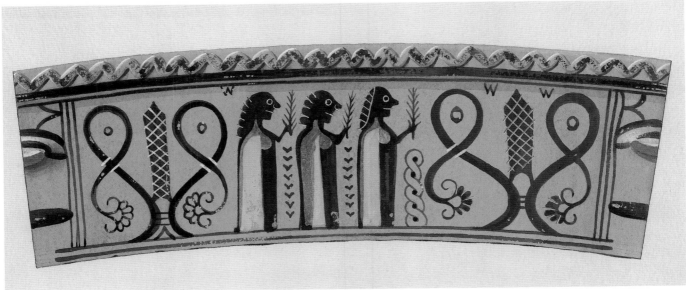

FIGURE 132C

56. Putting it together from fragments (and how!)
(Fig. 134)

P 460 (Painting no. 330)
Middle Protoattic
Protoattic votive deposit H 17:4
Restored height of vessel: 0.500
Burr 1933, pp. 577–579, no. 145, figs. 35, 37; Cook 1934–1935, p. 216.

Few illustrations show the genius of Piet de Jong as an archaeo-logical illustrator as well as the ink drawing of P 460, which is arguably one of the finest—if not most fanciful—restorations of any fragmentary vessel anywhere. The original fragments of P 460 were published, together with sherds from various other Protoattic amphoras and kraters, by Dorothy Burr [Thompson], who also presented the restored drawing at a scale of about 1:7. The fragments of the vessel, as preserved (Fig. 133), are clearly of a large vase on a stand. Determining the exact shape was no easy feat, since the restored drawing shows a vessel of open form but not painted inside. The angles preserved on the fragments at the rays on the lower wall of the bowl and at the palmette design above indicated that a kalyx shape was most probable. Not only did de Jong have to visualize the shape, he also had to deal with a vessel that was fenestrated, since some of the fragments preserve clear cuttings, indicating that part of the stand consisted of fairly complex cutout open-work. If restoring the shape was difficult, the reconstruction of the painted decoration—itself very poorly preserved—from the surviving pieces involved great artistic skill and imagina-tion. Throughout the drawing, de Jong was careful to indicate the preserved fragments, and these show clearly how very little of the vessel was actually preserved and the fact that there were virtually no significant joins between the various "floating" components of the vase; the height and diameter of the bowl, like the overall height of the stand, and the exact shape and size of the painted rays are all matters of speculation. Most illustra-tors would have been content to draw some of the better-pre-served fragments, but it was typical of Piet de Jong to recon-struct boldly a magnificent vessel—whatever its accuracy—of a poorly understood period from a handful of sorry sherds.

FIGURE 133

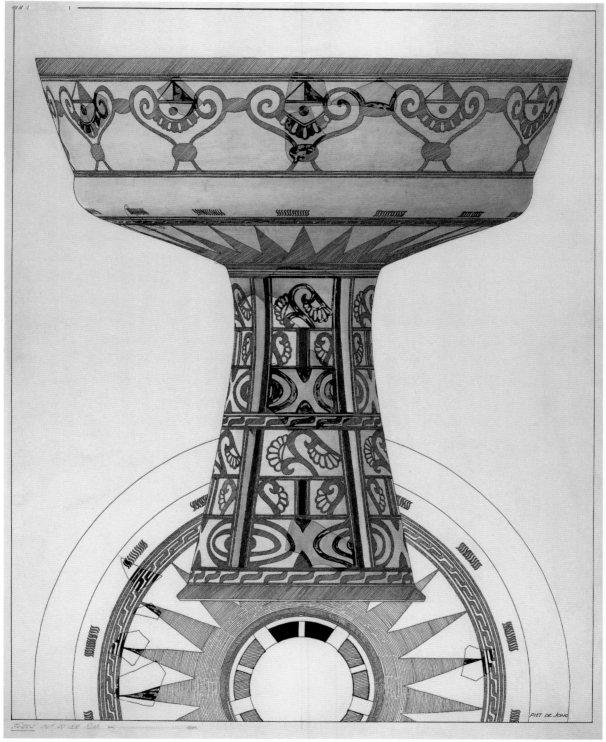

FIGURE 134

57. Protocorinthian and Protoattic (Fig. 135)

P 7143, P 7023 (Painting no. 77)
Protocorinthian (P 7143), Middle Protoattic (P 7023)
Pit and well D 11:5
Height: P 7143: 0.125; P 7023: 0.120
R. S. Young 1939, pp. 143–144, 149–150, nos. C 8, C 31, figs. 101,
 104, 105; *Agora* VIII, p. 51, no. 165, pl. 9 (P 7023); compare
 Coldstream 1968, p. 87; Papadopoulos 2003, pp. 222–224.

These two kotylai—one published as Protocorinthian by Rodney Young (P 7143), the other Protoattic (P 7023)—bring to the fore one of the most interesting and enduring aspects of Athenian pottery production: the phenomenon of *Corinthianizing*. They were found in the same deposit, dating to the late 8th and first half of the 7th century B.C., on the Kolonos Agoraios as the amphoras P 7024 and P 7280 (Figs. 116a, b). In discussing Athenian drinking vessels current at the end of the Geometric period, Nicolas Coldstream writes, "The decline in the quality of Attic drinking vessels coincides with the import of fine Corinthian kotylai, which inspired imitations." Similarly, in dealing with the kotyle P 13329 (Fig. 136), an Athenian-made version of a Corinthian shape represented by P 7143 and found in the floor packing of the Early Iron Age kiln near the later Tholos of Athens, Eva Brann believed that the Athenian versions of the kotylai were copied directly from Corinthian imports, with minimal lag time between prototype and copy.

A more penetrating analysis, however, one involving direct human agency, has been provided by Tom Dunbabin, who was among the first to argue that rather than imitating Corinthian pottery, the locally made Athenian versions of the Protocorinthian kotyle pointed to a Corinthian-trained potter—or potters—migrating to Athens and producing Corinthian-type vessels in the local fabric of Athens. The Middle Protoattic kotyle P 7023 represents a related but somewhat different phenomenon: it highlights a typical Protoattic handling of a Protocorinthian shape and linear decoration. The shape of P 7023, together with the framework of the decoration, is Protocorinthian; but in selecting and applying the decorative elements a chaotic effect is achieved, of which only the Protoattic potter was capable. The careful Protocorinthian bands and rays of P 7143 are replaced by the wild squiggles of P 7023 together with rays ending in spirals.

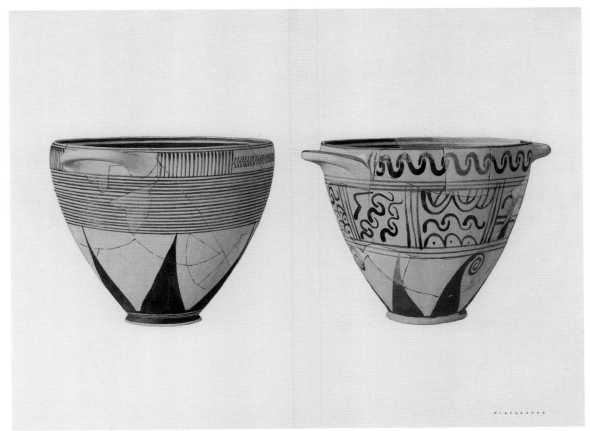

FIGURE 135

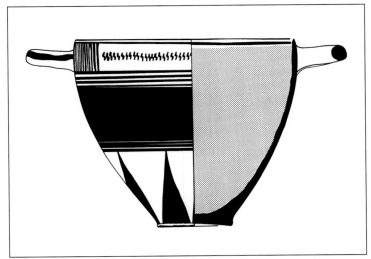

FIGURE 136

58. Protocorinthian imports (Figs. 137a, b)

P 10198, P 4801, P 4802 (Painting nos. 4, 18)
Corinthian, dated by context to the early 6th century B.C. or earlier
Storage pit B 14:5 (P 10198); well F 12:5 (P 4801, P 4802)
Height: P 10198: 0.093; P 4801: 0.057; P 4802: 0.081
Unpublished.

Most scholars have become accustomed to giving dates to Greek painted pottery with figured decoration, such as Athenian black- and red-figure and Corinthian, on the basis of style, an exercise that often involves subjective arbitrariness and occasionally a good leap of faith. A number of closed deposits in the area of the Classical Agora offer large nuclei of pottery that permit an insight into the types of wares current at any particular time or, at the very least, a terminus post quem, that is, that a given deposit was laid out at a particular time and that the material recovered from it can be no later than that date. The incidence of imported pots—such as the three Corinthian vessels assembled here—in such contexts is an added boon, as it permits the cross-linking of the Athenian and Corinthian sequences. Both deposits from which these three Corinthian pots derive offer large assemblages of material. The storage pit B 14:5 in which P 10198 (Fig. 137a) was found was filled late in the first quarter of the 6th century B.C., though it contains material that is earlier, including some that is late 8th century B.C. The dumped fill of well F 12:5, from which the small aryballos and alabastron (P 4801, P 4802, Fig. 137b) derive, included material running into the second quarter of the 6th century B.C., though much of the deposit was consistently late 7th century B.C. All three Corinthian vessels are in the standard pale fabric of Corinth and provide useful contrasts to the redder fabric of the kotylai P 7143 and P 7023 (Fig. 135). The aryballos and alabastron are good examples of typical Corinthian mass-produced diminutive commodity containers found in great numbers throughout the Mediterranean. The watercolor of the kotyle (P 10198), a form that represents a later development of shapes such as P 7143 (no. 57), bears the characteristic mark of Piet de Jong. The painted decoration of the original fragmentary vessel is badly peeled; to compensate for this shortcoming and to give some idea of the original decoration, de Jong has

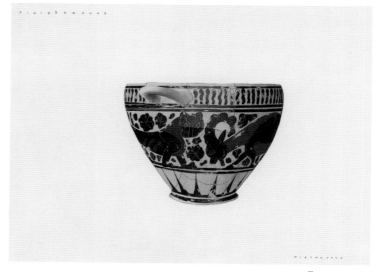

FIGURE 137A

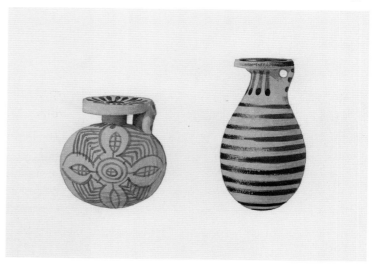

FIGURE 137B

not only filled in missing pieces, he took the liberty of adding incised decoration and other details onto fragments of the pot that have not survived and, at the same time, blackening the parts of the painted decoration most flaked in order to give a better sense of the decoration as the potter had originally intended.

59. THE EPIPHANY OF AN UNKNOWN GODDESS (FIG. 138)

T 175 (Painting no. 262)
Mid-7th century B.C.
Protoattic votive deposit H 17:4
Height: 0.248; width: 0.133
Burr 1933, pp. 604–605, no. 277, figs. 72, 73; Kunze 1946, p. 99;
 Agora VIII, p. 87, no. 493, pl. 30 (with references).

An evocative female figure faces forward, arms raised, hands with palms out and the fingers spread, between rearing snakes. Although she is not holding the snakes, the reptilian heads are close to her hands; the head of the snake on the left is horned, that on the right extends its fangs. Her head is in relief; the hair is painted red and is arranged in short curls on the forehead and long wavy locks down to the shoulders, and there is a diadem painted bluish-green, with dots. The arms, eyebrows, and eyes are painted red; the irises of the eyes are painted bluish-green, the pupils red. The triangular face and long hair are characteristic of an Early Archaic style that has come to be known as Daidalic. The costume worn by the female is belted and pinned, and its elaborate designs arranged in different sets of polychromy led Dorothy Burr to suggest that it represents an outer and an inner garment. Although the plaque is complete, with holes in the upper corners, the surface of the lower left side is badly damaged, with the result that virtually nothing survives of the lower left quarter. Piet de Jong was responsible for the watercolor of the plaque itself, whereas the profile was prepared by Mary Wyckoff (Simpkin). Eva Brann considered that the style of the whole plaque would be that of the Ram Jug Painter at his acme. Emil Kunze was the first to state categorically that the figure on the plaque is a goddess rather than an adorant, her gesture one of epiphany, that is, how the revealed deity appears to humans. The name of the goddess, however, remains unknown. The fact that terracotta shields were evidently offered to her gives no certain clue to her identity, for similar votives were found at Eleusis, the Temple of Hera at Tiryns, and in the dromos of the Mycenaean tholos tomb at Menidi, though later miniature shields are sometimes associated with Hera. Similarly, the snakes do not establish her iden-

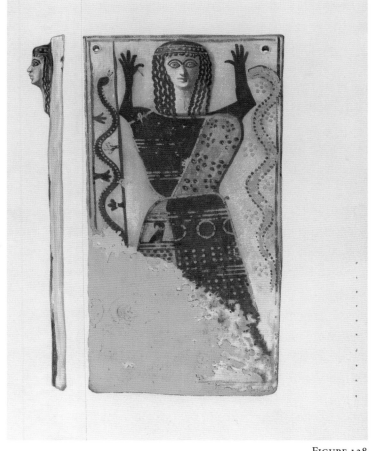

FIGURE 138

tity beyond doubt, as these may accompany a *potnia theron*, or Athena, or some older chthonic goddess. The combination of upraised arms and snakes, however, strongly points in the direction of Minoan Crete and, whatever her name, this plaque most likely depicts a 7th-century B.C. version of a goddess well known in the Aegean Bronze Age.

60. WARRIORS' SHIELDS AS VOTIVE TERRACOTTA MINIATURES
(FIGS. 139A–C)

T 183, T 202, T 181 (Painting nos. 232, 234, 253)
Protoattic
Votive deposit H 17:4
Estimated diameter: T 183: 0.140–0.150; T 202: 0.110; T 181: 0.280
Burr 1933, pp. 609–614, nos. 283, 291, 287, figs. 75, 79, 81.

Fragments of about thirty-three miniature terracotta votive shields were encountered in the votive deposit H 17:4. Most were wheelmade and decorated with thick matt colors, including white, red, yellow, and bluish-green. Among the many decorated shields, whether complete or fragmentary, selected and published by Burr, only those with either poorly preserved or difficult to read decoration were illustrated in watercolors by Piet de Jong. The three shields presented here are all fragmentary. The smallest, T 202 (Fig. 139b), appears to have been decorated with a star pattern of sorts, which is not very clear; the largest, T 181 (Fig. 139c), has alternating groups of red and green triangles on the rim and a six-petal ornament at the center. Only T 183 (Fig. 139a) has a figured scene, depicting a horse and rider. Whether floral, geometric, or figured, these emblems mimicked those on actual shields. The great round shield—the *hoplon* (ὅπλον), from which *hoplites* (ὁπλῖται) took their name—was the most important item in the panoply of the Early Iron Age warrior and, as such, a worthy dedication in any sanctuary or votive deposit. Some shields were boldly displayed as public exhibits, such as the celebrated bronze shields taken by the Athenians from the Lakedaimonians at the Battle of Pylos in 425 B.C. and dedicated in the Stoa Poikile in Athens (no. 104). In addition to these real shields, miniature votives, both in bronze and terracotta, are well known from various sites in Greece and South Italy. Not all shield dedications were, however, military in nature. According to the *scholia* on Pindar, *Olympian Odes* 7.83 (152), the festival of Hera is called the Aspis and the prizes are artifacts made of bronze, especially shields and garlands of myrtle. The miniature shields follow the convex shape and offset flat rim of real shields, and their interior is often equipped with the central armband (πόρπαξ) and a hand grip at the rim (ἀντιλαβή), though some of the smaller examples have only one handle near the rim. This new, two-handled arrangement, often depicted in vase painting and even in monumental sculpture from as early as the 7th century B.C., replaced the earlier τελαμών, or sling, thereby allowing the warrior greater mobility. According to Herodotos (1.171), it was the Carians who invented the shield holder—the word used by Herodotos is ὀχάνη—that is, the band fastened on the underside of a shield, through which the bearer passed his arm.

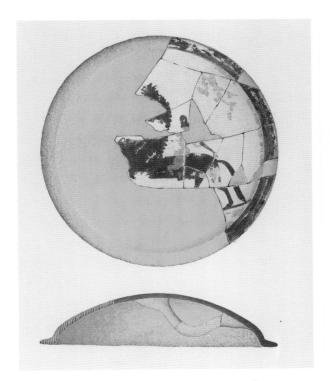

FIGURE 139A

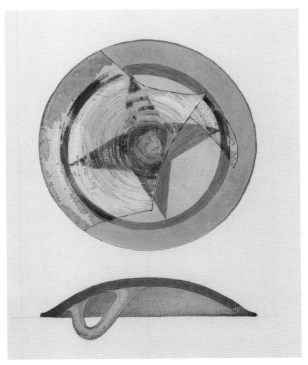

FIGURE 139B

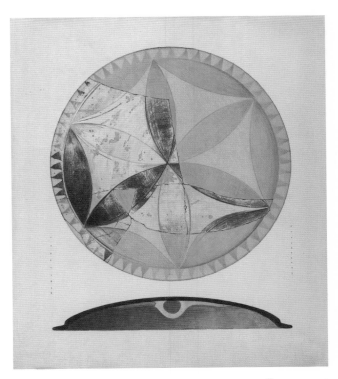

FIGURE 139C

61. TERRACOTTA CHARIOTEERS, MOURNERS, ANIMALS, AND OTHERS (FIG. 140)

T 751, T 756, T 754, T 752, T 758, T 807 (Painting no. 79)
Early Protoattic
All from "sacrificial pyre" tomb G 12:19, except for T 807, from the
 pyre associated with tomb G 12:24
Height: T 751: 0.139; T 756: 0.027; T 754: 0.037; T 752: 0.039; T 758:
 0.080; T 807: 0.154 (preserved maximum length, as restored)
Shear 1936a, p. 27, fig. 25; R. S. Young 1939, pp. 53–55, 61–67,
 nos. XI 18, XII 14–16, 19, 24, figs. 36, 40, 42.

These small terracotta figurines, deposited in early-7th-century B.C. tombs, include a variety of birds (T 756) and animals, particularly dogs (T 754, T 752), but it is the human figures that are the largest and most elaborately decorated. They include the charioteer, complete with chariot car (T 751), a seated human figure (T 758), and the seated mourner, arms raised to the head (T 807), with a smaller mourner painted on the torso of the figure, front and back. Burned as part of the funerary ritual, a number of these terracottas were reconstructed from fragments, some of which were heavily fire affected, joining directly with fragments unscathed by burning. Related figurines, including production discards, together with damaged pottery, potters' test pieces, lamps, and various other terracottas, such as spindlewhorls, beads, or buttons, associated with the workshop making such figurines, were found in deposit S 17:2 in the eastern portion of the area of the later Agora. Similar figurines were dedicated in the nearby City Eleusinion, in the votive deposit published by Dorothy Burr [Thompson], and related figurines were found in the excavations of the Athenian Acropolis, particularly those in the cavity of "Base A" underneath the Bastion and Temple of Athena Nike, and at a number of sites in Attica, including Eleusis and Menidi. The various contexts in which such figures were found—sanctuaries, votive deposits associated with small shrines, tombs, and even in the dromos of the Mycenaean tholos tomb at Menidi—indicate that they served different functions associated with cult and funerary rituals.

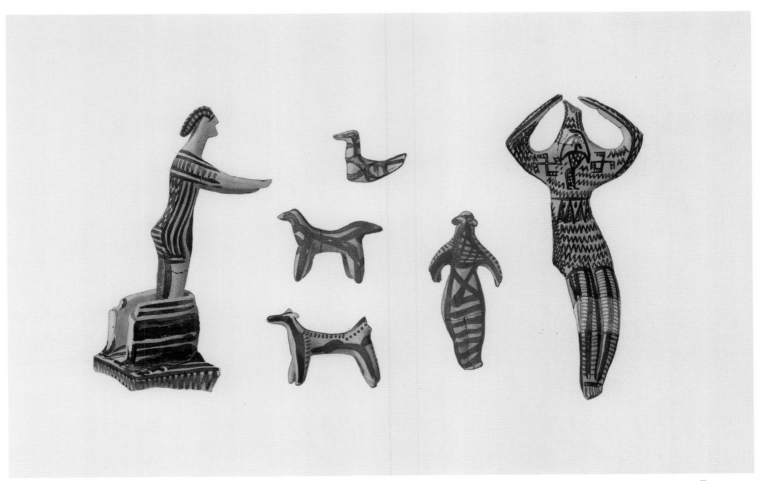

FIGURE 140

CHAPTER 7

Archaic and Classical Odds and Ends

John K. Papadopoulos
with Susanne Ebbinghaus, Kathleen M. Lynch, and James P. Sickinger

62. Sella Cacatoria: A child's highchair cum potty
(Figs. 141a–e)

P 18010 (PD no. 844; Painting nos. 352, 355, 354, 353)
Context ca. 575–560 b.c.
Well A 17:1
Height: 0.343
Thompson 1948, pp. 184–185, nos. 1, 2, pl. 65; *Agora* VIII,
 pp. 100–101, under no. 600; Brumbaugh 1966, p. 90; Thompson
 1971, figs. 39, 40; Thompson 1976, pp. 240–241, fig. 125; Rühfel
 1984, p. 36, fig. 19; Morris 1985, p. 402, pl. 103b; Lamberton and
 Rotroff 1985, p. 22, fig. 42; Lynch and Papadopoulos 2006.

When first discovered in 1947, P 18010 defied identification. It stumped even the normally ingenious Homer Thompson, who wrote in 1948,

> The purpose for which the utensil was intended is puzzling and its interpretation is made difficult by the lack of comparative material. That it was actually used is proven by the much worn state of the rim of the drum and of the front part of its floor, i.e., just within the window. The elaborate design shows that it was not, like so many black-figure stands, intended simply for the support of a round-bottomed lebes or the like. That it served as a brazier is ruled out by the absence of any trace of burning.

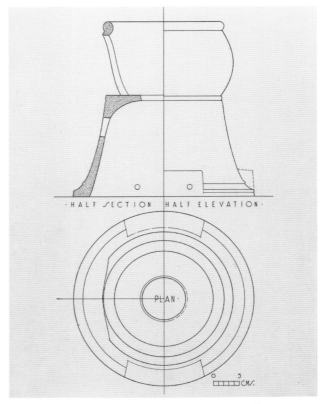

FIGURE 141A

Thompson went on to associate the stand—*faute de mieux*—with psykters or wine coolers, an interpretation in part suggested by the provision for drainage, and that it was connected with a particular type of drainage is now assured. The real use of the enigmatic stand was determined by Peter Corbett as a baby's commode on the basis of red-figure representations, and thereafter the identification of fragments of similar stands was easy. Indeed, fragments of four similar commodes dating to the second half of the 7th century b.c. were published in *Agora* VIII. The commodes are basically standed bowls, with a hole cut into the side of the bowl for the baby's legs and another hole at the bottom of the bowl; in the side of the stand are smaller holes thought to facilitate lifting, and there are additional smaller holes further down, all of which are shown on the section, elevation, and plan drawings by Piet de Jong (Fig. 141a). The commode was spectacularly decorated in black-figure technique, well captured by de Jong but only recently published in full. The side with the "window" for the baby's legs served as the principal, front side. Beside the "window" there is a siren (Fig. 141d) on one side (the opposite side is not preserved), and at the back of the bowl is a large floral ornament with palmette and lotus (Fig. 141e). The smaller hole on the stand below the window is flanked by a lion and a siren, with floral ornament below (Fig. 141b). The hole on the opposite side of the stand is flanked by birds, probably geese (Fig. 141c). There is a wavy line around the base of the bowl and a row of loops around the preserved foot of the stand. As the red-figure representations established, the stand was used as a child's highchair. It was particularly useful for a child who could not yet walk, keeping the infant happily in place while the mother was attending her duties. At the same time, it served as a potty—a child's portable privy—known in Classical and Hellenistic literature as a λάσανον. Indeed, the vessel was put to appropriate use by young Konstantinos Spanos the moment he was placed inside it (Fig. 142).

—*John K. Papadopoulos and Kathleen M. Lynch*

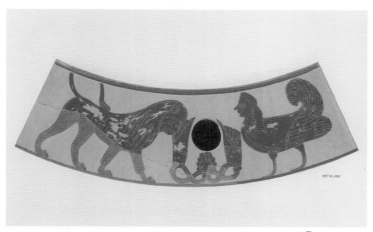

FIGURE 141B

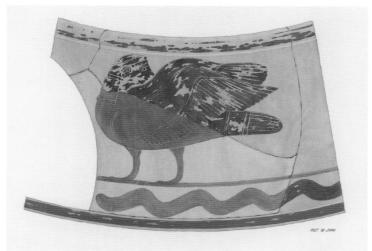

FIGURE 141C

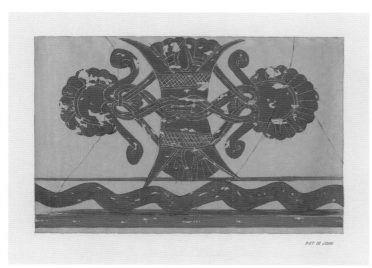

FIGURE 141D

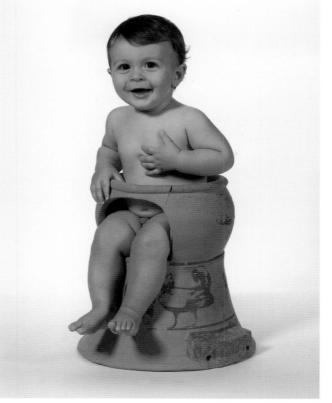

FIGURE 142

FIGURE 141E

63. The lydion and bakkaris (Fig. 143)

P 15253, P 15265, P 15266, P 15267 (Painting no. 103)
Ca. 575–550 B.C. (P 15253); ca. 550–525 B.C. (P 15265–P 15267)
Tomb B 21:4 (R. S. Young 1951, grave 5: P 15253), tomb B 21:5
 (R. S. Young 1951, grave 10: P 15265–P 15267)
Height: P 15253: 0.082; P 15265: 0.105; P 15266: 0.068; P 15267:
 0.063
Shear 1940, pp. 301–303, figs. 41–43; Young 1951, pp. 88–89, 91–92,
 figs. 7, 8, pls. 38f, 39a, 40a, 41a; *Agora* VIII, p. 58, no. 237 (noted);
 Agora XII, p. 157; *Agora* XIV, pp. 15–16, pl. 26a; cf. Shear 1930,
 pp. 422, 423, fig. 15.

Laconically referred to as "unguent-pots" in *Agora* XII and elsewhere, the usual name for this distinctive shape—lydion—indicates one possible source, and indeed numerous examples, especially those bearing the characteristic marbled decoration, have been found at Lydian Sardis. The shape, however, was clearly copied by Greek potters in a number of regional workshops, particularly in Ionia and East Greece generally, though scholars have identified, among others, Athenian and Lakonian versions of the shape. Of the lydia assembled here, P 15253 (Fig. 143, left) has been noted in the past as possibly Lydian, whereas the remainder are usually compared with Ionian products. The shape is characterized by a thick-walled, bulbous body, which greatly reduced the capacity of the vase, as well as a flaring foot and a neck that spread out to a, variously proportioned, flattish rim. The lydion as a pot appears to have been imported for its contents, particularly the so-called Lydian unguent known as *bakkaris*. Whatever the precise nature of this substance, the shape of the lydion—with its wide, open mouth—suggests that it cannot have been a liquid. Although a number of less complete lydia are found in wells in the area of the Classical Agora, most of the intact examples come from graves. All four examples of the shape illustrated by Piet de Jong were found in 6th-century B.C. tombs in the Archaic cemetery on the west slopes of the Areiopagos. Lydia, whenever they are found in burials, normally occur in small numbers, ranging from one or two to several in a given tomb. This is a pattern repeated myriad times across the Greek world, from nekropoleis in Samos to the burial grounds of Archaic South Italy. The first complete lydion found at Corinth, published by T. Leslie Shear in 1930, was found "lying in the earth beside a stone coffin which had been previously opened." This is an intriguing pattern, because unlike other small commodity containers, such as Corinthian aryballoi and alabastra, lydia are relatively uncommon in domestic contexts or as votive offerings in sanctuaries, but popular as small personal belongings accompanying the dead.

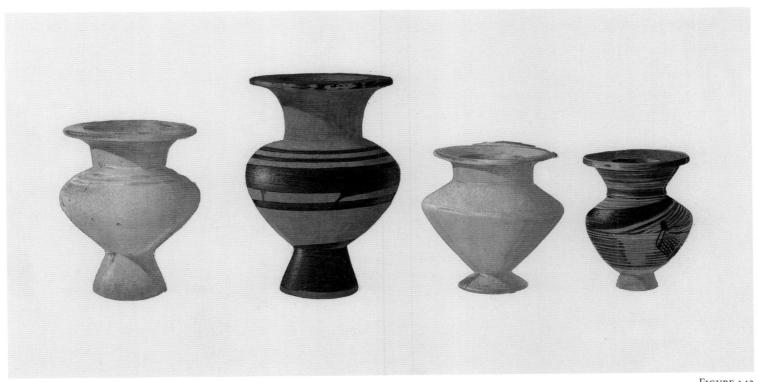

FIGURE 143

64. The kneeling boy (Figs. 144a–c)

P 1231 (Painting nos. 185, 219; PD no. 476)
Ca. 540–530 B.C. (context ca. 575–535 B.C.)
Rectangular Rock-cut Shaft (at a depth of 16.25 m), deposit G 6:3
Height: 0.255
Shear 1933b, p. 459, fig. 8; Vanderpool 1937; Vanderpool 1938,
 pp. 393–394, fig. 30; Lane 1948, pp. 43–44, pl. 61; Richter 1960,
 pp. 77–78; *Agora* XIV, p. 186, pl. 93; Camp 1986, pp. 133, 138,
 pl. VII; Camp 1990, pp. 250–251, no. 29, fig. 154.

In his seminal publication of this unique terracotta plastic vase, Eugene Vanderpool wrote, by way of introduction, the following paragraph that summarizes the salient features of this remarkable terracotta:

> The finest and most important piece of archaic art that has been found thus far in the Agora Excavations is a terracotta plastic vase in the form a kneeling youth tying a fillet around his head. The figure represents a victorious athlete and was probably intended to be dedicated to some divinity by the winner of an athletic contest. In spite of its small size . . . and the commonplace material of which it is made it is a work of art of the first rank, and as we study it we shall find that in quality it is to be compared not so much with other plastic vases and terracotta figurines as with the finest bronze statuettes and with monumental sculpture; that it is, in fact, a statue in miniature in which we can observe all the stylistic traits of contemporary sculpture.

In the Agora Museum and in most published photographs the piece is shown with a ribbon restored around the youth's head. The existence of such a ribbon is attested by the position of hands and fingers and on the analogy of contemporary vase painting. The figure is hollow, topped by a vase mouth, and served as a container for oil or some other liquid. A number of scholars, including Sir John Beazley, believed that the vessel was an import to Athens, probably of East Greek manufacture, and certainly there are a number of roughly contemporary East Greek vases in the Agora, such as the Fikellura amphora (no. 65) and the lydia (no. 63) illustrated in this chapter. Other scholars maintain that this is a little masterpiece of the mature Archaic art of Attica.

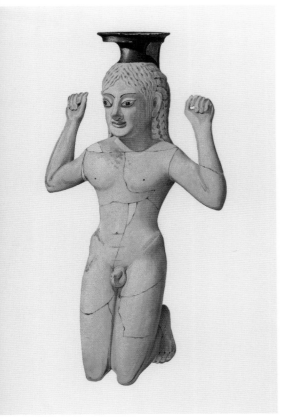

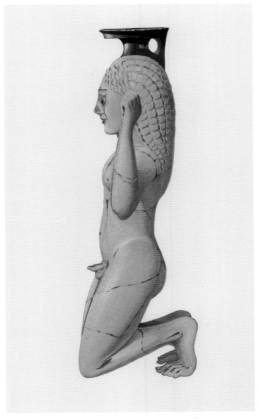

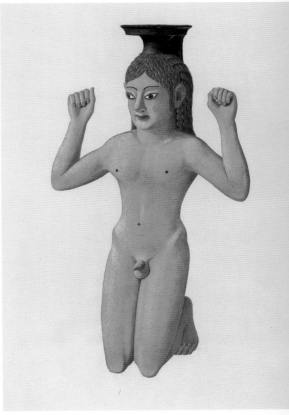

FIGURE 144A FIGURE 144B FIGURE 144C

65. FIKELLURA AMPHORA (FIG. 145)

P 13009 (Painting no. 133)
Context no later than ca. 500 B.C.
Well U 24:1
Height: 0.285
Shear 1939a, pp. 234–235, fig. 32; noted *Agora* XII, p. 192, n. 32,
 p. 399 (under U 24:1); cf. Boardman 1998, pp. 147–148; Cook
 and Dupont 1998, pp. 77–78.

One of the most distinctive ceramic finds of the 1938 season of excavations in the Athenian Agora was the imported East Greek small amphora or amphoriskos P 13009. The vessel is a characteristic example of a style of pottery that has come to be known as Fikellura, which takes its name from the locality at ancient Kameiros on Rhodes, where one of the first finds of this ware was made. Long considered to be either of Rhodian or Samian manufacture, the style, which is easy to recognize, was a product of Miletos, and analysis of the fabric has indicated that the clay is Milesian, a conclusion supported by recent excavations at the site that show its frequency in Archaic deposits there. Developing out of the earlier 7th-century Wild Goat Style of Miletos, Fikellura pottery is believed to have been the inspiration of a single potter. The style came into being shortly before the middle of the 6th century B.C. and continued through the end of the century. From its inception, Fikellura ware introduced new decorative patterns and schemes that render it one of the most easily recognizable of Greek pottery styles. One of the most idiosyncratic of the new patterns is the row of crescents on the lower body, together with floral ornaments in black. The distinctive spindly shape of the small amphora is the second most popular in the repertoire after the broad amphora, and similar slim amphoras are also known in other East Greek styles, such as Klazomenian. The Fikellura style circulated widely in East Greece, particularly in Rhodes and Samos, and is well known at Milesian colonies in the Black Sea, especially Istria near the mouth of the Danube, where the style was imitated. Its occurrence farther west is less common, and P 13009 is one of the few examples of this ware to have been found in Athens.

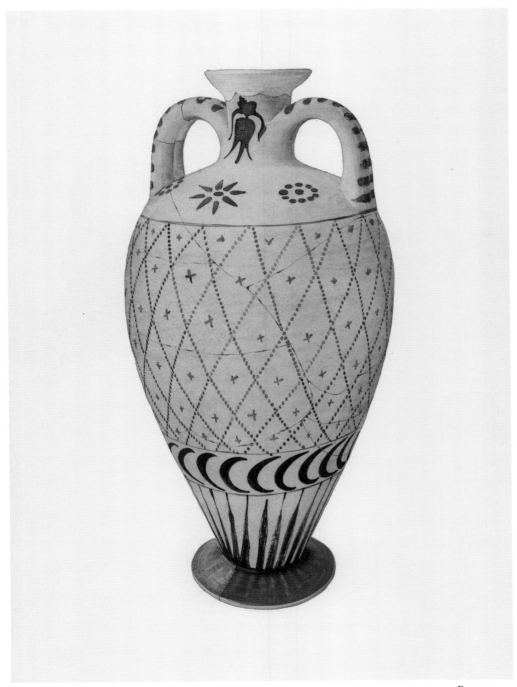

FIGURE 145

66. A TEMPTING RHYTON (FIG. 146)

P 3255 (Painting no. 180)
Late Archaic: ca. 500–480 B.C.
Section G in fill overlying bedrock, found in association with sherds
 of the 6th century B.C.
Height: 0.203
Shear 1934, p. 863, fig. 11; Shear 1935c, pp. 366–367, fig. 23.

The sobriquet "most curious ceramic object" reflects some of the bewilderment that this unique vessel caused among its excavators, who concluded that it was used "at more frivolous symposia to add to the merriment of the company." A perfectly rounded, now fragmentary clay tube forms a semicircle, which is supported on four small feet and terminates in a human head and arms at one end. The other end may originally have consisted of a rim around the main opening of the vessel but was broken and filed down already in antiquity, thereby upsetting the balance of the piece. Black gloss covers the "body," and there are traces of red paint on hair, cheeks, and arms.

An actual hole in the human mouth reveals the function of the object: it is a pouring vessel or rhyton, as the ancient Greeks would have called it. One could drink from a rhyton by directing the jet of liquid from the nozzle down one's throat, or decant it into a cup. One could also pour libations to a god or hero. The rhyton from the Agora with its apparently female spout seems to have been inspired by the same idea underlying contemporary Attic oinochoai and kantharoi formed as young women's heads: the all-male participants of the symposium receive their wine from a woman, in this case directly from her mouth. Our wine-bearing woman may in fact be irresistible. Although there are no specific bird-shaped elements, her curved body with four stumpy legs recalls Archaic and Classical siren vases. The rhyton appears to liken the effects of wine to the extreme bliss and oblivion caused by the sirens' song. The angle chosen by Piet de Jong for his watercolor leaves the lively impression of a woman singing, with her breast pushed forward and head thrown back. Her song is wine.

—*Susanne Ebbinghaus*

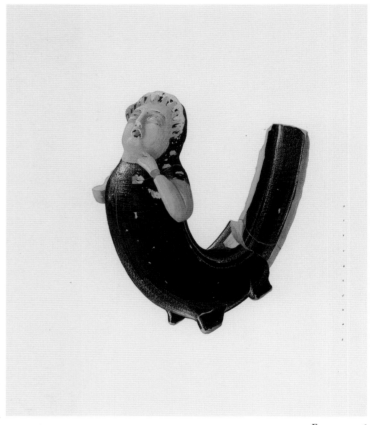

FIGURE 146

67. Mater Caelaturae (Figs. 147a, b)

T 563 (Painting nos. 238, 239)
End of the 6th century B.C.
Deposit E 14:11 (filling behind retaining wall, mostly 6th century
 B.C. and earlier)
Maximum preserved dimension: 0.053
Shear 1935c, p. 370, fig. 26; Thompson 1939, pp. 285–286; *Agora* XI,
 p. 37, n. 129; Nicolls 1984, p. 26, fig. 3.

Piet de Jong made two illustrations of T 563, one of the fragment as preserved (Fig. 147a), the other showing only the head of Herakles (Fig. 147b). The following description is taken from page 285 of Dorothy Burr Thompson's 1939 paper:

> *Plasticen matrem caelaturae et statuariae scalpturaeque dixit.* "Modelling," said Pasiteles, "is the mother of metal-chasing, of making statues, and of carving stone." Not only did the artist make studies and preliminary models in clay and wax, but throughout all his activities, he reverted to the softer media for testing his work. This modelling obviously differs considerably from the routine modelling and mould-making by the coroplast engaged in making figurines of commercial character. Thus when the excavations produced from the débris of metalworking establishments moulds for bronze-casting and moulds and trial pieces taken from metal originals, they were easily recognized. Though made of common clay, they retain with startling freshness the imprint of lost masterpieces of ancient casting.
>
> Of the clay impressions taken from metal originals only one is archaic. True to its age, it is a brilliant bit of modelling, a head not easy to forget, broken from a thin terracotta plaque. . . . A better preserved example from the Acropolis shows that the scene was the struggle of Herakles with the Nemean lion. The two pieces obviously derive from one original, though details, like the shape of the head, show that they come not only from different moulds but from different patrices. On the Agora piece traces of the paw of the lion clawing at the front of the head indicate that the position of the beast was identical on the two plaques.

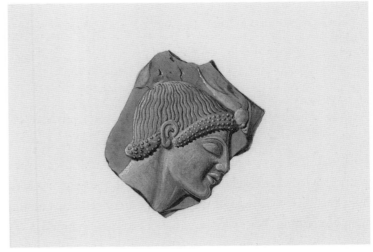

FIGURE 147A

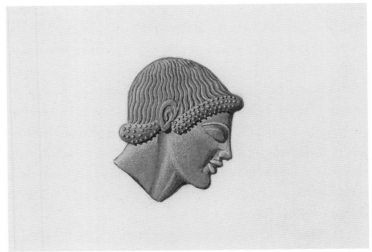

FIGURE 147B

68. WRITING ON POTTERY (FIGS. 148A–C)

P 6074 (Painting no. 13); P 12494 (Painting no. 11); P 5287, P 5299,
 P 4894, P 4891, P 4764, P 5355 (Painting no. 35)
6th century B.C. (P 6074); ca. 416 B.C. (P 12494); 480s B.C. (P 5287,
 P 5299, P 4894, P 4891, P 4764, P 5355)
P 6074: Archaic layer under the Hellenistic Metroon; P 5287,
 P 5299, P 4894, P 4891, P 4764, P 5355: mostly from building fill
 of the Strategeion(?), area E–F 12–14; P 12494: from the top of a
 6th-century B.C. well (P 8:5) (intrusive)
Maximum dimensions: P 6074: 0.102; P 5287: 0.135; P 5299: 0.11;
 P 4894: 0.085; P 4891: 0.106; P 4764: 0.073; P 5355: 0.107; P 12494:
 0.085
P 6074: *Agora* XXI, p. 7, no. A 2, pl. 1.
P 5287, P 5299, P 4894, P 4891, P 4764, P 5355: Shear 1936a,
 pp. 39–40, fig. 39; *Agora* XXV, nos. 136 (P 5287), 632 (P 5299),
 275 (P 4894), 1054 (P 4891), 29 (P 4764), 916 (P 5355).
P 12494: Shear 1939a, p. 246, fig. 47; Vanderpool 1972, pp. 227, 248,
 fig. 32; *Agora* XXV, no. 308.

Broken fragments of pottery had many potential uses, especially as writing materials. Excavations in the Athenian Agora have uncovered thousands of fragments scratched or painted with everything from shopping lists to names to practice alphabets or *abecedaria*, as here (Fig. 148a). *Abecedaria* were probably composed as learning aids or simply for fun, and in this example, the writer has made two tries; a first attempt may have been aborted because the letter *delta* was omitted. In the second line the sixth letter is *digamma*, which does not appear in literary texts.

Sherds (*ostraka*) were also part of the institution of ostracism, a practice by which the Athenians banished individuals considered a danger to public order for ten years and without loss of civic rights or property. *Ostraka* served as ballots onto which citizens wrote the name of the person they wanted to ostracize. Voters might also include the candidate's father, as on these *ostraka*, his deme, or both.

Thousands of *ostraka* survive, including over 1,200 from the Agora. The first group illustrated here (Fig. 148c) probably comes from the first ostracism, because it includes an *ostrakon* for Hipparchos, son of Charmos (Fig. 148c, top left). According to Aristotle (*Ath. Pol.* 22.3), Hipparchos was the first victim of ostracism in 487 B.C., and since he probably never returned to Athens, this *ostrakon*, and those with it, should date from

that year. But the luck of the others in this group was only temporary. Four of them—Megakles, Xanthippos, Aristides, and Themistokles—eventually suffered the same fate.

Ostracism remained in use throughout the 5th century, until ca. 416 B.C. At that time, the political leaders Nikias and Alkibiades realized that they were potential victims, so they joined forces and engineered the ostracism of the unpopular, and less prominent, Hyperbolos. An *ostrakon* against Hyperbolos from the Agora Excavations may illustrate their machinations. Texts on *ostraka* are usually incised into the surface of the sherd, but in this case, Hyperbolos's name has been painted (Fig. 148b), a possible indication that the ballot had been prepared beforehand for distribution to voters.

Individual *ostraka* also exhibit variations in orthography and spelling and thereby shed light on the literate habits of ordinary Athenians. The author of one of the ostraka wrote the letter *rho* twice in the name of Xanthippos's father, Ariphron (Fig. 148c, center right), which is normally spelled with a single *rho*, while the voter who composed the *ostrakon* against Themistokles (Fig. 148c, lower right) included two *sigmas* in his name. Noteworthy is the presence of an *omega* in the name of Themistokles' father, Neokles; that letter does not appear officially in the Athenian alphabet until the end of the 5th century B.C.

—James P. Sickinger

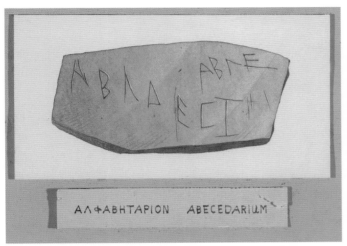

FIGURE 148A

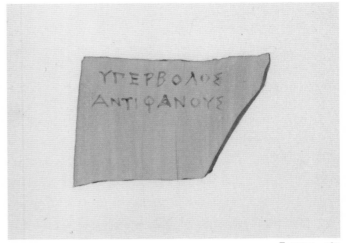

FIGURE 148B

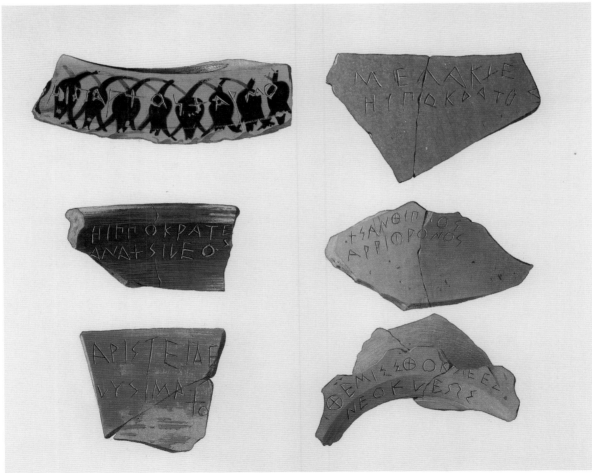

FIGURE 148C

69. A SEXUAL INSULT ON THE BASE OF A LEKANE (FIG. 149)

P 5157 (Painting no. 34)
Context ca. 470–460 B.C.
Well H 6:5 (well by stoa pier III)
Diameter of base: 0.133
Shear 1936a, p. 36, fig. 36; Beazley 1946, pp. 20–21; Milne and
 von Bothmer 1953, p. 218; *Agora* XII, p. 362, no. 1794, fig. 21;
 Agora XXI, p. 13, no. C 18, pl. 5.

Piet de Jong's watercolor of the inscription on the base of the fragmentary lekane was published as a black-and-white image by T. Leslie Shear in 1936. Shear presented the inscription in the form of a dactylic hexameter divided between the outer rim of the bottom of the base and its inner disc. Shear read the inscription as: "φησὶν ὁ γράψας Ε[ὐφρόν]ιος Σωσίας κατάπυγον," which he freely translated as: "Euphronios who painted the vase (or scratched the inscription) says Sosias be damned!" Although admitting that all the letters were clear except those of the name Euphronios—which were deliberately deleted—Shear was firm in his belief that this was the Euphronios of vase-painting fame and went on to discuss the rivalry between Euphronios and Euthymides. A decade later, Sir John Beazley noted that the order of the words must be: "Σωσίας κατάπυγων. Εὐφρόνιος φησὶν ὁ γράψας," but did not question Shear's reading of Euphronios, though he added, "If the potters mentioned are the potters [Sosias and Euphronios], they must have been well on in years." Beazley's reading was subsequently accepted by various vase-painting authorities. In her catalogue of love names and hate names in *Agora* XXI, however, Mabel Lang correctly read the inscription as:

Σοσίας καταπύγον
hός φησιν ho γράφσας

More than this, Lang questioned altogether the identity of Euphronios: "Although it has been suggested that a name was obliterated before φησιν, it seems unlikely, since both paint

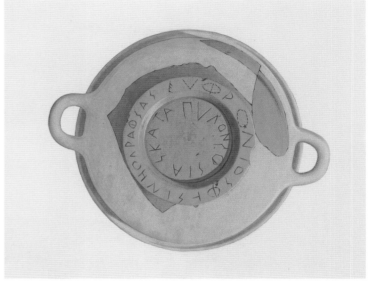

FIGURE 149

and surface are preserved." A recent examination of the piece confirmed Lang's conclusion. Consequently, following Lang's reading of the Greek, a better translation in English would be: "Sosias is given to unnatural lust! So says the writer." Since the graffito was scratched onto the underside of a lekane—not painted or incised prior to firing—the insult need not have anything to do with the potter Sosias. As patron of the artist, Shear asked de Jong to present in his watercolor a few letters that were never there and this de Jong performed flawlessly, though he carefully distinguished between real letters and those he reconstructed.

70. ATHENIAN COMEDY IN COLOR (FIGS. 150A–E)

P 23856, P 23900, P 23985, P 23907, BM 98.2-27.1 (Painting nos.
 359, 357, 358, 356, 360)
Context ca. 420–400 B.C.
Well Q 15:2, north of the Nymphaeum (except for Fig. 150e)
Height: P 23907: 0.245; P 23900: 0.245; P 23985: 0.155 (maximum
 dimension); P 23856: 0.140 (as preserved)
Crosby 1955; Webster 1960, pp. 261–263, pl. 65; Richter 1965,
 p. 340, fig. 458; Thompson 1971, front cover; Lang 1974, fig. 50.

Four oinochoai (Figs. 150a–d)—found in 1954 in the same late-5th-century B.C. well in the southeast corner of the market square, close to the Panathenaic Way and to the north of the Nymphaeum—together with a fifth similar vase now in the British Museum (Fig. 150e) are technically unique, decorated with polychrome paint laid directly on the unglazed surface of the pot and then fired. The oinochoai themselves, made of thin, gritty, micaceous fabric, are ordinary domestic jugs familiar to many ancient Athenian households. They were made and decorated by the same person—the complete specimens have a height of 0.245 m—with scenes connected with the theater, specifically Old Comedy, in a highly individual style, referred to by Gisela Richter as burlesque. First published by Margaret Crosby, the five jugs are the Athenian counterparts of the South Italian phlyax and the Boiotian Kabeiric vases. The fact that three of the five scenes have parallels from South Italy reinforced the belief that the phlyax vases reflected scenes from Athenian comedy. One of the oinochoai (Fig. 150a) shows Tyro and her sons, Pelias and Neleus, identified by the fragmentary inscription restored to read: [ΠΕΛΙΑ]Σ ΤΥΡΩ ΝΗΛΕΥΣ. Another (Fig. 150b) shows a sexless, clean-shaven reveler or komast—to be clean-shaven for Aristophanes, as T. B. L. Webster cogently noted, meant effeminacy and worse. A third oinochoe (Fig. 150d), the one most often illustrated, depicts two bearded running figures carrying a large white object on a spit, interpreted as an "obelias cake" (ὀβελίας ἄρτος)—and thus the fig-

ures are obeliaphoroi—while the fourth Agora oinochoe shows Dionysos (identified by a fragmentary inscription), together with a companion (Fig. 150c), thus far known by the first three letters of his name: ΦΟΡ (conceivably, but not certainly, Phormion). Dionysos and friend are shown as grotesquely fat figures facing each other with an indeterminate object, possibly a dog, between them; Dionysos is in no way distinguished from ordinary mortals and the exaggerated fatness of god and companion suggests the padded figures of comic actors. The final oinochoe (Fig. 150e) shows a man seated on a blue fish rowing with a pair of very long oars; related figures in South Italy have been interpreted as either Taras or Arion, but Webster prefers to see this figure as a chorus man, like the "Gentlemen Fish" who formed the chorus of Archippos's *Ichthyes*, and the long oars as stilts, between which a canvas fish was suspended. In her publication of the oinochoai, Crosby asked, "[W]ere these informal pots perhaps not made to be sold at one of the festivals of Dionysos, possibly the Anthesteria?" In a similar vein, Webster saw the five oinochoai as part of a set made for a particular occasion, but more specifically for the production of a successful comedy, and he visualized a contemporary play, with a chorus of fishmen, containing scenes for Tyro, Pelias, and Neleus, a clean-shaven reveler without phallos—perhaps a poet on his way to or from a party—two men carrying a giant cake, and, of course, Dionysos and his companion.

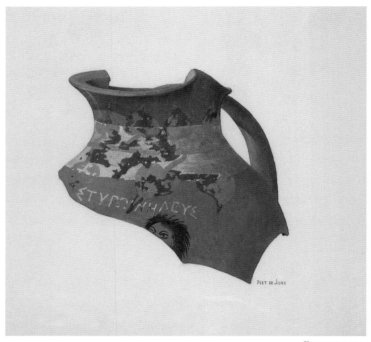

FIGURE 150A

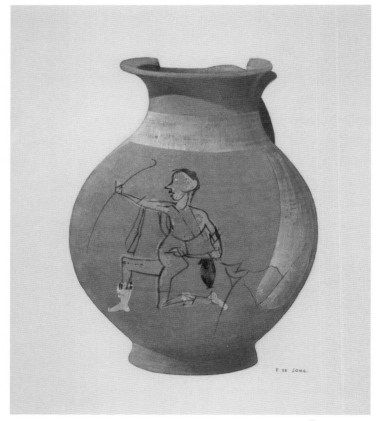

FIGURE 150B

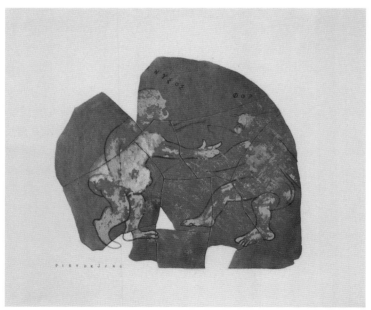

FIGURE 150C

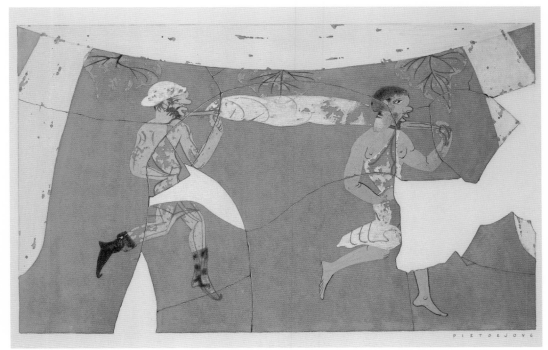

FIGURE 150D

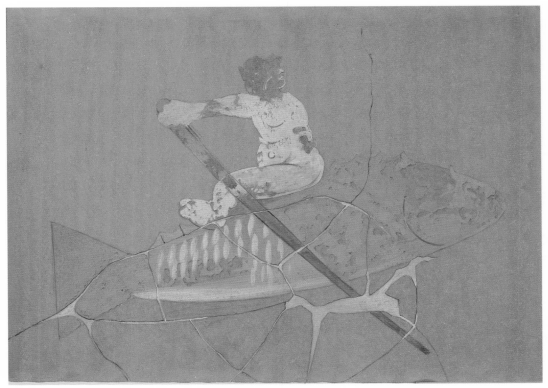

FIGURE 150E

71. A SIX-MINUTE TIMER FOR THE LAWCOURTS (FIGS. 151A, B)

P 2084 (PD nos. 468, 467)
Beginning of the 4th century B.C.
Well H 12:11
Height: 0.232; capacity: 6.4 liters
S. Young 1939; *Agora* XXVIII, pp. 77–78, 226–230, pl. 13; Camp
 1990, pp. 244–245.

Discovered in a well some two meters to the southeast of the Tholos precinct wall, the unique example of a klepsydra illustrated here is one of the most characteristic aspects of the Athenian lawcourts. The identity of this distinctive pot was established by Suzanne Young in 1939, with subsequent information, including testimonia, assembled in *Agora* XXVIII. In the *Athenaion Politeia* (67.2), Aristotle explains:

> There are klepsydras with small tubes for outflow into which they pour water against [whose flow] the litigants must speak at their trials. Ten choes are given for cases involving over 5,000 drachmai and three choes for the second speech, seven choes for those up to 5,000 drachmai and two choes for the second speech, five choes for those under 1,000 and two choes for the second speech, and six choes for suits involving rival claims for which there is no second speech. He who has been chosen by lot to measure the water stops up the tube when the secretary is about to read a statute or law or testimony or agreement.

In keeping with Aristotle's testimony, this klepsydra (Fig. 151a) holds two choes, as the painted inscription XX indicates. As Mabel Lang explains in *Agora* XXVIII, two such vessels appropriately placed (Fig. 151b) could be used for all the private cases specified by Aristotle that involve two choes (6.4 liters) or a multiple of two. The vessel has a small, bronze-lined outlet at the bottom and a larger hole under the rim that allows it to be filled to exactly the same level each time. The lower hole was closed with a stopper until the speaker began; the plug was then removed and the speaker could continue until the water ran out. It took about six minutes for this two-choes klepsydra to discharge its water. On the upper wall of the vessel are faint traces of the word Ἀντιοχ[ίδος], the name of one of the ten tribes of Athens, indicating tribal ownership.

FIGURE 151A

FIGURE 151B

72. An official Athenian dry measure (Figs. 152a, b)

P 3559 (Painting nos. 181, 241)
Second half of the 4th century B.C.
Cistern shaft F 11:2, west of the Tholos
Height: 0.132
Shear 1935c, pp. 346–347, fig. 5; H. A. Thompson 1937, p. 165,
 fig. 98b; *Agora* X, p. 52, no. DM 44, pls. 14, 18, 34.

Found throughout the area of the Classical Agora, in a variety of contexts, were a number of official Athenian dry measures. The example illustrated here (Fig. 152a) by Piet de Jong was found on the west side of the Agora, not far from the Tholos. The vessel was mended from many joining fragments, with the missing parts restored in plaster. In typical fashion, de Jong went to great lengths to render as carefully as possible the various fragments and missing segments. Around the cylindrical measure, on the upper wall, in large letters, was painted δημόσιον. According to Mabel Lang in *Agora* X, the gender of *demosion* probably requires *metron* to be understood. Between the first and last letters is a stamp with the head of Athena, painted separately by de Jong (Fig. 152b); between the M and the O is a stamp with a double-bodied owl and the letters AΘE (Fig. 152a). The latter stamp is a larger version of the diobol coin type of early-4th-century B.C. Athens. Marks on the rim interior were for the attachment of a handle, which does not survive, and there is evidence to suggest that the inside wall was thickened by adding clay. The capacity of the measure is about 1.7 meters, the equivalent of 1½ *choinikes*. According to a variety of ancient sources, one Athenian *choinix* was the equivalent of four *kotylai*, and 48 *choinikes* made up a *medimnos*. These, together with the *hekteus* and *hemihekt*, were the principal units of Athenian dry measures.

FIGURE 152A

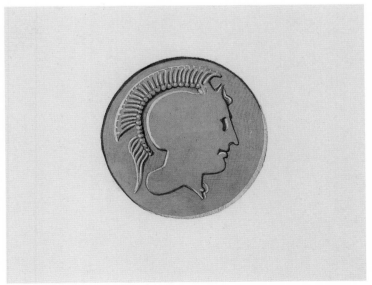

FIGURE 152B

CHAPTER 8

Athenian Black-Figured
and Black-Gloss Pottery

Kathleen M. Lynch

73. An early Attic black-figured amphora by the Nettos Painter (Fig. 153)

P 1247 (Painting no. 290)
Nettos Painter
Ca. 610 B.C.
From lower fill of the Rectangular Rock-cut Shaft (G 6:3); fill deposited during the 6th century B.C., but closed with fill from the Persian destruction of Athens in 479 B.C. See also P 1544 (no. 86) and P 1257 (no. 78). For upper fill, see discussion under P 2698 (no. 96).
Height: 0.457; maximum diameter: 0.345
Agora XXIII, p. 115, no. 117, pl. 13; *ABV*, 5, 2; *Para*, 2, 4; *Add²*, 2; Shear 1933b, pp. 457–458, fig. 6 (unrevised); Shear 1933d, pp. 292–293 (unrevised); Thompson 1933, pp. 293–294, fig. 3; Dugas 1935, p. 124, fig. 17 (unrevised, engraving after); Vanderpool 1938, pp. 367–371, no. 1, figs. 1–4 (fig. 4 = revised); Kübler 1950, no. 83, fig. 16 (unrevised); Scheibler 1961, pp. 39–40, fig. 37 (revised); *Agora* XIV, p. 15, pl. 25 (revised); Müller 1978, p. 254, no. 168, pp. 112–116; Beazley [1951] 1986, p. 14, pl. 12.1; Richter 1987, p. 299, fig. 417 (revised); Palaiokrassa 1994, pp. 4–5, pl. 2A (revised).

The lower fill of the Rectangular Rock-cut Shaft was formed around 540 B.C. but contains a number of objects that date significantly earlier. As described in the entry for no. 96, the shaft was probably constructed as a well but failed to function and thus became a convenient pit for refuse. The lower, earlier fill seems to be a mix of typical household material and special purpose vases (see also the pyxis, no. 78 [P 1257]). One of the most magnificent pieces from the deposit is this large amphora with sphinx decoration, which probably once adorned a grave (Fig. 153). The shape, a one-piece amphora, meaning that the neck was formed with the body and not added separately, is a form with funerary associations, although not exclusively. The lower deposit contained other one-piece amphoras, pyxides, and the celebrated kneeling boy figurine vase (no. 64). This assemblage suggests that the material represents the cleaning up of either a cemetery and grave offerings or offerings from a nearby shrine. The sphinx amphora was reassembled nearly completely, indicating that it was tossed into the shaft whole. The apotropaic sphinx is an excellent choice for a vase to mark a grave, and it is around this time that stone grave stelai begin to feature sphinxes.

The Nettos Painter, also known as the Nessos Painter, represents one of our earliest Attic black-figure painting personalities. This is the only piece certainly attributable to him from the Agora Excavations, although there are a dozen or so others that may be associated with him and his workshop. The majority of his work stayed in Attica and Aigina, and a number of pieces are known from cemetery sites.

The painting of the amphora by Piet de Jong preserves rare evidence of revision by the artist. The painting was originally published by T. Leslie Shear in 1933, but then it was revised and corrected for Vanderpool's definitive publication in 1938. The differences between the revised and unrevised versions are in the subsidiary decoration, but they are significant changes. Although the surface of the vessel is very worn (Fig. 154), the artist should have been able to see the designs in 1933. For example, the form of the curlicues on the neck and the rosettes on the rim were altered, and two of the dot rosettes on the body were removed. De Jong also eliminated the reserved band on the foot, among other more minor changes. These changes are still visible as pentimenti under the second application of gouache (see Chapter 2 on the painter's medium and technique).

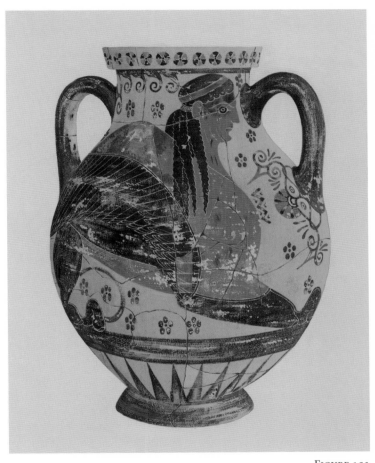

FIGURE 153

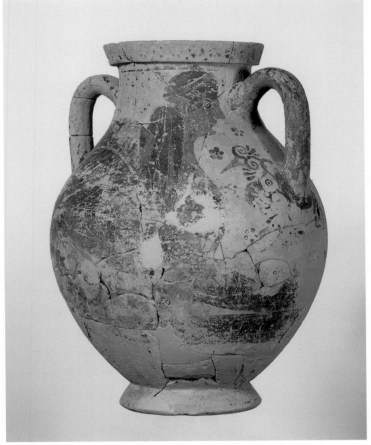

FIGURE 154

74. Black-figured horse-head amphora (Fig. 155)

P 12526 (Painting no. 136)
"The Horsehead Amphorae"
Early 6th century B.C.
Well R 17:3, located in the southeastern corner of the open space of
 the Agora
Preserved height: 0.257; diameter: 0.194; diameter of mouth: 0.109
Agora XXIII, p. 102, no. 13; *ABV*, 17, no. 43; *Add*², 5; Shear 1939a,
 p. 229, fig. 25; Picozzi 1971, p. 12, no. 2, pl. 2; Birchall 1972, p. 57,
 no. 12, unassigned I.

This vessel is a member of a large group of similar amphoras that were probably made for funerary purposes. The series begins in the last years of the 7th century and continues to the middle of the 6th century B.C. The form is always a one-piece amphora (type B) that has a pleasing, continuous profile from the neck, through the bulging middle to the foot. The handles on this type are always round in section. Painters decorated the shape in various ways, but in the early years of the 6th century B.C. they preferred to restrict the figural design to a reserved panel on the upper portion of the body and neck, surrounded by black. Each side usually bears the same image. In our case the image is the upper part of a horse's head and neck. This horse is early in the black-figure tradition, and the representation itself is, as Beazley proclaims, "fantastically mannered." The mane, eye, and bridle are reduced to incised decorative patterns. Even the curvilinear outline of the form echoes the sinuous curves of the linear details. Some of the horse-head amphoras have been found in graves, a few with the ashes of the deceased still in them. Others seem to have been used as offerings or to mark graves. The horse in ancient Greece implies wealth and status, and it carries a heroic quality, making it an appropriate image for funereal objects. To our modern eyes, the simple iconography of the vessel also evokes the solemnity of death. This example, from a domestic deposit, however, complicates our understanding of the function of this series. Did this amphora break before it could be used? Or was it in use in a household?

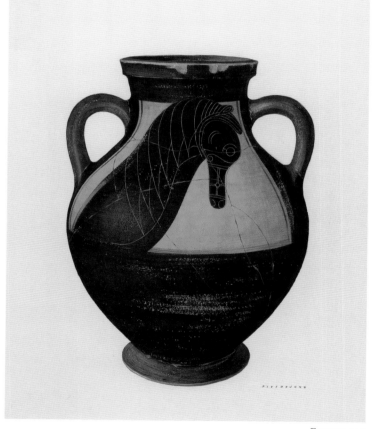

FIGURE 155

75. ORIENTALIZING LEKYTHOS WITH CONFRONTED COCKS
(FIG. 156)

P 3287 (Painting no. 26)
Unattributed
Ca. 600 B.C.
Well I 14:1, located in the southwestern corner of the open area of
the Agora
Height (without handle): 0.168; (with handle) 0.182; maximum
diameter: 0.128
Agora XXIII, p. 202, no. 787, pl. 73; Karo 1934, col. 135, fig. 6; Shear
1935c, p. 365, fig. 22.

Two cocks, facing an elaborate, intertwined lotus and palmette motif, adorn the body of this unusually rotund lekythos. It dates to the early years of black-figure in Athens and to the beginning of the enduring lekythos tradition of Greek pottery. The form seems to be an experimental cousin of the more popular and more slender Deinaira shape. The cocks on this vase are certainly decorative, and their artistic heritage lay in Orientalizing motifs of heraldic animals and frieze of animal procession. The cock, though, has other meanings in Greek culture. Sokrates' last words to his companion Crito, "We owe a cock to Asklepios" (Plato, *Phaedo* 118.a.7–8), indicate that a rooster could be a suitable offering to the gods. The cock was also a suitable gift for an older man to give to his younger beloved. Roosters seem to have been both a practical aspect of the home economy (raising hens for eggs) and a pet of sorts for young boys. A relief sculpture from the Acropolis shows boys engaging their leashed birds in a cock fight. Here, on a lekythos, a vessel that probably held a perfumed oil, the cock more likely refers to the world of love than gods.

In this painting, Piet de Jong suggests the fragmentary and worn condition of the vase, but he minimizes the fractures and the loss of glaze from the surface. His depiction of the incision and the flaking of the glaze at the edge of incised lines is remarkably realistic, although this detail improves on the actual condition of the vase.

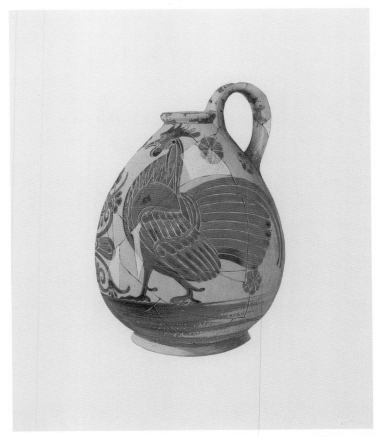

FIGURE 156

76. Conical black-figured support with animal friezes (Figs. 157a, b)

P 13012 (Painting nos. 263, 264)
Unattributed
First quarter of the 6th century B.C.
From use deposit in well V 24:2, located on the lower slopes of the Acropolis
Preserved height: 0.32; diameter at base: 0.34; diameter at top: 0.145
Agora XXIII, p. 171, no. 550, pl. 52; Shear 1938b, p. 59, fig. 14; Jantzen 1938, p. 550, fig. 7; Shear 1939a, p. 230, fig. 28; Lamberton and Rotroff 1985, fig. 6.

This support was once attached to a round-bottomed mixing vessel, possibly a krater or lebes, which has broken off from the stand. The support bears four registers of animal friezes. The bottom features a simple but rhythmic array of grazing geese while the upper registers present a variety of creatures. Piet de Jong prepared two views of the animal friezes. Since the friezes were continuous, there is no front to the support. In the portion illustrated in Figure 157a, we see the following: two lions posed heraldically; two puffed-up cocks flanking a lotus and palmette motif, their avian cousin the siren looking on; and a boar flanked by panthers. The heraldic lions, mouths open in a roar, and the panthers contemplating the large boar refer to the virtues of strength and power. The boar denotes the practice of hunting, echoed in the line of fowl below. This juxtaposition of traditional power symbols with references to the hunt reflects the heroic qualities associated with the hunting of wild animals by the Greeks. Victory in the hunt paralleled the ultimate victory—in battle. The cocks refer to a traditional love gift from older men to their young male beloveds, yet another kind of "hunt." The siren may be a subtle reminder of the turmoil of love. Another view of the stand (Fig. 157b) shows additional animals, including rams, geese, a panther, a boar, and a flying bird.

Animal friezes such as this have their origin in the Orientalizing tradition of the preceding century. During the 7th century B.C., Greece was particularly receptive to the traditions and artistic style of the Near East and Egypt. Motifs such as the heraldic lions and grazing geese entered the Greek artistic repertoire, where they matured into a style that is distinctively Greek. By the middle of the 6th century B.C. the monotony of these animal friezes gave way to more complex narrative scenes in Attic black-figure.

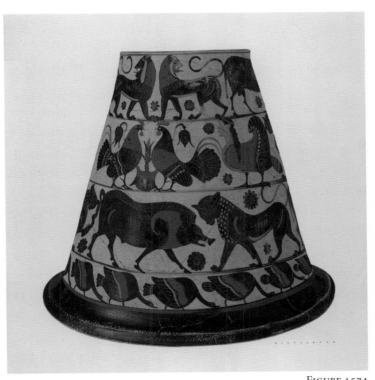

FIGURE 157A

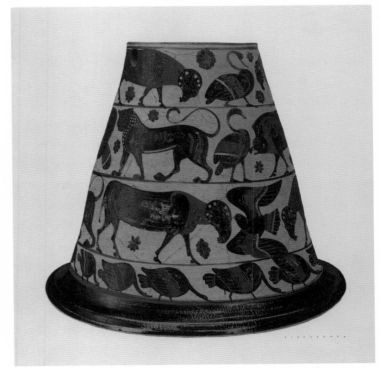

FIGURE 157B

77. Black-figured dinos with the Kalydonian boar hunt (Fig. 158)

P 334 (Painting no. 257)
Connected with the Group of the Dresden Lekanis
Ca. 580–570 B.C.
G 15:3, filling of the early 6th century B.C.
Height: 0.20; diameter (rim): 0.30
Agora XXIII, p. 178, no. 610, pl. 58; *ABV*, 23 (middle); *Add*², 7;
 Shear 1932, p. 387, fig. 6; Shear 1933b, p. 468, fig. 17; Young 1935;
 Brommer 1973, p. 310, bottom no. 2, p. 496, top no. 3; *LIMC* II,
 1984, pp. 940–950, no. 1, pl. 687, s.v. Atalante (J. Boardman);
 Immerwahr 1990, no. 76, pl. 3.15; Barringer 1996, fig. 14a, b;
 LIMC VIII, 1997, pp. 545–549, no. 8, pl. 353, s.v. Canes
 (G. Berger-Doer).

This fragmentary vessel is a dinos, a bowl used for the preparation of the wine and water mixture consumed at the symposium. It is round-bottomed and thus cannot stand by itself. It requires a support such as no. 76 (P 13012). The large, rounded form of the dinos has its origins in the bronze cauldrons popular in Greece since the Iron Age. As if to underscore this formal relationship, a bronze tripod cauldron is depicted at the far left of the fragmentary middle scene. The scenes on this vessel provide evidence of the lively period of early black-figure painting in Attica. The pot bristles with activity, but the focus is on the center of the middle band where we find the hunt for the Kalydonian boar. The boar has already killed a man, labeled Pegaios, who lies on the ground, blood streaming from his body. We know he is dead, for the painter has drawn an "X" over his still open eye. On the better-preserved left side of the fragment a nude man called Akastos approaches the boar with a spear in his right hand and knife in his left. In front of him a dog, named Theron, attacks the haunches of the massive boar. A draped figure at left is about to throw a red rock. In his left hand he holds the leash to an oddly shaped dog, rendered in outline, with an incised eye and mouth. We would call this a dachshund-like dog, but the animal could be a ferret or a martin, both of which were pets in antiquity. On the more fragmentary snout side of the boar appear the heads of the two canonical heroes associated with this myth: Meleager and Atalante. The name of the male is only partially preserved but the initial M is clear; the second head is beardless and is named ΑΤΑΛ . . . , although the painter does not follow the convention of added white for female flesh. The inscriptions are added in red, and they attest further to the pride and confidence of painting in this early, experimental period.

The central band includes other scenes unrelated to the boar hunt. At the far left of our fragment is the already mentioned tripod cauldron, behind which a man with a knife stands. He faces left toward a fragmentary galloping horse. It is possible that he is officiating at a horse race for which the prize is the tripod. In between this scene and the boar hunt is a scene of an ithyphallic, shaggy satyr harassing a maenad, who prepares to throw a rock at him. The rock-throwing analogy with the boar hunter may be a visual pun, for the upper band of the dinos preserves a raucous drinking scene. The majority of the top band on the preserved fragment is a lotus and palmette chain, which the painter has rendered with great care and detail. His care is paralleled in the care of Piet de Jong's painting of it. The third band, below the boar scene, features a frieze of parading animals. The incised details here are confident and meticulous, a quality that de Jong's painting captures marvelously.

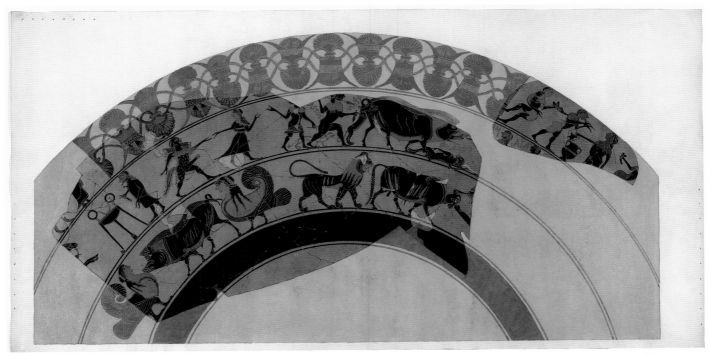

FIGURE 158

78. BLACK-FIGURED CORINTHIAN-TYPE PYXIS (FIG. 159)

P 1257 (Painting no. 125)
Unattributed
Ca. 575–550 B.C.
Lower fill of the Rectangular Rock-cut Shaft (G 6:3); shaft was used
 through much of the 6th century B.C. as a dumping area, but the
 deposit is closed with a substantial amount of debris from the
 Persian destruction of Athens in 479 B.C.
Height: 0.135; diameter: 0.143
Agora XXIII, p. 254, no. 1266; Shear 1933b, pp. 458–459, fig. 7;
 Shear 1933d, pp. 292–293; Shear 1933f, p. 328, bottom; Karo 1933,
 col. 203, fig. 4; Vanderpool 1938, pp. 393–396, 398, no. 31, figs.
 31–33; Matz 1955, p. 43, fig. 1; Brommer 1973, p. 84; *LIMC* IV,
 1988, pp. 808–809, no. 1428, pl. 538, s.v. Herakles (J. Boardman).

In this watercolor (Fig. 159), Piet de Jong demonstrates the advantage of his skills to archaeologists and art historians. The actual surface of this vessel is greatly abraded, as can be seen in the photograph (Fig. 160). The surface does preserve a ghost of the black-figured decoration and faint indentations of the incision. De Jong was able to reconstruct the scene accurately and in the appropriate style from these scant traces. In his painting he has also restored the missing handles and eliminated the fractures, thus presenting an unencumbered image of the original vessel. He does, however, represent the actual streaky condition of the surrounding black glaze, even carrying the streakiness onto the restored handles. The shape is a pyxis, used for the storage of cosmetics or jewelry, and is usually associated with women. The form of this pyxis, the Corinthian type, refers to the globular body and upright rim. The handles on the form vary in their position and orientation. The two upright handles here cause the pyxis to recall the shape of the marriage vase, the *lebes gamikos*.

The scene of Herakles driving a chariot drawn by two centaurs is not well known in Archaic or Classical Greek iconography but became popular in the Roman period in media ranging from mosaics to coins. His pose with his club raised threateningly and one foot braced against the chariot pole characterizes this as a battle scene; Herakles assumes the same position in the gigantomachy, the battle of the gods against the giants. We have no literary references to Herakles fighting from a centaur-driven chariot, although the scene may be an allusion to his battle with the drunken centaurs at the cave of Pholus (Apollodorus, *Bibliotheca* 2.5.4). It is also possible that the juxtaposition of the hero and the unlikely transport are meant to be humorous.

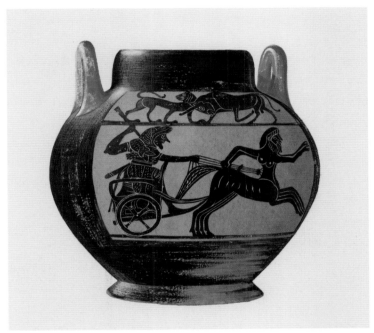

FIGURE 159

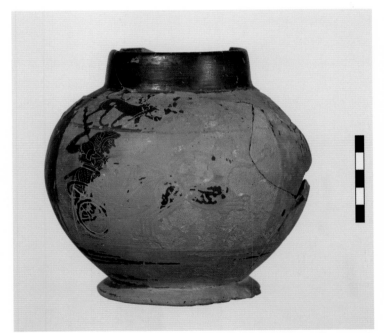

FIGURE 160

79. Alabastron by the Amasis Painter (Fig. 161)

P 12628 (Painting no. 135)
Amasis Painter
Ca. 560 B.C.
Well Q 18:1, located in the southeastern corner of the open area of the Agora
Preserved height: 0.092; diameter: 0.047
Agora XXIII, p. 253, no. 1257, pl. 88; *ABV*, 155, p. 688, no. 64; *Para*, 64; *Add*², 45; Shear 1938b, fig. 15; Vanderpool 1939, pp. 247–255, no. 1, figs. 1–7; Karouzou 1956, p. 35, no. 60, pl. 11; Amyx 1958, p. 215, n. 113; von Bothmer 1985, p. 43, fig. 34.

The shape of this vase, an alabastron, has its origins in Egypt, where the form appears in alabaster. In the Attic clay version the body becomes squatter than its Egyptian cousins, and the surface receives banded decoration. Eight figures fill the central band of this small vessel, yet they do not appear cramped in their frieze. The style is unmistakably that of the black-figure painter named the Amasis Painter. Although his real name does not survive, one can recognize his style on a range of shapes signed by a potter named "Amasis." There is much discussion over the meaning of the two types of signatures that appear on vases, but traditionally the one who signs *epoiesen* is taken to be the potter. In the case of the Amasis Painter, there is some speculation that the painter and potter are one and the same, although no signature of Amasis as painter, *egrapsen*, survives. The watercolor effectively captures the distinctive style of the Amasis Painter. He is equally happy painting on a miniature scale, as here, or on large amphoras. His slender figures stand tall and gesture with emotion and meaning. The careful detail of the painting and incision also define his style. All elements, from the figural scene to the subsidiary geometric bands, are meticulously finished. This illustration shows the ample added white and red used by the Amasis Painter. These painted touches liven up the surface, but since the figures do not adhere to perspective or gravity, they reinforce the surface of the vessel. The band of zigzag lines above the figural scene is another distinctive characteristic of this painter.

The iconography of the scene remains unclear, although the watercolor facilitates the study of the vase by unrolling the two scenes. At the center of one side is a running winged goddess between two standing men with spears. The goddess may be Artemis or Iris, but without attributes or narrative context her identity remains uncertain. The opposite side features a departure scene. Three draped but nude youths, two with spears, take their leave from two older men. The urgency of the action is implied by the movement and gestures of the youths.

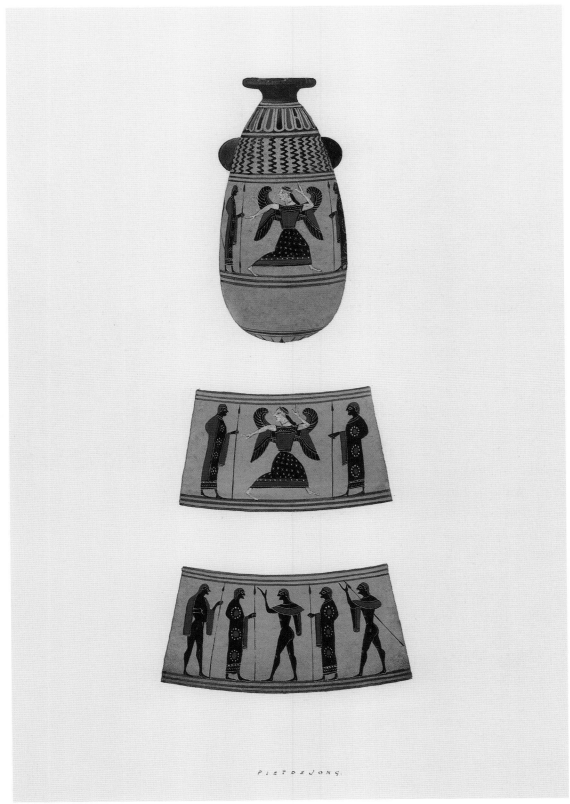

FIGURE 161

80. Black-figured tripod plate fragment with Herakles fighting the Amazons (Fig. 162)

P 1599 (Painting no. 128)
The Marmaro Painter
560 B.C.
Area J 12, near the southeastern corner of the open space of the Agora
Preserved height: 0.072; maximum diameter: 0.11
Agora XXIII, p. 272, no. 1426, pl. 97; *ABV*, 198, no. 3; *Add*[2], 53; Shear 1933e, p. 310, fig. 18; Shear 1935b, pp. 325–326, fig. 13; von Bothmer 1957, pp. 9, 24, no. 41, pl. 19:3; Brommer 1973, p. 22, no. 39.

This fragment probably preserves one leg of a tripod plate—a shallow, flat bowl with three broad legs—although other tripod shapes are possible. The square panels of the legs invite decoration, but their scale forces the painter to work in a miniature style. The Marmaro Painter has not only utilized the square field well, but he manages to convey the rush of battle with a complicated but contained composition. The painter captures the energy of the battle through a clash of angles formed by Herakles' spear and the shield of the dying Amazon. The angle of her shield echoes outward in the parallel lines of her companions' shields and legs. A complex array of overlapping planes creates great spatial depth to the scene. In fact, the awkward position of Herakles' left foot, projecting out from under the body of the dead Amazon, indicates that the painter was pressing his skills to their limit. Herakles versus the Amazons was a popular Archaic and Classical iconographical theme. In this version of the conflict we see the hero facing four of the warrior women single-handedly. It proclaims not only his strength as a fighter but the virtue of male-dominated Greek culture over the weaker, female society of the Amazons. He looms over his victims in his lion skin, which amplifies his scale; his knobby spear here is unusual but, taken with the animal skin, may refer to the natural power of the hero.

Piet de Jong presents the fragment accurately with very little restoration. For example, he leaves the flesh of the Amazons as a gray hue instead of restoring it to its original white. In addition, he faithfully represents the quirky meander borders of the fragment.

FIGURE 162

81. Black-figured amphora with Pegasos (Fig. 163)

P 13027 (Painting no. 129)
The North Slope Group
550–525 B.C.
Upper fill of well U 25:2, an unfinished well shaft on the lower
 slopes of the Acropolis
Restored height: 0.25; diameter: 0.164
Agora XXIII, p. 108, no. 60, pl. 8 (side B); *ABV*, 129, no. 1; *Add*², 35;
 Brommer 1973, p. 303, no. 1, bottom; Camp 1998, p. 5, fig. 7.

The winged horse Pegasos is the offspring of the gorgon Medusa and the god Poseidon. The horse and his human-formed brother, Chrysaor, were born from the blood of their mother as she was beheaded by the hero Perseus. Pegasos is associated with the hero Bellerophon, who managed to bridle the mythical horse with the assistance of Athena while it stopped to drink from a fountain in his hometown of Corinth. Together Bellerophon and Pegasos go on to do combat with the Chimaera, a fantastic beast combining goat, lion, and snake. Pegasos is not the only winged horse in Greek mythology; occasionally winged horses draw the chariots of the gods, implying the extraordinary powers that they—and their conveyance—possess. On this small amphora we cannot assume the figure behind Pegasos is Bellerophon without an inscription or identifying attributes. The draped youth is a standard figure in vase imagery and may simply represent a groom as seen on other vases with conventional horses waiting to be mounted. The outstretched tail and raised front hooves of the horse provide a feeling of action, as if the winged horse has just landed or will momentarily leap off the vase. The four dots below the horse may be filling ornaments, but to the modern eye they remind us how comic-strip puffs of dust are used to imply speed. The same scene appears on both sides.

Piet de Jong's painting presents the vase in a better condition than it really is. He restores missing pieces and gives the painter a steadier hand than is apparent on the vase. For example, the incision on Pegasos's wings appears fine and controlled in de Jong's rendition. On the pot itself, the incised lines vary in width and depth, creating a scratchy appearance. The quality of the vase-painter's work on this vase, and many others mass-produced like it, is less skilled than the work of contemporaries such as the painter Exekias and his students.

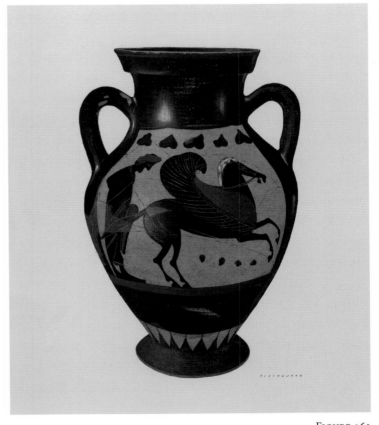

FIGURE 163

82. The North Slope krater: A black-figured kalyx-krater by Exekias? (Figs. 164a, b)

AP 1044 (Painting nos. 375, 376)
Ca. 525 B.C.
From a well along the north slope of the Acropolis
Height: 0.445; diameter top: ca. 0.53; diameter foot: 0.29
ABV, 145, no. 19, 672, no. 4; *Para*, 60; *Add*², 40–41; Broneer 1937, 1956; Beazley [1951] 1986, pp. 64–65; Moore 1986; Mackay 1988, 1999.

During the 1930s Oscar Broneer excavated the northern slopes of the Acropolis overlooking the Agora area. He revealed a number of intentionally filled wells put out of use roughly simultaneously in the last quarter of the 6th century B.C. These deposits contained many fine objects originating from the sacred spaces of the Acropolis and its slopes. When fragments of this black-figured krater emerged from the mud of the well, Broneer wiped away the dirt and immediately attributed the painting to the black-figure master Exekias, although the surviving fragments of this krater do not preserve his signature. Recently, other scholars have suggested that idiosyncrasies of the painting style better place this krater with a painter near Exekias or the Lysippides Painter, a student of Exekias who had mastered the great painter's style. Regardless of the exact attribution, the krater demonstrates monumentality paired with delicacy of detail that black-figure achieved at its peak. Piet de Jong captures the magnificent detail rendered by the vase-painter's hand. He faithfully records the meticulous incision, the variation of the weight of the incised lines, and the use of added colors. One of the paintings (Fig. 164a) features the artist's monogram cartouche (Type 7 signature), drawn separately and affixed in the bottom right corner.

The shape is a kalyx-krater. It is a variation on the krater shape, with a tall wall and upswung horizontal handles set low on the body. It is possible that the painter Exekias, who was also a potter, invented the shape. This krater is certainly one of the earliest examples of a form that would become very popular in red-figure. The form is used for mixing wine and water at the symposium.

The two full-scale paintings depict the two sides of the vase. The better-preserved side shows the introduction of Herakles to Mt. Olympos. De Jong has included the rim decoration frieze of lotus and palmettes in his painting. Herakles—missing but with his name preserved—stood in the car of a four-horse chariot accompanied by Athena and escorted by gods and goddesses; we only see the tip of Athena's spear. In front of the car Apollo plays the kithara and looks toward his sister, Artemis. Next is Poseidon, then an unidentified goddess—probably Aphrodite or Amphitrite—and finally Hermes leads the procession. Above the scene is a *kalos* inscription: "Onetorides is beautiful." These proclamations of a youth's attractiveness frequently adorn sympotic pottery; Exekias praises Onetorides' beauty on a few of his other pots.

The reverse preserves a portion of a scene from the *Iliad* (17.319ff.): the death of Achilles' companion Patroklos. When Achilles refused to join the battle, his friend donned his armor to convince the troops that the mighty warrior had changed his mind after all. The ruse backfired when Patroklos, mistaken for Achilles, received a death blow. The scene shown here refers to the next tragic step in the story. The Greek and Trojan troops strive to recover the mighty armor of Achilles, and in the end the contest over the possession of the armor will result in even more death. Of the Greeks, only the far left warrior, Diomedes, is preserved. Of the Trojans, the name of the first warrior, Hektor, survives.

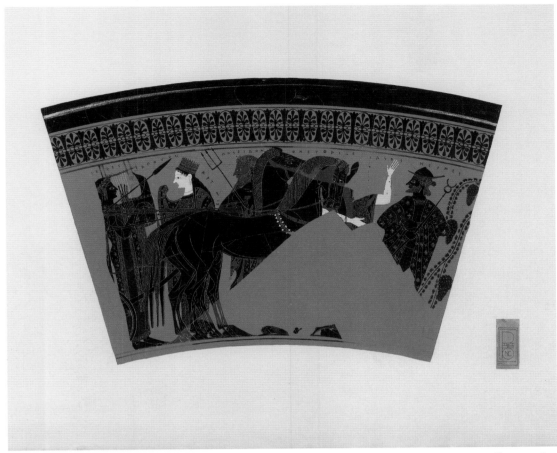

FIGURE 164A

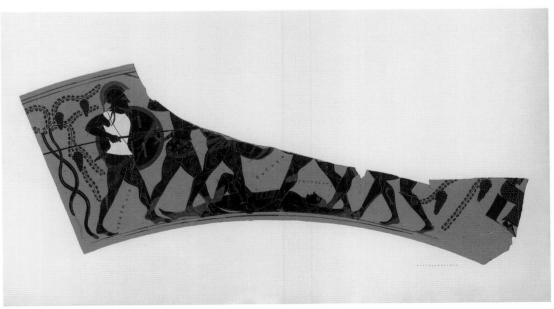

FIGURE 164B

83. BLACK-FIGURED WEDDING VESSEL (FIG. 165)

P 7897, P 7893 (Painting no. 138)
Unattributed
Late 6th century B.C.
E 14:5, unfinished well shaft filled with debris from cleanup following the Persian destruction of Athens in 479 B.C.
Height (without lid): 0.313; (with lid): 0.358; diameter (lebes): 0.18; diameter (stand at base): 0.142
Agora XXIII, p. 167, no. 516, pl. 49; Shear 1936c, p. 412, fig. 9; Shear 1937a, p. 372, fig. 36; Lamberton and Rotroff 1985, p. 11, fig. 21.

This shape, the *lebes gamikos*, is associated with weddings in ancient Athens. Although the precise use of the vessel remains unknown, the tall shape can be seen in vase-painting images outside houses or in the wedding chambers of brides. They are sometimes shown without their lids and with branches sticking out of the bowl. It is possible that they held an herbal infusion for the bride's bath. For a young Athenian woman, marriage marked the turning point of her life: a rite of passage. The images on vases associated with the wedding emphasize a young woman's transition from youth to adulthood. In this case, the vase focuses on another transition: that of the young woman from her childhood home to the new home of the groom's family. The remnants of the scene on the more poorly preserved side of this vase (not shown) make it clear that the scene depicted the bridal procession with the bride and groom in a chariot. The significance of this procession is underscored by the presence of Hermes and a female winged deity—probably Iris—who are present to lead the way to a new life. On the better-preserved side of the bowl we see a series of draped women who balance chests on their heads. These are probably relatives or household servants transporting the bride's dowry. A further reference is made to matronly virtue on the stand. Here pairs of women sit facing each other while working wool. Between two of the pairs stands a crow-like bird, which Lamberton and Rotroff consider a household pet, thus characterizing this scene as one of refined household labor. In ancient Greece women spun wool and wove as a demonstration of their virtue and dedication to the prosperity of the home.

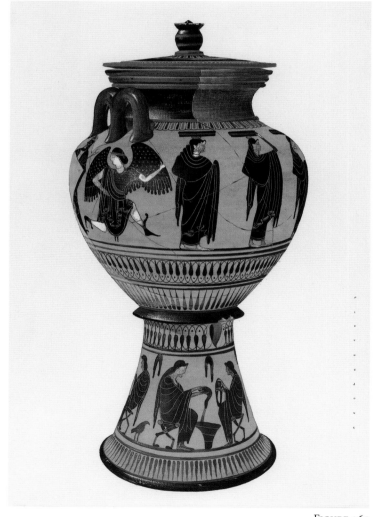

FIGURE 165

84. Theseus and Prokrustes on a pelike (Fig. 166)

P 12561 (Painting no. 132)
Antimenes Painter
Ca. 510–500 B.C.
Well G 11:3, near middle of Tholos, from period of use; the well is
 closed with debris from cleanup following the Persian destruction
 of Athens in 479 B.C.
Preserved height: 0.27; diameter: 0.19
Agora XXIII, p. 150, no. 391, pl. 38; Shear 1939a, p. 230, fig. 26;
 Brommer 1973, p. 245, no. 9; Neils 1987, p. 158, no. 35; *LIMC*
 VIII, 1994, pp. 922–951, no. 126, pl. 646, s.v. Theseus (J. Neils).

Side A (illustrated) of this pelike depicts an episode from
the heroic deeds of the Athenian hero Theseus. The youthful
hero, beardless but draped, moves to the right holding an axe
in his left hand. He looks back at the villain, Prokrustes, who
leans down to grasp a rock, in added white, in his right hand.
Prokrustes was a troublemaker who lived between Eleusis and
Athens. He would convince passersby to rest in one of his two
beds: one short, one long. He would torture the naturally short
of stature by forcibly stretching them to fit his long bed. The
naturally tall he would "trim" to fit the short bed. The beds are
not shown here, but the rural setting is implied by the large tree
in the background and the rock that Prokrustes grips. Theseus
defeats Prokrustes by giving him a dose of his own medicine:
our hero "trims" Prokrustes to fit his own short bed, thus en-
suring safe passage to Eleusis for all Athenians. Theseus's deeds
run somewhat parallel to those of the popular Peloponnesian
hero Herakles. In general, they both rid Greek neighborhoods
of nuisances. The Athenians enhanced Theseus's reputation at
the end of the 6th century B.C., which may have been associat-
ed with the political positioning of the Alkmeonid family. Re-
gardless of the politics, the hero comes to represent the clever,
resourceful Athenian spirit of the new democracy. In the first
quarter of the 5th century B.C. another political figure, Kimon,
will return the bones of Theseus to Athens for reburial in a
monument bearing paintings of his deeds. Theseus's deeds will
also be commemorated in the metopes of the Athenian Trea-
sury at Delphi and, in the mid-5th century, on the metopes of
the Parthenon. On side B, Dionysos is pictured with two satyrs
(not illustrated).

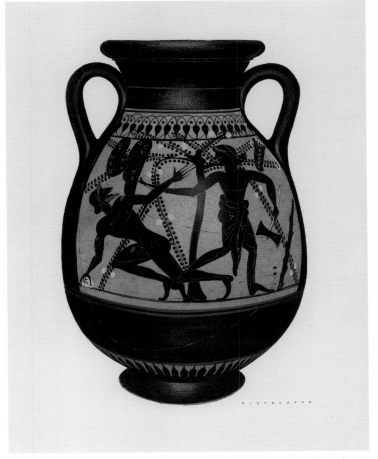

FIGURE 166

85. Black-figured trefoil-mouth oinochoe with Herakles and gods (Figs. 167a, b)

P 1134 (Painting nos. 122, 131)
Unattributed
Ca. 510–500 B.C.
Well G 15:1, located north of the Areiopagos, at the southwestern
 corner of the open space of the Agora
Preserved height: 0.246; diameter: 0.146
Agora XXIII, p. 196, no. 736, pls. 70, 71; Thompson 1933,
 pp. 292–293, no. 2, fig. 2.

This vase, an oinochoe, was used in the symposium to serve the mixture of wine and water to drinkers. Greeks did not drink their wine straight; in fact, they deemed those who did to be barbarians. Recipes for the dilution of the wine vary, but we can imagine about one part wine mixed with one to three parts water. The mixing occurred in a krater or dinos. A wine boy would then dip the oinochoe into the mixing bowl, fill it with wine, and serve the drinkers in turn. From literary descriptions, it seems that the boy would fill one cup and it would be passed down the line, creating a vivid image of the cups "flying round" the room as drinking became fast and furious.

The imagery on this oinochoe depicts Herakles in Olympos. He is seated among the gods: Athena, with her helmet and spear; Hermes, with his petasos—a type of traveling hat—and Dionysos, with his kantharos (drinking cup). They all sit beneath an arching vine. This assembly is not accidental. Athena accompanies Herakles because she is his patroness and sponsor for admission to Mt. Olympos. Her prominence in the tales of Herakles, although he is a Peloponnesian hero, accounts for his popularity in Athens. Hermes, as the messenger god, showed Herakles the way to Olympos, thus Hermes' presence here reminds the viewer of Herakles' "transformation" from mortal to immortal. Finally, Dionysos brings the imagery back to the function of the vase in the symposium. Any number of the gods could have been shown here, but the choice of Dionysos reflects the setting of the symposium. The pairing of Dionysos and Herakles may also have caused the viewer to remember how Herakles unsuccessfully challenged the god to a drinking contest. The symposiast also should not challenge the power of the god, lest he pay the physical price!

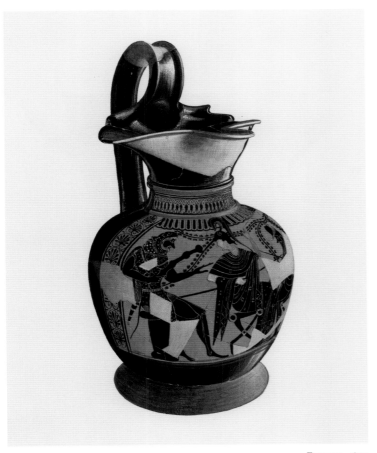

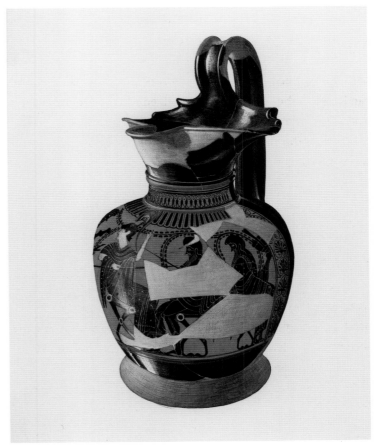

FIGURE 167A

FIGURE 167B

86. Black-figured Heron-class skyphos with komos (Fig. 168)

P 1544 (Painting no. 141)
Theseus Painter
Ca. 500 B.C.
G 6:3, Rectangular Rock-cut Shaft, upper fill (debris deposited
 during cleanup following the Persian destruction of Athens)
Height: 0.188; diameter (rim): 0.244
Agora XXIII, p. 279, no. 1486, pl. 100; *ABL*, p. 251, no. 47; *ABV*,
 518, no. 47; *Para*, 255, no. 47; Burkert 1966, p. 99, no. 13,
 pl. 3; Vanderpool 1946, p. 290, no. 63, pls. 38, 39; on the skyphos
 shape, see *ABL*, p. 144; Ure 1955; Borgers 1999.

Sides A and B of this large and lively drinking cup feature male dancers and female musicians. They cavort in a procession-like parade of wine-induced merriment called a *komos*. These impromptu parades frequently followed evenings of drinking at a symposium. Side B (illustrated) depicts three men—two beardless youths and an older male—dancing to the music of a female kithara player. The older male's attention has turned to the unaware kithara player, thus imparting a sexual overtone to the scene. On side A (not illustrated) another youth carries a transport amphora on his shoulder, making a direct reference to the source of their gaiety. The shape is large; the capacity, to the rim, is about three liters. The name of the shape refers to the common practice of placing a white heron-like bird under the handles. On our cup we find a goat under one handle (at the left of the painting) and a squatting reveler under the other (not visible). The Theseus Painter favored this shape, using its broad surface for some very unusual images. Ours is one of his more typical scenes.

Piet de Jong has chosen not to restore the missing fragments of the scene, and he does not restore the fugitive added white for the musician's flesh. Her hair is not white, but yellow: a color favored by painters of this shape. De Jong's rendering of the incised lines of the figures here is exquisitely meticulous. He captures the subtle variations in depth and width of the incised line, thus reflecting the fluidity that marks the Theseus Painter's style.

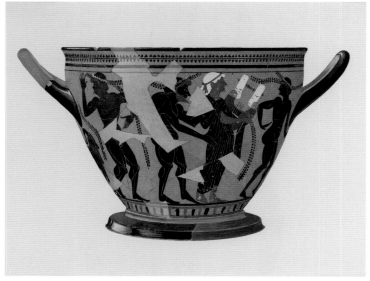

FIGURE 168

87. BLACK-FIGURED SUPPORT WITH ARTEMIS AND APOLLO
(FIGS. 169A, B)

P 9275 (Painting nos. 140, 127)
Unattributed, but compare to the work of the Diosphos Painter
 (*Agora* XXIII, p. 31)
500–490 B.C.
Large pit or shallow well M 17:4, located along the southern side of
 the Agora
Height: 0.134; diameter (estimated): 0.13
Agora XXIII, p. 174, no. 575, pl. 55; Shear 1937b, p. 180, fig. 4; Shear
 1937c, p. 432, fig. 19; Shear 1938a, p. 342, figs. 24, 25; Thompson
 1963, fig. 38; *LIMC* II, 1984, pp. 618–753, no. 1210, pl. 544, s.v.
 Artemis (L. Kahil); Camp 1980, fig. 14; for the shape in use, see
 Richter and Milne 1935, fig. 29.

This cylindrical form acted as a support for a pointed amphora.
Pointed amphoras, as their name indicates, do not have a foot
but terminate in a conical point. As a result, they cannot be
placed on a horizontal surface without a support. There are no
pointed amphoras in black-figure or red-figure known from
the Agora Excavations, but several of these supports have been
found, including one in red-figure by Euthymides with similar
iconography (P 4683 and P 4744, no. 93). There is a suggestion,
too, that this form may also have supported a Panathenaic am-
phora, which has a high center of gravity and narrow foot and
is thus prone to tip over. There is ample evidence for Panathe-
naic amphoras from the Agora.

Piet de Jong has painted two views of this support. In one
(Fig. 169a) he shows the actual form, but he has restored and
reconstructed missing portions of the fragmentary object. In the
other (Fig. 169b) he unrolls the continuous frieze for better com-
prehension of the scene. Again, missing fragments are generally
reconstructed and restored with the exception of the heads of
the horses, the top of the lyre, and the back legs of the deer. The
frieze depicts Artemis mounting a chariot drawn by four horses,
one white, and Apollo standing in front of the chariot holding a
lyre. Behind the chariot is a palm tree. A second palm tree, this
time with a deer, marks the beginning/ending of the scene. Al-
though Artemis and Apollo are not distinguished through dress
or label, we can be confident of their identification because of
the cluster of attributes. Apollo's lyre helps identify him as the
deer does Artemis, but palm trees clearly refer to the birth of
these twins under such a tree on the island of Delos.

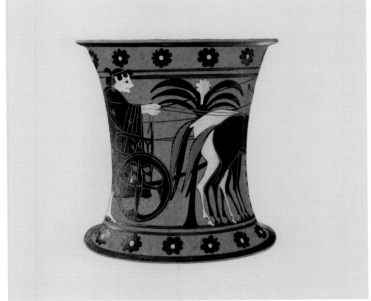

FIGURE 169A

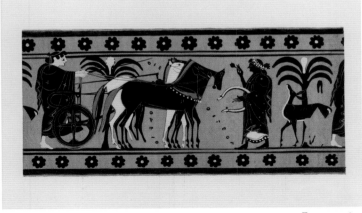

FIGURE 169B

88. Two black-gloss jars: An intact pelike and a misfired amphora (Figs. 170a, b)

P 12551, P 13014 (Painting nos. 124, 37)
Ca. 500–480 B.C. (P 12551); ca. 500 B.C. (P 13014)
Second well of building F, G 11:3, in period of use; well filled with
 debris from the cleanup following the Persian destruction of
 Athens (P 12551). Period of use from well V 24:2, on the north-
 ern slopes of the Acropolis (P 13014)
P 12551: height: 0.266; diameter: 0.193
P 13014: height: 0.254; diameter: 0.181
P 12551: *Agora* XII, p. 237, no. 19, pl. 1; Shear 1939a, p. 230, fig. 27
 (bottom center); Sparkes and Talcott 1958, fig. 48; for Tholos well,
 see Thompson 1940, pp. 25–26, 30–32, fig. 21; for jars in period
 of use, see Lawall et al. 2001, pp. 171–173 [Lynch].
P 13014: *Agora* XII, p. 236, no. 5, pl. 1.

Both of these jars were found at the bottom of wells among
material that fell into the well during the period of use. Their
find circumstances and relatively complete conditions indicate
that they fell into the well while being used to fetch water. The
pelike (Fig. 170a) is intact—it has no breaks. It would have
fallen in when the rope wrapped around its rim and handles
broke. The amphora (Fig. 170b), on the other hand, is broken
into many pieces, nearly all of which were recovered. This sug-
gests that this jar hit the side of the well, cracked, slipped off
its rope, and fell to the bottom. The use of black-gloss vessels
for this utilitarian function indicates that fine wares were not
always restricted to "fine" occasions: they performed practical
duties around the house.

The amphora (Fig. 170b) is meant to be black-gloss, but it
was misfired in the kiln to a reddish-brown color. Piet de Jong
has successfully captured the mottled and irregular surface
texture of the vase. This vessel reminds us that ancient pot-
tery kilns were hard to regulate, and certainly every firing must
have resulted in a variety of partially or wholly misfired pots.
Nevertheless, misfired vessels, such as this one, are found in
Athenian domestic debris, indicating that they were perfectly
functional, even if not perfectly fired.

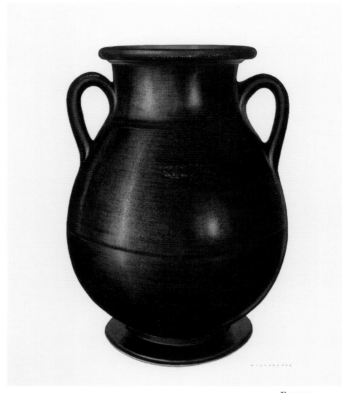

FIGURE 170A

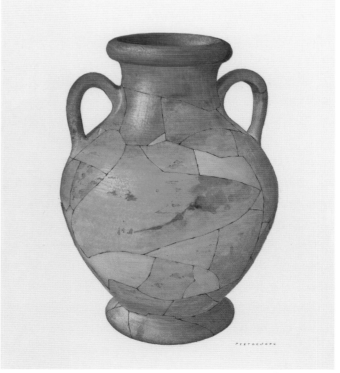

FIGURE 170B

89. BLACK-GLOSS "ACHAEMENID PHIALE" (FIGS. 171A, B)

P 9274 (Painting nos. 137, 42)
Ca. 500–480 B.C.
Large pit or shallow well M 17:4, located along the southern side of
the Agora
Height: 0.065; diameter: 0.164
Agora XII, p. 272, no. 521, fig. 6, pl. 23; Shear 1938a, pp. 343–344,
fig. 26; Miller 1993, p. 119, fig. 21.2; Miller 1997, pp. 137–138, fig. 36.

Not only does this beautifully glazed vessel attest to the skill of Attic potters, it also comments on the complex relationship of the Athenians with their foes in Persia. The shape is an omphalos phiale, a vessel used in Greek religion for pouring libations—liquid offerings to the gods. The omphalos, the knob in the center, which is concave beneath, facilitates a better grip with the fingers when the thumb rests on the rim. The horizontal ribbing on the vessel distinguishes it from typical Attic phialai. The ribs and the proportions of the shape indicate that the potter is emulating a metal Persian (Achaemenid) original. The Persians used this shape as a drinking vessel without overt religious connotations. In her studies of the relationship between Athens and Persia before and after the Persian Wars (490 B.C. and 479 B.C.), Margaret Miller has shown that the Athenians adopted some Persian cultural forms, including elements of material culture, as a way of diluting and absorbing the power of the conquered (or soon to be conquered) enemy. Miller argues that the use of the phiale as a drinking cup by Athenians indicates an adoption of Persian behavior as well. In this way, our phiale becomes a status symbol, marking the user as one who, through imitating the style of the enemy, demonstrates the dominance of his own, superior culture. This incorporation of foreign material culture and behavior as a statement of superior status is not unlike the "Orientalisme" fashions during the age of European imperialism. The glossy surface of this vessel seems to reflect its cultural context across the ages.

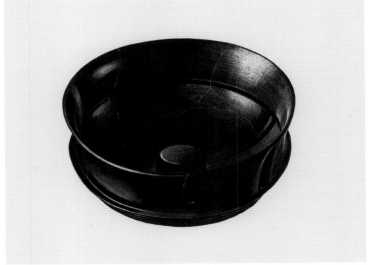

FIGURE 171A

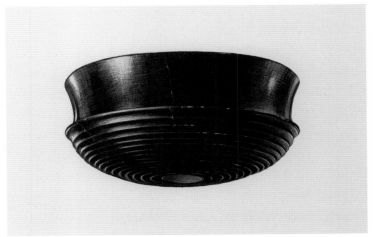

FIGURE 171B

90. Black-gloss vase of curious shape (Fig. 172)

P 7354 (Painting no. 12)
Late Classical, context: ca. 325–300 B.C.
E 3:1, cistern at depth of 4.60–5.00 m, located on the northern foot
 of the Kolonos Agoraios
Height: 0.113; diameter: 0.082
Agora XII, p. 320, no. 1205, pl. 39 (with further examples noted on
 pp. 163–164); Shear 1936b, p. 195, fig. 11; Shear 1936d, fig. 17;
 Karo 1936, p. 108, fig. 9; Shear 1937a, p. 373, fig. 38; Noble 1972,
 pl. 95 (discussion of a similar vessel; plate includes a fascinating
 X-ray revealing the pellet inside).

This enigmatic but well-made shape must have served a specific purpose in ancient Athens, but that purpose remains elusive to modern scholars. The body is a closed, mastos shape with articulated top "nipple." Between the handle and the nipple is a small, pierced hole. There is one vertical ring handle, perpendicular to which is an upright spout. The spout has a broad, funnel-like mouth and narrow neck, in which is a sieve. Inside the vessel is a pellet, which creates a rattling noise when shaken. Brian Sparkes and Lucy Talcott (*Agora* XII) classed the vessel (the only one of its sort from the Agora Excavations) among perfume pots with similar bulbous bodies and funnel-like spouts. Noble, however, described a similar vessel as a baby feeder or, rather, a "sippy cup," an intermediary between the nozzle feeder and a grown-up's cup. Noble saw the broad rim and closed form as a training cup for a toddler. The rattling bead inside may be a clever aural ornament when empty; adult, mastos-shaped, wine-drinking cups are known with rattles in their "nipples." But the bead might also serve to stir up liquid contents that are prone to separation. The closed vessel could be shaken quite vigorously, and the bead would blend the contents. Either way, this object represents the ingenuity of the ancient potters and the flexibility of their medium. Piet de Jong's drawing captures all the formal nuances of the vase except the rattling of the pellet inside.

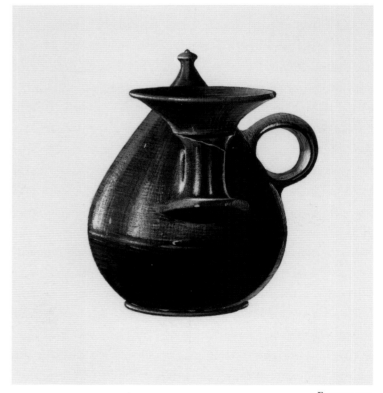

FIGURE 172

91. Mushroom jug (Fig. 173)

P 9428 (Painting no. 164)
425–400 B.C.
Well M 20:3
Agora XII, no. 166, fig. 3, pl. 9; Shear 1937b, p. 180, fig. 5; Shear
 1938a, pp. 345–346, fig. 30; Amyx 1958, p. 210, pl. 48i; Travlos
 1971, p. 392, fig. 517 (right); for the shape, see Corbett 1949,
 pp. 334–335.

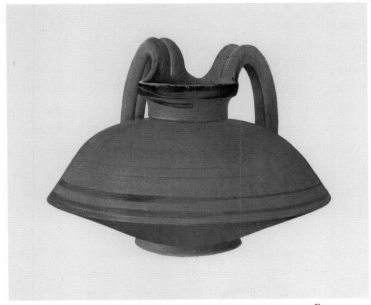

FIGURE 173

Even though this is a humble, coarseware jug, Piet de Jong uses as much care and precision in his drawing as he does on the finest of figured wares. In fact, his painting elevates the importance of the utilitarian pot. In particular, he has carefully reproduced the irregularity of the handles and their surface striations. Also, the streaky, unevenness of the bands on the body are given a calligraphic elegance not as apparent in the original. The shape is a pouring vessel in the oinochoe family, but its two handles distinguish it. The form was only popular during the second half of the 5th century B.C., although it has earlier origins. The double handles must have been useful for stabilizing the jug while filling it or passing it on to another person. The sharply delineated body allows pouring while trapping the dregs of the liquid, thus leading Corbett to suggest that it was used for wine in less formal occasions than symposia.

92. Lekane base with kalos names (Fig. 174)

P 5164 (Painting no. 207)
450–400 B.C.
Well H 6:5 (the same deposit that produced P 5113, no. 97)
Diameter (base): 0.18; estimated diameter (body): 0.371; preserved
 height: 0.24; restored height: 0.256
Agora XXI, p. 14, no. C 21, pl. 5; *ARV*², 1611, no. 8 (kalos names);
 Talcott 1936b, pp. 350–352, no. 6, fig. 21; Steiner 2002,
 pp. 364–366, figs. 8d, e.

This is a common object with a common type of inscription, but together the object and inscription are quite unusual. The circular field is the underside of a lekane, a multipurpose deep mixing bowl/basin with horizontal handles. They are found in household pottery assemblages, and a single house might have a dozen or more, just as we have numerous mixing bowls and buckets in our houses. This particular lekane bears two areas of inscription: on the interior floor of the bowl is incised a large, single X, and on the underside a series of names are incised within a grid. Piet de Jong's painting illustrates the inscription on the underside of the pot. The surface has been gridded very regularly, and letters have been placed carefully into this grid. The inscription consists of three male names declared "*kalos*"—beautiful. The first name is Therikles, son of Pichsonos, as indicated by Piet de Jong; the second is Timochsenos; and the third is Charmides. In the far left column appears "*theoi*," "gods," next to the first two names; thus, the inscription is according to the gods.

The surface of the pot as it is currently preserved is much less legible than as depicted in the painting by Piet de Jong or by the facsimile published by Lang in *Agora* XXI. There are discrepancies between the de Jong and Lang images. For example, the painting presents three additional letters, AMΣ, on the resting surface of the base and has more carefully represented surface flaws and other possible letters. In this case the de Jong painting is likely to be more accurate. Kalos names appear as inscriptions and graffiti nearly everywhere in ancient Athens: on buildings, sculpture, and vases. The statement "*Therikles kalos*" (Therikles is beautiful) refers to the culture of male beauty and the association of beauty with goodness

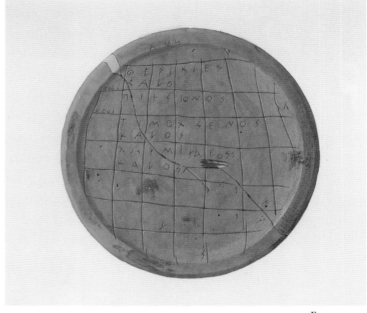

FIGURE 174

in ancient Greece. It also refers to the culture of homosexuality in ancient Greece, in which the bonds between men were strengthened through intimate associations, particularly those between young and older men.

Why should this inscription appear on the bottom of a household bowl? The arena for development of homosexual relationships was the symposium, or communal drinking event. It is possible that this household lekane was used as a krater during an evening of drinking, and just as such kalos names appear on figured kraters to invoke the spirit of the event, here they appear as well. Perhaps the lekane was drained of its contents then overturned to present a secret surprise!

CHAPTER 9

Attic Red-Figured and White-Ground Pottery

Kathleen M. Lynch

93. FRAGMENTS OF A RED-FIGURED SUPPORT BY EUTHYMIDES
(FIG. 175)

P 4683, P 4744 (Painting no. 160)
Euthymides
Ca. 515 B.C.
E–F 12–14 (B′ building fills, fill to north of building)
Ten nonjoining wall fragments and flaring rim (a and b illustrated).
 Estimated diameter (rim at outer edge): 0.25
Agora XXX, pp. 223–225, no. 585, fig. 32, pls. 61, 62; *ARV*², 28,
 no. 17; *Add*², 156; Talcott 1936a; Pfeiff 1943, pp. 54–55, pl. 2.4,
 opp. p. 40; Wegner 1979, pp. 10–11, pl. 6; *LIMC* II, 1984, p. 263,
 no. 642, s.v. Apollon (W. Lambrinudakis) = *LIMC* II, 1984,
 p. 710, no. 1157, s.v. Artemis (L. Kahil).

This cylindrical support for a pointed amphora or round-bottomed mixing bowl shares an iconographic theme with the black-figured support P 9275 (no. 87). Both feature Apollo and his sister Artemis. Additional fragments of P 4683 and P 4744 show the Delian palm tree, indicating that the scene occurs on the island of the divine twins' birth (Fig. 176). The fragments depicted by Piet de Jong preserve Apollo with his kithara and a second figure behind. Above the figures is a lotus and palmette band, punctuated with an elaborated frond above the head of Apollo. In the field between the two figures appears a partial inscription: Π Ο Λ Ι Ο. These few letters confirm for us the identity of the painter, whose masterful style already introduced him as a leader in the craft: Euthymides. The vase-painter Euthymides signed some of his works "Euthymides, son of Polios (ΕΓΡΑΨΕΝ ΕΥΘΥΜΙΔΕΣ ΗΟ ΠΟΛΙΟ)." Euthymides is one of a group of vase-painters who actively explored the potential and expressive power of the recently invented technique of red-figure. He and his colleagues, including Euphronios and Phintias, are known as the "pioneers" of red-figure. They embraced the calligraphic line of red-figure, which we can see here in the delicate lines of Apollo's chiton and himation. Euthymides uses various weighted lines and washes to describe the natural qualities of the materials and their reaction to the forces of gravity. A residual of the black-figure style can be seen in the treatment of Apollo's hair. The painter reverts to the black-figure technique of incision to form the projecting tuft of hair; his is part of a generation with a foot in both techniques.

The presence of this piece in the Agora is additionally significant because there are few works by the pioneers found in the excavations. That is, their works were not being used in the houses and commercial businesses of Late Archaic Athens. Vases by the pioneers, however, are found on the Acropolis, where their fine quality served well as offerings to the goddess.

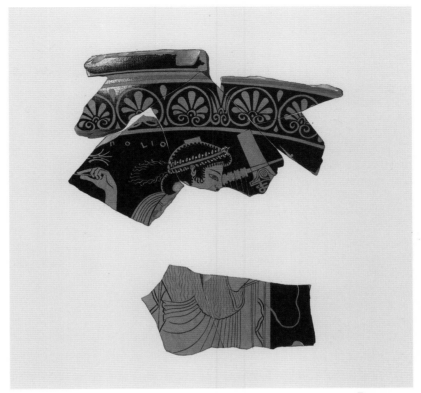

FIGURE 175

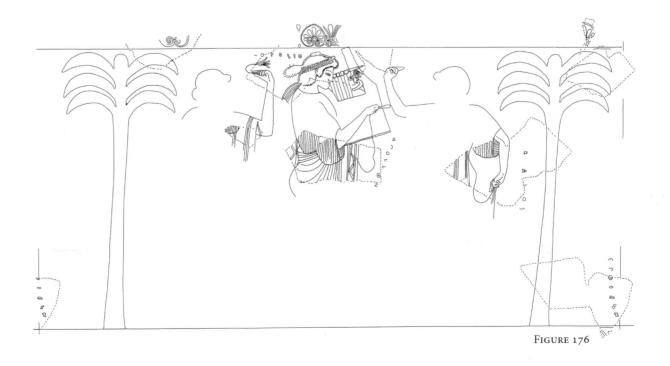

FIGURE 176

94. TWO SYMPOTIC VESSELS: A KALYX-KRATER WITH DIONYSOS AND A KYLIX WITH YOUTH PLAYING KOTTABOS (FIGS. 177A, B)

P 1855, P 1274 (Painting nos. 43, 44)

The Group of Polygnotos: undetermined (P 1855); manner of the Euergides Painter: Group of Acropolis 96 (P 1274)

Ca. 440 B.C. (P 1855); ca. 510 B.C. (P 1274)

Well R 13:4, at 2.00 m (P 1855); G 6:3 (Rectangular Rock-cut Shaft), upper fill (P 1274)

P 1855: preserved height: 0.227; preserved diameter: 0.208

P 1274: height: 0.055; diameter (rim): 0.132; diameter (with handles): 0.180; tondo: 0.057; diameter (foot): 0.060

P 1855: *Agora* XXX, p. 180, no. 274, pl. 37; *ARV*[2], 1057, no. 101; Talcott 1935, pp. 477, 497, no. 1, figs. 1, 4 (side B), 18; Matheson 1995, p. 468, no. PGU 112.

P 1274: *Agora* XXX, p. 342, no. 1572, pl. 148; *ARV*[1], 67, V, no. 3 [Painter of Agora 1274]; *ARV*[2], 105, no. 3; *Add*[2], 172 [Group of Acropolis 96]; Vanderpool 1946, p. 280, no. 35, pl. 30; Beck 1975, p. 53, no. 340, pl. 66; Roberts 1986, p. 9, fig. 5 (profile drawing); for kottabos, see Hoesch 1992, with bibliography.

Sympotic drinking is responsible for the majority of surviving Attic pottery. The ritualization of drinking wine in the symposium required specialized vessels. The krater, or mixing bowl, is the essential element of the symposium. In it Greeks mixed their wine with water, an action they claimed distinguished them from the uncivilized barbarians who drank their wine straight. In addition to the krater, an oinochoe was needed to serve the wine, and drinkers used specially designed drinking cups, kylixes, that set the activity apart from the ordinary act of slaking the thirst. We know that metal vessels existed, but most have not survived; the ceramic evidence, on the other hand, is abundant and speaks to a lively and characteristic pastime of Archaic and Classical Greece.

The god of wine, Dionysos, appears on the krater (Fig. 177a) with members of his retinue. To the left is a maenad, who holds an oinochoe and a torch, indicating that this is a nighttime scene. To the right is a satyr, a half-man, half-horse creature that represents the wildness within humans. The satyr plays the pipes and leads the lively procession. Dionysos holds a kantharos and a thyrsos, a staff topped with ivy, again symbolizing the wildness associated with the god. On the kylix cup (Fig. 177b), the figure on the interior is engaged in a game of kottabos. This drinking game took place in the context of the symposium. In addition to drinking, discussion and entertainment of various sorts rounded out the evening's activities. In the game of kottabos, the drinker drains his cup and flings the lees left in the bottom at a target, in this case the stand at left. No doubt success depended on strong wrists and timing. The image reflects the use of the cup on which it is painted. In symposia participants recline on their left elbows; the stem and handles of the kylix facilitate a good grip while reclining. In this case, the interior figure is off-center from the handles, but if the drinker inserted his right thumb through the right handle and raised the cup to his lips, the angle of the image would be correct for his view. Although a simple scene, the discourse between user and image would resonate and enliven the evening's activities.

FIGURE 177A

FIGURE 177B

95. A RED-FIGURED CUP WITH A WOMAN AND A DWARF
(FIG. 178)

P 2574 (Painting no. 165)
Unattributed
Ca. 500 B.C.
G 6:3, Rectangular Rock-cut Shaft
Height: 0.077; estimated diameter: 0.185; diameter (foot): 0.079;
 diameter (tondo): 0.107
Agora XXX, p. 319, no. 1411, pl. 132; Thompson 1933, p. 294, fig. 4;
 Karo 1933, col. 204, fig. 6; Vanderpool 1946, p. 282, no. 40, pls.
 31, 32; Robertson 1980, pl. 43a; Dasen 1990, p. 199, fig. 5; Dasen
 1993, pp. 228–229, 290, no. G13, pl. 49.1; Schäfer 1997, pp. 84, 112,
 no. VI 5 a, pl. 49.1; Grmek and Gourevitch 1998, p. 203, fig. 148.

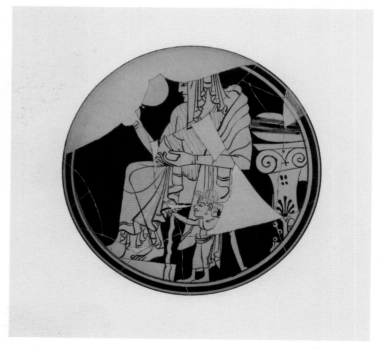

<div align="right">FIGURE 178</div>

This watercolor depicts the tondo of a red-figured kylix. The circular field contains an unusual scene of a seated woman attended by a dwarf. At the right we glimpse the head of a couch with an elaborate leg and pillow on top. The woman wears a veil, sits with her feet on a stool, and holds a mirror in her right hand. These elements impart a feeling of luxury to the image, complemented by the exotic nature of the dwarf attendant. He stands beside the woman, wears a wreath, and leans on a knobby stick. His dwarfism is expressed with an elongated head placed on a child-sized body. His scraggly mustache confirms that he is an adult. Analysis of this dwarf's condition suggests that he suffered from a rare form of dwarfism caused by hypopituitarism, a suggestion proposed by Grmek and Gourevitch; thus, the painter's awareness of the manifestations of this malady indicate a study from nature.

The woman is most likely a courtesan, a hetaira, although the imagery borrows from the visual vocabulary associated with brides. She is dressed as a discreet Athenian woman, although Martin Robertson has pointed out that her veil is a little too revealing for an upstanding Athenian woman. Further, the presence of the bed, which can sometimes refer to the marriage bed, more likely represents her livelihood. The exterior of this cup (not pictured) features a group of men and boys in a typical courting scene. Thus, on analogy to the exterior, it seems more likely that the woman is a hetaira than a bride-to-be. The wreathed dwarf in this case represents a connection to the symposium, where he might have been a source of entertainment or amusement, or a messenger for his mistress.

96. Coral red cup from the Rectangular Rock-cut Shaft (Figs. 179a, b)

P 2698 (Painting nos. 167, 177)
Unattributed
Ca. 500 b.c.
G 6:3, Rectangular Rock-cut Shaft
Height: 0.10; diameter (rim): 0.22; diameter (tondo): 0.089; estimated diameter (foot): 0.095
Agora XXX, p. 341, no. 1566, pl. 148; Shear 1933b, pp. 459–460, fig. 9; Shear 1933d, p. 293, fig. p. 294; Shear 1933e, pp. 310–311, fig. 19; Vanderpool 1946, pp. 285–287, no. 52, pl. 35; for the coral red glaze, see Cohen 1970–1971.

This kylix was found in the fill of a pit, probably an abandoned well shaft, which was used as a garbage dump. The squared form of the pit gave it its name, the "Rectangular Rock-cut Shaft." The shaft had two levels of fill: a lower one that dates to the mid-6th century b.c. and an upper one that dates to the early decades of the 5th century b.c. The kylix illustrated here was part of the upper fill, which is associated with the cleanup of debris following the Persian destruction of Athens in 479 b.c. When the Persians entered Athens they found the city abandoned; the Athenians had evacuated as the Persians approached. Nevertheless, the Persians sacked the city and the temples, including a predecessor to the Periklean Parthenon that was under construction at the time. Archaeologically there is ample evidence of a horizon of destruction both on the Acropolis and below in the Agora. In the excavations of the Athenian Agora archaeologists have found that once the Athenians returned to their damaged city, they proceeded to clean up by depositing broken pottery and building debris down wells. There are twenty-two wells from the Agora Excavations with such debris. This extensive group of material provides insight into daily life and the objects in use in both public and private Athens.

The rich colors of the painting convey the unusual treatment of the surface of the kylix. The tondo features the traditional red-figure scene on a black-gloss background, but the remainder of the interior and exterior, up to the rim, is covered with coral red (also called intentional red) glaze. The exact method of manufacturing this glaze still escapes archaeologists, but its rar-

FIGURE 179A

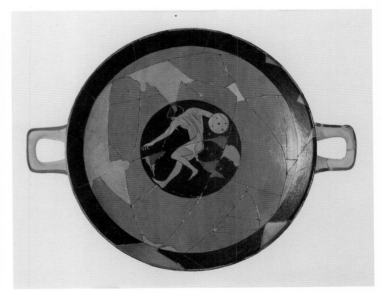

FIGURE 179B

ity, often poor preservation, and restriction to a handful of potters suggest that it was a difficult process. The scene of a discus thrower evokes the world of the gymnasium where boys would exercise to the appreciation of older men. The liaisons formed here would carry over to the world of the symposium, where the cup would be used. Its inscription, ΗΟ ΠΑΙΣ ΚΑΛΟΣ ("the boy is beautiful"), reminds us of this connection.

97. THREE OBJECTS FROM AN ARCHAIC SANCTUARY OF ZEUS? A RED-FIGURED KYLIX BY THE PAINTER OF AGORA P 42, A WHITE-GROUND KYLIX WITH LYRE PLAYER, AND A WHITE-GROUND "BOBBIN" WITH HELIOS (FIGS. 180A–G)

P 42, P 43, P 5113 (Paintings nos. 187, 277, 199, 169, 221, 205, 143)
Name piece of the Painter of Agora P 42 (P 42); Douris (Mertens, Moore) or follower of the Brygos Painter (Robertson) (P 43); manner of the Brygos Painter (P 5113)
All three pieces Late Archaic, ca. 480 B.C.
Well (H 6:5) by Stoa pier 3 (P 5113); area of I 6 (P 42, P 43)
P 42: height: 0.097; restored diameter (rim): 0.239; width (handles): 0.319; diameter (foot): 0.089
P 43: 0.84; estimated diameter (rim): 0.17
P 5113: diameter: 0.113
P 42: *Agora* XXX, p. 321, no. 1422, pl. 133; *ARV*², 415, no. 1; Talcott 1933, pp. 218–224, figs. 1–4; Bloesch 1940, p. 103, no. 1, pl. 29; Camp 1980, p. 3, fig. 2.
P 43: *Agora* XXX, p. 342, no. 1570, pl. 148; kalos name: *ARV*¹, 923, top; *ARV*² 1578; *Para*, 506; *Add*², 389; Talcott 1933, pp. 224–230, figs. 5, 6; Philippart 1936, pp. 18–19, no. 21, fig. 6; Wegner 1963, p. 92, no. 58, fig. 58; Mertens 1974, pp. 101–103, fig. 23; Thompson 1976, pp. 244–245, fig. 127; Mertens 1977, pp. 186, 182, no. 70, pl. 34.1; Wehgartner 1983, p. 53, no. 10; Robertson 1992, p. 155, fig. 161; Maas and Snyder 1989, p. 111, fig. 27 (see chap. 4 for the use and form of the instrument); for context, see also Rosivach 1978.
P 5113: *Agora* XXX, p. 351, no. 1640, pl. 153; Shear 1935d, fig. 4; Talcott 1936b, pp. 333–335, fig. 1; Brendel 1936, p. 280, fig. 8; Robertson 1959, p. 110 (figure), pp. 111–112; Mertens 1977, p. 142, no. 4; Wehgartner 1983, p. 156, no. 2; *LIMC* V, 1990, p. 1009, no. 11, pl. 632, s.v. Helios (N. Yalouris); Robertson 1992, p. 154, fig. 160; on the form: Shapiro 1985; Wehgartner 1983, pp. 154–160; Weiss and Buhl 1990; Richter 1928; Steiner 2002, pp. 369–370, fig. 11a.

These three objects were found underneath the Stoa of Zeus Eleutherios, located along the western side of the Agora square. The two kylixes, one in red-figure (Figs. 180a–c), the other white-ground (Figs. 180d, e), appeared under the floor of the stoa in a level associated with an altar and a small shrine. Although there is no confirming evidence that this was a shrine to Zeus, the continuity of the site with the later cult of Zeus Eleutherios is generally assumed by the excavators. The third item, the enigmatic "bobbin" form (shown in two watercolors, Figs. 180f, g, one as preserved, the other as reconstructed by Piet de Jong), came from a somewhat later well (H 6:5), which cut through this stratum. The excavators proposed that the unusual "bobbin" form and the only two other figured pieces in this well (P 5114, P 5115, not illustrated) fell from the layer under the stoa into the well as intrusions.

If this group of objects can be identified as offerings to Zeus, then we have a collection of votive offerings that give us insight into the preferences of Late Archaic worshipers in Athens. First, it is to be noted that all the objects stand out from the typical domestic goods. White-ground kylixes were largely used for dedications, not household drinking. The delicacy of the white field and added colors indicates that they could not be used frequently. The red-figured kylix also stands out with its elaborate decoration on both interior and exterior. Contemporary domestic cups typically have decoration only on the interior. This use of unusually high-quality figured pottery for offerings is paralleled by the Archaic and Early Classical pottery found on the Athenian Acropolis.

Piet de Jong prepared three different illustrations of the red-figured cup (P 42), each at a slightly different scale (Figs. 180a–c). Although the ink profile of the cup appears to be a measured drawing, the width at the handles is approximately 0.015 m smaller than the original. Most curious is the watercolor showing the exterior of the cup; here, Piet de Jong has flattened the surface of the cup in order to present the figures more clearly. Natural perspective would have caused the heads of the figures to disappear. The width of the cup in this watercolor is, therefore, approximately 0.025 m too large in order to account for the flattening out.

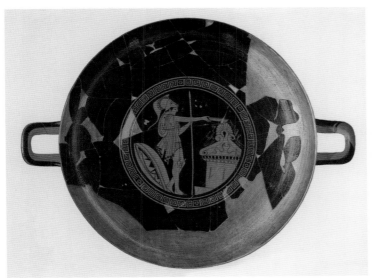

FIGURE 180A

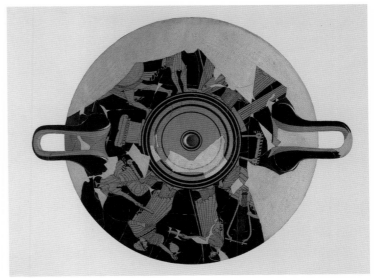

FIGURE 180B

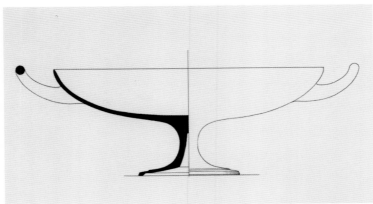

FIGURE 180C

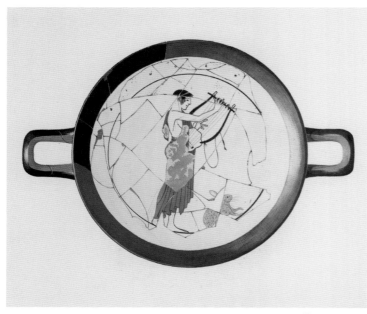

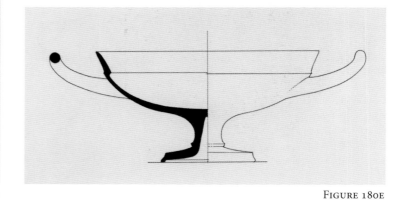

FIGURE 180D

FIGURE 180E

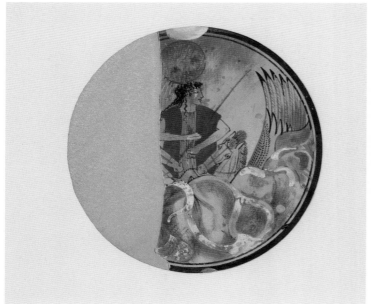

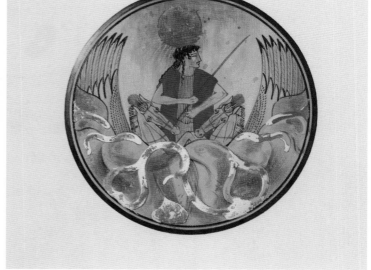

FIGURE 180F

FIGURE 180G

98. Red-figured kantharos with the Judgment of Paris from the area of the Tholos (Fig. 181)

P 4952 (Painting no. 168)
Unattributed
470–460 B.C.
E–F 12–14 (B′ building fills, fill to north of building)
Wall fragments with part of outturned rim (one of four nonjoining
 fragments, this one d). Maximum diameter (fragment d): 0.169;
 estimated diameter (rim): 0.260
Agora XXX, pp. 296–297, no. 1226, pl. 116; Riemann 1937, cols.
 101–102, fig. 3; Shear 1938a, p. 344, fig. 27; Shear 1938c, p. 6,
 fig. 6; Thompson 1940, pp. 127–128, fig. 95; Clairmont 1951,
 p. 50, no. K 144; Himmelmann-Wildschütz 1959, p. 16, fig. 18;
 Raab 1972, p. 178, no. 7; Jucker 1982, p. 14, fig. 5; *LIMC* IV, 1988,
 p. 710, no. 429, pl. 431, s.v. Hera (A. Kossatz-Deissmann).

This painting presents the largest of four fragments of a red-figured kantharos. The kantharos is a footed drinking cup with two vertical handles. It is best known as the drinking vessel of choice of Dionysos, the god of wine. It is not a common vessel type in clay, but details of its shape indicate that the form is metallic in origin. There are only a handful of fragments of red-figured kantharoi from the Agora Excavations, and this is the best-preserved one.

The scene is the Judgment of Paris, with Paris seated on a rocky perch contemplating the task the god Hermes is describing to him. Paris—who will later learn that he is a prince of Troy, Alexandros—must choose the most beautiful goddess from three: Hera, Athena, and Aphrodite. Hera, with hand on hip, is preserved on our fragment. Each of the goddesses offers Paris a reward, should he pick her. Paris prefers Aphrodite's promise: the most beautiful mortal woman in the world. The catch, though, is that the woman, Helen, is already married. Helen's husband, Menelaos, and his brother, Agamemnon, will lead the Achaean troops into battle against Paris/Alexandros and the Trojans. Thus, our fragment gives us a view of how the most famous of all conflicts started. The ancient Greek viewer would have known the story so well that this single frame would have been enough to prompt the whole epic narrative and its outcomes.

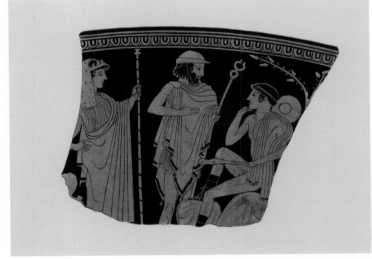

FIGURE 181

The Piet de Jong watercolor captures a distinctive characteristic of the surface treatment. The tree branches above the head of Paris and the spikes of Hera's crown are applied with a thick clay line. This raised clay line was sometimes gilded on red-figure pottery, but no indication of gilding survives on this example.

99. Red-figured amphora with Nike and charioteer (Fig. 182)

P 9486 (Painting no. 299)
Peleus Painter
Ca. 440–430 B.C.
Pit F 5:3 (upper cutting)
Height: 0.563; restored diameter: 0.415
Agora XXX, p. 135, no. 7, pls. 3, 4; *ARV*², 1040, 18; *Para*, 443; *Add*²,
 319; Shear 1938a, p. 344, fig. 28; Holloway 1966, p. 115, fig. 4;
 Beck 1975, p. 42, no. 55, pl. 47.256; Kephalidou 1996, p. 233,
 no. I 21, pl. 67; Neils 1992, p. 50, fig. 31; Matheson 1995, p. 440,
 no. PE 22, pl. 88; for the Panathenaia, see Neils 1992; for the Athe-
 nian cavalry and its association with the Agora, see Camp 1998.

The owner of this large amphora must have been a victor in the four-horse chariot race of the Panathenaic Games. The red-figured amphora depicts a charioteer racing his team to the left with Nike, the goddess of victory, swooping in to present him a very specific prize, a Panathenaic amphora. The Panathenaic Games were celebrated every four years in conjunction with the Greater Panathenaia, a festival to honor Athena Polias, the patron of the city. An entire day of the festival was devoted to equestrian games including horse racing, two-horse chariot racing, four-horse chariot racing, javelin throwing from horseback, and even jumping onto and off a moving chariot (the *apobates* contest). The winner of the four-horse chariot race received as a prize a number of Panathenaic amphoras filled with olive oil from the grove sacred to Athena. The precise number is not known, but the winner of the two-horse chariot race won 140 amphoras and it is likely that the more prestigious four-horse chariot race would have been accorded even more. The prize amounted to a cash award as each amphora held about 38 liters of oil, which could then be packaged in smaller containers for resale. It is estimated that the value of one jar of oil would have been about 18 drachmai, with one drachma being the daily salary for a laborer; thus, the winner of the two-horse chariot race took home about 2,500 drachmai. The form and decoration of Panathenaic amphoras preserved Archaic (eventually antique) traditions as a way of expressing the duration and legitimacy of the games. An amphora of Panathenaic shape has a characteristically tapering body, small foot, narrow neck, and echinus-shaped mouth. Thus, the vessel Nike presents to the charioteer on this amphora can easily be identified as one of the Panathenaic prize amphoras. The prize amphoras bore old-fashioned black-figure decoration, although the Peleus Painter leaves this one blank.

The red-figured amphora illustrated here was found in the northwest corner of the Agora area not far from the likely location of facilities associated with the Athenian cavalry. It is possible, then, that the owner of this amphora set it up in commemoration of his victory in a location where fellow horsemen might appreciate and remember his achievements.

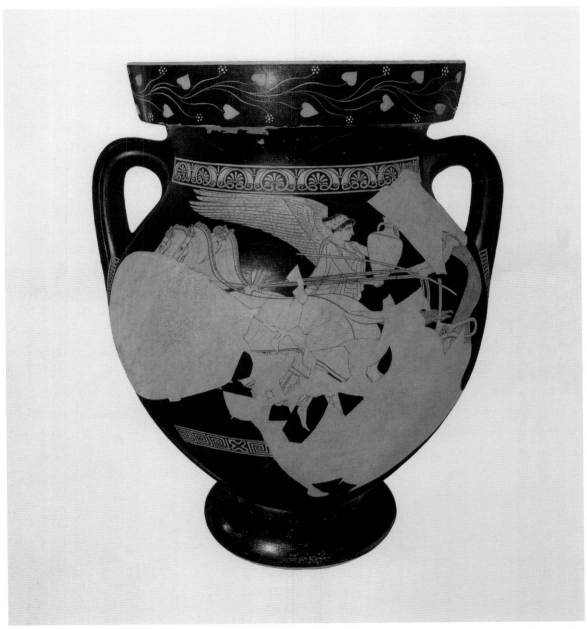

FIGURE 182

100. Red-figured kalpis with three women (Fig. 183)

P 6053 (Painting no. 166)
Manner of the Kleophon Painter
Ca. 430 B.C.
Cutting in bedrock, deposit E 14:4
Height: 0.285; diameter: 0.20
Agora XXX, p. 229, no. 603, pl. 65; *ARV*², 1149, no. 24; Amyx 1958, p. 201, pl. 48b; Matheson 1995, p. 427, no. KLM 32; Sabetai 1997, p. 321, fig. 6.

The voices of ancient Greek women are difficult to hear. Only rarely did they leave us their own words, and we are unable to attribute any art to women. Instead, we must rely on male voices and male-created images as evidence for the lives of Greek women. The male view is notoriously fraught with bias, whether intentional or a natural product of culture. The result is often a version of reality that tells us more about men and their desires than about women and theirs. Even so, during the second half of the 5th century B.C. there was an increase in the number of red-figured vases with scenes of the world of women. One theory for this sudden interest in the domestic lives of women relates the iconography to a change in the law of citizenship introduced by Perikles in 451 B.C. The new law stated that for a boy to be a full Athenian citizen, his father had to be a citizen and his mother had to be the child of citizens. In other words, the mother could not be a citizen herself (that was reserved for men), but she had to have citizen genes. The law was designed to discourage men from marrying foreign women, and thus created a new interest in proclaiming a woman's proper Athenian stock. In addition to genes, however, a proper Athenian should demonstrate culturally defined virtues. Certainly these virtues were ideals, but in the vase paintings, most likely the creation of male artists, we see a projection of these ideals and an affirmation of the values. The interesting question is who the intended audience was: men or women?

Once married, a "citizen-maiden" became more important, and there is a proliferation of scenes related to marriage. On this water jar the central woman is in the act of dressing. She holds the fold of her chiton in her mouth while she ties her belt, or girdle. As Victoria Sabetai has shown, the girdle symbolizes the transition from maidenhood to marriage as it will be the (literal) untying of the girl's virginity, to be removed by the husband on the wedding night. Later the girdle is untied when the woman is pregnant, another significant transition from wife to mother. Our quiet scene may not be the night of the wedding, but the reference to the girl's girdle reminds us that she is on the threshold of change.

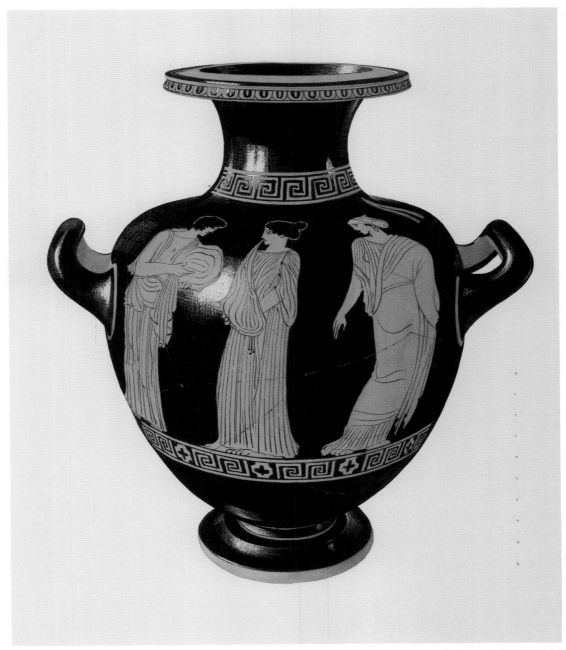

FIGURE 183

101. THREE FUNERARY VASES (FIGS. 184A–E)

P 10280, P 10277, P 10369 (Painting nos. 46, 154, 144, 175, 176)
Bird Painter (P 10277, P 10280), Thanatos Painter (P 10369)
Ca. 430 B.C. (P 10280); ca. 430–420 B.C. (P 10277); ca. 440 B.C.
 (P 10369)
Graves D (P 10277, P 10280) and F (P 10369) in the Lenormant
 Street Cemetery
P 10280: height: 0.265
P 10277: height: 0.263
P 10369: height: 0.304; diameter: 0.10
P 10280: *ARV*², 1233, no. 16; *Para*, 467; Shear 1936b, p. 203, fig. 23
 (top, center); Shear 1937a, p. 361, fig. 24 (top, center); Boulter
 1963, p. 121, no. D3, pls. 39, 41.
P 10277: *ARV*², 1233, no. 17; *Add*², 352; *Para*, 467; Shear 1936b,
 p. 203, fig. 23 (top row, second from left); Shear 1937a, pp. 361–362,
 figs. 24 (top row, second from left), 25; Boulter 1963, pp. 120–121,
 no. D1, pls. 39 (top, second from left), 40, 41; D. B. Thompson
 1971, fig. 62.
P 10369: *ARV*², 1228, no. 2; *Para*, 466; Shear 1936e, p. 118, fig. 1;
 Shear 1937a, pp. 360–361, fig. 22 (second from left), 23; Boulter
 1963, pp. 123–124, no. F1, fig. 4, pls. 40, 43 (top, second from
 left), 44.

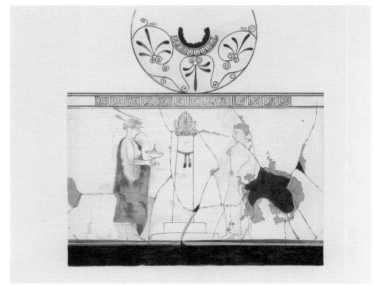

FIGURE 184A

The three vessels illustrated here are oil jars or bottles—lekythoi—excavated from Classical period graves outside of the Agora proper but within the zone of the Agora Excavations. They were all placed within graves, but, interestingly, P 10277 (Figs. 184b, c) and P 10280 (Fig. 184a) come from inhumations, while P 10369 (Figs. 184d, e) comes from a cremation. The gray discoloration of P 10369 is a result of the cremation fire. The oil they held may have served a purpose in the funerary ritual, but P 10369 featured a hidden, small chamber inside its body, which meant the vessel held only a token amount of oil. White-ground lekythoi, that is, those with a white surface onto which the figures are painted, are exclusively funerary. In the mid- to late 5th century B.C. the painting often features polychrome details, such as the crimson garments on P 10277 and P 10280 (Figs. 184b, c, a).

The three scenes are quite similar: each features a tomb, at which a mourner stands and the dead person "appears." However, each has a different type of tomb. On P 10277 (Figs. 184b, c), the tomb itself is the upright cut stone post, a stele, on a four-stepped base. The ovoid form behind the stele, a *tymbos*, is a stylized rendition of a burial mound and thus a reference to heroic burials. On P 10369 (Figs. 184d, e) we see another form of stele with a broader upright slab on a three-stepped base. On P 10280 (Fig. 184a) the stele is topped with a palmette and more elaborate moldings. These tomb forms reflect archaeological evidence of elaborate graves in the Classical period. The graves from which these lekythoi were excavated did not have such markers; thus, the imagery may be a projection of ideal grave types.

In each of the graveside scenes, the living mourner is presumably the one bearing a gift: on P 10277 and P 10369 (Figs. 184b–e) a woman brings an alabastron and on P 10280 (Fig. 184a) a woman brings a plemochoe. It was the women of Athens who tended the family graves and observed grave cult. On P 10369 the nude athlete is the dead youth (Figs. 184d, e). His toned muscles are complemented by the scraper he holds and the oil jar in the background. Here the boy is celebrated for his heroic athletic qualities, although this, too, may have been more idealistic than realistic.

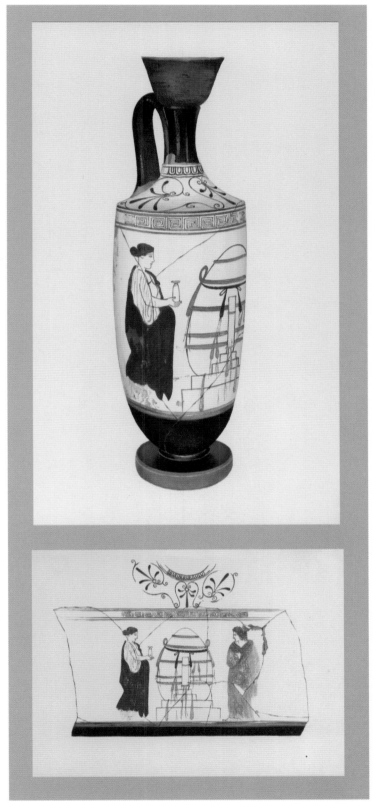

FIGURES 184B, C

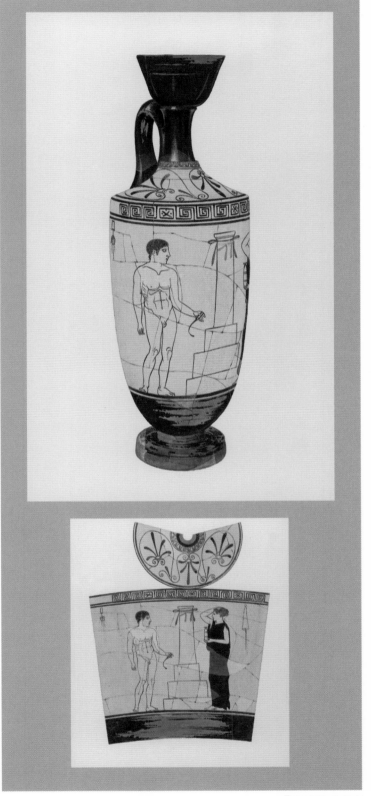

FIGURES 184D, E

102. A GIFT FOR A CHILD: RED-FIGURED CHOUS WITH A DOG
(FIG. 185)

P 7685 (Painting no. 8)
Unattributed
Ca. 400 B.C.
Pit D 15:4
Height: 0.078; diameter: 0.06
Agora XXX, p. 251, no. 782, pl. 81; van Hoorn 1951, p. 83, no. 184,
 fig. 522; Sparkes and Talcott 1958, fig. 58; Rühfel 1984, p. 171,
 fig. 101; Miller 1997, p. 159, fig. 72; for the dog, see Brewer, Clark,
 and Phillips 2001, pp. 85–87, 93–94.

The shape of this pouring vessel, its small size, and its iconography associate it with the Anthesteria festival in honor of Dionysos at Athens. On the first day of this festival the Athenians open the jars of new wine. On the second day they drink the wine—by the jugful. In fact, the second day is marked by a drinking contest in which the first participant to drain a chous (a pitcher holding 3.2 liters) of wine won. Notably, the wine was unmixed—that is, it was not cut with water as wine in the symposium always was. Participation in the festival was probably limited to citizen males, but a feature of the festival was the presentation of three-year-old boys. The festival marked their "debut" in society and formed an important activity in the public celebration of their future as Athenian citizens. The small size of our vessel indicates that it was a gift, or souvenir, for a young Athenian boy who had celebrated his first Anthesteria.

The iconography of the small choes frequently represents a boy's world and sometimes a boy's view of the Anthesteria festival. In the Piet de Jong painting he shows two of the three figures on this chous. Two boys (the hand of the left boy appears at the very left of the painting) converge on a female who is moving to the right. She is dressed in an elaborate chitoniskos and holds a cake intended as a treat for the festival. Between the two figures runs a dog. Dogs frequently appear on choes, telling us that Athenian boys, like children today, bonded with household pets. The dog is probably a Maltese (known in an-

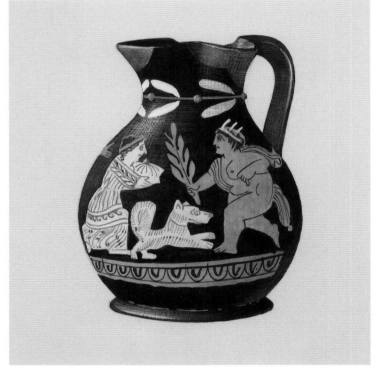

FIGURE 185

tiquity as a Melitean), which was bred and domesticated as a household pet. Above the scene is a painted wreath of olive leaves. This is a figurative reminder of the olive wreath the participants wore during the festival. Thus, in this small object we catch a glimpse of a perspective rare in antiquity: that of a child's world.

CHAPTER 10

Bronzes and Bronze Sculpture

Carol C. Mattusch

103. BRONZE HEAD OF A YOUNG WOMAN WITH A TOPKNOT
(FIG. 186)

B 30 (Painting no. 218)
Late Classical to Hellenistic, between ca. 400 and 200 B.C.
From a well to the west of the Royal Stoa (deposit H 6:4)
Height: 0.20
Shear 1933g, pp. 519–527; Woodward 1937, pp. 159–170; D. B.
 Thompson 1944; Harrison 1977, p. 424; Thompson 1978;
 Mattusch 1988, pp. 172–174; Mattusch 1996, pp. 121–125.

This head for a statue of about half life-size was cast with a tri-angular section of the chest, to be slotted into the neckline of a bronze chiton. Both head and neck were covered with sheet gold, apparently over sheet silver, and Piet de Jong's delicate gold lines around the face and up the side of the neck refer to roughly cut grooves in the bronze into which gold wire was fitted to fasten the thin metal sheets. He also added a profusion of delicate curls to the broken knob on top of the young woman's head (cf. Fig. 187), surely basing his restoration on the topknots that are illustrated frequently in paintings and reliefs dating between the last quarter of the 5th century and the 1st century B.C. But he did not paint in the missing eyes, although it was common practice in antiquity to inset bone or ivory whites and colored stone pupils and irises into the eye sockets of bronze statues.

The hairstyle provides only a general clue to the date of this enigmatic head; that it came to rest in a well alongside pottery of ca. 200 B.C. or slightly earlier provides another broad clue. We may never know whom she represents. She was first identified as coming from one of the bronze statues of Victories (*Nikai*) mentioned in literary sources. These statues are reported to have stood in the Parthenon, covered with the Athenians' gold reserves, two talents (nearly fifty-two kilograms) per statue. They were stripped when gold was needed for coins during the fiscal crisis of the Peloponnesian War in 407/6 B.C., replated, and then stripped again in ca. 294 B.C., when Lachares appropriated the gold to pay his troops. After that, nothing more is said of the bronze statues. Can this head, once covered with gold and silver, be from one of those statues? And how could fifty-two kilograms of gold be configured to fit such a diminutive figure?

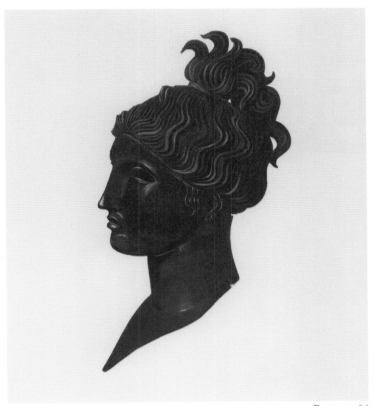

FIGURE 186

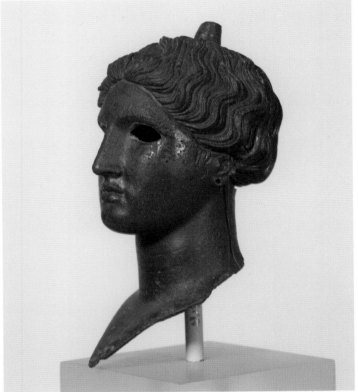

FIGURE 187

104. Bronze shield taken by the Athenians from the Lakedaimonians at Pylos (Figs. 188a, b)

B 262 (Painting nos. 208, 209)
425 B.C.
From a cistern on the Kolonos Agoraios, filled ca. 300 B.C.
 (deposit D–E 8–9:1)
Diameter: ca. 0.97
Shear 1937d, pp. 140–143, figs. 1–3; Shear 1936b; Shear 1937a,
 pp. 346–348; *Agora* III, pp. 40–41; Lang 1960, figs. 33, 34; *Agora*
 XIV, pp. 92–93; Thompson 1976, p. 255; Camp 1986, pp. 71–72.

After the defeat of the Persians in 479 B.C., the Painted Stoa (Stoa Poikile) was built at the northwest corner of the Agora, evidently one of Kimon's efforts to beautify the city center. Outside the stoa stood the famous bronze statue of Hermes of the Marketplace (Hermes Agoraios); inside were hung panel paintings by the great artists Polygnotos, Mikon, and Panainos, all illustrating Athenian victories over real or legendary enemies from Troy to Marathon. Taking the same theme further, the Athenians used the stoa to display shields they had taken from their enemies, especially those of the 292 Spartans they had so gloriously captured at Pylos in 425 B.C. and who, according to Thucydides (4.40.1–2), had surprised everyone by giving up their arms instead of fighting to the death. The paintings were gone when Pausanias visited Athens in the 2nd century A.D., but he saw shields hanging in the stoa, and he was told that those smeared with pitch for protection against age and corrosion were the ones from Pylos (1.15.4). He mentions no inscriptions.

It is nothing short of remarkable that one of the Spartan shields from the Stoa Poikile was recovered from a cistern filled in ca. 300 B.C. and that an inscription proclaiming the shield's origin is still legible (Fig. 188a). The battered circular shield, about one meter in diameter, is made of sheet bronze, which was probably once attached to a sturdy leather backing. Around the rim is a 5- to 6-centimeter-wide decorative border consisting of four repoussé guilloches (Fig. 188b). But four rows of large letters made of crudely punched dots in the center of the shield are the victor's enthusiastic proclamation: "The Athenians from the Lakedaimonians from Pylos."

FIGURE 188A

FIGURE 188B

224

105. BRONZE MIRROR (FIG. 189)

B 475 (Painting no. 215)
Late 6th century B.C.
From grave A in Lenormant Street
Diameter: 0.148
Boulter 1963, pp. 116–118, no. A12; Thompson 1971, fig. 33.

This hand mirror, cast during the late 6th century B.C., has a flat handle topped by a pair of volutes and a palmette, from which delicate tendrils curl outward. The depressions that form three decorative elements indicate that they were once inlaid, probably with black niello, red copper, and silver—or tin, a cheaper alternative. The round depressions at the centers of the decorations may have held brightly colored stones. The disk of the mirror itself, once polished on one side to catch a woman's reflection, is now badly corroded.

In Athenian vase painting of the Classical period, a young woman looking into a mirror may represent a bride preparing for her marriage; or a mirror and a wreath may hang on the wall behind a bride. In general, a mirror, like a wool basket or a perfume jar, identifies a domestic scene. As early as the Archaic period, women dedicated mirrors to Artemis or to Iphigenia, to Persephone, bride of Hades, and to Zeus. This mirror was found in a grave, along with early-5th-century lekythoi, a memorial to female beauty and glamor.

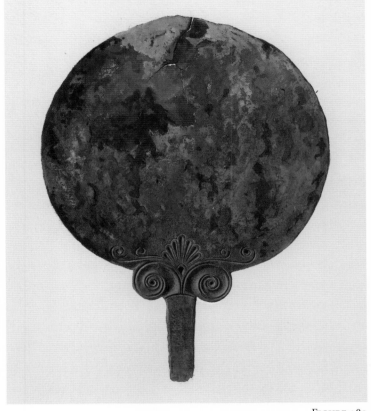

FIGURE 189

for no	may you fare well
other girl	bride
O bridegroom	and let the bridegroom
such as this one now	fare well

(Sappho, frags. 113 and 117, trans. Anne Carson)

106. Bronze herm-shaped handle for a vessel (Fig. 190)

B 361 (Painting no. 246)
Context: 1st–3rd centuries A.D.
From bottom fill of well D 12:1
Height: 0.115
Unpublished.

The rim is too damaged to reveal the shape of the vessel to which this curious handle belonged, of whose small face only the left eyebrow, the right eye, and the end of the chin survive, though these are rendered by Piet de Jong so as to give the face a comical expression. The sloping chest and the arm-bosses are unmistakably the features of a herm, and a lively symmetrical design of tendrils and petals in silver inlay ornaments the standard rectangular shaft.

It is tempting to recognize in the small battered head the cap and youthful face of Hermes, whose image topped the earliest Greek herms of the 6th century B.C. Because Hermes was the protector of travelers, cities, and homes, these odd monuments were set up at street corners, on boundaries, at gateways, and in doorways, as well as in the sanctuaries of various gods, in the gymnasium, and in the palaestra. There was even a cult of the herms. Thucydides attests to their ubiquity when he describes the Athenians' outrage upon discovering one morning in 415 B.C. that the herms at all the street corners had been mutilated during the night. This act of vandalism was taken as an ill omen for the Athenian expedition to Sicily, which was indeed a disaster. Alkibiades, one of the generals who had been chosen to lead the Athenian navy against Sicily, was even accused of being one of those who had vandalized the herms (Hermokopidai), but the charges were temporarily dropped, and Alkibiades went to Sicily. When he was recalled for a full investigation, he took sanctuary with the Spartans.

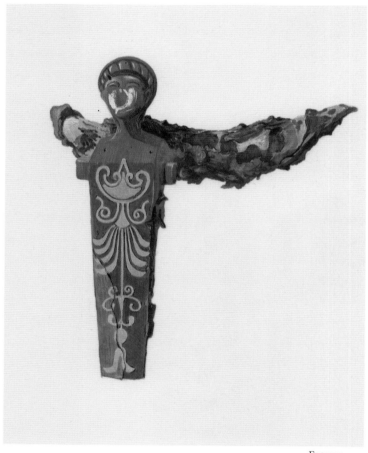

FIGURE 190

Chapter 11

Ivory and Terracotta Sculpture

Carol Lawton

107. IVORY STATUETTE OF APOLLO LYKEIOS (FIG. 191)

BI 236 (Painting no. 198A)
2nd or 3rd century A.D., Roman copy of a bronze statue of the 4th
 century B.C.
From a well cut in the rock on the hilltop of Kolonos Agoraios
 (deposit B 12:1)
Height: 0.30
Shear 1936c, pp. 403–406, fig. 1; Shear 1937a, pp. 349–350, figs. 13,
 14; D. B. Thompson 1959, no. 60; Camp 1990, p. 266, fig. 156;
 Milleker 1986, pp. 264–269, no. 18, pls. 50–54.

On April 30, 1936, some fifteen meters into the excavation of
a well on the hill of Kolonos Agoraios overlooking the Agora,
the excavators came upon small pieces of ivory, including a
head, arm, and part of a leg, that were immediately recog-
nized as coming from a statuette of outstanding workmanship.
The painstaking recovery and reconstruction of the statuette,
quickly identified as a miniature Roman copy of a famous
Greek statue of Apollo Lykeios that once stood in the Athenian
gymnasium called the Lykeion, constitutes one of the more re-
markable achievements of conservation in the early days of the
excavation. Over the next two weeks the excavators continued
emptying the well, sifting the earth as they went, and even-
tually recovered over two hundred fragments of the statuette
(Fig. 192). The fragments were placed in a moist container to
keep them from drying out and splitting, and they were then
cleaned and treated with a preservative. Since the statuette was
considered one of the most important objects found up to that
point in the excavations, an effort was made to find an ivory
specialist to restore it. The search was unsuccessful, and the
delicate and challenging task of restoration was instead under-
taken by Josephine Shear, the excavation numismatist and wife
of the director, and J. Bakoules, the vase-mender. In the course
of several weeks they were able to fit even the tiniest fragments
into their original positions, and the result was a nearly com-
plete statuette, missing only a few minor parts that were re-
stored in beeswax. The genius of Piet de Jong's watercolor of
the Apollo is that it captures the artistic quality of the statuette
and at the same time graphically documents the many frag-
ments from which it was so painstakingly reconstructed.

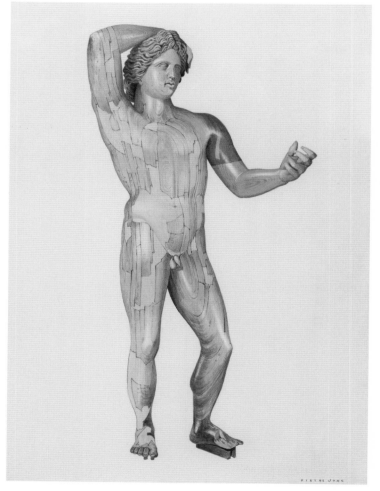

FIGURE 191

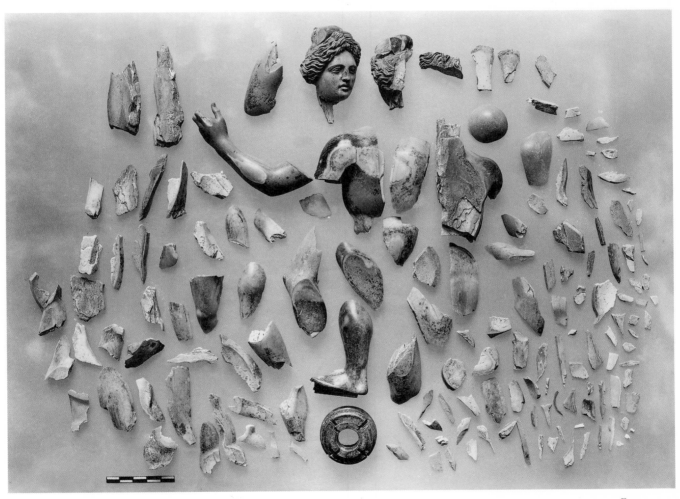

FIGURE 192

108. TERRACOTTA HEAD OF A HELMETED WARRIOR (FIG. 193)

T 3253 (Painting no. 349)
Ca. 460 B.C.
From the basin of the water clock built against the north side of the
 Rectangular Peribolos (area I 14, section K)
Preserved height: 0.20
Thompson 1953b, p. 144 (top); H. A. Thompson 1954, pp. 61–62,
 pl. 14a; Cook and Boardman 1954, p. 144; Richter 1969, p. 94,
 fig. 115; Nicholls 1970, pp. 117–120, 134, no. B1, pls. 32–34.

This terracotta head of an unidentified helmeted warrior was found in ruins associated with a large building in the southwest corner of the Agora that has been variously identified. Since the head is made of a weather-resistant fabric of probable Corinthian manufacture that resembles the material used for roof tiles and simas, it may have been part of the rooftop decoration of that building. Although terracotta sculpture was frequently used for architectural decoration in the Greek cities of Italy and in Corinth, the material was seldom employed for this purpose in Athens, presumably owing to the ready availability of marble. The Agora may have been an exception, however, since a number of fragments of large-scale terracotta sculpture have been found in the vicinity of public buildings there, principally buildings that were built or repaired after the Persian destruction of 479 B.C. Although the association of the fragments with specific buildings is for the most part conjectural, one example can be corroborated in ancient literature. The Roman traveler Pausanias, author of a guide to the antiquities of ancient Greece, noted on his tour of the Agora that there were statues of baked clay on the roof of the Royal Stoa; fragments probably belonging to them have been found nearby. Rooftop statues, or akroteria, are rare on buildings other than temples, and the terracotta examples from the Agora are perhaps an indication of the importance Athenians attached to their civic buildings as they refurbished their badly damaged city in the Early Classical period. Piet de Jong's watercolor carefully details the warrior's Thracian-type helmet, decorated on both sides with the winged horse Pegasos, and in pencil he has attempted a reconstruction of the helmet's missing crest.

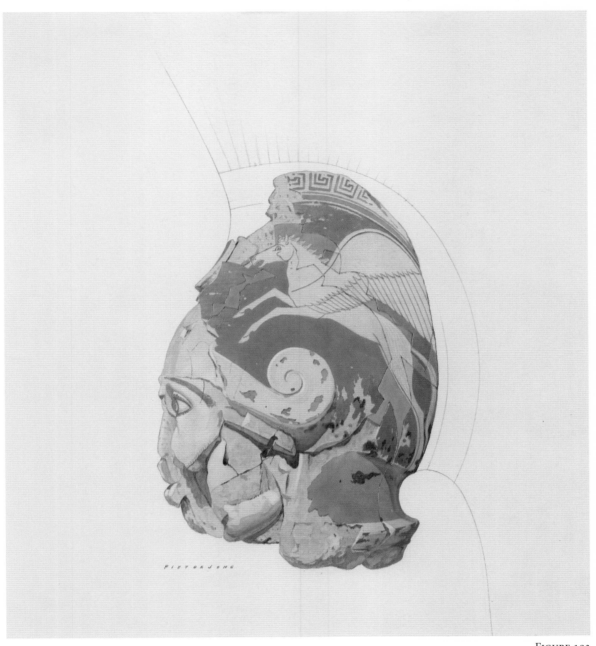

FIGURE 193

CHAPTER 12

Hellenistic Pottery

Susan I. Rotroff

109. Sotadean kantharos (Fig. 194)

P 2322 (PD no. 472)
Ca. 425 B.C.
From a well east of the Panathenaic Way, filled with household
 debris around 425 B.C. (well R 13:4)
Preserved height: 0.057
Talcott 1935, pp. 500–501, no. 8, figs. 4, 19, 20; *Agora* XII, p. 281,
 no. 641, pl. 27.

A photograph does not communicate much about either the shape or the decoration of this object (Fig. 195). Only the stumps of its handles remain, but originally they looped high above the rim—as de Jong has restored them—transforming it from a rather ordinary cup into a flamboyant, even elegant chalice. An earlier cup of the same shape was signed by the potter Sotades, a remarkably innovative craftsman who delighted in the invention of eccentric and playful shapes: a libation bowl with a cicada perched at the middle of the floor; cups in the form of animals' heads or even of figured groups. Perhaps he invented the shape illustrated here; in any event, it has been dubbed the Sotadean kantharos in his honor.

The photograph gives no hint of the delicate garland of ivy and berries that runs around the rim. This is because whoever painted this vessel used an unusual technique: instead of leaving the stems, leaves, and dots free of gloss, as in red-figure, he painted the garland directly onto the fully glazed surface, using dilute solutions of two kinds of clay as his pigment. This had some advantages. It was possible to produce a more colorful design: stem and leaves in pinkish buff; berries in white. It may also have saved some time, since painting such a delicate design directly would have been easier than silhouetting it with gloss. The disadvantage, however, is that the clay paint did not stick; all but a few faint traces of pinkish buff have flaked away. The design survives only in a faint discoloration of the gloss, which can just barely be seen by moving the cup back and forth in an oblique light. It is only through Piet de Jong's painting that we can appreciate the cup as it came from the hands of its maker.

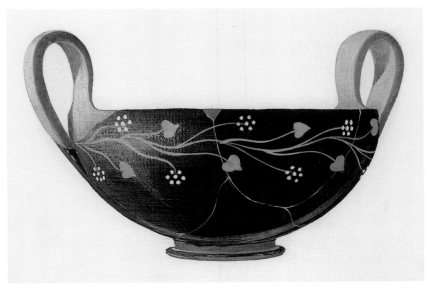

FIGURE 194

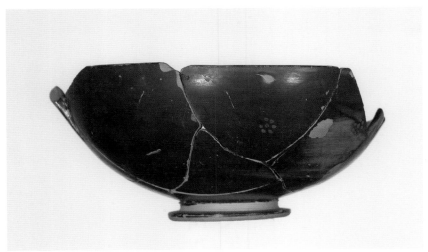

FIGURE 195

110. West Slope amphoras (Figs. 196a, b)

P 1106, P 3185 (Painting nos. 162, 173)

275–250 B.C. (P 1106); 120–110 B.C. (P 3185)

From a cistern system filled with debris of the late 4th and 3rd
centuries (H 16:3); and a Roman well (F 15:3) cut through a Hel-
lenistic cistern (F 15:2), which was probably the source of P 3185

Height: P 1106: 0.21; P 3185: 0.237 (as restored)

P 1106: Thompson 1934, pp. 334–335, no. B 3, figs. 15, 16; Rotroff
1991, p. 69, no. 2, fig. 2, pl. 14; *Agora* XXIX, pp. 285–286, no. 409,
fig. 24, pl. 39.

P 3185: Thompson 1934, pp. 398–399, no. E 59, figs. 87, 88; Rotroff
1991, p. 93, no. 98, fig. 22, pl. 41; *Agora* XXIX, p. 290, no. 438,
fig. 31, pl. 43.

In the Hellenistic period (ca. 330–1st century B.C.) red-figure
was replaced by West Slope technique, named after the find
spot of the first large collection of this pottery to be studied
(a well on the lower western slopes of the Acropolis). In West
Slope technique, decoration was applied to the already glazed
surface using two colors of "paint" (actually dilute solutions of
clay), white and pinkish buff, sometimes enhanced by incision.
Although the technique was not new (see no. 109), it came into
its own in this period, ushering in a new aesthetic of pottery
decoration. The complex figured compositions and narrative
of red-figure were abandoned, replaced by leaping dolphins,
floral and geometric designs—as here—and isolated motifs
with religious or festive connotations.

The table amphora is one of the most characteristic shapes
decorated in this manner. Athenian potters invented it—unless
they adopted it from some as yet undiscovered source—near the
beginning of the 3rd century B.C., initiating a series that was to
last until the early 1st century B.C., when the sack of Athens by
the Roman general Sulla dealt a devastating blow to the pot-
tery industry. Because of their rich decoration we can assume
that West Slope amphoras were meant for display, probably in
the context of the symposium, but their precise function at the
dinner party is uncertain. Perhaps they held small quantities
of undiluted wine, kept at the ready for subsequent mixings
in the krater. The archaeological contexts of the two amphoras
pictured here tell us that about 150 years of ceramic develop-
ment lies between them. Stylistic changes in the painted motifs
and more subtle alterations in silhouette can be observed, but
they are still recognizably the same shape and are very close to
the same size; whatever their function, it remained the same
over the centuries.

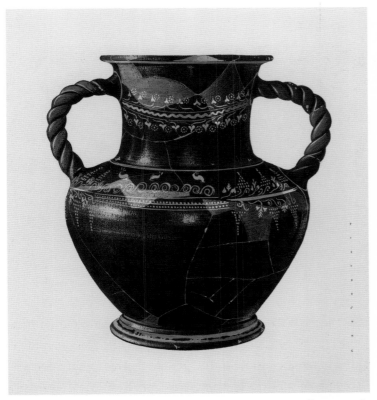

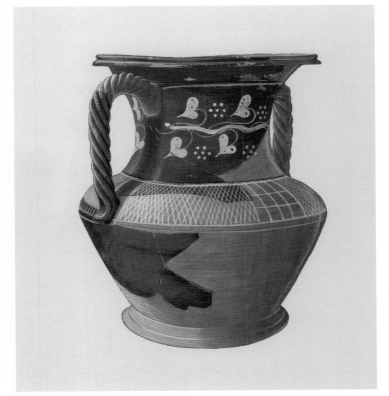

FIGURE 196A

FIGURE 196B

111. A LETTERED CUP (FIG. 197)

P 7379 (Painting no. 163)
Ca. 300–280 B.C.
From a cistern northwest of the Agora square, filled with workshop
and domestic debris around 250 B.C. (cistern E 3:1)
Height: 0.114
Shear 1937a, p. 373, fig. 37; *Agora* XXIX, p. 259, no. 165, fig. 13, pl. 15.

Around the year A.D. 200, the learned encyclopaedist Athenaios composed a voluminous work titled *Deipnosophistai*. Frequently translated as *The Sages at Dinner*, it describes an imagined dinner party where guests display their erudition by quoting tags of ancient text on a wide range of topics. Since wine is being drunk in plenty, drinking cups emerge as a natural subject of conversation, and we are treated to a long list of these, each illustrated by quotations from Athenaios's apparently boundless files.

Somewhere near the beginning of the list is the *grammatikon ekpoma*—the "lettered cup." Two Athenians describe one in a 4th-century comedy (Athenaios 11.466d–e):

A. It was round and old and really small,
 Its handles badly bent and crumpled,
 Around it letters ran. . . .

B. Eleven
 Gold ones, right? "To Zeus the Savior!"

Then, in the elevated diction of 5th-century B.C. tragedy (Athenaios 11.466f), a group of satyrs decipher an inscription:

The god's bright cup keeps calling me
with beaming letters: D and I
third comes an O, then N and Y,
nor does it lack the S and OY.

Put them all together, they spell Dionysou—"[this belongs to] Dionysos."

These cups were made of metal, and none has survived the ages, but clay cups with exactly the same inscriptions have.

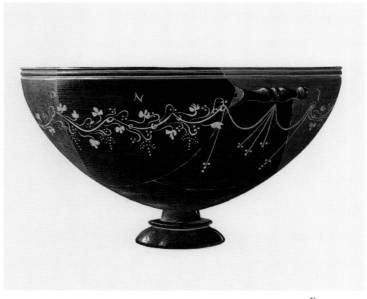

FIGURE 197

Like the cup that attracted the satyrs, the one pictured here names the wine god Dionysos (the letters ONY of the middle of the name are visible in the painting). Others found at the Agora name Aphrodite, Amphiaras, Agatha Tyche (Good Fortune), Asklepios, Hermes, and Zeus the Savior.

What do the names mean? They are in the genitive, suggesting that the cup in some way belonged to the god. Successive mixings of wine and water were dedicated to different gods (often to Zeus the Savior), and that custom may be reflected here. We may also, however, invoke another use of the ancient Greek genitive—the genitive of exclamation: our cup may read, "To Dionysos!!"

112. Skeuomorph (Fig. 198)

P 5719 (Painting no. 183)
Ca. 275–260 B.C.
From a cistern filled with potter's debris at the end of the 3rd
 century B.C. (E 14:1)
Height (to rim): 0.168
Shear 1936a, p. 38, fig. 38; Rotroff 1991, p. 74, no. 29, fig. 6, pl. 21;
 Agora XXIX, pp. 250–251, no. 85, fig. 9, pl. 9.

An unlikely shape for a clay pot: handles that swoop above the rim and turn sharply back down, almost begging to be snapped off, a projecting flange below the rim to catch dribbles from the lip of a messy drinker, and a ribbed lower body, impossible to create on the potter's wheel. The same features, though, make perfect sense in metal, suggesting that this cup is a "skeuomorph"—an object that reproduces in one material something that is normally made in another. This one is a faithful, downmarket replica of the metal cups favored by the Early Hellenistic wealthy—fabulous vessels of bronze or silver, perhaps even—rarely—of gold, with engraved, embossed, and gilded decoration.

The dolphins that leap across the wall might not seem the most logical decoration for a drinking cup. To an ancient viewer, however, they would have brought to mind the wine god Dionysos who once, disguised in human form, took passage on a ship that turned out to be manned by pirates. When they attempted to attack him, he resumed his true form and turned his abductors into dolphins who, as former men, still retain an interest in human beings. It is probably because of this association that 3rd-century B.C. Athenian potters often painted dolphins on drinking cups and other vessels used for wine service.

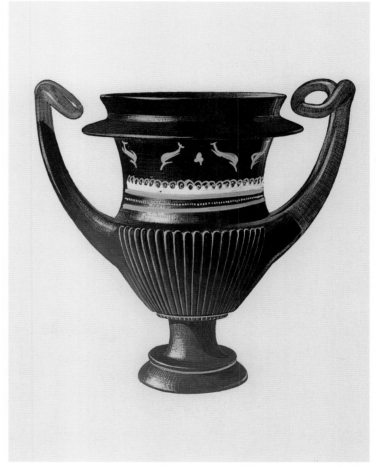

FIGURE 198

113. EGYPTIAN FRIENDSHIP (FIG. 199)

P 5811 (Painting no. 189)
275–260 B.C.
From a cistern filled with potter's debris at the end of the 3rd
 century B.C. (E 14:1)
Height (to rim): 0.163
Shear 1936a, p. 38, fig. 38; Rotroff 1991, p. 76, no. 30, fig. 6, pl. 21;
 Agora XXIX, pp. 249–250, no. 77, fig. 8, pl. 8.

Like much West Slope pottery, this elegant drinking cup is decorated with generalized sacred symbols. Grape bunches recall Dionysos, patron of wine and drinking, and torches bound with fillets refer to the sacred and festive occasions on which they were carried. The central motif is easily recognizable as a cornucopia, a symbol of plenty and well-being familiar from the modern Thanksgiving table. For the ancient Greeks, who also knew it well, it was the horn of Amaltheia, the nymph (or perhaps goat) who nursed the baby Zeus, and whose horn produced whatever the heart desired. The horn pictured on this cup, however, is special. Close inspection of the pot shows a detail Piet de Jong omitted: a sinuous line running the length of the horn and turning it into a double horn, or dikeras (Fig. 200). The double horn appears for the first time on coins of Arsinoe II of Egypt, the powerful queen who revived the old Egyptian regal custom of brother-sister marriage and exercised decisive power over her brother and husband, Ptolemy Philadelphos ("he who loves his sibling"), during a time when Athens and Egypt were closely allied against a common enemy, Macedon. That is, in fact, the very time when this cup was painted, and it makes a political as well as religious statement, highlighting Athens' alliance with Egypt by using the queen's symbol as a central motif. Like the cup above (no. 111), it is a "lettered cup," but here the word *philias* (friendship) replaces the name of a divinity. This inscription, not at all uncommon on 3rd-century B.C. cups and usually referring to companionship among fellow drinkers, is extended here to encompass amity between allied states.

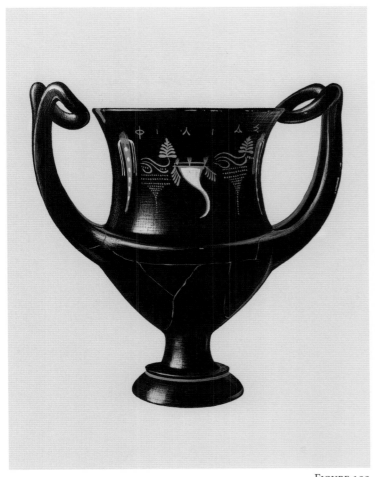

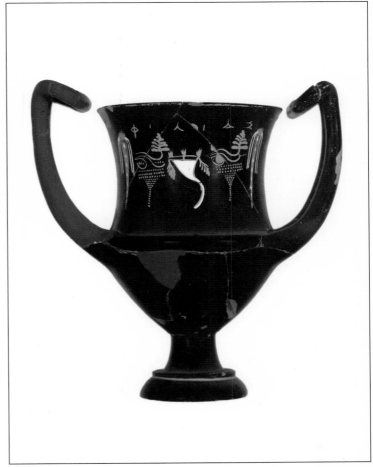

FIGURE 199

FIGURE 200

114. THE RED AND THE BLACK (FIG. 201)

P 10437 (Painting no. 188)
275–250 B.C.
From a well (B 13:7) filled in the 3rd century B.C.
Height: 0.115
Agora XXIX, p. 262, no. 193, fig. 14, pl. 18.

In most ways this is a perfectly pedestrian cup. The shape, capacious but hardly elegant, was amply represented in the cupboards of 3rd-century B.C. Athenians, and the West Slope decoration is perfunctory. An accident of firing, however, has turned it into something a little more interesting. The almost magical chemistry of the gloss coating of Attic pottery determined that, depending on the conditions in the kiln, the surface could turn out either a dark, glossy black or a bright red—as well as an infinite number of shades in between. When the potter loaded his kiln for firing, stacking the vessels so as to get as many as possible into the narrow space, this cup sat at an angle in the pot below it, in a position that restricted the flow of gases around its lower body. In the course of the three-stage firing process, the slipped surface of the pot should have first turned red, then, as air was blocked off from the kiln, black. By the time the last phase of firing began, and air was readmitted to the kiln, the temperature should have risen high enough to fuse the surface so that it would be unable to absorb oxygen and, therefore, remain black. The lower part of this pot, however, insulated by the vessel within which it was stacked, failed to reach the temperature required for this fusion, and so it turned red again when air entered the kiln. Although this might count as a production error, the effect is not unattractive and it is possible that it was even actively sought.

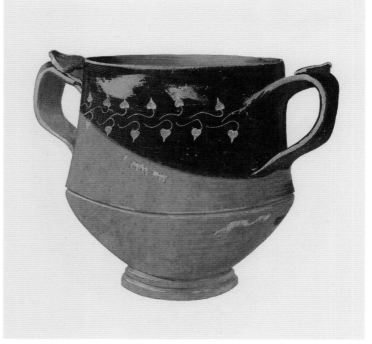

FIGURE 201

115. A MACEDONIAN HUNT (FIG. 202)

P 6878 (Painting no. 296)
3rd century B.C.
From a cistern drawshaft (D 12:2), filled with debris in the 1st
 century B.C.
Height: 0.317
Shear 1937a, pp. 374–376, fig. 39; *Agora* XXI, p. 55, no. G 21, pl. 31;
 Agora XXIX, pp. 270–271, no. 271, fig. 18, pls. 26, 27; Rotroff
 2003.

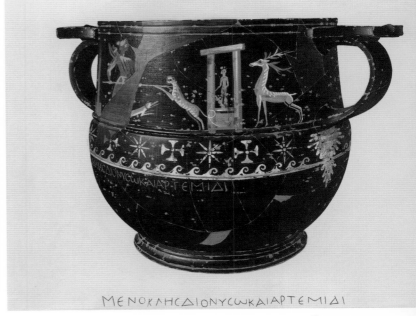

FIGURE 202

Here we have a case of gigantism, a vessel in the shape of a wine cup but nearly three times the normal size. No one could have used it for drinking, and an incised label on the lower body tells us that one Menekles (probably the right reading, although Piet de Jong rendered the name Menokles) dedicated it to Dionysos and Artemis. The raucous god of wine and the chaste goddess of the hunt make an odd pair; presumably Menekles had his reasons for personal devotion to both of them. He deposited his offering in a shrine in the 3rd century B.C.; protected in that sacred setting, it had become a venerable antique by the time it was discarded two centuries later.

Menekles' gift preserves the only figured scene in Attic West Slope technique to have survived from antiquity. Both sides are decorated; de Jong has painted the better preserved of the two. The setting is a sanctuary, indicated by a statue in a little shrine and, at the far left, a sacred pillar. Artemis, accompanied by her hunting hound, rams a spear into the throat of a panther—strangely, the familiar animal of her co-honoree, Dionysos—while a magnificent stag watches. On the other side, human hunters bag a boar and a lion. Wild boar might lurk in the forested uplands of Attica, but unless one traveled very far east- or southward, lions could be found only in the game parks maintained by Macedonian kings. A Macedonian connection is further hinted by the starburst in the frieze below the figured scene, a symbol that occurs frequently on Macedonian armor and coinage. Menekles must have had significant contacts in Macedon and perhaps here commemorates his participation in a royal Macedonian hunt; personal confrontation with such noble and dangerous prey would certainly have been the experience of a lifetime.

116. ANTIQUITY REVIVED (FIG. 203)

P 3155 (Painting no. 152)
150–110 B.C.
Found in a Roman well (F 15:3) that had been cut through a Hellenistic cistern (F 15:2), probably its original source
Height: 0.27
Thompson 1934, pp. 423–426, no. E 153, fig. 111, pl. III; Hübner 1993, pp. 51–52; *Agora* XXIX, p. 405, no. 1631, fig. 98, pls. 128, 129.

Tastes in pottery—as in food—vary from place to place. Athenians preferred glossy black pottery, Phoenicians liked red, while in parts of Italy, Sicily, and Asia Minor a dark gray surface was the norm. Since Athenian potters never deliberately produced this effect, we can be certain that this gray-ware krater is an import, arriving in Athens as the treasured personal possession of a traveler or immigrant, probably from the East.

If the shape looks familiar, it is because 18th-century silversmiths adopted it as a wine cooler, a tradition that we fall heir to today (Fig. 204). Their models were Late Hellenistic vessels much like this in shape, but much larger and made of marble. These fantastic megakraters were favored by the ancient wealthy as garden decoration, imparting an Alice-in-Wonderland strangeness to the landscape, where men and women walked among vessels from a giant's table. Some of these marble kraters made their way to northern collections; others were drawn by the Italian artist Piranesi (1720–1778); both his etchings and the objects themselves served the silversmiths as models, as they gave the shape a new life in modern times. Details of the gray-ware krater suggest that there were ancient metal ones, too: the stamped ovolo on the shoulder and the grooved handles with their drooping leaf attachments and lion heads have the look of metalware.

Around the upper body parades a series of single figures, each an individual clay plaque attached to the wall. Some are easy to recognize: the ecstatic dancer to right of center is a maenad, a devotee of the god Dionysos, and the veiled woman holding a tall torch left of center may be Leto, mother of the gods Apollo and Artemis—though what the two of them would be doing in the same company we cannot say. And who is the fellow on the left, striding purposefully rightward with a sack (or wineskin?) over his shoulder and his right arm raised in greeting or salute? A satyr, perhaps? His identity—and whether these are gods and demigods or humans in divine costume and what rite or festival they celebrate—remains a mystery.

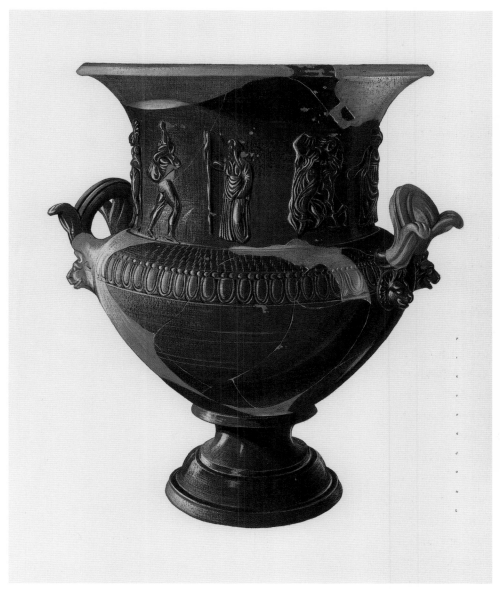

FIGURE 203

FIGURE 204

117. Symplanos lagynos (Figs. 205a, b)

P 3375, P 3188 (Painting nos. 170, 190)
150–110 B.C.
From Thompson's group E (F 15:2), and the Roman well (F 15:3)
 cut through it
Height: P 3375: 0.166; P 3188: 0.183
P 3375: Thompson 1934, p. 403, no. E 70, fig. 92; *Agora* XXIX,
 pp. 390–391, no. 1507, fig. 89, pl. 115.
P 3188: Thompson 1934, p. 405, no. E 73, fig. 92; *Agora* XXIX,
 p. 396, no. 1552, fig. 93, pl. 121.

For a Greek of the 2nd or 1st century B.C., the long-necked decanter known as the lagynos was as symbolic of good times as a champagne bottle or a tipped martini glass is today. The *Greek Anthology*, a collection of ancient poetry compiled in the Byzantine period, includes several short verses addressed to the lagynos. Observing the inverse relationship between the contents of his lagynos and his own sobriety, one poet writes,

> Why is it that when I am sober you are drunk; but when I get drunk, you get sober? That's a crime against the laws of conviviality!

"Sweetly babbling, softly chuckling, mellifluous, long-necked . . . lagynos!" apostrophizes another poetic drinker, adding, "I've waited for you a long time, but now I hold you in my hand!" To drink from a lagynos was to gratify all the senses—through the taste and smell of the wine, the beauty of the flagon and its feel as you cradled it in your arms, and the gurgle of the wine passing through the narrow neck.

The decanter's design responded to new customs. No longer were wine and water mixed in a krater for distribution to the assembled drinkers; rather, drinkers brought their own tipple (several ancient sources describe a lagynos as *symplanos*, "fellow wanderer") and prepared individual mixtures in their wine cups (or even drank the beverage neat). The finest ceramic lagynoi were made in the East, decorated with red or black paint on a light ground. P 3375 (Fig. 205a), with its vertical lower wall, plain handle, and painted brown wreaths, was probably made in Asia Minor, perhaps not far from Pergamon; the very squat and angular P 3188 (Fig. 205b) with its rope handle and bright red banded decoration may come from Cyprus.

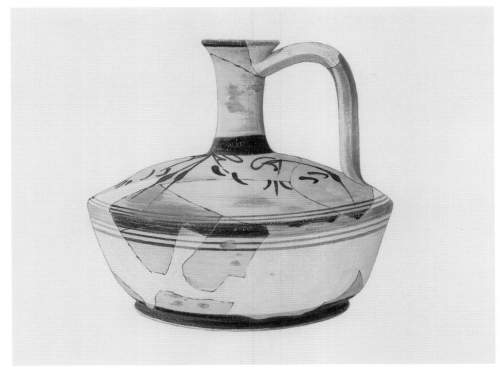

FIGURE 205A

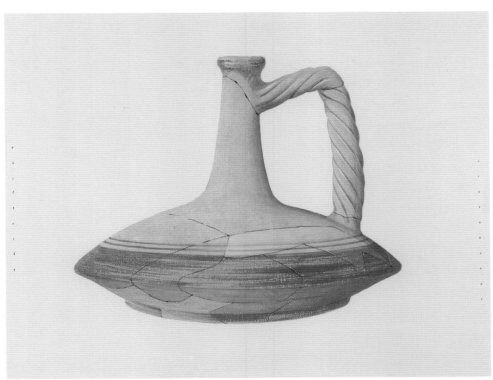

FIGURE 205B

118. DEATH IN ALEXANDRIA: HADRA VASE (FIG. 206)

P 6313 (Painting no. 182)
230–210 B.C.
From a cistern filled in the second half of the 3rd century (E 14:1)
Height: 0.322
Shear 1936a, p. 37, fig. 37; Callaghan and Jones 1985, p. 15, fig. 5f;
Agora XXIX, p. 389, no. 1500, pls. 113, 114.

Hadra vases take their name from an Egyptian village just east of Alexandria, the largest and most splendid city of the Hellenistic era. There, early in the 20th century, archaeologists excavated one of the major cemeteries of the ancient city. Some of the dead had been cremated, their ashes placed in vessels like the one illustrated here, distinguished by both shape (a hydria, or water jar) and decoration (designs in dark gloss and incision on the clay surface). A number of them were inscribed with the name of the deceased—often foreign visitors to the city—and the date of death, which ultimately made it possible to date this pottery quite precisely.

The Alexandrian provenance naturally led to the assumption that these distinctive vessels were made in Egypt; but in the 1970s Peter Callaghan, an Australian archaeologist studying Hellenistic pottery at Knossos, in Crete, noticed an uncanny resemblance between the designs on the Hadras and the motifs painted on West Slope pottery unearthed on the Cretan site. Idiosyncratic details of the drawing of simple motifs—like the stylized dolphins that cavort along the lower register of the hydria pictured here—led him to believe that the Hadras and his Cretan pottery had been decorated by the same artists. Callaghan took his observations to Richard Jones, a specialist in the chemical analysis of ceramic fabric and, at that time, director of the Fitch Laboratory of the British School at Athens. Through analysis of samples of the Knossian West Slope and of Hadra vases, Jones was able to confirm Callaghan's hypothesis, establishing that this common Alexandrian artifact was in fact a Cretan import. This one, from the Athenian Agora, is also from Crete; its context, a deposit of domestic and workshop debris, shows that the vessels were not always intended for the graveyard.

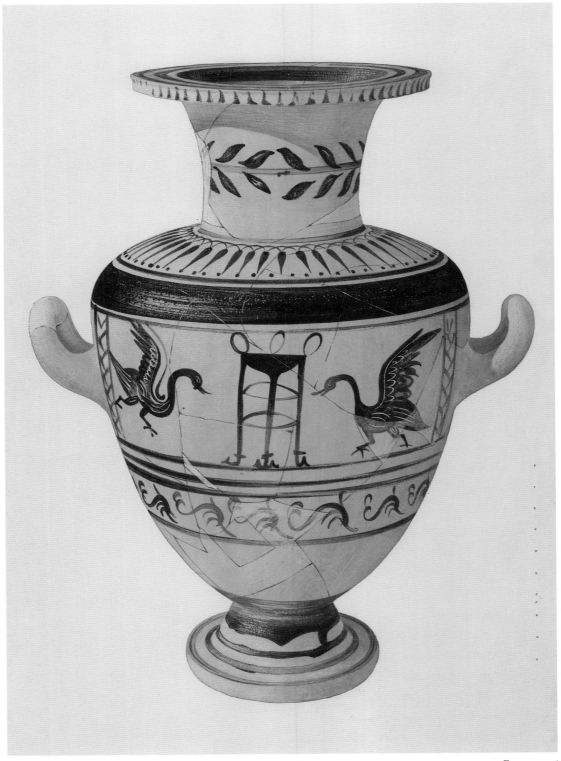

FIGURE 206

119. Oil of lilies (Fig. 207)

P 6154 (Painting no. 194)
4th century B.C.
From a cistern (D 15:3) outside the southwest corner of the Agora
 filled in the 4th century B.C.
Height: 0.295
Williams 1969, p. 59, fig. 9; *Agora* XII, pp. 339–340, no. 1484, pl. 63;
 Agora XXXIII, no. 396.

Everything about this pot marks it as an outsider. The shape, though once a staple of Athenian pottery, had been out of vogue for centuries when this amphora was potted in the 4th century B.C. The sketchy pattern of lilies and banded decoration in matte black and red paint on a slipped pinky-gray surface is equally foreign to Attica. Close parallels can be found in Cypriot pottery of the preceding century, but this amphora did not come from Cyprus. It is made of a hard-fired material known as "blister ware," a specialty of potters at the great mercantile city of Corinth. The name comes from the blisters that form within the wall and on the surface during firing. Although this sounds like a disadvantage, something about the clay formula renders blister ware virtually impervious, a quality that makes it ideal for the storage and shipment of valuable liquids, especially oil.

This amphora, then, was shipped from Corinth to Athens for the sake of the oil it contained. Its small size and the floral pattern tell us that this was perfumed oil, a wildly popular and widely traded item. The potters who made this vessel would have worked closely with the perfume makers; they may all have been members of one family. The Cypriot decoration hints that they were easterners, and the floral pattern suggests the amphora contained *susinon*—perfume of lilies—whose very name entered the Greek language from a Semitic source. We may imagine a family firm of Cypriot potters and perfumers in Corinth, using their closely guarded secret recipes to produce both the container and the commodity. Carefully packed into the hold of one of Corinth's merchant ships, this amphora and others like it traveled to Athens (many have been found at the Agora), the Cyclades, Macedonia, northwestern Greece, and even Italy.

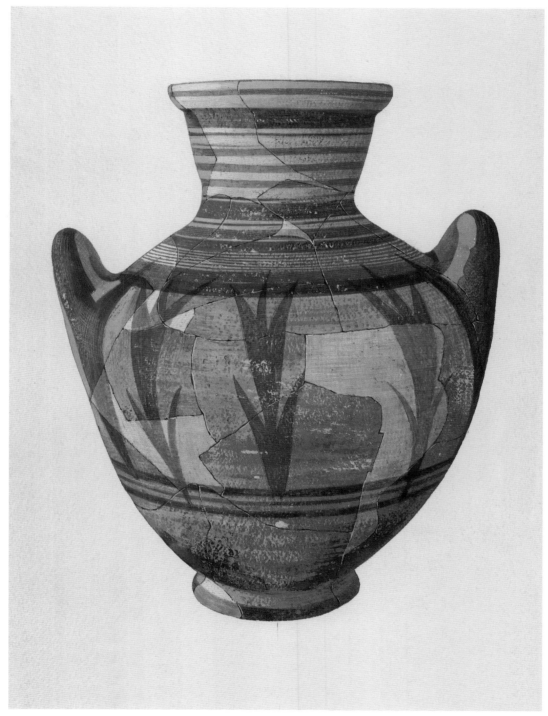

FIGURE 207

120. GARDEN LORE (FIG. 208)

P 7051 (Painting no. 36)
Around the turn of the era
The grove on the south side of the temple of Athena and Hephaistos
 (D–F 6–8:1)
Height: 0.19
D. B. Thompson 1937, p. 407, no. B 5 b, fig. 9.

This is just what it looks like: a flower pot, tapering like its modern descendant and with a hole in its bottom. It and eleven others like it were found in a row of deep, square cuttings in bedrock running parallel to the south side of the temple of Athena and Hephaistos on the Kolonos Agoraios, overlooking the Agora (Fig. 209). Dorothy Thompson, who supervised their excavation in the 1930s, and her husband, Homer, were keen gardeners, and Dorothy quickly recognized the meaning of what she had found: the remnants of the formal garden that once surrounded the temple. The pots, placed well below the ancient ground level, were not containers for potted plants, but rather preserve traces of the method used to make the plantings. Ancient gardeners knew that species that are difficult to grow from seed or from cuttings can be rooted while still on the mother plant in a process known as layering. Cato the Elder, a crusty Roman patriot of the 2nd century B.C., describes the procedure in his book on agriculture: "[T]o root a branch while it is still on the tree, make a hole in the bottom of a pot or basket and push the branch you want to root through it. Fill the pot or basket with earth, tamp it down well, and leave it on the tree. When it is two years old, cut the branch below the basket, slit the basket down the side and through the bottom, or, if you have used a pot, break it, and plant the branch in a trench with the basket or pot" (*De agricultura* 52.133). The technique is not suitable for all species, but Cato recommends it for olive and fruit trees, myrtle, laurel, Praenestine nuts, plane trees, and grape vines. We may imagine a grove made up of a selection from that list surrounding the temple at about the time of the birth of Christ.

FIGURE 208

FIGURE 209

CHAPTER 13

Terracotta and Faience Figurines

Susan I. Rotroff and Margaret Rothman

121. A GOOD TRICK (FIG. 210)

T 1731 (Painting no. 223)
Third quarter of 4th century B.C.
From a well (O 18:2) filled with household debris around 320 B.C.
 and nicknamed "the hedgehog well" after this figurine
Length: 0.077
Shear 1939a, p. 242, fig. 42; D. B. Thompson 1954, p. 87, no. 11, pl. 19.

"The fox knows many tricks, the hedgehog one great one," wrote the 7th-century B.C. poet Archilochos. The hedgehog's most famous trick, of course, is to roll itself into a bristling ball whenever danger approaches. According to some ancient authors, however, it knew others as well. Both the great Roman polymath and naturalist Pliny the Younger (1st century A.D.) and the Greek biographer and essayist Plutarch (late 1st–2nd century A.D.) assert that the hedgehog gathers food by rolling in fruit, which it then transports, impaled on its spines, back to its nest—either for its young hoglets or to store for use in the winter. This figurine illustrates the ruse, catching the hedgehog in the act, with the fruit—perhaps figs—arranged neatly on its spiny back and sides.

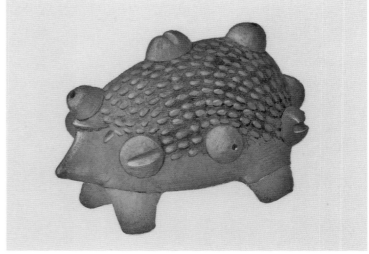

FIGURE 210

 The tale of the thieving hedgehog is repeated in other texts, both ancient and medieval, but modern naturalists are skeptical. The hedgehog prefers insects, slugs, and earthworms to fruit (although it will eat almost anything); it does not bring food back to its nest but eats it where it finds it; nor, as a hibernating animal, does it require a winter larder. And yet modern observers have repeated the tale and even illustrated the phenomenon (Fig. 211). The solution may lie in yet another puzzle, the mysterious hedgehog activity known as "self-anointing." When confronted with a triggering substance (which varies widely from animal to animal), hedgehogs chew and lick it, producing a frothy spittle, which they then spray over their spines and fur with a flicking motion of the tongue. These antics entail a fair amount of thrashing about, in the process of which a hedgehog might inadvertently skewer fruit that happens to be lying in its vicinity. Self-anointing hedgehogs—like a cat on catnip—are oblivious to their surroundings, unaware that they have taken on an illicit cargo of fruit and are thereby acquiring a reputation for thievery.

FIGURE 211

122. MOTHER OF THE GODS (FIG. 212)

T 1546 (Painting no. 211)
Hellenistic
Strewn throughout Hellenistic fill in area F 4, on the northern side
 of the Kolonos Agoraios
Height: 0.137
Shear 1938a, p. 353, fig. 39; D. B. Thompson 1954, pp. 99–103, pl. 23.

This terracotta represents a remarkably tall and elaborate form of the *polos*, a crown worn by any number of Greek goddesses but probably adopted from the sacred iconography of the East. The square cutouts at the top reproduce the crenellations of a city wall, in a variant most frequently associated with a divinity the Greeks addressed as "Mother of the Gods." Behind that title stands the great Anatolian mother goddess, Kubaba, who entered Greece and Greek worship under the name Kybele, bringing with her an entourage of ecstatic, tambourine-playing dancers and her familiar animal, the lion. Despite these foreign trappings, Kybele's worship was firmly established at Athens. In the 6th century B.C. she had a little temple at the western foot of the Kolonos Agoraios; later her sanctuary was incorporated into the archives of Athens, and this exotic imported divinity became the protector of the day-to-day records of Athenian legal life.

The *polos* wears a skirt, is crowned with two wreaths, and has a veil that, if extended, could cover the figured scene on the front like a curtain. Perhaps we are being treated to a peek into the mysteries of the cult—initiation was necessary for full participation in Kybele's rites. The enthroned figure in the uppermost register, who wears a veiled *polos* and carries a tambourine, is either the goddess herself or an initiate decked out in her regalia. The dance in the middle register (and perhaps in the sketchily executed lower register as well) represents her rites, which included ecstatic singing and dancing to the beat of the goddess's tambourine. Perhaps some initiate commemorated a high point of her spiritual life by the gift of this image of her goddess in a now vanished shrine.

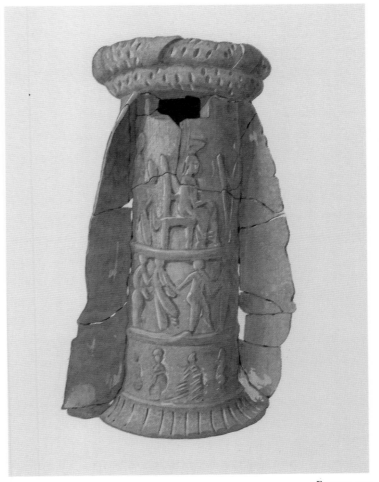

FIGURE 212

123. IMAGE OF A VANISHED GEM (FIG. 213)

T 1035 (Painting no. 226)
Hellenistic or Early Roman
From fill ranging in date from late 1st century B.C. to late 1st
 century A.D. (deposit B–C 10–11:1)
Length: 0.056; thickness: 0.006
Shear 1936b, p. 201, fig. 20.

By the end of the Hellenistic period, the chariot as an engine of war or even as a conveyance had been out of use in Greek lands for over a thousand years. It survived, however, in the world of sport, where it remained a potent symbol of rank, affluence, and power. Wealthy people kept stables of thoroughbreds trained to race with the quadriga, the four-horse chariot. This was the most dangerous and exciting of competitions, a climax of such international festivals as the great games of Zeus at Olympia.

Naturally one raced to win, and the image here piles on auspicious symbols. The charioteer is none other than Nike, the goddess of victory herself, identified by the wings that grow from her shoulders. In case the outcome should be in any doubt, she waves the palm of victory in place of a whip. Not many people, of course, were able to participate in such races; but images of a winning team could shed good luck, and perhaps for this reason racing Nikai closely similar to this one are common in many different media: wall paintings and plaques, coins, shields, metal vessels, pottery, gold jewelry, and gems. Piet de Jong has drawn a cast taken from the ancient clay mold (where the figures are reversed and in intaglio), and at three times natural size to catch the detail. That mold is itself an impression of yet another object; to judge from the regular oval shape of the field and the slightly concave surface of the mold, the original may have been a large cameo or a glass gem. By means of the mold, this lucky image could be transferred to other objects—clay plaques, perhaps, or metal items decorated in repoussé—affordable for the average Athenian.

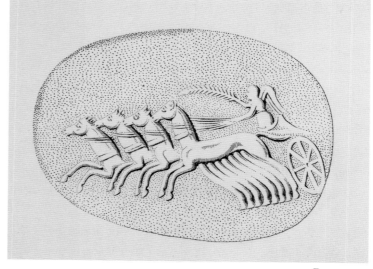

FIGURE 213

124. Guardian of the Dead (Fig. 214)

G 62 (Painting no. 229)
3rd century B.C.
From a cistern system (drawshaft D 11:2) on the south slopes of the
 Kolonos Agoraios, filled in the late 3rd century B.C.
Preserved height: 0.042
Shear 1936b, pp. 195–196, fig. 12; Shear 1937a, p. 376, fig. 41.

Instead of looking to the future for the solutions of enduring questions, the Greeks often turned to the past. It was a common notion that old texts—like the verses of the mythical poets Homer and Orpheus—preserved truths about the nature of the universe, though couched in language that was difficult to penetrate. Likewise, ancient cultures harbored mysteries that a person might tap into through study or initiation.

Egyptian culture, the Greeks knew, was much older than their own and it was therefore a natural place to turn for enlightenment. Worship of Egyptian deities entered Athens as early as the 4th century B.C. and became increasingly popular in the Hellenistic period, when someone brought this talisman to the city. The favored divinity was Isis, a goddess who began her long life as wife of Osiris (legendary first king of Egypt and later ruler of the afterlife) but developed into a universal goddess. Ancient hymns attributed to her the establishment of the paths of heavenly bodies, the invention of law, navigation, marriage, justice, and religious devotion, and even such fundamental human instincts as love between parent and child. She had the advantage, from a Greek perspective, of being fully human in appearance. Among her entourage, however, was the jackal-headed Anubis. According to very ancient myth, after Isis had gathered together the severed limbs of the murdered Osiris, Anubis assembled them and mummified the body, thereby reviving the king. Thereafter, he guided the souls of deceased initiates on the perilous journey to the underworld, and thus played a key role in the achievement of the eternal bliss that the religion of Isis promised.

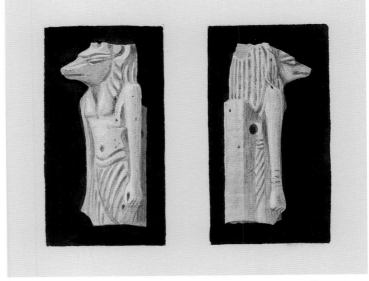

FIGURE 214

This little faience amulet reproduces a statue of the god. He stands in the traditional rigid pose of Egyptian figural sculpture, his back supported by a pillar, and wears the striped headdress and pleated kilt of Egyptian royalty. He glares fiercely, his long ears (now broken away) pricked vertically alert to the threats confronting the soul under his protection.

CHAPTER 14

Roman Pottery, Lamps, and Glass

John K. Papadopoulos, with E. Marianne Stern

125. The goblin jug (Fig. 215)

P 10714 (Painting no. 193)
A.D. 1–50
From a well (E 14:2) on the Kolonos Agoraios filled with contents
 from the 1st century B.C. to the 1st century A.D.
Height: 0.205
Shear 1938a, pp. 347–348, fig. 31; cf. *Agora* V, p. 15, discussion
 under no. F 45; *Agora* XXXII, forthcoming.

This red-gloss jug with barbotine motifs in the form of fantastic "goblins," which were made separately in molds and attached to the surface of the vase, has been recently classified by John Hayes as a variant of Pontic Terra Sigillata. The workshop that produced this distinctive ware has still not been located, but it was possibly in the area of the Propontis or Sea of Marmara. Jugs of this shape and fabric are common in the 1st century A.D., and during the first half of the century such vessels appear occasionally with barbotine ornament.

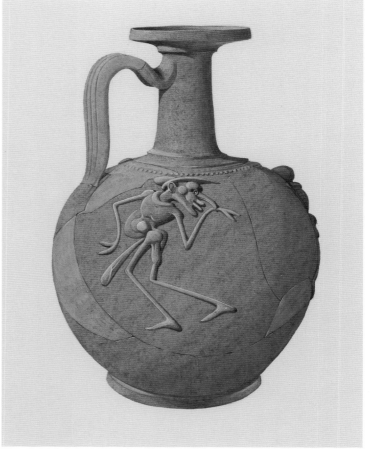

 The most distinctive aspect of this jug is the figured decoration. Three large, grotesque figures appear as if they were dancing around the body of the vase. The figure in front is skeletal in appearance; those on the sides—including the figure illustrated by Piet de Jong—both from the same mold, are equally grotesque, with a large penis and testicles, an elongated beak for a nose, and a pointed cap pushed back on the head. The illustrated figure moves toward the left, belly pointing forward, but with upper torso and head looking back, toward the skeleton-like figure. In his preliminary publication of the vase, T. Leslie Shear speculated that these figures may represent caricatures of the comic actors in the farces that were popular in Italy and Greece in the Augustan age.

FIGURE 215

126. An Arretine bowl by C. Amvrivs (Fig. 216)

P 3277 (Painting no. 14)
Ca. A.D. 20–50
From a well (G 8:1) on the slopes of the Kolonos Agoraios
Height: 0.066; diameter (rim): 0.146
Shear 1935c, pp. 367–368, fig. 24; Iliffe 1936, p. 27; Oxé, Comfort, and Kenrick 2000, p. 174, no. 19 (16 263); *Agora* XXXII, forthcoming; for historical background, see *Agora* V, p. 2.

The original identification of this bowl as an Arretine product by T. Leslie Shear in an early preliminary report has stood the test of time, although for a while vessels such as these in the eastern Mediterranean were generically referred to as "Western Sigillata." Arretine pottery, named after the town in northern Italy (Arretium) where it was produced, represents one of the most distinctive Italian red-gloss products exported to Greece and the eastern Mediterranean. In Athens, the earlier black-gloss tradition of the Classical and Hellenistic periods gradually came to an end in the course of the 1st century B.C., the decline accelerated by the Roman sack in the earlier years of that century. In 86 B.C. Roman troops under Sulla breached the fortifications of Athens between the Sacred Gate and the Piraeus Gate and laid waste the city. The Potters' Quarter, which lay in the path of the invaders, suffered severely. As Henry Robinson vividly reconstructs in *Agora* V, "many potters, with their families, if they had been fortunate enough to survive the famine of the siege-days, may have fallen prey to the slaughter wreaked by Sulla's soldiers on those early March days when Athenian blood flowed in the streets of the market and the Kerameikos." Despite the severity of the sack, black-gloss continued to be produced in Athens for a while, albeit of inferior quality, but its days were numbered and by the early 1st century A.D., thanks in part to the imports from Italy and the east that flooded the market, it faded into oblivion.

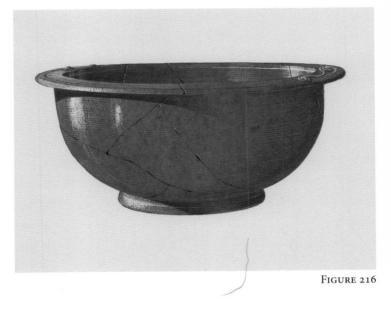

FIGURE 216

Piet de Jong's watercolor captures well the color and the restrained double spiral of the relief decoration on the rim of the vessel, but even de Jong's ingenuity was not enough to render both the pot in its entirety *and* the stamp at the center of the interior. The latter abbreviates the maker's name: CAMVRI, which is stamped within a footprint. John Iliffe, in his study of potters' stamps on Sigillata wares in the Near East, reconstructs the name as C.AMVRIVS.

127. An old woman who slaughtered? (Fig. 217)

P 9892 (Painting no. 191)
Late 3rd century A.D., after 267
From the fill of well M 17:1 (*Agora* V, group M)
Height: 0.135
Shear 1938a, p. 348, fig. 32; *Agora* V, p. 101, no. M 190, pls. 26, 57.

The distinctive shape of this vessel is sometimes referred to as jug and sometimes as mug. This particular example was one of four one-handled vessels of Athenian manufacture that could have been used for both pouring and drinking—hence jugs/mugs—from well M 17:1 with words painted around the body in large white letters in cursive script. Some of the inscriptions seem appropriate enough for vessels holding wine: one bears a wish for a long life, another a greeting to the "beautiful fair one." More enigmatic, however, is the word on the vase illustrated by Piet de Jong. The word ΣΦΑΞΙΓΡΑΙΑ (Σφαξιγραῖα) appears only on this vessel and on a similar jug/mug thought to derive from a slightly earlier layer in the same well (P 9903, no. M 145). The word, which begins to the right of the handle, was interpreted by T. Leslie Shear as "the old woman who slaughtered." Shear added that this was probably a proper name. Henry Robinson was less sure and he noted another possible interpretation, namely one that would associate the initial element σφαξι– with the form σφάξ, σφαγός, as in the meaning of "throat" or "gullet." Robinson, however, was unwilling, or unable, to expand on the meaning, though he noted that Eugene Vanderpool, always an avid reader of problematic inscriptions, called attention to the use of διασφάξ, "in sens. obsc." Again, there was no elaboration. Liddell and Scott give the primary meaning of διασφάξ as "any opening made by violence, rent, especially gorge, through which a river runs" (alternative meanings include: divisions of blood vessels, fissure in the liver, sluice, and gill cavity [in fish]), and this would be appropriate to the sense that Vanderpool pointed out. Whatever the meaning of διασφάξ, however, it is difficult to see what it has to do with the word Σφαξιγραῖα, and until a more el-

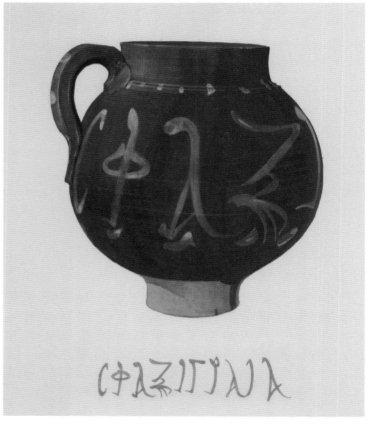

FIGURE 217

egant reading is offered, Shear's suggestion—"an old woman who slaughtered" as a personal name—should not be categorically dismissed. A plausible alternative, one combining Shear's interpretation with those of Robinson and Vanderpool—and one appropriate for a vessel used for pouring or drinking wine—would be to read Σφαξιγραῖα as "old lady's gullet," as in "Mother's ruin."

128. A Late Roman decanter (Fig. 218)

P 10005 (Painting no. 172)
4th century A.D., ca. 325–350+
From the fill of well A 14:1
Height: 0.242
Agora V, p. 76, pl. 39, noted under no. L 24.

This vessel is one of the best-preserved examples from the Athenian Agora of a Late Roman vessel that has come to be known as a "decanter," though by what name it was known to the ancients we may never know. It was found in a well near the south edge of the Kolonos Agoraios in a deposit dated to the years around the middle of the 4th century A.D. The vessel, which stands on a ring foot, is characterized by an ovoid body and a narrow neck, with a prominent horizontal flange at its midpoint—above which the neck is wheel-ridged—and two grooved vertical handles. The painted decoration, which includes linked spirals rotating clockwise toward the center, diagonal stripes, and tear-shaped blobs, is made up of a white paint, rather faintly preserved for the most part, over a streaky, matt, brownish glaze.

In his typical fashion, Piet de Jong has brought to life both the decoration of the pot, which is rather dull as it survives, and the shape of the vase. He achieved the latter through his habit of "tilting" the pot in such a way as to be able to show virtually all of its details simultaneously, from the grooving of the handles and the grooves at the juncture of body and neck to the wheel-ridging on the upper neck and the exterior form of the base. As is so often the case, de Jong manages to bring out the very best in the objects he illustrates, whether magnificent or pedestrian.

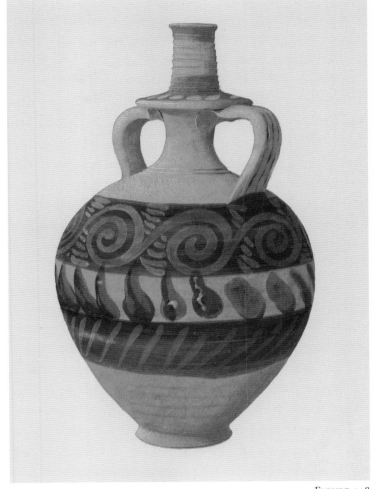

FIGURE 218

129. AN AFRICAN BOWL (FIG. 219)

P 9656 (Painting no. 192)
Ca. A.D. 500–525
From the fill of well M 17:1 (*Agora* V, group M)
Height: 0.055; diameter: 0.207
Agora V, p. 116, no. M 349, pls. 36, 71; Hayes 1972, pp. 150–151,
 no. 4, pp. 250–252, stamp no. 147; *Agora* XXXII, forthcoming.

This red slip bowl is a classic example of African Red Slip ware, one of several Late Roman fine wares that dominated the Mediterranean market in ceramic tableware, especially of open forms—plates, bowls, and the like—from the 2nd and 3rd centuries through the years of the 6th and early 7th centuries A.D. The bowl is a characteristic example of a shape designated by John Hayes, laconically, as Form 97. The vessel is a small bowl with a flat or slightly convex rim, tilted downward, with the edge scalloped to form eight to ten slightly concave sides; here there are ten sides. There is usually, as is the case here, one deep groove close to the lip, following the scalloping, and another close to the inner edge. Although originally dated by Henry Robinson to the late 6th century A.D., the chronology of the bowl was revised on the basis of context by John Hayes to the years of the first quarter of the 6th century. A number of examples of this shape bear stamped decoration at the center of the floor on the interior. Here a swastika in a square is surrounded by a single circular groove at the center of the interior.

Although Piet de Jong rarely drew sections of vessels in the watercolors he prepared, the manner in which P 9656 was broken and preserved easily gave him the scope to illustrate not only the section but effectively both the interior and exterior of the vessel. His watercolor is a peek into all aspects of the pot.

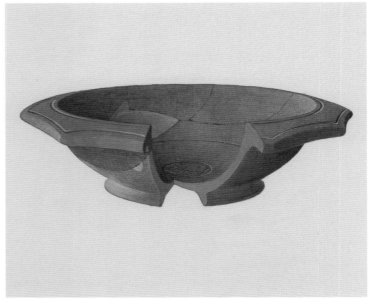

FIGURE 219

130. Aphrodite(?), Hermes, and a bull on three Roman lamps (Figs. 220a, b)

L 2709, L 2710, L 2810 (Painting nos. 184, 245)
First half of the 3rd century A.D.
From drain channel system, E 5:4
Width: L 2709: 0.084; L 2710: 0.086; L 2810: 0.091
Shear 1938a, pp. 355–356, fig. 43; *Agora* VII, pp. 117–118, 128, pls. 17, 20, 49.

The three lamps illustrated here were all found in the same deposit dating to the first half of the 3rd century A.D. Together, they represent some of the most characteristic and finest examples of mold-made lamps of the period. All three lamps bear the name of the maker on the base; two (L 2710 and L 2810) were made by Elpidēphoros (appearing either as Ἐλπιδηφ|όρου or Ἐλπιδηφό|ρου), the other (L 2709) bears the name Πρείμου; both names appear in the genitive. The most interesting aspect of the three lamps is the relief decoration on the disks. Piet de Jong presented all three lamps on one sheet, illustrated from above (Fig. 220a). There is little on this sheet of his characteristic tilting and maneuvering of objects in order to show them in all of their three-dimensionality.

The lamp at the top of the watercolor shows a draped woman, standing three-quarters right, holding a large tray with offerings; she stands beside, and looks toward, a small, evidently round naiskos with a domed roof. The two front columns are clearly visible, and two other columns are just visible in the background. On a base, within the naiskos, stands a goddess, perhaps Aphrodite, though there is no visibly diagnostic attribute that establishes her identity (perhaps the Monopteros of Aphrodite at Knidos and Tivoli?). The goddess holds something in her left hand and rests her right hand on a small herm. The lamp on the lower right shows the god Hermes—identified by his kerykeion or caduceus, which he holds in his left hand—his drapery and petasos slung over his left shoulder. The god is moving to the left and his right hand passes behind the head of a prancing ram; the movement of the god seems all the more animated by the forward movement of the ram. God and ram move within an architectural space defining a sanctuary—to the left there is a high stele on a base, to the right an altar on which has been placed a relief-decorated plaque. Piet

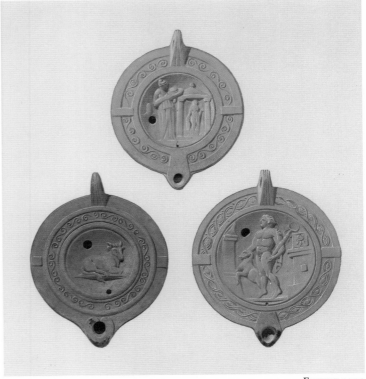

FIGURE 220A

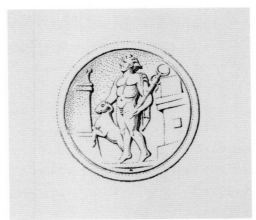

FIGURE 220B

de Jong also prepared an inked drawing of the same lamp (Fig. 220b). The decoration of the third lamp is more circumscribed: it shows a bull—more clearly a bull in Piet de Jong's watercolor than in the published photograph of the lamp—lying down on a well-defined baseline.

131. Mosaic glass plate (Fig. 221)

G 541 (Painting no. 361)
Mid-3rd century A.D.
From the Herulian destruction debris on the floor of the South
 House, room 23 (deposit B 17:1)
Height: 0.052; estimated diameter (rim): 0.346
Weinberg 1962; Brill 1962; *Agora* XXXIV, no. 153; comparanda:
 Feugère 2001; Goldstein 1979, no. 792; Harden et al. 1987, no. 9;
 Stern and Schlick-Nolte 1994, no. 148; Williams and Zervos 1982,
 pp. 133–134, pls. 42a, 43; Oliver 2001, p. 356, fig. 7.

Mosaic glass vessels are among the finest luxury wares of the Hellenistic and Roman periods. Typically, the vessels are made from slices of glass rods showing a colorful motif in their section. One of the most common motifs is a rosette or flower, and it is from this that the technique is often called millefiori ("thousand flowers"). But there are many other designs. What sets the Agora plate apart from the usual mosaic glass vessels is the fact that it does not show a dense pattern of one or more polychrome motifs extending through the thickness of the wall. Rather, the background is composed of polygonal sections of monochrome blue glass rods. The central human figure seated in the tub-shaped boat and the fish swimming along the rim are actually preformed mosaic glass elements embedded in the background. Although the term "inlaid" has been used for this technique, the figural elements are not inlaid in the technical sense. The background was not removed for inserting them; it merely was displaced when the preformed figural elements were pushed into the heat-softened surface of the glass.

About half of the central portion of the plate is preserved, as well as two pieces of the rim that do not join and two other small nonjoining fragments. Although the glass itself is in an advanced state of deterioration and severe weathering of the surface has caused considerable changes in the original colors, Piet de Jong's painstaking reconstruction shows that the Agora plate must once have been a magnificent showpiece. The background is turquoise or aquamarine blue. The only preserved fish is silver and greenish gold. The central figure—perhaps Eros fishing—wears a narrow-brimmed hat, dark in the cen-

tral part and opaque white in the top and bottom portions, like the chubby childlike face. The eyes, brows, and curly hair appear black. The rounded object emerging from behind the figure is probably his creel, a basket for carrying freshly caught fish; it is dark blue with lighter zigzags and crescents (now covered with golden iridescence) indicating the wickerwork of the basket. The tub or boat is opaque white except for the wavy stripes of silvery glass.

Stylistically and technically the Agora plate belongs to a small group of flat plaques or tiles and vessels (plates and bowls) decorated with embedded mosaic inlays depicting fish in a blue sea, but the only other example from a known find spot is a fragmentary plate found at the site of a Roman villa in the vicinity of Narbonne in southern France. Published by Michel Feugère, the fragments of the Narbonne plate were found on the surface and could not be precisely dated. The blue-ground of these objects, however, is not made of mosaic glass. The unconventional technique of assembling sections from monochrome rods to compose the Agora plate is unique in antiquity, although it could have been invented by any glassworker familiar with the conventional technique of making mosaic glass vessels. In Murano (Venice) some plates with large monochrome areas are still being made this way.

The prefabricated mosaic inlays of the plates and plaques are closely related to isolated fish inlays, some with remains of plaster backing, perhaps for embedding in a wall, as in the examples in the Corning Museum of Glass mentioned by Sidney Goldstein and by Donald Harden, and others that preserve no

trace of how they might have been used, such as those discussed by E. Marianne Stern and Birgit Schlick-Nolte. These, in turn, are similar to the mosaic fish in a glass opus sectile panel excavated at Corinth in a context dated to the end of the 3rd century and published by Charles Williams and Orestes Zervos. The Corinth panel, together with another recently excavated in Rimini, Italy, are further discussed by Andrew Oliver. The relatively large number of isolated fish inlays preserved from antiquity suggests the existence of one or more workshops specializing in the production of figural mosaic glass inlays that were sold to glassblowers and other artisans. The Agora plate, with its curious background of blue mosaic glass sections, may have been made in one of these specialized centers rather than in a workshop that routinely made cast glass vessels as were, in all probability, most of the other blue plates and tiles decorated with prefabricated mosaic glass elements.

—*E. Marianne Stern, based on the published description by Gladys D. Weinberg*

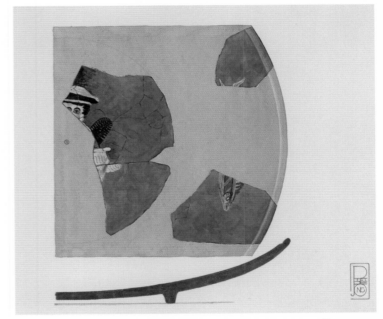

FIGURE 221

CHAPTER 15

Roman Mosaics

Barbara Tsakirgis

Introduction

When we think of mosaics today, we call to mind the stone floors of vast public buildings or the ethereal images on the vaults of Byzantine churches, but, in fact, the technique of mosaic began as a flooring for houses. Rounded river pebbles were pressed into the earthen floors of early houses in Greece in order to prevent the daily passage of feet from eroding the hard-packed earth. Over time, the decorative possibilities of the pebbles were recognized and mosaic floors with intentional decoration began in earnest. In the 5th century B.C., at sites such as Olynthos in northern Greece, Classical mosaics display a series of decorative borders echoing the motifs used in vase painting and using just two colors, black and white. Some of these early mosaics depict mythological scenes in a panel at the center of the floor, but many are simply a number of concentric frames, each with a different floral or geometric pattern. Into the 3rd century B.C., mosaic floors were found only in the best rooms of houses, often the andron, a dining room where the male head of the house entertained his friends.

Technical innovations in mosaics occurred over the 4th and 3rd centuries B.C. In the second half of the 4th century we begin to see color used in the designs, first to enliven the patterns and eventually to indicate light and shadow and thus to depict three dimensions. In the following century, mosaic artists from around the Mediterranean began to recognize the greater painterly qualities that could be achieved in mosaic floors if the pebbles were cut into cubic tesserae and placed flush against each other. Thus the technique of mosaic as we commonly see it today was born.

The two mosaics illustrated here, one painted by Piet de Jong (Fig. 223) and the other by Marian Welker (Fig. 222), are later descendants of the early mosaic floors. One certainly adorned a major room of a Late Roman house and the other possibly did; the use of the Late Roman building that lay over the earlier Metroon has not been convincingly identified. This building may also have been a Late Roman house. Both mosaics from the region of the Agora are colorful, especially that in the house from section ΠΠ (A 2103) in which terracotta and glass as well as the traditional stone were used for tesserae (Fig. 222). The tesserae are set fairly close together to create numerous patterns, some quite intricate and some known from other parts of Late Roman Athens.

Unlike Piet de Jong's paintings of vases and architectural members, Marian Welker's renderings of the mosaics contain little if any gouache. The colors vary from a very dilute application of paint in the field of the house mosaic to use of concentrated color in the border of the same. In her copying of the mosaics, Welker treats missing elements very differently than de Jong does in his painting of vases. A comparison between the photograph of the house mosaic and Welker's painting shows that she filled in many areas of the mosaic that are no longer extant and gave no indication of where the surviving mosaic ends and the restoration begins. In her painting of the floor from the house in ΠΠ, Welker has also straightened the lines of some of the designs in the mosaic; the actual rows of tesserae are in many cases not entirely straight.

For a long time mounted on the west wall of the Agora Museum, the watercolor by Marian Welker depicts the overall composition of the floor as a large square area bordered by two decorative frames, an inner guilloche and an outer interlocking double meander (Fig. 222). The central square field is depicted in undifferentiated white, with a few electric blue tesserae indicated in the lower right corner. In her painting Welker liberally reconstructs the floor with little to no indication of where the actual floor is damaged or missing. The mosaic itself is extremely ruinous, especially in the central section; here, Welker's only indication of the damage is her limited indication of colored tesserae in the corner of the central square area. Surrounding the square area on four sides is a panel or passage filled with pale gray tesserae arranged in wavy lines; the actual tesserae are white. On two sides of this passage there extends a broad, colorful band forming a decorated L-shaped area, filled with a variety of motifs. Overall the colors are intense in tone and quite varied in palette; they include red, pink, yellow, green, pale blue, black, and electric blue. As with the mosaic over the earlier Metroon (Fig. 223), this is a bird's-eye view with no distortion of the perspective. There is no signature on the front, though the scale, "1:10," appears in pencil on the lower left corner.

An important question to ask, but one impossible to answer due to the poor state of preservation of both the room and its contents, is the function of the room. The high-quality work and the colorful tesserae suggest that this was a public room of the house, but no furniture was discovered here to help identify the space. The walls of the room are virtually

FIGURE 222

nonexistent, and such traces as do exist show that the mosaic was not centered in the room; perhaps the floor is a replacement for an earlier one. Such a practice should not surprise the modern reader. In our own houses today we alter the configurations and interior decoration to suit our present needs and up to the level of décor that our pocketbooks will support. The configuration of the mosaic pattern suggests that something was centered on or around the large square in the middle of one leg of the L-shaped panel, but without extant furniture, the arrangement is left to our imagination.

132. Mosaic floor over the earlier Metroon (Fig. 223)

No inventory no. (PD no. 168)
5th century A.D.
Room III of the later phase (VI) of the Metroon on the west side of
 the Agora, uncovered in 1934
Dimensions of original room: 15.65 × 7.95
Thompson 1937, pp. 198–199; Spiro 1978, figs. 3, 4, 5; *Agora* XXIV,
 pl. 45.

This painting is a true watercolor; there is no gouache for the
tesserae. Colors include cream white, pale red, pale blue, and
black, while paste white was used to highlight the areas where
tesserae are missing. The mosaic is presented from a bird's-eye
perspective; there is no distortion in the angle of view. The
watercolor is signed on the reverse: "Metroon, Room III from
south. Late Roman Mosaic. P. De Jong, 1934." The painting is
in two sections, an overall view of the mosaic rendered at 1:50
and a detail of the west side rendered at 1:10. A roughly rect-
angular area of floor appears in the overall view, bordered on
the long north side by a band of blue tesserae; the full width of
this band is not preserved. Within that band, and extending on
the north and west sides of the floor, is a cream-colored field
on which is depicted a series of circles, bordered in red and
black and colored blue; the circles are linked by a line of black
tesserae. Within this band, and following the same outlines of
the room, is a black ivy vine on a cream field. Single red ivy
leaves alternate on either side of the vine. A central rectangular
field of cream tesserae is covered with an overall pattern of al-
ternating red and blue petals that creates quatrefoils formed by
interlocking circles. The center of each quatrefoil is occupied
by a poised square of black tesserae. Gaps in the floor, where
tesserae are now missing, are shown scattered on the western
end of the central field and near the eastern limits of the floor
as it is depicted in the painting. Against the long south side of
the floor appears a rectangular mat of blue tesserae, decorated
with a diagonally arranged grid in black. The mat may indicate
the location of a no longer extant doorway.

 The close-up view of the west end of the floor includes up
to the third circular form on the north side of the room. The
colors used are the same in both the overall painting at 1:50
and the detail at 1:10.

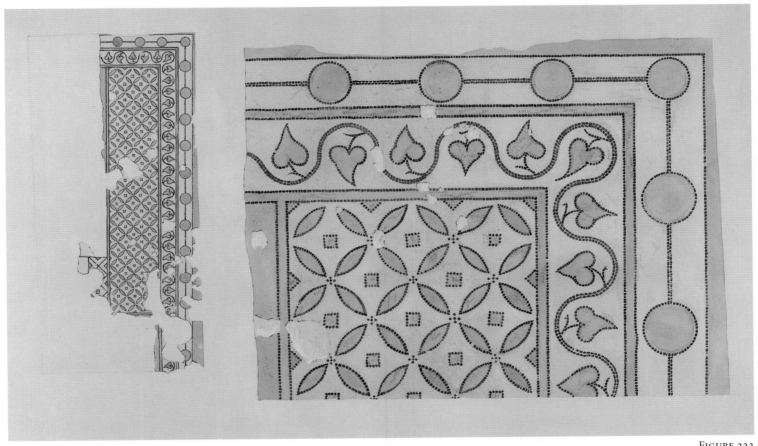

FIGURE 223

CHAPTER 16

Byzantine and Post-Byzantine Pottery

Camilla MacKay

133. TWO-HANDLED POLYCHROME CUP (FIG. 224)

P 9981 (Painting no. 10)
Middle Byzantine
From a cistern in section ΘΘ at 27/ΚΔ, east of Valerian Wall near
 the church of Hypapanti
Height: 0.063; diameter: 0.089
Frantz 1938, p. 457, no. B3, fig. 19; *Byzantine and Post-Byzantine
 Art,* no. 265; for polychrome ware, see Megaw and Jones 1983,
 esp. p. 236; Hayes 1992, p. 36; Sanders 2001.

This attractive two-handled cup is a well-preserved example
of polychrome ware, a white-bodied glazed pottery that was
produced somewhere in the vicinity of Constantinople. Poly-
chrome-ware vessels, like this one, are well illustrated in hand-
books of Byzantine pottery, although they are comparatively
rare finds both in the region of Constantinople and abroad.
Nonetheless, polychrome ware was widely exported, and some
of the best-known examples are not from Constantinople but
from sites throughout the eastern Mediterranean and the Bal-
kans. Finds of polychrome ware are rarer in Istanbul, near
where it was manufactured, than in the Byzantine provinces.
Moreover, the colors on polychrome ware found in Istanbul
are less adventurous than those on exports (blue, for instance,
appears on examples found in Corinth, but almost never ap-
pears on examples from Istanbul). This piece, like most from
Athens, is decorated in drabber colors—black, brown, and yel-
lowish-brown glaze—but Piet de Jong has restored the colors
to their original brightness. The pottery continues to attract
interest because of its color and decoration: just as its frequent
presence in publications of Byzantine pottery is due in no small
part to its photogenic nature, presumably a major aspect of its
desirability in all areas of the Byzantine provinces was also due
to its appearance; its rarity reflects its cost. Polychrome ware
was imported to Greece primarily in the 11th to 12th centu-
ries and is completely unlike the type of pottery produced in
Greece at that time in that its glaze is more decorative than
practical. Polychrome ware predates the use of glaze for non-
functional purposes on Greek pottery and may have helped
stimulate local production of glazed, decorated pottery.

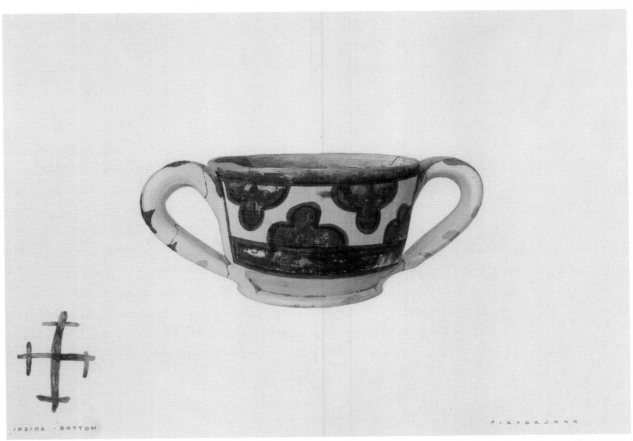

INSIDE · BOTTOM

PIET DE JONG

FIGURE 224

134. SGRAFFITO PLATE (FIG. 225)

P 5314 (Painting no. 272)
12th century
Section Ξ, well at 54/ΜΣΤ
Height: 0.043; diameter: 0.299
Frantz 1938, p. 462, fig. 27; *Byzantine and Post-Byzantine Art*,
 no. 298, also pp. 228–249; cf. Maguire 1997; for the Pelagonnesos
 wreck, see Ioannidaki-Dostoglou 1987; Kritsas 1971; Throck-
 morton 1971; for scientific analysis, see Waksman and Spieser
 1997, esp. pp. 116–117; for trade of the ware in general, see
 Sanders 2000, esp. pp. 171–173.

Plates of this type have become one of the most recognized forms of Byzantine glazed pottery. Shallow plates with up-turned vertical rims and similar decoration appear through-out the eastern Mediterranean and are instantly recognizable as Byzantine. Apart from excavated examples, like this one, numerous similarly decorated bowls and plates derive from shipwrecks. Few shipwrecks have been well documented, how-ever, and many pieces from such wrecks have surfaced on the antiquities market. Ceramics from shipwrecks are often com-plete and unbroken, and therefore are particularly valuable. A partially published shipwreck from the island of Pelagonnesos in the Sporades was looted and many of the pieces dispersed to private collections. The Agora plate illustrated here, with its concentric circles of fine sgraffito decoration interrupted by heavier inscribed champlevé medallions, is very similar to bowls from the Pelagonnesos wreck. This type of sgraffito is one of the most common types of Byzantine pottery seen in museums and collections (outside archaeological collections) of the eastern Mediterranean, and has therefore come to rep-resent Byzantine pottery par excellence.

The origin of these plates is not known. No one center has been claimed as a site of manufacture, and preliminary sci-entific analysis of some pieces indicates that more than one center of production was involved. This particular bowl does not appear to have been made in Athens, although it may be a Greek product. The fact that this type of sgraffito is found in widely separated excavations and that examples exist in col-lections worldwide from unspecified shipwrecks would sug-gest substantial trade. In contrast with the 11th century (cf. the polychrome-ware cup above), glazed pottery was traded in vastly greater quantities by the 12th century, an indication of the growth of the Middle Byzantine economy.

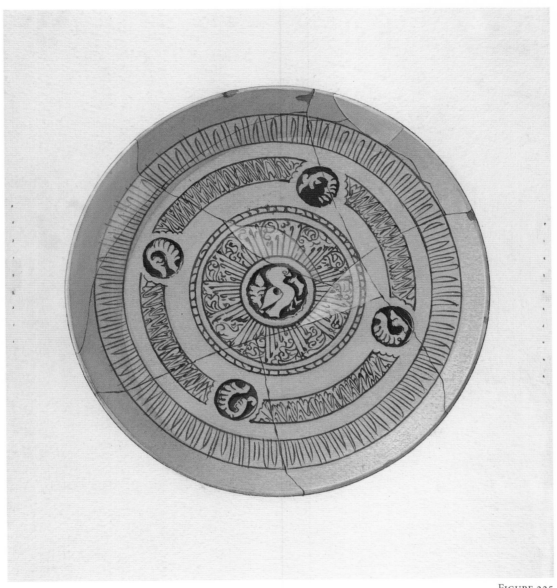

FIGURE 225

135. Two sgraffito plates with warriors fighting dragons (Figs. 226a, b)

P 2123, P 9396 (Painting nos. 273, 295)
12th century
P 2123: section H at 55/IB; found in an amphora
P 9396: section Σ, pithos at 15–17/ΠΕ–ΠΣΤ
P 2123: height: 0.049; diameter: 0.245
P 9396: height: 0.071; diameter (estimated): ca. 0.290
P 2123: unpublished.
P 9396: Frantz 1938, p. 464, figs. 30, 33; Frantz 1940–1941, fig. 3
opposite p. 88; cf. Frantz 1941a; Maguire 1997, p. 256; for Digenis
Akritas, see *Corinth* XI; Notopoulos 1964; Beaton 1981; Beaton
and Ricks 1993; Saunier 1993; Jeffreys 1998.

Both of these plates are examples of a common theme of Middle Byzantine sgraffito—warriors fighting dragons. Digenis Akritas, about whom there is an extensive tradition in the form of written and oral epic and folk songs, is the most famous dragon slayer of Byzantine romances, and such scenes on Byzantine pottery are usually interpreted as illustrations of his legend. Digenis Akritas was the son of an Arab emir and a Greek woman, thus his name: Digenis means "twice-born"; an *akritas* was a frontier soldier or commander. The earliest written form of the story dates to the late 13th or early 14th century, but the tradition is much older. The story as preserved in the earliest written versions reflects, generally, the situation on the Euphrates frontier in the 9th and 10th centuries, with a heavy admixture of fantasy. For example, at the age of twelve, Digenis Akritas, on his first hunt, killed two bears and a deer with his bare hands, and later he rescued a girl from a three-headed dragon.

These plates depict single-headed snakes or "dragons," and Alison Frantz has pointed out that some elements of the iconography of these warriors match Digenis Akritas's description in the epic, particularly the long, curly hair and kilt. There are numerous examples from Athens of sgraffito plates with warriors and dragons. Not surprisingly, the most fabulous and romantic aspects of Digenis Akritas's story are popular in the later Akritan song tradition, and scenes on pottery have more in common with Akritic folk songs than with the written epic.

Yet Digenis Akritas is only one—albeit the most famous—of the heroes of Byzantine romances, and the association between his story and the dozens of preserved scenes of warriors and dragons is tenuous. Unidentified folktales with similar themes may be represented on these pots, and there is no way to state with certainty the identification of generic warrior versus dragon scenes like these. Although scenes of heroes and dragons do not necessarily have any connection with Akritan songs, the elements unique to Digenis Akritas's story on several pots make this usual identification an attractive one.

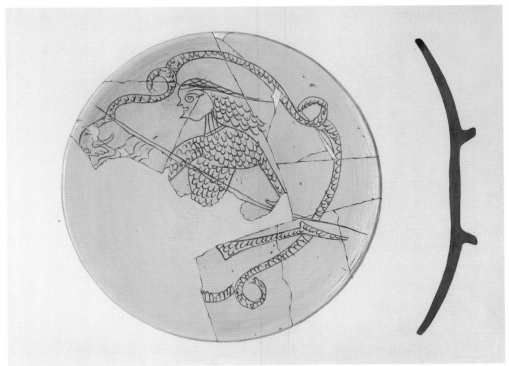

FIGURE 226A

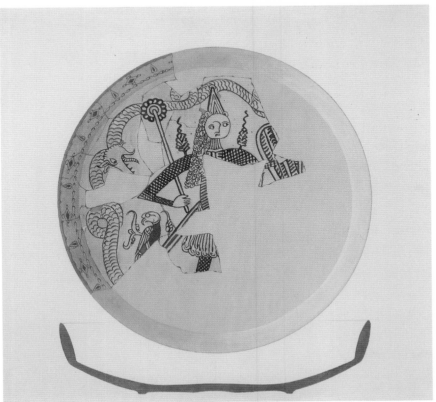

FIGURE 226B

136. A SGRAFFITO DISPLAY PLATE (FIG. 227)

P 5026 (Painting no. 274)
12th century
From a circular brick- and stone-lined pit connected with Byzantine
 levels: section N, pit at 24/MA
Height: 0.044; diameter: 0.245
Frantz 1961, no. 19; cf. Soteriou 1934–1935; Miles 1956.

This plate, one of the finest unearthed in the Agora Excavations, was a valuable showpiece in its own day. It was broken across the middle and repaired with holes for wires not long after it was made. The break and the holes rendered it unusable as a vessel. Yet even when whole, this plate may have been valuable primarily for display and not for practical use. It is an exceptionally well-manufactured piece: large, carefully potted, and carefully decorated, with white slip covering the entire interior and exterior and glazed inside with a clear, pale yellow glaze. Its provenance is not known, but it is unlike most Athenian sgraffito pottery of the period.

The outside band of sgraffito decoration is an elaborately repetitive pseudo-Kufic design. Kufic is a style of Arabic script that was adopted for purely decorative purposes by Byzantine artists starting in the 10th century. By the 11th century it had become a common Middle Byzantine decorative feature of architecture, pottery, and textiles. Several churches in Athens—for example, the Church of the Holy Apostles in the area of the Agora Excavations—preserve pseudo-Kufic tile or sculptural decoration. There are very few examples of actual Kufic (true Arabic) inscriptions from Athens, although they do exist; most of the Kufic decoration in Athens (and all Kufic decoration on pottery) is purely decorative. Influence may have come primarily from Islamic art, especially minor arts such as textiles that were acquired in trade. The feline in the central medallion is common to both Islamic and Byzantine tradition; animals occur frequently on Islamic and Middle Byzantine pottery, particularly animals associated with hunting.

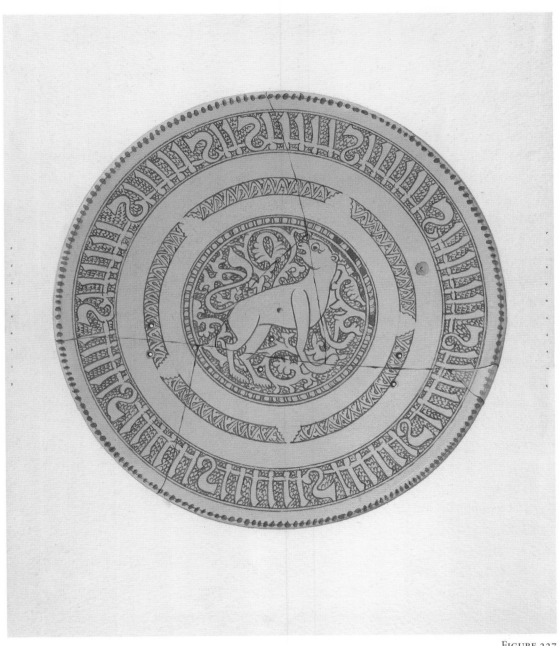

FIGURE 227

137. An Ottoman pitcher with painted lion (Fig. 228)

P 1902 (Painting no. 178)
Ottoman
Height: 0.242; diameter: 0.18
Section Z, square well at 66/B
Frantz 1942, pp. 2 (for chronology), 8, fig. 12.1; Thompson 1962,
 p. 187; Thompson 1976, p. 278; Frantz 1961, fig. 61; see also Hahn
 1991.

This pitcher, decorated with a stylized, chained lion, was probably manufactured in Athens, most likely near where it was found in the area of the Classical Athenian Agora. Although an example of locally produced pottery, in all respects it shows considerable Italian influence. The shape and decoration are features of the pottery of Athens under Ottoman rule. Glazed pitchers and painted pictorial decoration are virtually unknown in Athens before the 15th century and were probably produced by local kilns only in the 16th and 17th centuries. Two kilns where blue and white painted pottery was manufactured were located underneath a church that was seen in 1676 by the traveler Jacob Spon. Although there were probably other kilns producing this type of pottery, perhaps beyond the third quarter of the 17th century, the height of production must have been in the 16th century or in the early 17th century.

Glazed pitchers only came into widespread use in Greece in the Ottoman period. Some were imported from Italy during the Frankish period (13th–14th century in particular), but virtually no Italian pottery was imported to Athens until much later. At no time in the Frankish or Ottoman period did Athens import significant amounts of pottery (as did, for example, Corinth). The contrast of this pitcher with the type of pottery that precedes it is striking. The change in local styles is dramatic: from dull, graceless sgraffito bowls to lively and colorful pieces like this one. Painted decoration on an opaque white ground indicates newfound technical expertise. This is probably tin-glazed, unlike earlier lead-glazed sgraffito; Italian tin-glazed maiolica is found frequently on other sites in Greece, but manufacture in Greece is first identified in Athens.

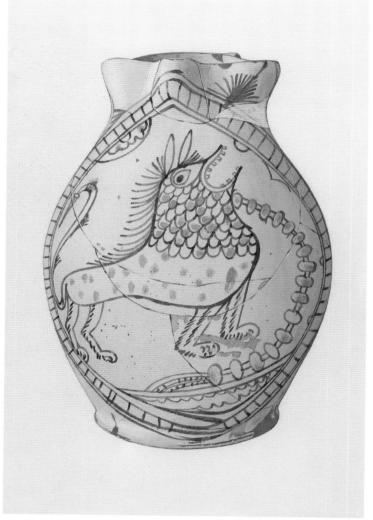

FIGURE 228

138. ITALIAN SGRAFFITO PLATE WITH DOGE (FIG. 229)

P 5673 (Painting no. 179)
16th century
Section M, well near southwest corner of burnt building
Height: 0.031; diameter: 0.215
Frantz 1942, p. 16, fig. 37; Frantz 1961, p. 62; H. A. Thompson 1962,
 p. 187; H. A. Thompson 1976, p. 278.

Piet de Jong's paintings of other late vessels are accurate depictions of the pottery as preserved. Here, however, he restored a large part of the plate. The plate itself is missing several chips and the upper third is gone; in addition, the entire surface of the preserved bowl is abraded.

A doge, identified by his distinctive hat—*corno*—and fur cape, reclines before an elaborate columned window. The bowl was made in northern Italy (perhaps Padua, as Alison Frantz has noted) in the 16th century. The entire figure of the doge is preserved, but most of the right-hand column is a restoration. De Jong indicated the restoration of the upper part of the bowl by painting it in slightly lighter and duller colors. The missing pieces within the bowl itself are indicated by a different shorthand, with a white overlay. This is one of the most celebrated of the late finds from the Agora Excavations: Italian imports being rare enough that this one stands out, apart from depicting such a distinctively western European scene. When this plate was made, the doge was probably meant to be recognizable (beards were not a universal fashion for doges in the 16th century). Doges were little more than figureheads at that time, however, and once the plate arrived in Athens, it likely lost association with a particular official whose ceremonial importance had little standing outside Venice.

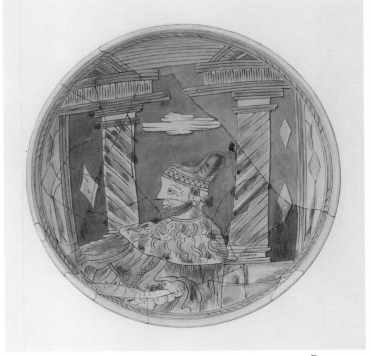

FIGURE 229

Late Byzantine and Post-Byzantine Frescoes from Ayios Spyridon

Camilla MacKay

Introduction

ONE OF THE MOST EXTENSIVE SERIES of Piet de Jong's water-colors are the paintings of Late Byzantine and post-Byzantine frescoes from the small private chapel of Ayios Spyridon, which was torn down during the course of the Agora Excavations in the 1930s. Piet de Jong painted the later frescoes—those dating to the 17th century—in the mid-1930s and they were then removed before the chapel was demolished. During the course of demolition, it was discovered that a few earlier (15th- and 16th-century) frescoes were preserved under the later plaster of the east wall; Piet de Jong painted these, too, before the chapel was completely demolished. The two phases of the church are indicated on the plan (Fig. 230). As for the dating, this was determined largely by material in situ. In the course of the demolition of the chapel, a small inscription on a fragment of an Ionic capital was found built into the north wall, which gave the date A.D. 1613. The inscription was part of the second phase of the building and, therefore, provides a terminus post quem for the later frescoes. The earlier frescoes should date before A.D. 1613 and, on the basis of style, coupled with coin and pottery evidence, they are best placed in the 15th century.

On the initiative of Alison Frantz, the then photographer of the Athenian Agora and an archaeologist whose interests lay in late antiquity and Byzantium, most of the frescoes were re-mounted in the 1950s in the narthex of the Church of the Holy Apostles, a Byzantine church that was constructed in the area of the Classical Agora. Frantz published the frescoes of both periods (Frantz 1935, 1941b), and for her article on the later frescoes, she used de Jong's watercolors to illustrate her discussion of the iconography (Frantz 1935). Frantz's 1935 publication is one of the few contributions in English to study post-Byzantine

art. Some fifty years later, Manolis Chatzidakis (1987, p. 100) lamented that the study of later post-Byzantine art was hampered by the lack of adequately illustrated publications.

The record of the frescoes Piet de Jong preserved is remarkable. Given the damaged nature and illegibility of the original frescoes today, de Jong's watercolors not only attract attention to these interesting and important frescoes, they allow for a better understanding of the details and colors of the frescoes. Only two frescoes of the earlier phase of decoration are well preserved (Saint Stephen and Saint Blasios). Although they decorated a small provincial chapel, the similarities between the faces of these two paintings and the coloring and style of paintings from Mt. Athos and Mistra were already noted in the early 1940s (Shear 1940, p. 294; Frantz 1941b, p. 198). The better-preserved and far more extensive later cycle represents an otherwise poorly documented period. Most dated Ottoman-period fresco cycles are from the 18th century; cycles of the 17th century in Attica are rare.

The later frescoes fall into the most conservative category of post-Byzantine painting. Post-Byzantine church art—although it departs from strictly canonical Byzantine representation—reveals a conservative tradition, and these particular paintings adhere to this conservatism. The artist who painted this chapel was clearly not influenced by Western religious art, and the limited palette of colors—in this case mostly ochre, dark red, dark orange, gray, and white against a dark gray background—is typical of the style. Unlike more ambitious contemporary paintings, such as the frescoes in the narthex of the church at Kaisariani on Mt. Hymettos, the artist of Saint Spyridon did not attempt any narrative scenes, although the Annunciation flanking the apse

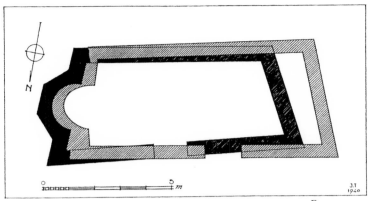

FIGURE 230

is an exception to this rule. Three types of saints predominate: bishops, monastic saints, and martyrs, and all frequently appear in Byzantine frescoes and mosaics in Greece. The interest in these frescoes is the evidence they provide for post-Byzantine art of the private sphere and its conscious and deliberate adherence to Byzantine tradition.

It is noteworthy that Piet de Jong's record of these frescoes survives, given the general lack of interest in the period by the staff of the Agora Excavations and the amount of time the

project must have taken. In 1939, Ayios Spyridon was already partly demolished when the earlier phase of the chapel was discovered. The excavator's notebook entry for February 27, 1939, betrays his palpable frustration with the time allocated to studying the Late Byzantine frescoes:

> With cold gray weather we face the gloomy prospect of having to build a house around the saints so that de Jong may paint them. This means very considerable delay in the work of the section—for we cannot count on much less than 3 weeks before Piet can finish.

In fact, de Jong's paintings of the four Late Byzantine frescoes took nearly two months to complete. The twenty-three copies of the post-Byzantine frescoes from Ayios Spyridon must have taken Piet de Jong far longer. Although photographs of the chapel survive, the frescoes themselves are on display to the public in the Church of the Holy Apostles. Piet de Jong's time was well spent, for his paintings restore and bring alive the original frescoes, which are a testimony of the art and faith of private Athenians in Ottoman Athens.

139. SAINT STEPHEN; SAINT BLASIOS; SAINTS BLASIOS AND ELEUTHERIOS (FIGS. 231A–C)

Painting no. 310; Painting no. 324; Painting no. 323
15th century A.D. (Paintings nos. 310, 324); 17th century A.D.
 (Painting no. 323)
Painting nos. 310 and 324 from earlier phase of east wall of Ayios
 Spyridon (demolished); Painting no. 323 from the north wall of
 the later phase of the church; all three now located in narthex of
 the Church of the Holy Apostles
Frantz 1941b.

The earlier frescoes are few and damaged. The talent of the artist, however, can be recognized in the two saints, Stephen and Blasios, who occupy the lower register of the east wall on either side of the apse (Figs. 231a, b). A century or two later, Saint Blasios also appeared in the later panel of Saints Blasios and Eleutherios from the north wall (Fig. 231c). Both artists followed the same iconographic tradition for Saint Blasios, but the difference in style between the two periods is evident. Both were painted in a similarly limited palette of colors. The clothing of the earlier frescoes gives some indication of the body beneath, but on the later frescoes the clothing is only a pattern applied to the outline of the body. The faces of the earlier saints are more individualized than the later ones, where the hairstyle is the most distinguishing feature.

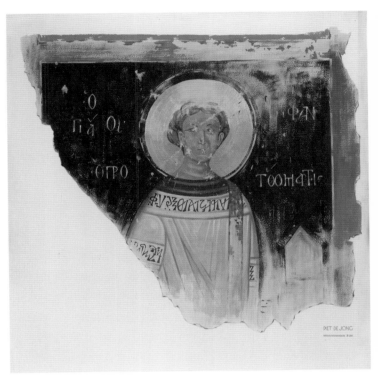

FIGURE 231A

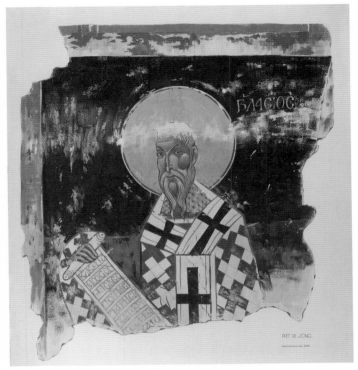

FIGURE 231B

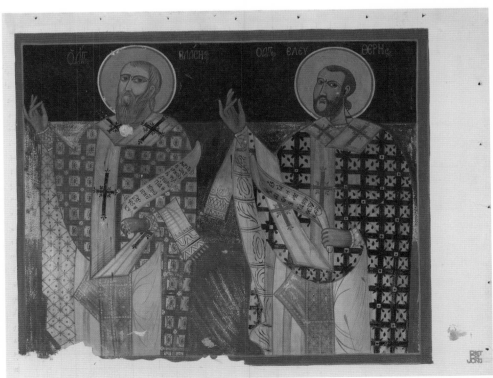

FIGURE 231C

140. Saint Demetrios; Saint Spyridon; Angel of the Annunciation (Figs. 232a–c)

Painting no. 325; Painting no. 321; Painting no. 320
17th century
From later phase of east and south walls of Ayios Spyridon
(demolished); now located in the narthex of the Church of the
Holy Apostles
Frantz 1935.

Saint Demetrios (Fig. 232a) on horseback slaying a gladiator is a common counterfoil to Saint George, and we can probably conjecture that Saint George occupied the same location on the north wall of the chapel. As common as the scene of Saint Demetrios on horseback became, Alison Frantz (1935, pp. 458–463) pointed out that this iconography seems to be a post-Byzantine development. Demetrios, a martyr and the patron saint of Thessalonike, was first depicted as a martyr and then as a military saint. Horses play no part in the original story of Demetrios and the gladiator, the latter slain in the arena in Thessalonike. The artist himself may not even have recognized that this depiction was a relatively recent trend. The story seems to be a conflation of a later miracle of Saint Demetrios, namely the rescue of the bishop Cyprianus from barbarians (shown as the small figure seated behind Demetrios), with the earlier story of Demetrios and the gladiator. Mural painting during the Ottoman period, despite the conscious conservatism frequently displayed, was not a completely static art. The actual fresco of Saint Demetrios was and is quite damaged; while indicating the damage, Piet de Jong restored enough to make the fresco legible, especially for the purposes of publication in black and white.

Saint Spyridon, the eponymous saint of the chapel, was a 4th-century shepherd from Cyprus who became bishop of Trimithous (Fig. 232b). His legend states that he was present at the Council of Nikaia in A.D. 325 and the Council of Serdica in 342. His relics were transferred to Constantinople and then to Corfu in 1453. Here he is represented, as usual, wearing the robes of a bishop but with a special cap to indicate his peasant origins.

Both the earlier and later phases of Saint Spyridon were decorated with the Virgin and the Angel of the Annunciation flanking the apse (Fig. 232c). In single-aisled Byzantine churches without domes, this is a common decorative theme; the Annunciation heralded the incarnation of Christ, whose image would probably have been located in the apse, and the tradition continued into the Ottoman period.

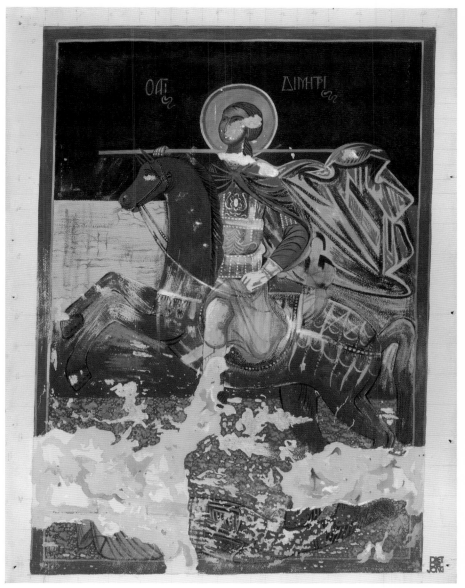

FIGURE 232A

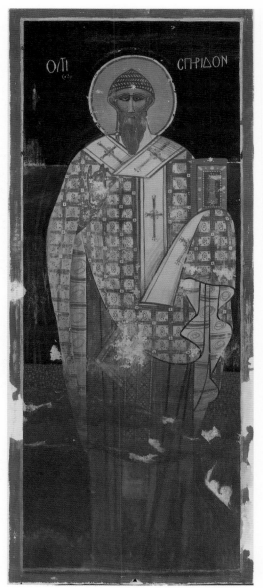

FIGURE 232B

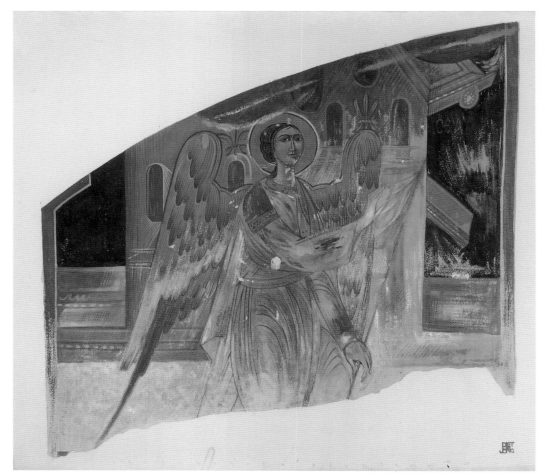

FIGURE 232C

The Art of Labeling:
Piet de Jong's Signatures and Labels

John K. Papadopoulos

ALTHOUGH SUCH A CONSUMMATELY VISUAL PERSON, Piet de Jong loved to write on or label his paintings. A wonderful example of his art of labeling is his plan of the Agora and Acropolis, a classic Piet de Jong pedagogical illustration (Fig. 233). This, together with the plans of the Agora through various phases of its history (nos. 1–5, Figs. 64–68, also no. 6, Fig. 69), was prepared shortly after the reconstruction of the Stoa of Attalos was completed, in 1957 and 1958, in order to be hung in the newly opened Agora Museum to the benefit of visitors. The labeling appears in both English and Greek, and the heading—"Agora and Akropolis"—is accompanied by a splendid Attic owl, taken from the Classical coinage of the city. The plan as a whole presents a cogent summary of the topography of central Athens as it was understood by the Agora excavators in the mid-1950s. Everything about the watercolor is typical of Piet de Jong's style, from the flamboyant north arrow—which does not point upward (most modern plans place the Acropolis at the bottom)—to the characteristic signature in the form of a cartouche. This plan, together with Figures 64–69 and part of the same series, is among his most heavily labeled, but many of the simpler watercolors were not only signed but often accompanied by the inventory or identification number of the object in question and sometimes, if required, a note on the scale and whatever else was needed to clarify the understanding of the illustration. This labeling was always artful: it provided the necessary detail without competing with the object for attention. Moreover, the labeling blended with the watercolor in such a way as to become an integral part of the whole.

To illustrate the point, I have selected three typical watercolors of architectural details from the Athenian Agora. The first, a painted terracotta sima (Fig. 234), has all the required labeling on the lower blank border below the watercolor. Using his typical red ink, Piet de Jong provides all the necessary information that is required. From left to right this includes a minimalist scale showing a solid bar measuring one centimeter (the object was rendered at 1:1), the actual label of the watercolor, which reads: "FRONT developed flat"—this is not a watercolor of a sima in perspective but rather the decoration of the sima rendered flat—followed by Piet de Jong's signature (an example of Type 2, for which see below). The primary heading "FRONT" is in uppercase, whereas the secondary information "developed flat" is in lowercase. This lettering is designed to be part of the watercolor; the scale is carefully aligned with the left edge of the sima, the signature with the right edge, while the identifying heading is neatly centered. There is additional labeling in the lower left corner of the paper, running parallel to the lower edge, which reads: "A 814 AA 110 section on separate sheet." This was written in black ink and was not intended to be part of the watercolor per se, but rather an aid for subsequent users, giving the inventory (A 814) and excavation section (AA 110) numbers of the terracotta, together with a note that a lateral section through this sima was to be found on a separate sheet.

Another classic example of Piet de Jong's art of labeling is the watercolor of the wall paintings of the Roman South House in section ΠΠ (Fig. 235). All four walls of one room of the house are elegantly combined on one horizontal sheet, beginning with the west wall on top, the east wall on the bottom, with the south (center left) and north (center right) walls in between. Another minimal scale consists of a bar measuring one centimeter

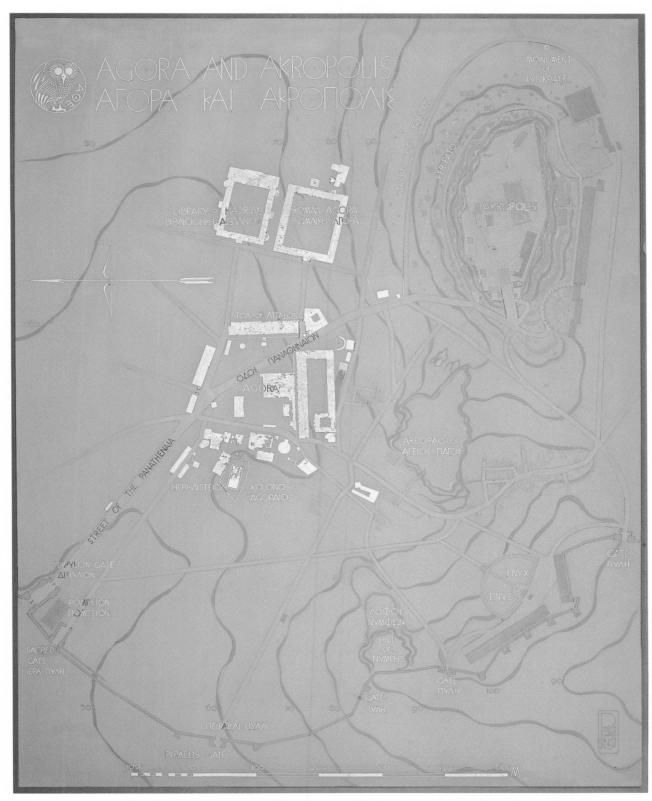

FIGURE 233. Watercolor plan by Piet de Jong of the Agora and the Acropolis prepared for the newly reconstructed Stoa of Attalos (PD no. 2862)

FIGURE 234. Watercolor by Piet de Jong of a painted terracotta sima, A 814 (PD no. 242)

FIGURE 235. Watercolor by Piet de Jong of the wall paintings of the South House in section ΠΠ (PD no. 1351)

FIGURE 236. Watercolor by Piet de Jong showing three views of a painted
eaves tile of the Classical period, A 633 (PD no. 216)

labeled "10 cms." The drawing is at a scale of 1:10. The labeling, all of which is in red ink, is centered at the top and bottom, with the scale and the labels for the north and south walls forming the central focus of the composition. Piet de Jong's signature (another example of Type 2, specifically Type 2a) appears at the bottom, aligned with the right side of the main part of the watercolor, but in letters that are smaller than the labeling for the east and west walls. His authorship is clear, but subordinate to the labels of the material. A common, though by no means standard, trait is the manner in which Piet de Jong has rendered his Us as Vs and his characteristic Ss. To the right side of the main portion of the watercolor, Piet de Jong provides an enlarged de-

tail of the painted floral ornament seen at a smaller scale in each of the west, east, and south walls. The detail is accompanied by its own scale, in which one centimeter equals three centimeters. Here as elsewhere the lettering is meticulous, well measured, and perfectly spaced. Fine pencil guidance lines for the lettering are clearly visible. The lettering is not only an integral part of watercolor, it helps structure the composition.

The final example is smaller and vertically oriented, but it provides a wonderful example of how Piet de Jong managed three views of the one terracotta eaves tile on a single sheet of paper with economy and elegance (Fig. 236). The three views are labeled "FRONT," "UNDERNEATH," and "SECTION" in

uppercase letters of similar size. The label separating the underneath view from the section appears diagonally, following the inclination of the tile. The scale, in uppercase letters of smaller size, appears at the lower left side, aligned with the lowest projecting element of the tile. Again, the scale is a solid single bar measuring one centimeter. The painted decoration of this Classical eaves tile is thus rendered at actual size. The signature, this time an example of Type 6, appears in lowercase letters except for the P and J at the lower right, but set slightly in for the sake of balance with the scale. The lettering, characteristically, is in red.

As already noted, much of the labeling that was part of the watercolor was done in red ink. A few watercolors are labeled with black ink, primarily those of objects that were themselves largely black, including nos. 103, 104 and 115 (Figs. 186, 188a, 202); occasionally, as in the example of no. 33 (Fig. 103b), the labeling is in pencil. Among the many watercolors in the Archives of the Athenian Agora—and the same is true for Piet de Jong's watercolors and drawings in the University of Cincinnati and the American School of Classical Studies at Athens—few are without signature or some form of labeling that is in the distinctive hand of Piet de Jong. All of the watercolors presented in this volume are either signed by Piet de Jong or accompanied with a note crediting the artist, except for Figure 222 by Marian Welker.

Among the watercolors and ink drawings in the Athenian Agora, there are essentially seven basic types of signature that Piet de Jong used throughout his long career, though there is a good deal of variety within most of these types. These were all formulaic signatures, and there are no examples of the typical signature one would find on a bank check or a formal document. A few of his earlier works are thus signed, such as the ink sketch of Grave Circle A at Mycenae shortly after its restoration in 1922 (Fig. 11), and a good example of his "real" signature accompanied his photographic portrait (Hood 1998, frontispiece). But it seems that for most of his work in Greece, Piet preferred one or other of his standard, formulaic signatures.

I have assembled some typical examples of the signatures of Piet de Jong in Figures 237a, b. The two most common are Types 1 and 2 (Fig. 237a), followed by Type 7 (Fig. 237b). The other types are, in comparison, rare. Type 1 signatures are written vertically with no spacing between the first name and surname. Although this signature can appear in various parts of the watercolor, it is more often than not written close to and parallel with the right side of the sheet of paper. Type 1 signatures are almost always in uppercase and are particularly common on the smaller watercolors. Type 1 signatures are sometimes written in miniscule letters that are easily overlooked, and even when they are visible they are sometimes barely legible with the naked eye. On larger watercolors the signature itself can be larger. The other common type of signature, Type 2, comes in several varieties. Essentially this signature is written horizontally. It can appear almost anywhere on the watercolor, but is usually below the object and most often on the right side; exceptions, however, are not uncommon (e.g., Fig. 18). Type 2a has letters in uppercase and there is no spacing between the artist's first name and surname. Type 2b is also in uppercase letters, but with a space between Piet and de and Jong. Type 2c is the same as Type 2b, but with the letters in lowercase except for the P and J, while in Type 2d, which is found on only two watercolors in the Agora (Figs. 40a, b), there is a dot between Piet and de, and another between de and Jong. Type 2 signatures are found on watercolors of all sizes.

The less common signatures of Types 3–6 are as follows: Type 3 is a simple "P. de J.," which is related to the Type 6 "P. de Jong." Type 4 signatures are monograms composed of J, P, and de; they are found in two varieties, labeled 4a and 4b, with Type 4a differing from Type 4b in that the lower curve of the J projects well below the rest of the monogram (see Fig. 237b). Type 5 signatures are closely related to Type 4, even though the artist's entire name is spelled out. "Piet" is above "de," which is above "Jong," though the first three letters vertically placed form a monogram of sorts from which the letters of the rest of his name extend. Type 5 signatures are primarily found on larger watercolors, particularly on some of the Byzantine and post-Byzantine frescoes from Saint Spyridon. Signatures of Types 3, 4, and 6 can be found on watercolors of virtually any size.

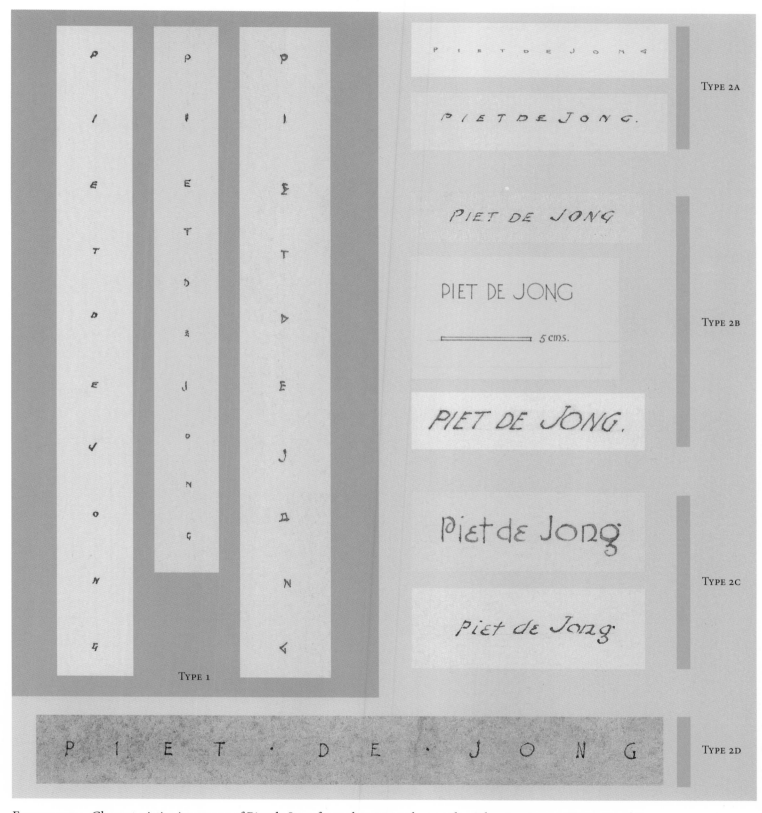

FIGURE 237A. Characteristic signatures of Piet de Jong from the watercolors in the Athenian Agora, Types 1 and 2

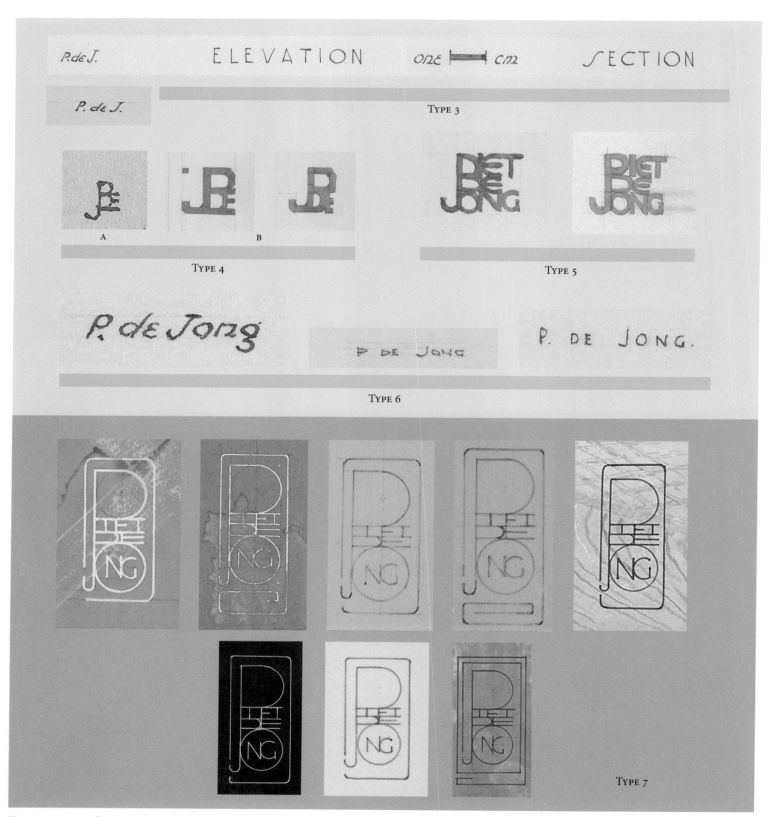

FIGURE 237B. Characteristic signatures of Piet de Jong from the watercolors in the Athenian Agora, Types 3–7

Piet de Jong's most distinctive and well-known signature, however, is what I have here termed Type 7, which essentially resembles the cartouche of an Egyptian pharaoh. The signature is a monogram enclosed in a rectangle that is usually open at the lower left corner. The J and the P form one symbol, the n and g of Jong are enclosed within the O, while the de is compressed between the P and the "ong." There is a good deal of variety in Type 7 signatures, but these are subtle, and I have refrained from subdividing the type, though this could easily be done. For example, on some Type 7 signatures, "Piet" appears in full; sometimes the "i" is not distinguished, as it is part of the JP monogram, and sometimes the "iet" of Piet is omitted altogether. Among the smaller Pylos watercolors now stored in the American School of Classical Studies at Athens, there are even further varieties of monograms that do not occur on the Piet de Jong watercolors in the Athenian Agora (Fig. 238). The definitive study, therefore, of the signatures of Piet de Jong awaits to be written.

There is also quite a bit of other lettering on the watercolors, in addition to that already presented above. Notes on scale are particularly common, including: FVLL SIZE, VNDER SIZE, HALF SIZE, ¼ ACTVAL SIZE, FOVR TIMES FVLL SIZE, SCALE FOVR TENTHS FVLL SIZE, NOTE SCALE OF 17·20THS, Scale 2 to 3, Scale 3-1, Scale 8-10, Scale 4/5, a more prosaic 4/1, and so on. Rarely, as on the watercolor of a Hellenistic krater (no. 116, painting no. 152) or the Geometric skyphos (no. 41, painting no. 30), "full size" is indicated with a singular FS monogram, while on another watercolor (not published) it appears as "F.S." written vertically.

On nos. 56 and 103 (Painting nos. 330 and 218) and others, there is a note, in pencil, that reads: "Fixed but do not rub." And there is a long prominent arrow pointing to the note. This notation is primarily found on illustrations drawn with ink. Arrows indicating the correct orientation of the watercolor are found on a number of paintings; these are often accompanied by the word "top" for clarification and include, among others, nos. 46, 47, 69, 134, and 136 (Painting nos. 95, 98, 47, 34, 272, 274). Such arrows are most commonly found on watercolors of Geometric and Byzantine pots where the orientation, especially the interior of a pot, can sometimes be unclear. On

the small Byzantine pot no. 133 (Painting no. 10), the dipinto next to the vase is accompanied by a note that reads: "INSIDE : BOTTOM."

In a number of watercolors the corner of the sheet of paper often bears a small symbol, such as a lozenge, a square, a bisected triangle, an asterisk, or starburst with dot at center, usually in pencil. These symbols serve a variety of purposes, sometimes to visually balance lettering found on the opposite corner, sometimes to aid visual guidance, or to just finish off a drawing or watercolor. Quite often the top left corner of the sheet of a watercolor is nicely squared off with the inventory number of the object written horizontally along the top and the notification of scale—most often "FVLL SIZE"—written vertically down the left side beginning at the top.

As for the paper used, Anne Hooton has already discussed this in Chapter 2. All of the watercolors presented in this volume were prepared by Piet de Jong on standard, commercially available, white watercolor paper. There are various grades, ranging from rough to relatively smooth, mostly, but not exclusively, cold pressed. Several of the watercolors were prepared on unbleached watercolor paper with a light brown or tan hue (especially Figs. 43, 64–68), and on one only example, Figure 69, the watercolor was painted directly onto black paper. In contrast to the watercolors, the majority of ink drawings were prepared on white card, including Figures 44b, 81a–c (mostly ink and pencil, though on one of the drawings gold paint is used), 87, 90b, 91a, 108, 134, 141a, and 151b. Of these, only one, Figure 141a, clearly preserves the stamp of the manufacturer: Schoeller Durex Paper. Occasionally, an ink drawing was done on a sheet of watercolor paper, such as Figure 180c.

The state of preservation of the watercolors varies. Those stored in the Architects' Office of the Agora Excavation generally fared better than the watercolors put on display. The majority of the archived watercolors were stored in transparent wax paper sleeves, while some of the larger ones were protected by sleeves made of various types of paper or clear plastic. Since the inception of the project to publish the Piet de Jong watercolors, acid-free museum-quality tissue paper has been used to protect the paintings. Of the watercolors shown on display, those in the Agora Museum were variously damaged by

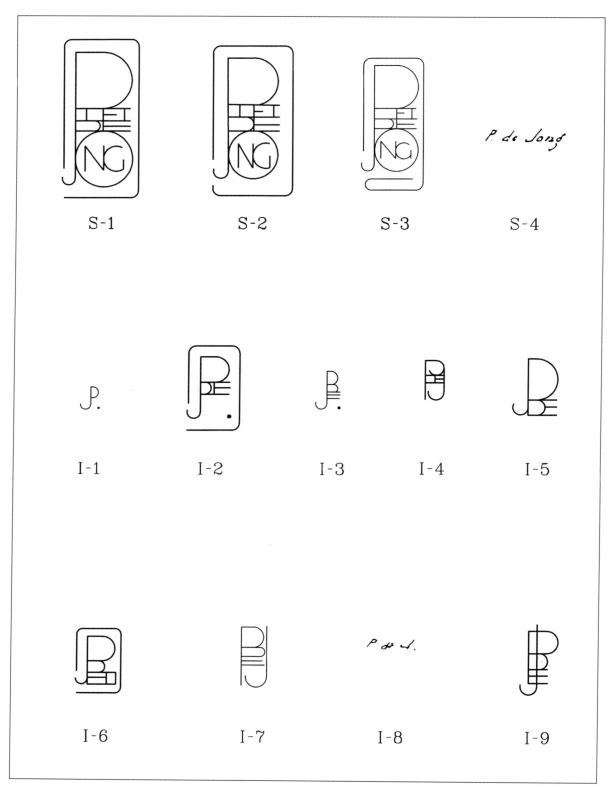

FIGURE 238. Characteristic signatures of Piet de Jong from the Pylos watercolors in the Archives of the American School of Classical Studies at Athens

dirt (primarily dust), rising damp, light, and some by silverfish. Of the watercolors on display within the colonnade of the stoa, but not inside, there was quite a bit of water and sunlight damage. Generally speaking, however, the majority of the watercolors are well preserved.

Digital images of all the Piet de Jong watercolors in the Athenian Agora are available on the Agora Web site and the originals are stored, as they always have been, in the Architects' office, the very same office that Piet de Jong never liked!

Table 2 lists all of the Piet de Jong images presented in this volume that are currently in the Agora. Included in the table are the catalogue number, figure number, painting or PD (which stands for "plans and drawings") number, and the dimensions of each image, as well as the orientation and type of signature.

TABLE 2. List of Piet de Jong Images in the Agora and Their Signature Types

Cat. #	Fig. #	Painting #	Size (meters)	Orient.	Signature
Ch. 1	3	318	0.784 × 0.564	Vert.	Type 4b
Ch. 1	4	227	0.126 × 0.178	Vert.	Type 6
Ch. 1	5	351	0.348 × 0.508	Vert.	Type 2b
Ch. 1	6	PD 21	0.727 × 0.487	Vert.	Type 2b
Ch. 1	40a	PD 846	0.647 × 0.486	Horiz.	Type 2d
Ch. 1	40b	PD 847	0.593 × 0.463	Horiz.	Type 2d
Ch. 1	42	PD 1014	0.998 × 0.630	Horiz.	Type 7
Ch. 1	43	327	0.778 × 0.575	Horiz.	Type 2b ARCHT. DEL.
Ch. 1	44a	230	0.254 × 0.178	Horiz.	Type 2b
Ch. 1	44b	252	0.250 × 0.163	Horiz.	No signature
Ch. 2	50	217	0.253 × 0.354	Vert.	Type 2a
Ch. 2	53	309	0.776 × 0.566	Horiz.	No signature
Ch. 2	54a	9	0.253 × 0.177	Horiz.	Type 1
Ch. 2	56	302	0.504 × 0.356	Horiz.	Type 2a

Cat. #	Fig. #	Painting #	Size (meters)	Orient.	Signature
Ch. 2	59	307	0.575 × 0.776	Vert.	Type 4b
Ch. 2	61	63	0.255 × 0.357	Vert.	Type 2b
Ch. 2	63	308	0.771 × 0.564	Horiz.	No signature
1	64	PD 2857	0.875 × 0.677	Vert.	Type 7 1957
2	65	PD 2858	0.865 × 0.671	Vert.	Type 7 1957
3	66	PD 2859	0.857 × 0.680	Vert.	Type 7 1957
4	67	PD 2860	0.879 × 0.679	Vert.	Type 7 1958
5	68	PD 2861	0.855 × 0.680	Vert.	Type 7 1957
6	69	PD 2865	1.071 × 0.734 as mounted	Vert.	Type 7
7	70	333	0.683 × 0.550 as mounted	Horiz.	No signature visible
8	72	PD 608	0.623 × 0.494 as mounted	Vert.	Type 2b
9	73	329	0.765 × 0.565	Horiz.	Type 2b
10	74a	PD 2159	1.346 × 0.579 as mounted	Horiz.	Type 7
10	74b	PD 1629	1.386 × 0.595	Horiz.	Type 7
11	76a	278	0.508 × 0.356	Horiz.	Type 2a
11	76b	159	0.354 × 0.253	Horiz.	No signature
12	77	PD 1422	1.019 × 0.667	Horiz.	Type 7
13	78a	158	0.253 × 0.355	Vert.	Type 1
13	78b	250	0.253 × 0.177	Horiz.	No signature
14	79a	146	0.354 × 0.253	Horiz.	Type 2a
14	79b	157	0.358 × 0.255	Horiz.	Type 2a
14	79c	147	0.355 × 0.255	Horiz.	Type 2a
15	80a	142	0.330 × 0.222	Horiz.	Type 2a
15	80b	149	0.330 × 0.222	Horiz.	Type 2a
15	80c	151	0.255 × 0.355	Vert.	Type 2a
15	80d	153	0.356 × 0.254	Horiz.	Type 2b
15	80e	148	0.253 × 0.355	Vert.	Type 2a

Cat. #	Fig. #	Painting #	Size (meters)	Orient.	Signature	Cat. #	Fig. #	Painting #	Size (meters)	Orient.	Signature
16	81a	235	0.165 × 0.127	Horiz.	No signature	31	100b	67	0.253 × 0.355	Vert.	Type 1
16	81b	236	0.241 × 0.179	Horiz.	No signature	32	102a	285	0.298 × 0.415	Vert.	Type 2b
16	81c	237	0.241 × 0.178	Horiz.	No signature	32	102b	55	0.253 × 0.353	Vert.	Type 1
17	82	340	0.213 × 0.226	Vert.	No signature	33	103a	64	0.254 × 0.355	Vert.	Type 1
18	83	280	0.357 × 0.508	Vert.	Type 2b	33	103b	68	0.254 × 0.355	Vert.	Type 1
19	84a	339	0.255 × 0.358	Vert.	Type 1	33	103c	66	0.355 × 0.253	Horiz.	Type 1
19	84b	347	0.217 × 0.287	Vert.	Type 2a	34	104a	33	0.354 × 0.253	Horiz.	Type 1
19	84c	348	0.219 × 0.287	Vert.	Type 2a	34	104b	32	0.355 × 0.253	Horiz.	No signature
20	85a	54	0.254 × 0.356	Vert.	Type 2a	34	104c	65	0.354 × 0.253	Horiz.	Type 1
20	85b	196	0.357 × 0.254	Horiz.	No signature	34	104d	62	0.355 × 0.254	Horiz.	Type 1
21	87	336	0.265 × 0.201	Horiz.	No signature	35	105	69	0.253 × 0.353	Vert.	Type 1
22	89	224	0.177 × 0.253	Vert.	Type 2a	36	106	300	0.447 × 0.346	Horiz.	Type 1
23	90a	335	0.403 × 0.499	Vert.	Type 2a	37	108	231	0.188 × 0.137	Horiz.	No signature
23	90b	334	0.254 × 0.356	Vert.	Type 1	38	109	82	0.358 × 0.255	Horiz.	Type 2c
24	91a	195	0.358 × 0.255	Horiz.	Type 2b	39	110	283	0.559 × 0.385	Horiz.	Type 2a
24	91b	204	0.325 × 0.251	Horiz.	No signature	40	111a	45	0.254 × 0.355	Vert.	Type 1
24	91c	294	0.565 × 0.333	Horiz.	Type 2a	40	111b	107	0.254 × 0.356	Vert.	Type 2a
25	92	61	0.255 × 0.357	Vert.	Type 2b	40	111c	288	0.304 × 0.464	Vert.	Type 1
26	93	342	0.254 × 0.177	Horiz.	Type 1	40	111d	104	0.253 × 0.354	Vert.	Type 2a
27	95	27	0.356 × 0.254	Horiz.	Type 2b	41	112a	30	0.353 × 0.253	Horiz.	Type 1
28	96a	362	0.252 × 0.354	Vert.	Type 7	41	112b	3	0.253 × 0.177	Horiz.	Type 1
28	96b	363	0.254 × 0.357	Vert.	Type 7	41	112c	20	0.253 × 0.178	Horiz.	Type 1
28	96c	364	0.253 × 0.356	Vert.	Type 7	41	112d	87	0.355 × 0.253	Horiz.	Type 1
29	97a	21	0.178 × 0.254	Vert.	Type 1	42	113a	85	0.353 × 0.253	Horiz.	Type 1
29	97b	22	0.254 × 0.178	Horiz.	No signature	42	113b	73	0.353 × 0.253	Horiz.	Type 2a
30	99	365	0.310 × 0.469	Vert.	Type 7	42	113c	109	0.355 × 0.253	Horiz.	Type 1
31	100a	92	0.255 × 0.355	Vert.	Type 2a	42	113d	57	0.229 × 0.292	Vert.	Type 1

of Ge

pecially of

Cat. #	Fig. #	Painting #	Size (meters)	Orient.	Signature
43	115a	270	0.311 × 0.466	Vert.	Type 1
43	115b	108	0.254 × 0.355	Vert.	Type 1
44	116a	293	0.511 × 0.351	Horiz.	Type 1
44	116b	112	0.355 × 0.253	Horiz.	Type 1
45	118a	115	0.253 × 0.354	Vert.	Type 1
45	118b	297	0.566 × 0.192	Horiz.	Type 1
46	119a	95	0.355 × 0.253	Horiz.	Type 1
46	119b	98	0.355 × 0.254	Horiz.	Type 1
47	120a	72	0.253 × 0.353	Vert.	Type 1
47	120b	70	0.353 × 0.253	Horiz.	Type 1
47	120c	74	0.358 × 0.255	Horiz.	Type 1
47	120d	86	0.353 × 0.252	Horiz.	Type 1
47	120e	53	0.353 × 0.253	Horiz.	Type 1
47	120f	94	0.346 × 0.252	Horiz.	Type 1
47	120g	93	0.354 × 0.252	Horiz.	Type 1
47	120h	84	0.353 × 0.253	Horiz.	Type 1
47	120i	47	0.356 × 0.253	Horiz.	Type 1
48	122	41	0.355 × 0.254	Horiz.	Type 1
49	124a	75	0.253 × 0.353	Vert.	Type 1
49	124b	201	0.252 × 0.354	Vert.	Type 1
49	124c	24	0.253 × 0.355	Vert.	Type 1
50	125a	58	0.229 × 0.336	Vert.	Type 1
50	125b	59	0.231 × 0.335	Vert.	Type 1
50	125c	271	0.564 × 0.281	Horiz.	Type 2b
51	126	345	0.252 × 0.354	Vert.	Type 2b
52	127a	206	0.353 × 0.252	Horiz.	Type 1
52	127b	25	0.253 × 0.354	Vert.	Type 2a
52	127c	303	0.540 × 0.539	Horiz.	Type 1
53	129a	76	0.253 × 0.355	Vert.	Type 1
53	129b	291	0.309 × 0.469	Vert.	Type 1
54	130a	344	0.426 × 0.335	Vert.	Type 2b
54	130b	346	0.351 × 0.508	Vert.	Type 2b
55	132a	71	0.356 × 0.255	Horiz.	Type 2a
55	132b	105	0.254 × 0.355	Vert.	Type 2a
55	132c	367	0.505 × 0.299	Horiz.	Type 7
56	134	330	0.561 × 0.715	Vert.	Type 2b
57	135	77	0.355 × 0.254	Horiz.	Type 2a
58	137a	4	0.255 × 0.178	Horiz.	Type 2a
58	137b	18	0.253 × 0.178	Horiz.	No signature
59	138	262	0.254 × 0.353	Vert.	Type 1
60	139a	232	0.199 × 0.252	Vert.	No signature
60	139b	234	0.153 × 0.252	Vert.	No signature
60	139c	253	0.358 × 0.411	Vert.	Type 1
61	140	79	0.355 × 0.254	Horiz.	Type 1
62	141a	PD 844	0.301 × 0.460	Vert.	No signature
62	141b	352	0.507 × 0.357	Horiz.	Type 2b
62	141c	355	0.356 × 0.254	Horiz.	Type 2b
62	141d	354	0.356 × 0.254	Horiz.	Type 2b
62	141e	353	0.355 × 0.254	Horiz.	Type 2b
63	143	103	0.353 × 0.255	Horiz.	Type 2a
64	144a	185	0.253 × 0.354	Vert.	Type 1
64	144b	219	0.252 × 0.353	Vert.	Type 1
64	144c	PD 476	0.252 × 0.354	Vert.	Type 2b
65	145	133	0.354 × 0.252	Vert.	Type 2b

Cat. #	Fig. #	Painting #	Size (meters)	Orient.	Signature	Cat. #	Fig. #	Painting #	Size (meters)	Orient.	Signature
66	146	180	0.253 × 0.354	Vert.	Type 1	82	164b	376	0.785 × 0.574	Horiz.	Type 2a 1937
67	147a	238	0.176 × 0.252	Vert.	Type 1	83	165	138	0.253 × 0.355	Vert.	Type 1
67	147b	239	0.176 × 0.252	Vert.	Type 1	84	166	132	0.252 × 0.354	Vert.	Type 2a
68	148a	13	0.133 × 0.071	Horiz.	No signature	85	167a	122	0.252 × 0.354	Vert.	Type 1
68	148b	11	0.140 × 0.106	Horiz.	No signature	85	167b	131	0.252 × 0.353	Vert.	Type 1
68	148c	35	0.355 × 0.253	Horiz.	No signature	86	168	141	0.353 × 0.252	Horiz.	Type 1
69	149	34	0.355 × 0.253	Horiz.	Type 1	87	169a	140	0.356 × 0.254	Horiz.	Type 2a
70	150a	359	0.255 × 0.230	Horiz.	Type 2b	87	169b	127	0.355 × 0.252	Horiz.	Type 2a
70	150b	357	0.229 × 0.280	Vert.	Type 6	88	170a	124	0.252 × 0.354	Vert.	Type 2a
70	150c	358	0.255 × 0.229	Horiz.	Type 2a	88	170b	37	0.252 × 0.354	Vert.	Type 2a
70	150d	356	0.346 × 0.240	Horiz.	Type 2a	89	171a	137	0.354 × 0.252	Horiz.	Type 2a
70	150e	360	0.325 × 0.240	Horiz.	No signature	89	171b	42	0.355 × 0.254	Horiz.	Type 2a
71	151a	PD 468	0.354 × 0.252	Horiz.	Type 1	90	172	12	0.177 × 0.252	Vert.	No signature
71	151b	PD 467	0.299 × 0.251	Horiz.	Type 7	91	173	164	0.355 × 0.253	Horiz.	Type 2a
72	152a	181	0.354 × 0.253	Horiz.	Type 1	92	174	207	0.355 × 0.252	Horiz.	Type 1
72	152b	241	0.176 × 0.252	Vert.	Type 1	93	175	160	0.252 × 0.354	Vert.	Type 1
73	153	290	0.397 × 0.295	Vert.	Type 1	94	177a	43	0.253 × 0.354	Vert.	Type 1
74	155	136	0.252 × 0.354	Vert.	Type 2a	94	177b	44	0.353 × 0.253	Horiz.	Type 1
75	156	26	0.253 × 0.353	Vert.	Type 1	95	178	165	0.292 × 0.229	Horiz.	Type 1
76	157a	263	0.355 × 0.507	Vert.	Type 2a	96	179a	167	0.354 × 0.253	Horiz.	Type 1
76	157b	264	0.356 × 0.508	Vert.	Type 2a	96	179b	177	0.353 × 0.252	Horiz.	Type 1
77	158	257	0.672 × 0.343	Horiz.	Type 1	97	180a	187	0.353 × 0.253	Horiz.	Type 1
78	159	125	0.292 × 0.228	Horiz.	Type 1	97	180b	277	0.468 × 0.309	Horiz.	Type 1
79	161	135	0.252 × 0.354	Vert.	Type 2a	97	180c	199	0.351 × 0.217	Horiz.	No signature
80	162	128	0.291 × 0.228	Horiz.	Type 1	97	180d	169	0.291 × 0.227	Horiz.	Type 1
81	163	129	0.252 × 0.354	Vert.	Type 2a	97	180e	221	0.260 × 0.176	Horiz.	No signature
82	164a	375	0.787 × 0.570	Horiz.	Type 7	97	180f	205	0.355 × 0.253	Horiz.	Type 1

Cat. #	Fig. #	Painting #	Size (meters)	Orient.	Signature	Cat. #	Fig. #	Painting #	Size (meters)	Orient.	Signature
97	180g	143	0.353 × 0.252	Horiz.	Type 1	117	205b	190	0.354 × 0.253	Horiz.	Type 1
98	181	168	0.350 × 0.255	Horiz.	Type 2a	118	206	182	0.253 × 0.354	Vert.	Type 1
99	182	299	0.390 × 0.566	Vert.	Type 2a	119	207	194	0.254 × 0.354	Vert.	No signature
100	183	166	0.253 × 0.355	Vert.	Type 1	120	208	36	0.355 × 0.253	Horiz.	Type 1
101	184a	46	0.355 × 0.255	Horiz.	No signature	121	210	223	0.253 × 0.176	Horiz.	Type 2a
101	184b	154	0.253 × 0.355	Vert.	Type 1	122	212	211	0.254 × 0.356	Vert.	Type 2a
101	184c	144	0.355 × 0.254	Horiz.	No signature	123	213	226	0.250 × 0.163	Horiz.	No signature
101	184d	175	0.253 × 0.355	Vert.	Type 2b	124	214	229	0.178 × 0.127	Horiz.	Type 2a
101	184e	176	0.253 × 0.353	Vert.	Type 2b	125	215	193	0.254 × 0.356	Vert.	Type 2a
102	185	8	0.255 × 0.175	Horiz.	Type 2b	126	216	14	0.253 × 0.178	Horiz.	No signature
103	186	218	0.253 × 0.354	Vert.	Type 1	127	217	191	0.352 × 0.234 as mounted	Horiz.	Type 2a
104	188a	208	0.351 × 0.256	Horiz.	Type 1	128	218	172	0.255 × 0.355	Vert.	Type 2a
104	188b	209	0.256 × 0.356	Vert.	No signature	129	219	192	0.356 × 0.255	Horiz.	Type 2a
105	189	215	0.250 × 0.360	Vert.	Type 1	130	220a	184	0.355 × 0.253	Horiz.	Type 2a
106	190	246	0.177 × 0.253	Vert.	No signature	130	220b	245	0.254 × 0.178	Horiz.	No signature
107	191	198A	0.253 × 0.355	Vert.	Type 2b	131	221	361	0.329 × 0.252	Horiz.	Type 7
108	193	349	0.254 × 0.356	Vert.	Type 2a	132	223	PD 168	0.750 × 0.506	Horiz.	Type 6
109	194	PD 472	0.253 × 0.177	Horiz.	Type 1	133	224	10	0.250 × 0.177	Horiz.	Type 2a
110	196a	162	0.253 × 0.354	Vert.	Type 1	134	225	272	0.311 × 0.468	Vert.	Type 1
110	196b	173	0.253 × 0.354	Vert.	Type 1	135	226a	273	0.468 × 0.309	Horiz.	Type 1
111	197	163	0.355 × 0.253	Horiz.	Type 1	135	226b	295	0.566 × 0.394	Horiz.	Type 2a
112	198	183	0.253 × 0.355	Vert.	Type 1	136	227	274	0.311 × 0.470	Vert.	Type 1
113	199	189	0.253 × 0.355	Vert.	Type 1	137	228	178	0.253 × 0.354	Vert.	Type 1
114	201	188	0.355 × 0.255	Horiz.	Type 2a	138	229	179	0.252 × 0.353	Vert.	Type 1
115	202	296	0.458 × 0.360	Horiz.	Type 1	139	231a	310	0.572 × 0.786	Vert.	Type 2b
116	203	152	0.252 × 0.353	Vert.	Type 1	139	231b	324	0.568 × 0.776	Vert.	Type 2b
117	205a	170	0.354 × 0.253	Horiz.	Type 1	139	231c	323	0.772 × 0.575	Horiz.	Type 5

Cat. #	Fig. #	Painting #	Size (meters)	Orient.	Signature
140	232a	325	0.573 × 0.777	Vert.	Type 5
141	232b	321	0.575 × 0.763	Vert.	No signature
141	232c	320	0.774 × 0.577	Horiz.	Type 5
Ch. 18	233	PD 2862	0.861 × 0.678	Vert.	Type 7
Ch. 18	234	PD 242	0.507 × 0.356	Horiz.	Type 2c
Ch. 18	235	PD 1351	0.506 × 0.378	Horiz.	Type 2a
Ch. 18	236	PD 216	0.355 × 0.253	Vert.	Type 6

EPILOGUE

THE STRUCTURE OF THIS BOOK on the watercolors by Piet de Jong in the Agora has been largely diachronic, providing a chronological sweep of the material from the Athenian Agora beginning with the Neolithic period and ending with the post-Byzantine era. I wanted, however, to finish this book not with Piet de Jong's latest work in Greece but with three watercolors that are among his earlier paintings of the land he loved so much. In the 1920s, well before the excavations of the Athenian Agora were initiated, Piet de Jong made a series of watercolors of the Athenian Acropolis. These paintings, which now hang in Loring Hall of the American School of Classical Studies, were originally part of the Blegen Collection. Among other views, they include several details of the most enduring monuments of the South Slope of the Acropolis: the Monument of Thrasyllos, the Stoa of Eumenes, and the small chapel of Panayia Chrysospiliotissa; the majority of these watercolors are signed by Piet and dated to 1927. A more general, but tightly framed, view of the South Slope, showing the Monument of Thrasyllos with Panayia Chrysospiliotissa from the west-southwest, the south wall of the citadel looming behind, and Mount Hymettos in the far distance, is captured in a painting also dating to 1927 (Fig. 239). The watercolor, with the nearer of the two Corinthian columns at the upper left barely making it into the frame, is signed with a characteristic Type 2b signature. The verticality of the columns above the Monument of Thrasyllos is amplified by the two cypress pines in the right foreground, the nearer of which, like the nearer of the two columns, only partly makes it into the frame. Of all the choregic monuments of Athens, that of Thrasyllos enjoyed an especially dominant position above the auditorium of the Theater of Dionysos. Constructed in 320/19 B.C., the monument made use

of a natural cave, which was later converted into the chapel of Panayia Chrysospiliotissa; a façade with three piers fronted the cave and supported a frieze with sculptured wreaths, with the prize tripod displayed above. The monument itself was drawn by Stuart and Revett in the 18th century but was destroyed by Turkish gunfire in the Siege of the Acropolis in 1826–1827, though it is currently under restoration by the Greek Ministry of Culture, supervised by Kostas Boletis. The two Corinthian columns above, also built to display prize tripods, date to the Roman period.

The second of the three watercolors shows an interior detail of the colonnade of the Parthenon (Fig. 240). Slightly smaller than the view of the South Slope but sharing a similar vertical orientation, the painting is signed by Piet de Jong with one of his characteristic Type 6 signatures ("P. de Jong"). The date, however, is not very clear, and it is difficult to distinguish between 1923 and 1928. One of the remaining watercolors in this series is dated to 1928, while all the rest date to 1927. Although the painting could date to 1928—the year in which, among other things, Piet de Jong prepared a number of color plates for Carl Blegen's excavations at Ayioryitika—the possibility that it was painted earlier is high, particularly since 1923 was the year in which Piet was officially appointed architect of the British School. The view is not the typical rendering of the Parthenon from the northwest—the view that had already become a cultural icon by the 1920s, serving as a sort of metonymic representation of Greece—but an interior detail of the northeast corner of the building. The painting as a whole is more of an architect's sketch in watercolor than it is a finished work by an archaeological illustrator. The beauty of this watercolor, like that of the South Slope (Fig. 239), is that it was

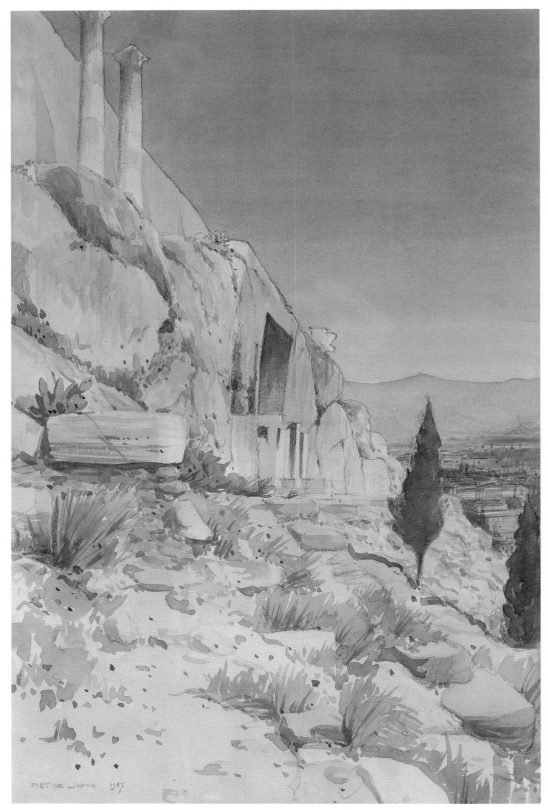

FIGURE 239. The South Slope of the Athenian Acropolis. Watercolor by Piet de Jong dated 1927 in the Collection of the American School of Classical Studies at Athens (P 87.10), formerly in the Blegen Collection (no. 425). Vertical orientation (0.410 × 0.590 m as mounted), with a Type 2b signature

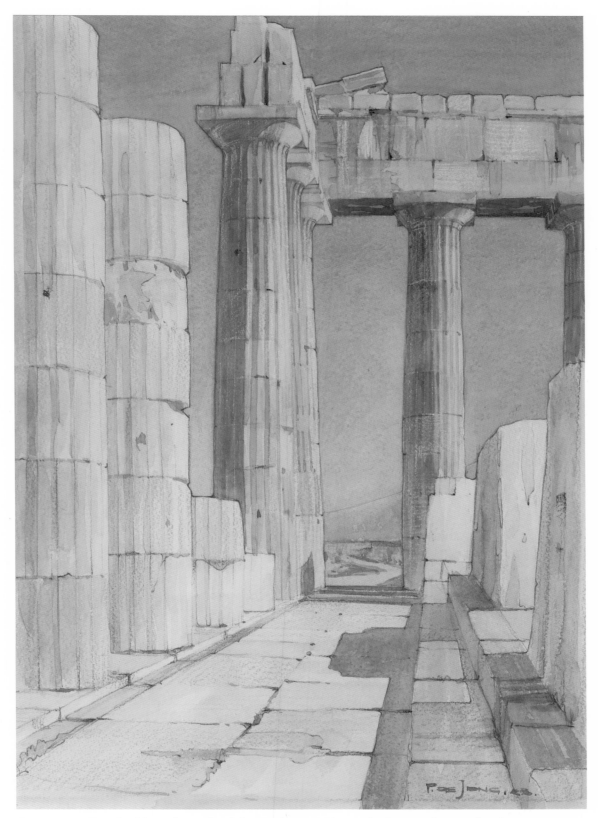

FIGURE 240. Detail of the colonnade of the Parthenon. Watercolor by Piet de Jong dated 1923 or 1928 in the Collection of the American School of Classical Studies at Athens (P 87.13), formerly in the Blegen Collection (no. 428). Vertical orientation (0.370 × 0.490 as mounted), with a Type 6 signature

Figure 241. Seashore. Watercolor by Piet de Jong dated 1928 in the Collection of the American School of Classical Studies at Athens (P 87.12), formerly in the Blegen Collection (no. 427). Vertical orientation (0.385 × 0.515 as mounted), with a Type 1 signature

prepared by Piet de Jong not for someone else. These images were never designed for publication in an archaeological monograph, even though a blatantly archaeological theme pervaded them both. Rather, he painted them for himself.

This is nowhere clearer than in the watercolor of the seashore that now also hangs in Loring Hall (Fig. 241). Dated to 1928 and signed with what was to become one of Piet's most common signatures—the plain Type 1 signature that has his name written vertically down the lower right side of the picture—the landscape eschews archaeology altogether. It is a simple landscape of a rocky seashore. I do not recognize the beach, but it is an all too familiar representation of Greece. As for the places where Piet was working in the 1920s, these were many: Crete, Mycenae, Sparta, Halae, Eutresis, Zygouries, and Corinth, to mention only a few; and even those sites that lay a fair distance inland—like Mycenae, Sparta, Eutresis,

and Zygouries—were never at any great distance from the sea. The landscape was painted while Piet and Effie were living in Greece, the year before Piet joined Humfry Payne at Perachora and two years before Piet and Effie bought their home in Norfolk. A sense of what Piet and Effie were like in the 1920s is provided by the photograph of the couple in what appears to be the garden of Effie's apartment on Kydathenaion Street, taken by Queenie Dewsnap probably in 1921 or soon afterward (Fig. 8).

Throughout his life, Piet de Jong was a keen observer, as the watercolors in this volume amply attest and as his critical and penetrating caricatures of the "giants of the day" (Figs. 33a, 35, 36) clearly show. In his own words—without any reference to anything—Piet de Jong once stated (Hood 1998, p. 279), "Isn't it strange how one lives and learns, simply by observation and keeping one's eyes open."

—*John K. Papadopoulos*

References

Agora = The Athenian Agora: Results of Excavations Conducted by the American School of Classical Studies at Athens, Princeton

III	R. E. Wycherley, *Literary and Epigraphical Testimonia*, 1957
V	H. S. Robinson, *Pottery of the Roman Period: Chronology*, 1959
VII	J. Perlzweig, *Lamps of the Roman Period: First to Seventh Century after Christ*, 1961
VIII	E. T. H. Brann, *Late Geometric and Protoattic Pottery: Mid 8th to Late 7th Century B.C.*, 1962
X	M. Lang and M. Crosby, *Weights, Measures, and Tokens*, 1964
XI	E. B. Harrison, *Archaic and Archaistic Sculpture*, 1965
XII	B. A. Sparkes and L. Talcott, *Black and Plain Pottery of the 6th, 5th, and 4th Centuries B.C.*, 1970
XIII	S. A. Immerwahr, *The Neolithic and Bronze Ages*, 1971
XIV	H. A. Thompson and R. E. Wycherley, *The Agora of Athens: The History, Shape, and Uses of an Ancient City Center*, 1972
XXI	M. Lang, *Graffiti and Dipinti*, 1976
XXIII	M. B. Moore and M. Z. Pease Philippides, *Attic Black-Figured Pottery*, 1986
XXIV	A. Frantz, *Late Antiquity: A.D. 267–700*, 1988
XXV	M. Lang, *Ostraka*, 1990
XXVII	R. F. Townsend, *The East Side of the Agora: The Remains beneath the Stoa of Attalos*, 1995
XXVIII	A. L. Boegehold, J. McK. Camp II, M. Crosby, M. Lang, D. R. Jordan and R. F. Townsend, *The Lawcourts at Athens: Sites, Buildings, Equipment, Procedure, and Testimonia*, 1995
XXIX	S. I. Rotroff, *Hellenistic Pottery: Athenian and Imported Wheelmade Table Ware and Related Material*, 1997
XXX	M. B. Moore, *Attic Red-Figured and White-Ground Pottery*, 1997
XXXII	J. W. Hayes, *Roman Pottery: Fine-Ware Imports*, forthcoming
XXXIII	S. I. Rotroff, *Hellenistic Pottery: The Plain Wares*, forthcoming
XXXIV	G. D. Weinberg and E. M. Stern, *Vessel Glass*, forthcoming

Alram-Stern, E. 1996. *Die ägäische Frühzeit* 1: *Das Neolithikum in Griechenland* (Österreichische Akademie der Wissenschaften, Phil.-Hist. Klasse, Veröffentlichungen der mykenischen Kommission, Vol. 16), Vienna.

Amyx, D. A. 1958. "The Attic Stelai: Part III," *Hesperia* 27, pp. 163–254.

———. 1988. *Corinthian Vase-Painting of the Archaic Period*, Berkeley.

Angel, J. L. 1945. "Skeletal Material from Attica," *Hesperia* 14, pp. 279–363.

Appadurai, A., ed. 1986. *The Social Life of Things*, Cambridge.

Åström, P., and R. E. Jones. 1982. "A Mycenaean Tomb and Its Near Eastern Connections," *OpAth* 14, pp. 7–9.

Barringer, J. 1996. "Atalanta as Model: The Hunter and the Hunted," *ClAnt* 15, pp. 48–76.

Beaton, R. 1981. "'Digenes Akrites' and Modern Greek Folk Song: A Reassessment," *Byzantion* 51, pp. 22–43.

Beaton, R., and D. Ricks. 1993. *Digenis Akrites: New Approaches to Byzantine Heroic Poetry*, Ashgate.

Beazley, J. D. 1946. *Potter and Painter in Ancient Athens*, London.

———. [1951] 1986. *The Development of Attic Black-Figure*, Berkeley.

Beck, A. 1975. *Album of Greek Education*, Sydney.

Benton, S. 1961. "Cattle Egrets and Bustards in Greek Art," *JHS* 81, pp. 44–55.

Birchall, A. 1972. "Attic Horse-head Amphorae," *JHS* 92, pp. 46–63.

Blegen, C. W. 1928. *Zygouries: A Prehistoric Settlement in the Valley of Cleonae*, Cambridge, Mass.

———. 1937. *Prosymna: The Helladic Settlement Preceding the Argive Heraeum*, Cambridge, Mass.

———. 1952. "Two Athenian Grave Groups of about 900 B.C.," *Hesperia* 21, pp. 279–294.

Blegen, C. W., and M. Rawson. 1966. *The Palace of Nestor at Pylos in Western Messenia*, Vol. I: *The Buildings and Their Contents*, Princeton.

Blegen, C. W., M. Rawson, W. Taylour, and W. P. Donovan. 1973. *The Palace of Nestor at Pylos in Western Messenia*, Vol. III: *Acropolis and Lower Town, Tholoi, Grave Circle, and Chamber Tombs, Discoveries outside the Citadel*, Princeton.

Blegen, E. P. 1952. "Archaeological News: Classical Lands—Greece, 1950–1951," *AJA* 56, pp. 121–125.

Bloesch, H. 1940. *Formen attischer Schalen von Exekias bis zum Ende des strengen Stils*, Bern.

Boardman, J. 1998. *Early Greek Vase Painting*, London.

Boegehold, A. L. 1965. "An Archaic Corinthian Inscription," *AJA* 69, pp. 259–262.

Borgers, O. 1999. "Some Subjects and Shapes by the Theseus Painter," in *Proceedings of the XVth International Congress of Classical Archaeology, Amsterdam, July 12–17, 1998*, ed. R. F. Docter and E. M. Moormann, Amsterdam, pp. 87–89.

Boulter, C. G. 1963. "Graves in Lenormant Street, Athens," *Hesperia* 32, pp. 113–137.

Brann, E. T. H. 1960. "Late Geometric Grave Groups from the Athenian Agora," *Hesperia* 29, pp. 402–416.

———. 1961a. "Late Geometric Well Groups from the Athenian Agora," *Hesperia* 30, pp. 93–146.

———. 1961b. "Protoattic Well Groups from the Athenian Agora," *Hesperia* 30, pp. 305–379.

Brendel, O. 1936. "Der Schild des Achilles," *Die Antike* 12, pp. 272–288.

Brewer, D., T. Clark, and A. Phillips. 2001. *Dogs in Antiquity: Anubis to Cerberus*, Warminster.

Brill, R. H. 1962. "An Inlaid Glass Plate in Athens, Part II: Laboratory Examination," *JGS* 4, pp. 37–47.

Brommer, F. 1973. *Vasenliste zur griechischen Heldensage*, 3rd ed., Marburg.

Broneer, O. 1937. "A Calyx-krater by Exekias," *Hesperia* 6, pp. 469–486.

———. 1956. "The North Slope Krater: New Fragments," *Hesperia* 25, pp. 345–349.

Brumbaugh, R. S. 1966. *Ancient Greek Gadgets and Machines*, New York.

Buck, R. J. 1964. "Middle Helladic Mattpainted Pottery," *Hesperia* 33, pp. 231–313.

Burkert, W. 1966. "Greek Tragedy and Sacrificial Ritual," *GRBS* 7, pp. 87–121.

Burr, D. 1933. "A Geometric House and a Proto-Attic Votive Deposit," *Hesperia* 2, pp. 542–640.

Buschor, E. 1954. *Bilderwelt griechischer Töpfer*, Munich.

Byzantine and Post-Byzantine Art = Βυζαντινή και μεταβυζαντινή τέχνη· Αθήνα, Παλαίο Πανεπιστήμιο, 26 Ιουλίου 1985–6 Ιανουαρίου 1986, Athens 1986.

Callaghan, P. J., and R. E. Jones. 1985. "Hadra Hydriae and Central Crete: A Fabric Analysis," *BSA* 80, pp. 1–17.

Camp, J. McK., II. 1980. *Gods and Heroes in the Athenian Agora* (Agora Picture Book 19), Princeton.

———. 1986. *The Athenian Agora: Excavations in the Heart of Classical Athens*, London.

———. 1990. *The Athenian Agora: A Guide to the Excavation and Museum*, 4th ed., Athens.

———. 1998. *Horses and Horsemanship in the Athenian Agora* (Agora Picture Book 24), Princeton.

Camp, J. McK., II, and W. B. Dinsmoor Jr. 1984. *Ancient Athenian Building Methods* (Agora Picture Book 21), Princeton.

Chatzidakis, M. 1987. *Έλληνες Ζωγράφοι μετὰ τῶν Alose (1450–1830)*, I, Athens.

Clairmont, C. 1951. *Das Parisurteil in der antiken Kunst*, Zurich.

Cohen, B. 1970–1971. "Some Observations on Coral-Red," *Marsyas* 15, pp. 1–12.

Coldstream, J. N. 1968. *Greek Geometric Pottery: A Survey of Ten Local Styles and Their Chronology*, London.

Cook, J. M. 1934–1935. "Protoattic Pottery," *BSA* 35, pp. 165–219.

Cook, R. M., and J. Boardman. 1954. "Archaeology in Greece, 1953," *JHS* 74, pp. 142–169.

Cook, R. M., and P. Dupont. 1998. *East Greek Pottery*, London.

Corbett, P. E. 1949. "Attic Pottery of the Later Fifth Century from the Athenian Agora," *Hesperia* 18, pp. 298–351.

Corinth = Corinth: Results of Excavations Conducted by the American School of Classical Studies at Athens

XI C. H. Morgan II, *The Byzantine Pottery*, Cambridge, Mass. 1942

XIII C. W. Blegen, H. Palmer, and R. S. Young, *The North Cemetery*, Princeton 1964

Crosby, M. 1955. "Five Comic Scenes from Athens," *Hesperia* 24, pp. 76–84.

Dasen, V. 1990. "Dwarfs in Athens," *OJA* 9, pp. 191–207.

———. 1993. *Dwarfs in Ancient Egypt and Greece*, Oxford.

Davison, J. M. 1961. "Attic Geometric Workshops," *YCS* 16, pp. 1–161.

Desborough, V. R. d'A. 1948. "What is Protogeometric?" *BSA* 43, pp. 260–272.

———. 1952. *Protogeometric Pottery*, Oxford.

Dinsmoor, W. B. 1941. *Observations on the Hephaisteion* (*Hesperia* Suppl. 5), Princeton.

Dinsmoor, W. B., Jr. 1976. "The Roof of the Hephaisteion," *AJA* 80, pp. 223–246.

Docter, F. R. 1991. "Athena vs. Dionysos: Reconsidering the Contents of SOS Amphorae," *BABesch* 66, pp. 45–49.

Dugas, C. 1935. "Bulletin Archéologique. IV. Céramique. Peinture. Mosaïque," *RÉG* 48, pp. 122–132.

Feugère, M. 2001. "Plat ou pinax? Un verre à décor mosaïque de Narbonne," *JGS* 43, pp. 11–19.

Frantz, A. 1935. "Late Byzantine Paintings in the Agora," *Hesperia* 4, pp. 442–469.

———. 1938. "Middle Byzantine Pottery in Athens," *Hesperia* 7, pp. 429–467.

———. 1940–1941. "Digenis Akritas: A Byzantine Epic and Its Illustrators," *Byzantion* 15, pp. 87–91.

———. 1941a. "Akritas and the Dragons," *Hesperia* 10, pp. 9–13.

———. 1941b. "St. Spyridon: The Earlier Frescoes," *Hesperia* 10, pp. 193–198.

———. 1942. "Turkish Pottery from the Agora," *Hesperia* 11, pp. 1–28.

———. 1961. *The Middle Ages in the Athenian Agora* (Agora Picture Book 7), Princeton.

Fraser, A. D. 1940. "The Geometric Oinochoe with Crossed Tubes from the Athenian Agora," *AJA* 44, pp. 457–463.

Furumark, A. 1941. *The Mycenaean Pottery: Analysis and Classification*, Stockholm.

Gerstel, S. E. J. 1999. *Beholding the Sacred Mysteries: Programs of the Byzantine Sanctuary*, Seattle.

Goldstein, S. M. 1979. *Pre-Roman and Early Roman Glass in the Corning Museum of Glass*, Corning.

Gombrich, E. H. 1960. *Art and Illusion*, New York.

Grace, V. R. 1956. "The Canaanite Jar," in *The Aegean and the Near East: Studies Presented to Hetty Goldman on the Occasion of Her Seventy-fifth Birthday*, ed. S. S. Weinberg, New York, pp. 80–109.

———. 1979. *Amphoras and the Ancient Wine Trade* (Agora Picture Book 6), Princeton.

Grmek, M., and D. Gourevitch. 1998. *Les maladies dans l'art antique*, Paris.

Hafner, G. 1952. *CVA Deutschland 8, Karlsruhe, Badisches Landesmuseum 2*, Munich.

Hahn, M. 1991. "A Group of 15th/16th Century Jugs from Western Crete," *Acta Hyperborea* 3, pp. 311–320.

Hampe, R. 1936. *Frühe griechische Sagenbilder in Böotien*, Athens.

Harden, D. B., et al. 1987. *Glass of the Caesars*, Milan.

Harrison, E. B. 1977. "Alkamenes' Sculptures for the Hephaisteion: Part I, The Cult Statues; Part II, The Base; Part III, Iconography and Style," *AJA* 81, pp. 137–178, 267–287, 411–426.

Hävernick, T. E. 1968. *Doppelköpfchen* (Wissenschaftliche Zeitschrift der Universität Rostock, 17 Jahrgang 1968, Gesellschafts- und Sprachwissenschaftliche Reihe, Heft 7/8), Rostock.

Hayes, J. W. 1972. *Late Roman Pottery*, London.

———. 1992. *Excavations at Saraçhane in Istanbul*, Vol. 2: *The Pottery*, Princeton.

Hetherington, P. 1974. *The "Painter's Manual" of Dionysius of Fourna*, London.

Himmelmann-Wildschütz, N. 1959. *Zur Eignenart des klassischen Götterbildes*, Munich.

Hoesch, N. 1992. "Das Kottabosspiel," in *Kunst der Schale: Kultur des Trinkens*, ed. K. Vierneisel and B. Käser, Munich, pp. 272–275.

Holloway, R. 1966. "Music at the Panathenaic Festival," *Archaeology* 19, pp. 112–119.

Hood, R. 1998. *Faces of Archaeology in Greece: Caricatures by Piet de Jong*, Oxford.

Hübner, G. 1993. *Die Applikenkeramik von Pergamon: Eine Bildersprache im Dienst des Herrscherkultes* (Pergamenische Forschungen 7), Berlin.

Iliffe, J. H. 1936. "Sigillata Wares in the Near East: A List of Potters' Stamps," *QDAP* 6, pp. 4–53.

Immerwahr, H. R. 1990. *Attic Script: A Survey*, Oxford.

Immerwahr, S. A. 1966. "The Use of Tin on Mycenaean Vases," *Hesperia* 35, pp. 381–396.

——. 1982. "The Earliest Athenian Grave," in *Studies in Athenian Architecture, Sculpture, and Topography Presented to Homer A. Thompson* (*Hesperia* Suppl. 20), Princeton, pp. 54–62.

Ioannidaki-Dostoglou, I. 1987. "Les vases de l'épave de Pélagonnissos," in *Recherches sur la céramique byzantine* (*BCH* Suppl. 18), ed. V. Déroche and J.-M. Spieser, Athens, pp. 157–171.

Jantzen, U. 1938. "Archäologische Funde vom Sommer 1937 bis Sommer 1938. Griechenland," *AA* 53, cols. 541–585.

Jeffery, L. H. 1990. *The Local Scripts of Archaic Greece: A Study of the Origin of the Greek Alphabet and Its Development from the Eighth to the Fifth Centuries B.C.* (rev. ed., with a supplement by A.W. Johnston), Oxford.

Jeffreys, E. 1998. *Digenis Akritis: The Grottaferrata and Escorial Versions*, Cambridge.

Jones, R. E. 1986. *Greek and Cypriot Pottery: A Review of Scientific Studies*, London.

Jucker, I. 1982. "Ein etruskischer Spiegel mit Parisurteil," *MusHelv* 39, pp. 5–14.

Karo, G. 1933. "Archäologische Funde vom Mai 1932 bis Juli 1933. Griechenland und Dodekanes," *AA* 48, cols. 191–262.

——. 1934. "Archäologische Funde vom Juli 1933 bis Juli 1934. Griechenland und Dodekanes," *AA* 49, cols. 123–196.

——. 1936. "Archäologische Funde vom Sommer 1935 bis Sommer 1936. Griechenland und Dodekanes," *AA* 51, cols. 94–181.

Karouzou, S. 1952. "Ἀρχαϊκὰ μνημεῖα τοῦ Ἐθνικοῦ Μουσείου," *AE* 1952, pp. 137–166.

——. 1956. *The Amasis Painter,* Oxford.

Kephalidou, E. 1996. *Νικητὴς,* Thessaloniki.

Kerameikos = Kerameikos. Ergebnisse der Ausgrabungen, Berlin
 I W. Kraiker and K. Kübler, *Die Nekropolen des 12. bis 10. Jahrhunderts*, 1939
 IV K. Kübler, *Neufunde aus der Nekropole des 11. und 10. Jahrhunderts*, 1943

Kritsas, C. 1971. "Τὸ Βυζαντινὸν ναυάγιον Πελαγόννησου–Αλόννεσου," *AAA* 4, pp. 176–182.

Kübler, K. 1950. *Altattische Malerei*, Tübingen.

Kunze, E. 1946. "Zeusbilder in Olympia," *Antike und Abendland* 2, pp. 95–113.

Lamberton, R. D., and S. I. Rotroff. 1985. *Birds of the Athenian Agora* (Agora Picture Book 22), Princeton.

Lamerle, P. 1939. "Chronique des fouilles et découvertes archéologiques en Grèce en 1939," *BCH* 63, pp. 284–324.

Lane, A. 1948. *Greek Pottery*, London.

Lang, M. 1960. *The Athenian Citizen* (Agora Picture Book 4), Princeton.

——. 1969. *The Palace of Nestor at Pylos in Western Messenia*, Vol. II: *The Frescoes*, Princeton.

——. 1974. *Graffiti in the Athenian Agora* (Agora Picture Book 14), Princeton.

Lang, M., and C. W. J. Eliot. 1954. *The Athenian Agora: A Guide to the Excavations,* Athens.

Lawall, M. L., J. K. Papadopoulos, K. M. Lynch, B. Tsakirgis, S. I. Rotroff, and C. MacKay. 2001. "Notes from the Tins: Research in the Stoa of Attalos, Summer 1999," *Hesperia* 70, pp. 163–182.

Lichardus, J., and M. Lichardus-Itten. 1994. "Probleme der griechischen Kupferzeit," in *Festschrift für Otto-Herman Frey*, ed. C. Dobiat, Marburg, pp. 274–394.

Liddell, H. G., and R. Scott. 1996. *A Greek–English Lexicon*, 9th ed., rev. H. S. Jones, Oxford.

Lindblom, M. 2001. *Marks and Makers* (*SIMA* 127), Jonsered.

Lynch, K. M., and J. K. Papadopoulos. 2006. "*Sella Cacatoria*: A Study of the Potty in Archaic and Classical Athens," *Hesperia* 75, pp. 1–32.

Lyons, C. L., and J. K. Papadopoulos. 2002. "Archaeology and Colonialism," in *The Archaeology of Colonialism*, ed. C. L. Lyons and J. K. Papadopoulos, Los Angeles, pp. 1–23.

Maas, M., and J. M. Snyder. 1989. *Stringed Instruments of Ancient Greece*, New Haven, Conn.

Mackay, E. A. 1988. "Painters Near Exekias," in *Proceedings of the 3rd Symposium on Ancient Greek and Related Pottery: Copenhagen, August 31–September 4, 1987*, ed. J. Christiansen and T. Melander, Copenhagen, pp. 369–378.

——. 1999. "Exekias' Calyx-krater Revisited: Reconsidering the Attribution of Agora AP 1044," in *Proceedings of the XVth International Congress of Classical Archaeology, Amsterdam, July 12–17, 1998*, ed. R. F. Docter and E. M. Moormann, Amsterdam, pp. 247–251.

Maguire, E. D. 1997. "Ceramic Arts of Everyday Life," in *The Glory of Byzantium: Art and Culture of the Middle Byzantine Era, A.D. 843–1261*, ed. H. C. Evans and W. D. Wixom, New York, pp. 254–270.

Marwitz, H. 1959. "Kreis und Figur in der attisch-geometrischen Vasenmalerei," *JdI* 74, pp. 52–113.

Matheson, S. 1995. *Polygnotos and Vase Painting in Classical Athens*, Madison, Wisc.

Mattusch, C. C. 1988. *Greek Bronze Statuary*, Ithaca.

——. 1996. *Classical Bronzes*, Ithaca.

Matz, F. 1955. "*Belli Facies et Triumphus*," in *Festschrift für Carl Weickert*, ed. G. Bruns, Berlin, pp. 41–57.

Mayer, R., and S. Sheehan. 1975. *Artist's Handbook of Materials and Techniques*, 3rd ed., New York.

McAllister, M. 1959. "The Temple of Ares at Athens," *Hesperia* 28, pp. 1–64.

McCabe, R. A. 2004. *Ἑλλάδα· Τὰ χρόνια τῆς ἀθωότητας [1954–1965]*, Athens.

Megaw, A. H. S., and R. E. Jones. 1983. "Byzantine and Allied Pottery: A Contribution by Chemical Analysis to Problems of Origin and Distribution," *BSA* 78, pp. 235–263.

Meritt, L. S. 1984. *History of the American School of Classical Studies at Athens: 1939–1980*, Princeton.

——. 1996. "Athenian Ionic Capitals from the Athenian Agora," *Hesperia* 45, pp. 121–174.

Mertens, J. R. 1974. "Attic White-Ground Cups: A Special Class of Vases," *MetMJ* 9, pp. 91–108.

——. 1977. *Attic White-Ground: Its Development on Shapes Other Than Lekythoi*, New York.

Miles, G. C. 1956. "The Arab Mosque in Athens," *Hesperia* 25, pp. 329–344.

Milleker, E. J. 1986. "The Statue of Apollo Lykeios in Athens" (diss. New York University).

Miller, M. 1993. "Adoption and Adaptation of Achaemenid Metalware Forms in Attic Black-Gloss Ware of the Fifth Century," *AMIran* 26, pp. 109–146.

——. 1997. *Athens and Persia in the Fifth Century B.C.*, Cambridge.

Milne, M. J., and D. von Bothmer. 1953. "ΚΑΤΑΠΥΓΩΝ, ΚΑΤΑΠΥΓΑΙΝΑ," *Hesperia* 22, pp. 215–224.

Molyneaux, B. L., ed. 1997. *The Cultural Life of Images: Visual Representation in Archaeology*, London.

Moore, M. 1986. "Athena and Herakles on Exekias' Calyx-krater," *AJA* 90, pp. 35–39.

Morris, I. 2000. *Archaeology as Cultural History: Words and Things in Iron Age Greece*, Oxford.

Morris, S. P. 1984. *The Black and White Style: Athens and Aigina in the Orientalizing Period*, New Haven, Conn.

———. 1985. "ΛΑΣΑΝΑ: A Contribution to the Ancient Greek Kitchen," *Hesperia* 54, pp. 393–409.

Mountjoy, P. 1986. *Mycenaean Decorated Pottery: A Guide to Identification*, Göteborg.

Müller, P. 1978. *Löwen und Mischwesen in der archaischen griechischen Kunst*, Zurich.

Mylonas, G. E. 1957. Ὁ Πρωτοαττικὸς Ἀμφορεὺς τῆς Ἐλευσῖνος, Athens.

Neils, J. 1987. *The Youthful Deeds of Theseus*, Rome.

———. 1992. "The Panathenaic Amphoras: Their Meaning, Makers, and Markets," in *Goddess and Polis: The Panathenaic Festival in Ancient Athens*, ed. J. Neils, Hanover, N.H., pp. 29–51.

Nicholls, R. 1970. "Architectural Terracotta Sculpture from the Athenian Agora," *Hesperia* 39, pp. 115–138.

———. 1984. "La fabrication des terres cuites," *Histoire et archéologie* (dossiers) 81, pp. 24–31.

Noble, J. V. 1972. "An Unusual Attic Baby Feeder," *AJA* 76, pp. 437–438.

Notopoulos, J. A. 1964. "Akritan Iconography on Byzantine Pottery," *Hesperia* 33, pp. 108–133.

Ober, J., and C. W. Hedrick, eds. 1993. *The Birth of Democracy: An Exhibition Celebrating the 2500th Anniversary of Democracy at the National Archives, Washington, D.C., June 15, 1993–January 2, 1994*, Athens.

Oliver, A. 2001. "A Glass Opus Sectile Panel from Corinth," *Hesperia* 70, pp. 349–363.

Oxé, A., H. Comfort, and P. Kenrick. 2000. *Corpus Vasorum Arretinorum: A Catalogue of the Signatures, Shapes, and Chronology of Italian Sigillata*, 2nd ed., Bonn.

Palaiokrassa, L. 1994. "Ein neues Gefäss des Nessos-Malers," *AM* 109, pp. 1–10.

Papadopoulos, J. K. 1994. "Early Iron Age Potters' Marks in the Aegean," *Hesperia* 63, pp. 437–507.

———. 1997. "Knossos," in *Conservation of Archaeological Sites in the Mediterranean Region. Proceedings of the Conference Organized by the J. Paul Getty Trust, 6–12 May 1995*, ed. M. de la Torre, Los Angeles, pp. 93–125.

———. 1998. "A Bucket, by Any Other Name, and an Athenian Stranger in Early Iron Age Crete," *Hesperia* 67, pp. 109–123.

———. 1999. "Tricks and Twins: Nestor, Aktorione-Molione, the Agora Oinochoe and the Potter Who Made Them," in *Meletemata: Studies in Aegean Archaeology Presented to Malcolm H. Wiener as He Enters His 65th Year* (*Aegaeum* 20), ed. P. P. Betancourt, V. Karageorghis, R. Laffineur, and W. D. Niemeier, Liège, pp. 633–640.

———. 2003. *Ceramicus Redivivus: The Early Iron Age Potters' Field in the Area of the Classical Athenian Agora* (*Hesperia* Suppl. 31), Princeton.

Papadopoulos, J. K., and S. A. Paspalas. 1999. "Mendaian as Chalkidian Wine," *Hesperia* 68, pp. 161–188.

Papadopoulos, J. K., and E. L. Smithson. 2002. "The Cultural Biography of a Cycladic Geometric Amphora: Islanders in Athens and the Prehistory of Metics," *Hesperia* 71, pp. 149–199.

Papadopoulos, J. K., J. Vedder, and T. Schreiber. 1998. "Drawing Circles: Experimental Archaeology and the Pivoted Multiple Brush," *AJA* 102, pp. 507–529.

Payne, H. G. G. 1935. "Archaeology in Greece, 1934–1935," *JHS* 55, pp. 147–171.

Petrakis, S. L. 2002. *Ayioryitika: The 1928 Excavations of Carl Blegen at a Neolithic to Early Helladic Settlement in Arcadia* (INSTAP Prehistory Monograph 3), Philadelphia.

Pfeiff, K. 1943. *Apollon: Die Wandlung seines Bildes in der griechischen Kunst*, Frankfurt.

Philippart, H. 1936. "Les coupes attiques à fond blanc," *AntCl* 5, pp. 5–86.

Picozzi, M. G. 1971. "Anfore attiche a protome equine," *StMisc* 18, pp. 5–64.

Piggott, S. 1978. *Antiquity Depicted: Aspects of Archaeological Illustration*, London.

Praetzellis, A., and M. Praetzellis. 1998. *Archaeologists as Storytellers* (Historical Archaeology 32.1), Tucson.

Proust, Marcel. 1983. *Remembrance of Things Past*, trans. C. K. S. Moncrieff and T. Kilmartin, Harmondsworth.

Raab, I. 1972. *Zu den Darstellungen des Parisurteils in der griechischen Kunst*, Frankfurt.

Richter, G. M. A. 1928. "A Greek Bobbin," *BullMMA* 23, pp. 303–306.

———. 1960. *Kouroi*, 2nd ed., London.

———. 1965. *A Handbook of Greek Art*, 4th ed., London.

———. 1969. *A Handbook of Greek Art*, 6th ed., London.

———. 1987. *A Handbook of Greek Art*, 9th ed., London.

Richter, G., and M. Milne. 1935. *Shapes and Names of Athenian Vases*, New York.

Riemann, H. 1937. "Archäologische Funde vom Sommer 1936 bis Sommer 1937: Griechenland," *AA* 52, cols. 86–184.

Roberts, S. R. 1986. "The Stoa Gutter Well: A Late Archaic Deposit in the Athenian Agora," *Hesperia* 55, pp. 1–74.

Robertson, M. 1959. *Greek Painting*, Geneva.

———. 1980. "An Unrecognized Cup by the Kleophrades Painter?" in Στήλη· Τόμος εἰς μνήμην Νικόλαου Κοντολέοντος, ed. P. Kanellopoulos, Athens, pp. 125–129.

———. 1992. *The Art of Vase-Painting in Classical Athens*, Cambridge.

Roebuck, M. C., and C. A. Roebuck. 1955. "A Prize Aryballos," *Hesperia* 24, pp. 158–163.

Rosivach, V. 1978. "The Altar of Zeus Agoraios in the 'Heraclidae,'" *PP* 33, pp. 32–47.

Rotroff, S. I. 1991. "Attic West Slope Vase Painting," *Hesperia* 60, pp. 59–102.

———. 2003. "Minima Macedonica," in *The Macedonians in Athens, 322–229 B.C.*, ed. O. Palagia and S. Tracy, Oxford, pp. 213–225.

Rühfel, H. 1984. *Kinderleben im klassischen Athen*, Mainz.

Rutter, J. B. 1978. "A Plea for the Abandonment of the Term 'Submycenaean,'" *Temple University Aegean Symposium* 3, pp. 57–65.

Sabetai, V. 1997. "Aspects of Nuptial and Genre Imagery in Fifth-Century Athens: Issues of Interpretation and Methodology," in *Athenian Potters and Painters*, ed. J. H. Oakley, W. D. E. Coulson, and O. Palagia, Oxford, pp. 319–335.

Saltz, D. L. 1978. "Greek Geometric Pottery in the East: The Chronological Implications" (diss. Harvard University).

Sanders, G. D. R. 2000. "New Relative and Absolute Chronologies for 9th to 13th Century Glazed Wares at Corinth: Methodology and Social Conclusions," in *Byzanz als Raum: Zu Methoden und Inhalten der historischen Geographie des östlichen Mittelmeerraumes*, ed. K. Belke et al., Vienna, pp. 153–173.

———. 2001. "Byzantine Polychrome Pottery," in *Mosaic: Festschrift for A. H. S. Megaw*, ed. J. Herrin et al., Athens, pp. 89–103.

Saunier, G. 1993. "Is There Such a Thing as an 'Akritic Song'? Problems in the Classification of Modern Greek Narrative Songs," in *Digenis Akrites: New Approaches to Byzantine Heroic Poetry*, ed. R. Beaton and D. Ricks, Ashgate, pp. 139–149.

Schachermeyer, F. 1976. *Die ägäische Frühzeit* I: *Die vormykenischen Perioden* (Österreichisch Akademie der Wissenschaften, Phil.-Hist. Klasse 303), Vienna.

Schäfer, A. 1997. *Unterhaltung beim griechischen Symposion*, Mainz.

Scheibler, 1961. "Olpen und Amphoren des Gorgomalers," *JdI* 76, pp. 1–47.

Seager, R. 1912. *Explorations in the Island of Mochlos*, Boston.

Shapiro, H. A. 1985. "Greek 'Bobbins': A New Interpretation," *AncW* 11, pp. 115–118.

Shear, T. L. 1930. "Excavations in the North Cemetery at Corinth in 1930," *AJA* 34, pp. 403–431.

———. 1932. "The Excavation of the Athenian Agora," *AJA* 36, pp. 382–392.

———. 1933a. "The Latter Part of the Agora Campaign of 1933," *AJA* 37, pp. 540–548.

———. 1933b. "The American Excavations in the Athenian Agora, Second Report: The Campaign of 1932," *Hesperia* 2, pp. 451–474.

———. 1933c. "A Late Mycenaean Gold Signet-ring Found at Athens, Its Design—A Bull Headed Man Leading Two Captive Women—Recalling the Maiden Tribute to the Minotaur," *ILN*, August 26, 1933, p. 328.

———. 1933d. "Discoveries in the Athenian Agora in 1933," *Art and Archaeology* 34, pp. 283–297.

———. 1933e. "The Current Excavations in the Athenian Agora," *AJA* 38, pp. 305–312.

———. 1933f. "The 'Cock-horse' in Greek Art; and Roman Portrait Heads: New Discoveries in the Agora of Athens," *ILN*, August 26, 1933, pp. 326–328.

———. 1933g. "The American Excavations in the Athenian Agora, Second Report: The Sculpture," *Hesperia* 2, pp. 514–541.

———. 1934. "Discoveries Helping to Map the Athenian Agora," *ILN*, June 2 1934, pp. 862–863.

———. 1935a. "The Agora Excavations," *AJA* 39, pp. 437–447.

———. 1935b. "The American Excavations in the Athenian Agora, Sixth Report: The Campaign of 1933," *Hesperia* 4, pp. 311–339.

———. 1935c. "The American Excavations in the Athenian Agora, Seventh Report: The Campaign of 1934," *Hesperia* 4, pp. 340–370.

———. 1935d. "Treasure Trove at Athens: Ceramic Design including the Swastika," *ILN*, October 19, 1935, p. 648.

———. 1936a. "The American Excavations in the Athenian Agora, Ninth Report: The Campaign of 1935," *Hesperia* 5, pp. 1–42.

———. 1936b. "The Current Excavations in the Athenian Agora," *AJA* 40, pp. 188–203.

———. 1936c. "The Conclusion of the 1936 Campaign in the Athenian Agora," *AJA* 40, pp. 403–414.

———. 1936d. "A Feeding-bottle of 1000 B.C.; and Art Relics of Many Periods from the Athenian Agora," *ILN*, July 18, 1936, pp. 120–121.

———. 1936e. "Revelations from the Heart of Greek Culture," *ILN*, July 18, 1936, pp. 118–119.

———. 1937a. "The American Excavations in the Athenian Agora, Twelfth Report: The Campaign of 1936," *Hesperia* 6, pp. 333–381.

———. 1937b. "Excavations in the Athenian Agora," *AJA* 41, pp. 177–189.

———. 1937c. "Athens Two Thousand Years before Pericles: Pottery of the Late Neolithic and Other Early Periods Found in the Agora; with 'Black' and 'Red Figure' Ware," *ILN*, September 11, 1937, pp. 430–432.

———. 1937d. "A Spartan Shield from Pylos," *AE* 1937, pp. 140–143.

———. 1938a. "The American Excavations in the Athenian Agora, Fourteenth Report: The Campaign of 1937," *Hesperia* 7, pp. 311–362.

———. 1938b. "The Wonder City of Ancient Greece Yields New Secrets," *ILN*, July 9, 1938, pp. 58–59, 90.

———. 1938c. "Archaeological Notes: Latter Part of the 1937 Campaign in the Athenian Agora," *AJA* 42, pp. 1–16.

———. 1939a. "The American Excavations in the Athenian Agora, Sixteenth Report: The Campaign of 1938," *Hesperia* 8, pp. 201–246.

———. 1939b. "Discoveries in the Agora in 1939," *AJA* 43, pp. 577–588.

———. 1940. "The American Excavations in the Athenian Agora, Eighteenth Report: The Campaign of 1939," *Hesperia* 9, pp. 261–308.

Smithson, E. L. 1961. "The Protogeometric Cemetery at Nea Ionia, 1949," *Hesperia* 30, pp. 147–178.

———. 1974. "A Geometric Cemetery on the Areopagus: 1897, 1932, 1947," *Hesperia* 43, pp. 325–390.

———. 1977. "'Submycenaean' and LH IIIC Domestic Deposits in Athens," *AJA* 81, pp. 78–79.

———. 1982. "The Prehistoric Klepsydra: Some Notes," in *Studies in Athenian Architecture, Sculpture, and Topography Presented to Homer A. Thompson* (*Hesperia* Suppl. 20), Princeton, pp. 141–154.

Soteriou, G. A. 1934–1935. "Ἀράβικαι διακόσμησεις εἰς τὰ Βυζαντινὰ Μνημεῖα τῆς Ἑλλάδος," *Byzantinish-Neugriechische Jahrbücher* 11, pp. 233–269.

Sparkes, B. A. 1962. "The Greek Kitchen," *JHS* 82, pp. 121–137.

Sparkes, B. A., and L. Talcott. 1958. *Pots and Pans of Classical Athens* (Agora Picture Book 1), Princeton.

Spiro, M. 1978. *Critical Corpus of the Mosaic Pavements on the Greek Mainland, 4th–6th Centuries with Architectural Surveys*, New York.

Steiner, A. 2002. "Private and Public: Links between *Symposium* and *Syssition* in Fifth-Century Athens," *ClAnt* 21, pp. 347–380.

Stern, E. M., and B. Schlick-Nolte. 1994. *Frühes Glas der alten Welt, 1600 v. Chr.–50 n. Chr.: Sammlung Ernesto Wolf*, Stuttgart.

Stevens, G. P. 1954. "Lintel with the Painted Lioness," *Hesperia* 23, pp. 169–184.

Talcott, L. 1933. "Two Attic Kylikes," *Hesperia* 2, pp. 217–230.

———. 1935. "Attic Black-Glazed Stamped Ware and Other Pottery from a Fifth Century Well," *Hesperia* 4, pp. 477–523.

———. 1936a. "A Stand Signed by Euthymides," *Hesperia* 5, pp. 59–69.

———. 1936b. "Vases and Kalos-names from an Agora Well," *Hesperia* 5, pp. 333–354.

———. 1951. "Athens: A Mycenaean Necropolis under the Agora Floor," *Archaeology* 4, pp. 223–225.

Thompson, D. B. 1937. "The Garden of Hephaistos," *Hesperia* 6, pp. 396–425.

———. 1939. "Mater Caelaturae: Impressions from Ancient Metalwork," *Hesperia* 8, pp. 285–316.

———. 1944. "The Golden Nikai Reconsidered," *Hesperia* 13, pp. 178–181.

———. 1954. "Three Centuries of Hellenistic Terracottas, I: B and C," *Hesperia* 23, pp. 72–107.

———. 1959. *Miniature Sculpture from the Athenian Agora* (Agora Picture Book 3), Princeton.

———. 1971. *The Athenian Agora: An Ancient Shopping Center* (Agora Picture Book 12), Princeton.

Thompson, D. B., and R. E. Griswold. 1963. *Garden Lore of Ancient Athens* (Agora Picture Book 8), Princeton.

Thompson, H. A. 1933. "Activities in the American Zone of the Athenian Agora, Summer of 1932," *AJA* 37, pp. 289–296.

——. 1934. "Two Centuries of Hellenistic Pottery," *Hesperia* 3, pp. 311–480.

——. 1937. "Buildings on the West Side of the Agora," *Hesperia* 6, pp. 1–226.

——. 1940. *The Tholos of Athens and Its Predecessors* (*Hesperia* Suppl. 4), Baltimore.

——. 1948. "The Excavation of the Athenian Agora, Twelfth Season: 1947," *Hesperia* 17, pp. 149–196.

——. 1952a. "Excavations in the Athenian Agora: 1951," *Hesperia* 21, pp. 83–113.

——. 1952b. "Excavations in the Athenian Agora, 1952," *Archaeology* 5, pp. 145–150.

——. 1953a. "Excavations in the Athenian Agora: 1952," *Hesperia* 22, pp. 25–56.

——. 1953b. "The Athenian Agora: Excavation and Reconstructions," *Archaeology* 6, pp. 142–146.

——. 1954. "Excavations in the Athenian Agora: 1953," *Hesperia* 23, pp. 31–67.

——. 1959. *The Stoa of Attalos II in Athens* (Agora Picture Book 2), Princeton.

——. 1960. "Activities in the Athenian Agora, 1959," *Hesperia* 29, pp. 327–368.

——. 1962. *The Athenian Agora: A Guide to the Excavation and Museum*, 2nd ed., Athens.

——. 1976. *The Athenian Agora: A Guide to the Excavations and Museum*, 3rd ed., Princeton.

——. 1978. "A Golden Victory," in *Portfolio Honoring Harold Hugo*, Meriden.

Throckmorton, P. 1971. "Exploration of a Byzantine Wreck at Pelagos Island Near Alonnesos," *AAA* 4, pp. 183–185.

Townsend, E. D. 1955. "A Mycenaean Chamber Tomb under the Temple of Ares," *Hesperia* 24, pp. 187–219.

Travlos, J. 1971. *Pictorial Dictionary of Ancient Athens*, London.

Ure, A. D. 1955. "Krokotos and White Heron," *JHS* 75, pp. 90–103.

Vanderpool, E. 1937. "The Kneeling Boy," *Hesperia* 6, pp. 426–441.

——. 1938. "The Rectangular Rock-cut Shaft: The Shaft and Its Lower Fill," *Hesperia* 7, pp. 363–411.

——. 1939. "An Alabastron by the Amasis Painter," *Hesperia* 8, pp. 247–266.

——. 1946. "The Rectangular Rock-cut Shaft: The Upper Fill," *Hesperia* 15, pp. 265–336.

——. 1972. "Ostracism at Athens," in *Lectures in Memory of Louise Taft Semple*, II, *1968–1970*, Norman, Okla., pp. 217–250.

van Hoorn, G. 1951. *Choes and Anthesteria*, Leiden.

Vermeule, E. T. 1964. *Greece in the Bronze Age*, Chicago.

——. 1972. *Greece in the Bronze Age*, rev. ed., Chicago.

von Bothmer, D. 1957. *Amazons in Greek Art*, Oxford.

——. 1985. *The Amasis Painter and His World*, Malibu.

Wace, A. J. B. 1921–1923. "Excavations at Mycenae," *BSA* 25, pp. 1–504.

——. 1932. "Chamber Tombs at Mycenae," *Archaeologia* 82, pp. 1–242.

Waksman, S. Y., and J.-M. Spieser. 1997. "Byzantine Ceramics Excavated in Pergamon: Archaeological Classification and Characterization of the Local and Imported Productions by PIXE and INAA Elemental Analysis, Mineralogy, and Petrography," in *Materials Analysis of Byzantine Pottery*, ed. H. Maguire, Washington, D.C., pp. 107–133.

Webster, T. B. L. 1953–1954. "Attic Comic Costume: A Reexamination," *AE* 1953–1954, Vol. 2, pp. 192–201.

——. 1958. *From Mycenae to Homer*, London.

——. 1960. "Greek Dramatic Monuments from the Athenian Agora and Pnyx," *Hesperia* 29, pp. 254–284.

Wegner, M. 1963. *Musikgeschichte in Bildern* II: *Musik des Altertums, iv. Griechenland*, Leipzig.

——. 1979. *Euthymides und Euphronios*, Münster.

Wehgartner, I. 1983. *Attisch Weissgrundige Keramik*, Mainz.

Weinberg, G. D. 1962. "An Inlaid Glass Plate in Athens, Part I," *JGS* 4, pp. 28–36.

Weiss, C., and A. Buhl. 1990. "Votivgaben aus Ton: Jojo oder Fadenspule," *AA* 1990, pp. 494–505.

Williams, C. K., II. 1969. "Excavations at Corinth, 1968," *Hesperia* 38, pp. 36–63.

Williams, C. K., II, and O. H. Zervos. 1982. "Corinth 1981: East of the Theater," *Hesperia* 51, pp. 115–135.

Woodward, A. M. 1937. "The Golden Nikai of Athena," *AE* 1937, pp. 159–170.

Young, R. S. 1935. "A Black-Figured Deinos," *Hesperia* 4, pp. 431–441.

——. 1938. "Pottery from a Seventh Century Well," *Hesperia* 7, pp. 412–428.

——. 1939. *Late Geometric Graves and a Seventh-Century Well in the Agora* (*Hesperia* Suppl. 2), Princeton.

——. 1949. "An Early Amulet Found in Athens," in *Commemorative Studies in Honor of Theodore Leslie Shear* (*Hesperia* Suppl. 8), Princeton, pp. 427–433.

——. 1951. "Sepulturae Intra Urbem," *Hesperia* 20, pp. 67–134.

Young, S. 1939. "An Athenian Clepsydra," *Hesperia* 8, pp. 274–284.

Index